Manifestations of Venus

Art and sexuality

EDITED BY

CAROLINE ARSCOTT AND KATIE SCOTT

Manchester University Press
Manchester and New York

distributed exclusively in the USA by Palgrave

Published by Manchester University Press
Oxford Road, Manchester M13 9NR, UK
and Room 400, 175 Fifth Avenue, New York, NY 10010, USA
http://www.manchesteruniversitypress.co.uk

Distributed exclusively in the USA by
Palgrave, 175 Fifth Avenue, New York,
NY 10010, USA

Distributed exclusively in Canada by
UBC Press, University of British Columbia, 2029 West Mall,
Vancouver, BC, Canada V6T 1Z2

British Library Cataloguing-in-Publication Data
A catalogue record for this book is available from the British Library

Library of Congress Cataloging-in-Publication Data applied for

ISBN 0 7190 5521 0 *hardback* 1003169729
 0 7190 5522 9 *paperback*

First published 2000

06 05 04 03 02 01 00 10 9 8 7 6 5 4 3 2 1

Typeset by
D R Bungay Associates, Burghfield, Berks

Printed in Great Britain
by the Alden Press, Oxford

MANIFESTATIONS OF VENUS

MANCHESTER
UNIVERSITY PRESS

THE BARBER INSTITUTE'S
CRITICAL PERSPECTIVES
IN ART HISTORY SERIES

SERIES EDITORS
Tim Barringer, Nicola Bown
and Shearer West

EDITORIAL CONSULTANTS
John House, John Onians,
Marcia Pointon, Alan Wallach and Evelyn Welch

Our collection is dedicated to the babies born
during the conception and gestation of this book

Faith

William

Anna

Contents

Illustrations

Preface and acknowledgements

This book owes much to the energy and collective enthusiasm of our women colleagues at the Courtauld Institute of Art. Women teachers at the Courtauld started to meet regularly as a group in the mid-1990s, to exchange views about research and teaching, and for the fuller enjoyment of one another's company. That forum adopted the book project that the two of us had formulated, finding that it offered an opportunity for working out collaboratively the participants' variously historical, ideological, psychoanalytic and gender interests in the relationship between the aesthetic and the libidinal. Though only certain members of the group did ultimately submit chapters for this book, many were actively involved in the reading and discussion sessions and symposia organised in preparation of the text. We would like warmly to acknowledge the support and contributions of all our women colleagues, most particularly Joanna Cannon, Sarah Hyde, Julia Kelly, Susie Nash and Mignon Nixon. We were all delighted that Tag Gronberg from Birkbeck College joined the fray, making a great contribution to our discussions and allowing the enterprise to become a more rounded University of London endeavour. We are also happy that Jennifer Shaw has contributed a version of her excellent article on the Salon Venuses of 1863 and enjoy the serendipity of welcoming this piece home, as it were, since it was originally developed in London. We thank the editors of *Art History* in whose journal her essay was first published.

This publication takes Venus as the incarnation of sexual love *par excellence* and centres on her presence in art. It would have been possible to introduce myriad examples from the Renaissance to the twentieth century and our focus is necessarily selective. Our selection is designed to signal the range of issues operative in European art in the period under consideration. The multiple Venuses provide opportunities for comparison across this wide historical field and startling disparities emerge. But equally Venus pulls the project together. We dwell on the recurrence of the motif of Venus (and Cupid) as a way of engendering a coherent discussion of art and sexuality. Our contributing authors do not employ a uniform method, but this book does, nonetheless, represent a shared intellectual project. The aesthetic is central to our concerns, but for none of us is it to be considered in isolation from gender politics, from historical circumstances or from the constraints and morphologies of representational conventions. These premises are fundamental to the kind of art history that we inhabit and seek to develop. We hope

that the project will be of value to the wider scholarly community, offering material of interest to other academics and a useful resource for those planning courses and those taking courses in art history, history, and cultural and gender studies.

We are grateful to the staff in the Academic Office at the Courtauld Institute who have helped in many practical ways. We would also like to thank the research assistants who have helped assemble and prepare the manuscript, in particular Matthew Plampin and Sarah Monks. Finally we would like to thank Manchester University Press for taking on the book and for their responsiveness and commitment in seeing the work through to publication in time for RAE 2000.

<div style="text-align: right;">

Caroline Arscott

Katie Scott

</div>

Contributors

Caroline Arscott is Senior Lecturer in nineteenth-century British art at the Courtauld Institute of Art in London. She is on the editorial board of the *Oxford Art Journal*. She is a contributor to the following volumes of the Paul Mellon Centre's *Studies in British Art*: *Towards a Modern Art World* (1995), *Frederic Leighton: Antiquity, Renaissance, Modernity* (1999) and *Seductive Surfaces: The Art of Tissot* (1999). She has contributed an essay, 'Representing the Victorian city' which appears in *The Cambridge Urban History: Volume 3* (2000). She is currently completing a book-length study on Victorian art, technology and temporality.

Shulamith Behr is Senior Lecturer in German art at the Courtauld Institute of Art. She has contributed widely to the study of German Expressionism: as an editor, jointly with David Fanning and Douglas Jarman of *Expressionism Reassessed* (1993), as the visiting curator and author of the accompanying catalogues to the exhibitions on Conrad Felixmuller at Leicester and the Courtauld Institute in 1994, and as the author of *Expressionism* for Tate Gallery Publishing in 1999. She has published a growing body of work focusing on the contribution of women to the art world: she contributed to the catalogues of the Gabriele Münter (1992–93) and Sigrid Hjertén (1999) retrospectives held in Germany and Sweden and is completing *Women in Expressionist Culture: Artists, Patrons and Dealers* for Princeton University Press.

Tag Gronberg is Lecturer in History of Art and Design at Birkbeck College, University of London, and is on the editorial boards of *The Oxford Art Journal* and *The Journal of Design History*. She has published extensively on Parisian visual culture and is the author of *Designs on Modernity: Exhibiting the City in the 1920s Paris* (1998). Her current research is on twentieth-century Vienna.

Patricia Rubin is Reader in the art of the Italian Renaissance at the Courtauld Institute of Art. Her book *Georgio Vasari. Art and History* (1995) won the Mitchell Prize in 1995. She is the author of the catalogue, jointly with Alison Wright, of the exhibition *Renaissance Florence: The Art of the 1470s* mounted at the National Gallery in October 1999. She is editor with Giovanni Ciappelli of the recent *Art, Memory and Family in Renaissance Florence* (2000) and is currently completing *Images and Identity in Fifteenth-Century Florence* for Yale University Press.

Katie Scott is Lecturer in early modern French art and architecture at the Courtauld Institute of Art. She is the author of *The Rococo Interior: Decoration and Social Spaces in*

Early Eighteenth-Century Paris (1996) and editor with Genevieve Warwick of *Commemorating Poussin: Reception and Interpretation of the Artist* (1999). She is currently working on a book-length study of the relationship between art and law in eighteenth- and early nineteenth-century French art.

Jennifer Shaw works on issues of gender and subjectivity in nineteenth- and twentieth-century art and photography. She is Assistant Professor of Art History in the Department of Art and History of Art at Sonoma State University, California. She is currently working on an analysis of Claude Cahun's photographic and literary production. She is the author of *Dream States: Puvis de Chavannes, Modernism and the Fantasy of France* (2001)

Sarah Wilson is Reader in twentieth century art at the Courtauld Institute of Art. She has published extensively on European art, focusing on the years after 1945. She was notably involved with the exhibitions *Paris-Paris* (Centre Georges Pompidou, Paris, 1981), *Aftermath, New Images of Man* (Barbican Art Gallery, London, 1982) and *Paris Post-War* (Tate Gallery, London, 1993). She is preparing a major study of art and politics in France for Yale University Press, the exhibition *Paris, Capital of the Arts, 1900–1968* for the Royal Academy, London and is editor of the 'Revisions' series for Black Dog Publishing, which aims to recontextualise critical writings on European art by major philosophers and thinkers.

Joanna Woodall is Senior Lecturer in early modern Netherlandish art at the Courtauld Institute of Art. She edited, introduced and contributed to the book of essays, *Portraiture: Facing the Subject* (1997) and has written widely on portraiture and issues of realism for *Art History*, the *Berliner Jahrbuch*, the *Leids Kunsthistorisch Jaarboek* and the *Nederlands Kunsthistorisch Jaarboek*. Her contribution to this book develops an interest in the relationship between realism and desire which she first explored in an article on the ideological role of love in Netherlandish art published in *Art History* in 1996. She is currently completing a major study of the sixteenth century portrait specialist, Antonis Mor, for Yale University Press.

1

Introducing Venus

Caroline Arscott and Katie Scott

In the spring of 1820 a Greek peasant turning the sod on the island of Melos dis-
covered in a cavity opened up by the pressure of his plough the fragmented remains
of a Venus which has since become one of antiquity's most celebrated statues
(Figure 1). The brief story of the marble goddess's unearthing, of her mutilation, of
her triumphant arrival across the water to welcoming Western shores, and of her
diffusion by means of casts and copies promises a securely concrete example via
which initially to explore the complex seductiveness of a goddess who of all the
pagan gods, one might think, least stands in need of an introduction. Moreover, fig-
uratively speaking, the history and appearance of the *Venus de Milo* suggests
metaphors which capture something of the character of the collective endeavour
which has given life to the chapters in this book. Thus, excavation, or the bringing
to the surface of things formerly hidden, accurately describes the ways in which
manifestations of Venus have been sought out, sometimes in unexpected, superfi-
cially unpromising places.[1] Likewise, the armless state of the goddess, recovered
initially in, and with, parts evokes a past in pieces; by nature and necessity frag-
mented, ruined. Indeed, in her blatant imperfection she perfectly personifies the
disturbance, the inevitably shattering effects, of desire on the wholeness and
wholesomeness of tradition, the very effects with which we are concerned. Shifting
perspective from method to field, the circumstances of *Venus*'s 'rescue' – from an
island and across water – speak of re-birth, *renaissance*, in a way appropriately con-
sistent with the chronological parameters of this collection. We open with *the*
Renaissance for which the discovery of antiquity and more especially of Venus con-
stituted, according to Patricia Rubin in chapter 2, a defining moment. Finally the
grand scale of the reproduction and dissemination of the *Venus* raises questions
about the evergreen allure and enduring power of images of Love which any study
of the relations of art and sexuality must address.

 This introduction to Venus does not attempt to summarise the following chapters
but tries to indicate lines of enquiry that are forcefully suggested by the material con-
tained in the book. Contrary to expectation, perhaps, our discussion does not target
the issue of the feminine directly. Rather, our findings concerning gender arise tan-
gentially (but no less significantly) from a meditation on the figure produced by the

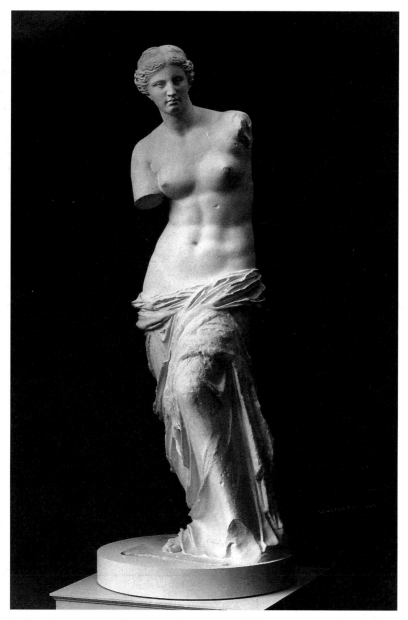

1 *Venus de Milo*, 2nd century BC, marble.

coincidence of art and sexuality. This chapter is a retrospective rumination, produced in the wake of this project. Our comments arise from the juxtapositions and common themes that emerge when an array of scholarly writing is assembled, as it is here, and we make propositions that point beyond the book itself, perhaps to further

avenues of research or to fresh ways of theorising the juncture between the aesthetic and the libidinal. We also give an inkling of the history of the Venuses, the literal objects, classical artefacts that held such a privileged cultural position in Europe, foregrounding the *Venus de Milo* as one prominent example. These Venuses interpose insistently between the figuring of Venus in art (which is the common theme of the chapters in this book) and the narratives alluded to, or the mythological realm that is invoked when Venus is represented. The Venus motif in early modern and modern art cannot help but maintain a reference to these classical artefacts, even when there is not a forceful visual resemblance. This strongly marked cultural authority of the Venuses produces a curious situation in which it is impossible to deploy Venus as a subject like any other subject for art because the objectness of these classical sculptures intrudes. We have tried to develop an account of the unique status of Venus as a sign that follows from this situation.

The finding of the *Venus de Milo*

In the vast literature that now exists concerning the discovery, attribution, dating, interpretation and projected restoration of the Louvre's near-naked icon the comte de Marcellus's *Souvenirs de l'Orient* (1839) has long been shunned as a tainted source.[2] As the secretary to the French ambassador to the Ottoman court at Constantinople, Marcellus had early taken charge of negotiations for the acquisition of the Venus and was thus supremely well placed to know all that transpired.[3] But, it is alleged, the demands of international diplomacy and royal sycophancy produced distortion in his recollections, forcing omissions of one kind and elaborating fantasies of another.[4] To be precise, the count stands accused of covering up a pitched battle between Frenchmen and Turks on the beaches at Melos for possession of the *Venus*, and of conspiring with members of the reception committee in Paris to discredit the evidence of an inscription found with the statue which unequivocally contradicted the attribution to Praxiteles many were eager to moot. Such deceits speak positively of the Venus as an object of desire: an object for possession of which life might be risked; an object so love-ly, so seductive that only the hands of one with a reputation for having rivalled nature could conceivably have made it.

Though Marcellus never admits to a fight, the *Souvenirs* repeatedly invoke strife between the contending French, Greek and Turkish parties for possession of the *Venus*. In general, this leitmotif of conflict reminds us that the figure of Venus came to stand for an eroticised beauty that was bound up with violence. She offered pleasure that was provisional; a dalliance that was prone to violent interruption and violent reversals. More particularly, the distribution of the means and use of force in the text in a pattern that contrasted the French (heavily armed but choosing rather to persuade by force of reason) with the Turks and Greeks (poorly equipped but willing in their ignorance and greed to seize the statue by force, though damage was certain) crudely and predictably put into play a set of reinforcing oppositions

between West and East, Christian and Muslim, reason and passion, civilisation and barbarism.[5] As such the violence of the narrative also had something to say about the origins of Western culture. In justification of a 'purchase' which verged on the plunderous, Marcellus mobilised what Martin Bernal has termed an 'ayrian' or Eurocentric view of Greek civilisation.[6] According to this model, the Egyptian origin, the black skin of Aphrodite was erased.[7] In its place arose a goddess white as the crests of the waves on which she mythically rode, or pearly as the shell in which she was thought to glide; her homeland no longer, or even once, the Levant but Europe. Marcellus was, from this perspective, only seizing that to which as a European he was particularly entitled. So-called Aryan historiography only gained currency in the nineteenth century but an Aryan attitude, that is a view of Greek antiquity as immediately accessible to and uniquely the heritage of the West, has a much longer history dating back to the Renaissance. It is largely from within this prejudiced paradigm that the works discussed in this book were produced and, consequently, largely from within it that they are explored.[8]

The stance of the artist

The cultural nearness of Venus is conveyed unintentionally in the *Souvenirs* by Marcellus's account of his efforts to gain possession of the Melian statue. From no more than a description at second hand and the sketchiest of sketches he apparently recognised her, and was forced to negotiate for her sight unseen.[9] Intentionally, of course, Marcellus's playing-up of his thwarted attempts to see the *Venus* served to guarantee the disinterestedness of his judgement during the negotiations. But this certainty, authority and detachment give way when he finally approaches the figure.[10] As a latter-day Anchises, he looks on her with the uncertain burning eyes of a lover.[11] The text maintains this dual perspective throughout: that of the 'father' who saves, protects and names the statue, thus more or less giving her new life, and that of the 'lover' whose feeling eyes consume her, and who by alternating turns of possessiveness and pride conceals or exhibits her to the view of others.[12] Moreover, taking account of the classical quotations deployed by Marcellus in praise of the statue it appears that the stance of the 'father' may be identified with that of the artist inasmuch as Lucretius, in *De Rerum Natura* (to which Marcellus refers), principally evokes Venus as the goddess of fecundity without whom 'nothing comes forth into the shining borders of light, nothing joyous or lovely is made'.[13] And just as the poet craved her as 'a partner' in writing his verses, so Marcellus acknowledges that it is chiefly to the discovery of her that his own creation, the *Souvenirs*, owes its interest and its worth.[14] However, the aesthetic and the libidinal are not ultimately separable, a state of affairs acknowledged by Marcellus's naming of the Melian goddess *Venus Victrix*, a title that by tradition refers to Paris's judgement in favour of the erotic beauty of Venus and of the promised rewards of love, but which here is reoriented to assert in Marcellus's judgement the superiority of this *Venus* above all others. The judgement of flesh and of stone are thus made one.

Many of the chapters in this book, notably those by Joanna Woodall, Tag Gronberg, Caroline Arscott and Katie Scott, are concerned similarly with artistic creativity as a Venus effect. And all attend in some way to the constant switching between ostensibly aesthetic and avowedly erotic desires provoked by contemplation of her image. Though Marcellus offers no self-aware account of his response, his indirectly made attribution of the *Venus* to Praxiteles[15] invokes a legacy of narrating the unstable conjunction of art and sexuality to which Wtewael's *Andromeda*, Sonia Delaunay's geometrically patched coats, Bouchardon's *Amour* and Gibson's *Venus* are just the most obvious successors. In Pliny's *Natural History* and in the historical tradition which descended from it to Winckelmann and beyond, Praxiteles stands for two things: the introduction of 'naturalism' or worldly pleasure to a formerly austere and ideal visual culture,[16] and the 'invention' of the female nude, most famously in the Aphrodite of Knidos.[17] The two elements came together in the fascination then and thereafter with the relationship between the sculptor and his model, the courtesan Phryne.[18] Praxitiles's capacity to transcend his materials, to capture nature *au vif* and to infuse it with thrilling sensuality is directly linked by Pliny to the sculptor's love of the model. The artist's desire elicits a corresponding response in the viewer; in the case of Alketas the Rhodian a desire so compulsive that a nocturnal rape of the work resulted.[19] Artist and viewer thus become linked in a powerful triadic relationship across the nude, marmoreal body of Venus. This geometry of love recurs most clearly in Woodall's analysis of Wtewael's *Perseus and Andromeda*: the painter and *liefhebber* (the painting's ideal, *amateur* viewer) are, Woodall argues, united by a drive to penetrate, to reach beyond, the lustrous surfaces of the painted nude in pursuit, though, of a disinterested, not a lustful, love. Gronberg uncovers at the 1925 *Exposition internationale des arts decoratifs et industriels* an analogous, though psychically and culturally more disturbing, complicity between the woman artist and the female consumer whose narcissistic desires were met by the Deco Venus and her irresistible girdle of fur. By contrast to such fictions of a libidinally accessible representation, Arscott and Scott variously maintain that the sublimated sexual interests of Gibson and Bouchardon respectively find expression in an extreme, almost perverse, attention to skin – its colour, its texture – the power of which ultimately repels as it fascinates.

Venus as a sign for art

The passage from Venus as a figure for artistic creativity to Venus as a sign for art itself is easily made. Since Venus is pre-eminent in beauty, as well as in sexual love, her presence in art triggers a meditation on the domain of the aesthetic. The special power of art can be presented and contemplated in terms of the libidinal sway of the goddess. Artistic allusions to Venus invite us to see art itself as cosubstantial with the body of the goddess: seductive in its contours, colour, texture or surface, irresistibly inciting feelings of pleasurable excitation. The Louvre's loss of its art treasures during the occupation was thus fittingly equated to the loss of a beloved

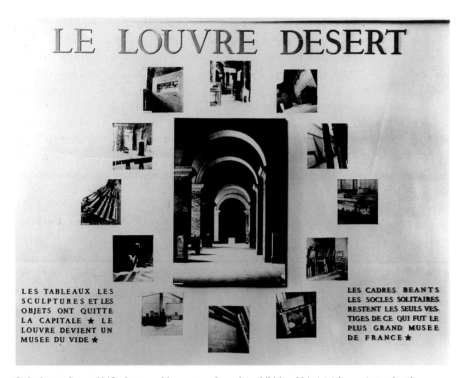

LE LOUVRE DESERT

LES TABLEAUX LES SCULPTURES ET LES OBJETS ONT QUITTE LA CAPITALE ★ LE LOUVRE DEVIENT UN MUSEE DU VIDE ★

LES CADRES BEANTS LES SOCLES SOLITAIRES RESTENT LES SEULS VES-TIGES DE CE QUI FUT LE PLUS GRAND MUSEE DE FRANCE ★

2 *Le Louvre Desert*, 1945, photographic montage from the exhibition *L'Activité des musées pendant la guerre*.

mistress via the mournful image of the *Venus de Milo*'s empty pedestal (Figure 2). However, the physical response posited is not, for the most part, envisaged as the base animalistic sexual response that society derogates. For the greater part of the period considered in this book, religion and philosophy recommended or instructed humankind to hold such sexual instincts in abeyance. The idea of Venus offered an alibi for sexual abandon. The seduction imagined as being perpetrated by the aesthetic, under the aegis of Venus, is the seduction of the arch-seductress. Venus is a goddess after all and her powers cannot be resisted by the mere will of mortals. The fantasy is of an irresistible, engulfing effect that sets asceticism and self-denial aside. The charms of the goddess and, by implication, aesthetic experi-ence, are conceived of as going beyond the brutal physical realm. Arousal mingles with worship, passion with veneration. The double nature of Venus, low and high, makes the metaphorical identification of Venus with art especially durable.

The obdurate physical existence of the art object, the fact that it has an irreducible material grounding, for instance in paint, stone, or fabric, has repeatedly proved an embarrassment to those wishing to make elevated claims for art. However, art's physicality can be acknowledged if it is identified with the corporeal manifestation of a divine being. The chapters in this book indeed make a point of addressing this physical and seductive side of Venus, and its analogue in art itself. Thus Woodall's

chapter draws out Wtewael's demonstration of the link between the double nature of Venus and the double nature of art. Both have a low aspect as well as an elevated one. Art is low first because of its physical substance: 'the messy, material debris of the painter's studio which lies behind pictorial beauty', as she puts it. But it is doubly so inasmuch as it necessarily refers to the natural world by an act of representation; it is thus rudely conjoined to the bones and filth of the fallen world. Shulamith Behr's chapter works through parallels between the depicted figure, whether Venus or servant girl, and the body of the painting's materials. So we encounter an analogy between the bare canvas and the anticipated congress of the paint with its virgin substance. Arscott discusses an allusion in Burne-Jones to clay as a sculptor's material, and posits a further allusion to the clay of the mortal body; all this at the point of maximum libidinal attention to the sculpted figure, in the sway of Venus. Lastly, Gronberg focuses attention on the ways in which fur stands on the border between painting and *art decoratif*, facing forwards as a sign of the (male) artist's mastery of his materials to the point of *trompe l'œil*, and facing backwards as feral stuff of female high fashion. So in all these cases the motif of Venus (whether explicit or implicit) triggers and facilitates an exploration within the artwork of the gross materialism of art, without losing sight of its highest and purest aspects.

Display

The degree to which the ideal or the real, the high or the low are in the ascendency in Venus is determined in no small measure by the spaces she haunts. The *Venus de Milo*'s establishment at the Louvre secured for her, in her dual capacity of ancient object and modern icon, a place which worked simultaneously for the elevation of beauty and the erasure of the sexual. As Ian Jenkins has made clear, nineteenth-century arrangements of antique sculpture tended initially to follow the conventions of an earlier era, conventions he characterises by a phrase taken from political discourse, 'the chain of being'. Accordingly, antiquities were grouped by estate not chronology.[20] Photographs of the *salles des antiquités* at the Louvre dating from as late as the 1870s (Figure 3) indeed confirm that the *Venus de Milo* presided over a section of long gallery lined with other divinities – Venuses, in the main – rather than a place populated by a heterogeneous assembly of fourth-century Greek works, the era from which she was thought to hail.[21] Hence, gods and goddesses were set apart and above noble heroes and vulgar mortals, their frigidly luminous divinity accentuated by strongly contrasting background colours, in this instance, the sumptuous red of a deeply folded curtain.[22] In the same spirit, scholarly and general catalogues and antiquarian histories spoke of her beauty in the predetermined, hushed terms demanded by the ideal.[23] That the politics of this aesthetic space were sexual, even in their denial of sexuality, was, however, humorously revealed in a caricature by Frederick Barnard (Figure 4) possibly produced during the Franco-Prussian war and in which a gormless French soldier gazes uncomprehendingly at the Venus as she rises

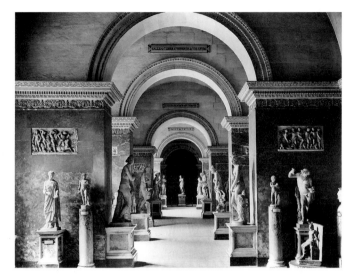

3 *Salles des antiquités, musée du Louvre,* after 1896, photograph.

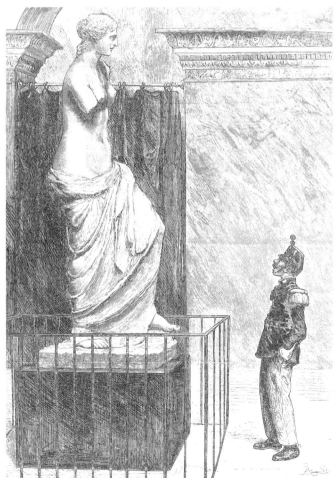

4 Frederick Barnard, *Venus and Mars at the Louvre, c.* 1871, wood engraving.

hugely above him. Entitled *Venus and Mars at the Louvre,* the image turns a trophy of conquest, a proof of potent royal ambition, into its opposite: evidence of France's glaring sexual, and by extension military and cultural, inadequacy.

Barnard's smugly satiric construction of France's pre-eminent Venus as 'Venus Dominatrix' notwithstanding,[24] so successful was the museum in positioning the goddess of Melos, and her *semblables,* in terms of ideal beauty that, for many, she lost all semblance of her defining sexual allure, residing at the Louvre in name only. In *Croquis de Paris* (1880), for instance, Huysmans contrasted his instinctive and energetic response to the realist mannequins in the rue Legendre with the tired, 'learned joys' of devotees of antiquity driven yawning into the Louvre on rainy days.[25] Between the gutter's realism and the museum's classicism a host of less starkly polarised spaces of Venus are explored by the contributors to this collection: the Renaissance house, the humanist's *kunstkamer,* the baroque palace, the public exhibition, the nineteenth-century studio and the twentieth-century trade fair. The hybrid space of the Salon (place of spectatorial amusement analogous to the boulevards *and* destination of art contiguous with the museum), for instance, generated desire for a canny Venus poised between purity and excess. Thus, according to Jennifer Shaw, in the depictions of the birth of Venus variously interpreted and submitted to the Salon by Cabanel, Baudry and Amaury-Duval in 1863, the crisply painted sea alluded metaphorically to the ebb and flow of woman's chaotic fertility; to the threat of her low. Shaw argues, moreover, that Cabanel owed his success with the critics to the finely judged tension he struck in his work between the rolling sexuality signified and the signifier's classic, elevating, mastery of sensuous form. The antinomies of inner and outer, celestial and material, feminine and masculine were thus maintained in perfect friction.

Taxonomy and aesthetic hierarchy

Attending to the display of Venus raises questions in addition to those of place. In the case of museums or collections it also draws attention to matters of classification and arrangement. Owing in part to the difficulty of securely dating antiquities, the organisation of nineteenth-century collections habitually dispensed with history; the groupings by subject matter suggesting on the contrary that all Venuses (for example) were of a moment, timeless and culturally equivalent; in short, variations on a form. The resultant loss of origin was deeply felt by Marcellus, among others. For him the Melian Venus was quite literally a souvenir, and to the last he wished to 'wrench' her 'from the obscurity in which she lives under the dull, chill vaults of the Louvre' – the display thus presented as a second entombment requiring a second rescue – and to restore to her 'a ray of that sunshine which witnessed her youth and illuminated her beauty'.[26] Specifically, Marcellus's nostalgia demanded that 'his' Venus be isolated in triumph under the canopy of a circular tempietto.[27] In sharp contrast, the gallery's almost infinitely extendible perspective (see Figure 3) threatened an indefinite seriality; Venus *en abyme*. However, as Susan

Stewart notes in her fine analysis of the contrasting modes of the souvenir and the collection, what the collection loses in warmth of historical remembrance it gains in cool formal or aesthetic discriminations.[28] Thus by such thronged assemblies of goddesses were Europe's scholars and aesthetes made increasingly sensible of difference between surviving antique Venuses.[29]

Though it was not until 1873 that the Swiss archaeologist J. J. Bernoulli made a comprehensive 'collection' of Greek Venuses,[30] the goddess had long before constituted an aesthetic category within which degrees of perfection and worth were variously apportioned by type: 'Anadyomene' ('Rising from the Sea'), 'Capitoline', 'Crouching', 'Genitrix', 'Sandalbinder', 'Victrix', etc.[31] The introduction of the *Venus de Milo*, the first authentic Greek work, to this relatively select company precipitated a re-evaluation of Venus's other incarnations. In the Melian figure was immediately discovered all that is 'ideal and sublime in art',[32] and thereafter her 'grand forms', 'noble bearing' and 'calm and impassive' expression were attributed to the necessarily 'solemn' beauty of a 'goddess'.[33] By contrast, the *Venus de' Medici* (Figure 5), compared in looks by the eighteenth-century antiquarian J. J. Winckelmann to the budding beauty of a rose in the afterglow of dawn,[34] attracted, a century later, the complaisant contempt of Wilhelm Lubke for whom she held no more than the questionable 'charms of a coquettish woman'.[35] What we have here is more than the recurring division of high and low. These patterns of critical fortune intersect significantly with the order of value that the modern science of myth was, from the mid-nineteenth century, striving to put into place.

Marcel Detienne has shown how from the moment that myths lost their quotidian powers of persuasion science envisaged mythology as a discourse of the scandalous, of the irrational, abject behaviour of the gods, for which it had to give some account.[36] Whether the final cause was advanced as linguistic or anthropological, the new mythology effected a radical separation between Greek religion and Greek myth, the first recognised as the product of ancient man's highest spiritual aspirations,

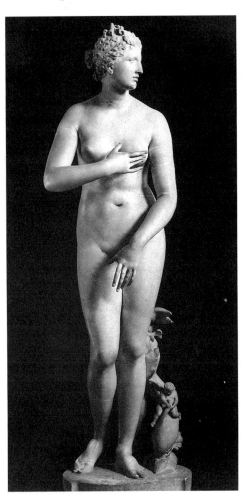

5 *Venus de' Medici*, 1st century BC, marble.

the second as gross imaginings prompted by his sinful curiosity. A similar process of bisection may be observed in judgements of taste. For instance, Le Comte de Lisle in his poem *La Vénus de Milo* (1852) pitilessly divides the goddess from the impassioned literary myths of her birth, her loves, her companions in beauty; the divinity beneath these unworthy narrative excrescences stands alone and partakes rather of the colourless inertia of stone.[37] Likewise, and to return to Lubke's cutting comments about the Medici *Venus*, the banal, human eroticism he spies in her is attributable above all to the turn of her head and her so-called 'pudica' gesture.[38] 'From her apparently modest bearing', writes Lubke, she 'seems to challenge the admirer whose attention she is seeking': the point being not so much whether the right arm that crosses the body at the level of the breasts and the left hand that hides the genitals convey shame or provocation, but rather that, either way, in the opinion of the nineteenth century, these gestures were reactive and thus marked her entry into narrative.[39] The *Venus de' Medici* had seemingly forfeited her divine autonomy and power.

Venus multiplied

If the history of the conservation and display of the *Venus de Milo* at the Louvre can be interpreted in terms of a pursuit of aura (arguments for the restoration of the goddess's gestures along with her limbs were consistently rejected; the *salle de Venus* and those spaces adjacent to it were gradually emptied of contaminating company), the phenomenon of her mass reproduction roundly reinstated the erotic. Honore Daumier's *L'amateur* (Figure 6) does not exhibit awe as he contemplates the goddess in his collection.[40] The miniaturisation of *Venus* reduces her to the domestic status of an object of desire and possession. Moreover the rising sexual temperature of the plaster is accentuated by drapery that has slipped in the process of repetition to reveal the slopes of the *mont de Venus* more clearly, by the lightly twisted remoulding of her upper body which together with the engaging angle of her head hint at interaction between statue and viewer. Like Freud's old boy who collects snuffboxes, Daumier's *L'amateur* is literally a 'lover'; the hunger of his gaze exposed by the typically spying look of the satyr on the pedestal behind him.[41] Though the point of Daumier's image is clarified by the liberties he takes with the *Venus de Milo*, by her reshaping as a *Venus de' Medici*, the projecting of libidinal fantasies on to the *Venus* is not dependent on this fiction of receptivity. Freud elaborates elsewhere on the seductiveness of the narcissistic woman – beautiful, self-regarding, out of reach.[42] Significantly, a much favoured 'restoration' of the Melian goddess had her staring at her own reflection in the shiny glare of a polished shield, a variation on ancient narratives of Venus's pleasure in her own image.[43] Thus for all the talk of the *Venus de Milo* in terms of ideal beauty, the dichotomy of goddess and coquette, of Virgin and Eve, was not as stable and unproblematic as that of religion and myth. Moreover, the viewer takes his pleasures on both sides of the border.

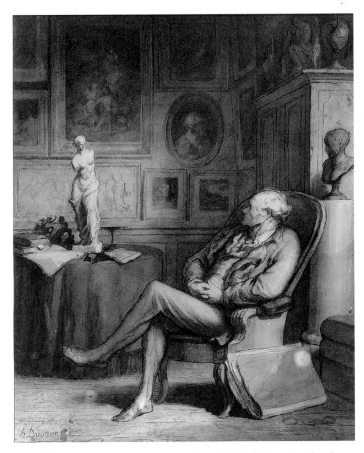

6 Honoré Daumier, *L'Amateur*, between *c.* 1863–70, black chalk, pen, wash and watercolour.

The divided body

In many cases the aesthetic and sexual charge of the Venuses is implicitly contingent on claims as to their wholeness and integrity as figures, that is to say, to their perfection as imitations. We recall that Marcellus's invocations of the beauties of the *Venus de Milo* unfolded as if the statue were undamaged. Moreover, as Mary Bergstein has shown, nineteenth-century photographs of it, such as Adolphe Braun's, attempted by choice of camera angle, depth of field and penumbral lighting similarly to deny the goddess's mutilation.[44] It seems that there was an urge to move from the fragment to the perfect whole, and a readiness to invest the potential for wholeness in the potent fragments of Venuses as they were found and displayed. The fragments of statuary were taken to contain not just doubtful intimations of complete symmetry and endowment but somehow to announce and

guarantee those qualities. In this respect they were used as a bulwark to the academic priorities and ideals that had been installed and developed in the early modern period. In an essay entitled 'The Venus de Milo and "internal objects"' (1979), Peter Fuller suggests that in the modern era a new sensibility emerged that valued the fragment in its own right, over and above the whole original. A claim is made for a shift in aesthetic sensibility.[45] Proceeding from a remark let slip by Adolf Furtwangler in his historiographically ground-breaking and otherwise 'objective' analysis of the *Venus* to the effect that the forfeiture of the arms was no great loss because the resulting fragment was aesthetically to be preferred to a whole original,[46] Fuller asserts the appeal of the injured goddess in the modern era and argues that it can and can only be fully explained in terms of Kleinian psychology.[47] Contrary then to Pliny's stylistic history of ancient art, and to much of the art and art theory that descended from it, Fuller argues that representations of the female body owe their sensual thrall not so much to the illusion, as to the dissolution of the real.

Fuller's remarks give us the opportunity to shift our focus from the specific history of the actual artefact the *Venus de Milo* and to think more generally about the psychic investment in this Venus and others. Whether there is an absolute shift in aesthetic criteria is debatable: the currency of Venus in European culture has always comprised a response to both the fragmentary and the whole. The conundrum is the ability to thrill to the fragment *and* conjure up the whole.

The 'internal objects' of Fuller's title refer to the dialectical process of introjection and projection by which, according to Melanie Klein, the ego is formed and develops. The child seeks to introject the good and fulfilling breast/mother and to project and attack the bad. According to Fuller, traces of this schizoid dualism are to be found in the conquest of the *Venus de Milo*: in the desire for her and, more tellingly, in the attacks upon her when possession was threatened.[48] Thus the removal of *Venus* from Melos was not for him racially but psychically motivated.

More important than this early phase, however, is the 'depressive' stage which succeeds and replaces it, so-called because from this moment the infant recognises that 'good' and 'bad' are no more than different responses to the same whole-objects and in so doing is overcome with feelings of remorse and loss for the loved one whom he or she has seemingly alienated by phantasised ill-treatment. For Fuller the reparative impulses to which the experience of desolation give rise betray themselves literally in the nineteenth-century obsession with restoring the statue. He notes, moreover, that many of these early projected restorations, in imitation of a group in the Capitoline, pair the *Venus* with Mars (Figure 7) over whom *Venus* is shown exercising a loving dominion by the caressing action of her restored limbs.[49] As the instrument of peace Venus thus connotes the return of life and prosperity after the death and destruction of war (Mars), and as such she gives explicit narrative articulation to the work accomplished by the reparative drives. If the libidinal investment in archaeological restoration is often not fully apparent in the examples sampled by Fuller it is, by contrast, a conspicuous

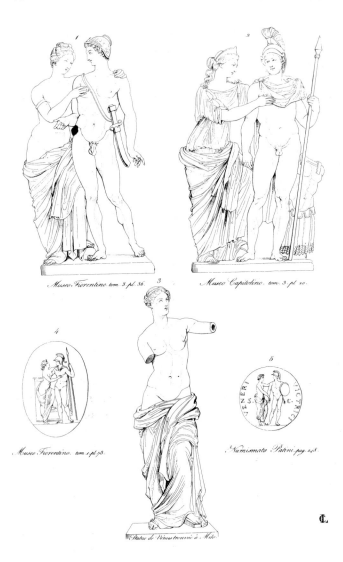

7 Quatremère de
Quincy, *Venus de Milo*,
c. 1802, line engraving.

leitmotif of Champfleury's satirical short story *Les bras de la Venus de Milo* (1873).
There Champfleury elides from the outset the penetrating gaze of the aptly
named M. Protococus, a German archaeologist, and his reconstruction by enact-
ment of the Venus's amorous pose.[50] The quest for carnal knowledge and the
search for archaeological or historical truth are thereby thoroughly, if grotesquely,
confused.

In many respects the accounts of the *Venus de Milo* by Marcellus and Fuller
could not be more different. Marcellus's is one of self-aggrandising discovery and
fantasised wholeness; Fuller's one of scholarly detachment, of the significance
of loss and of the phantasised part-object, though he acknowledges a need to

'confront' his own obsession with the work. Yet in other respects they have much in common. They share a view of Venus as the very ground of ambivalence.

Fuller's analysis has not remained unchallenged. His account of the aesthetic is underpinned by a claim for a genderless biological ideal, and layered upon that is an observation about a taste in the modern era (a preference for the fractured and incomplete) which is formulated from within modernism (and in his case a right-wards-moving modernism) and cannot see beyond the parameters of that positioning.[51] Kleinian analysis has of course been used very differently in more recent art historical analysis which takes the investigation of the pre-symbolic or the sub-symbolic in different directions.[52]

For our purposes his analysis is helpful in drawing attention to the way responses to ancient Venuses are governed by their appearance in parts. We can entertain the idea that these body parts relate to the part objects of Kleinian psychoanalysis, or indeed to the various objects, maternal body parts and their substitutes of Freudian psychoanalysis. The extreme intensity of cultural investment in Venus, shattered or complete, would seem to indicate a level of psychic investment, which, perhaps, can be investigated in a variety of ways. Most intriguingly in the late 1950s Jacques Lacan commented on the Kleinian school and their efforts to develop aesthetic theory in his 'Seminar VII' of 1959–60.[53] Lacan's attempt to develop ideas brought to the fore by the Kleinian school offers particular possibilities for our investigation because he forges a link between the psychic response to the part object and the cultural formations (religion, law, art) that are conditional on its special power. Since we are considering the role of Venus for art and as a sustaining presence in the academy,[54] Lacan's attention to the position and function of extreme pleasure in the fabric of cultural life is valuable to our project.[55] It offers a way of considering taste and response in a way that has the potential to overcome categorical polarisations, both at the level of periodisation and at a given historical moment. Instead of mapping entrenched and divergent positions in the responses elicited by the figure of Venus we can look for oscillations in response.

Lacan refers to Melanie Klein, Ella Sharpe and M. Lee as developing a theory of sublimation, and of the creative efforts that result. This theory attributes to sublimation an attempt to repair 'the imaginary lesions' that have occurred to the fundamental image of the maternal body'.[56] Lacan asks whether we can be satisfied with the Kleinian account, which seems to him to offer some purchase on the question of the link between the artwork and the notion of a damaged or fragmented maternal body; and predictably his answer is no.[57] Instead he is concerned to elaborate a field of the Thing (*das Ding*), which he describes as the most fundamental and most archaic of objects, the object for which we are always seeking, though we as conscious subjects never actually had it, the object that stands anterior to the signified, that is located not in the imaginary or the symbolic but forms part of that area that is inaccessible to language and conscious processes, the real. This real is associated with the Law in its most absolute formulation; the deepest desire and the most absolute prohibition are mobilised in relation to incest.

> What we find in the incest law is located as such at the level of the unconscious in rela-
> tion to *das Ding*, the Thing. The desire for the mother cannot be satisfied because it is
> the end, the terminal point, the abolition of the whole world of demand, which is the
> one that at its deepest level structures man's unconscious. It is to this extent that the
> function of the pleasure principle is to make man always search for what he has to find
> again, but which he never will attain, that one reaches the essence, namely that sphere
> of relationship which is known as the law of the prohibition of incest.[58]

This absolute law Lacan aligns with the universal maxim that structures the eth-
ical, the aesthetic and the sadistic. The sovereign good, the beautiful and agonising
universal destruction are aligned through a parallel reading of the Ten
Commandments, Kant and de Sade. These absolutes give some inkling of what is at
stake when the parameters of excitation permitted within the pleasure/unpleasure
logic of the pleasure principle are exceeded.[59] Lacan does not argue that the Thing
is equivalent to the fearful or benign Law but that it is structurally homologous, it
occupies the same place; it is somehow the same but opposite.[60] When the flood-
gates of desire are opened, speech is lost, and the utmost pain is inevitable.[61] This
beyond of the pleasure principle stands at the extreme limit of the social, accultur-
ated subject, even beyond or before acculturation, and yet Lacan is claiming that
the fearful real is crucial to society and culture. Indeed he is trying to establish the
role of this fearful real in ethics and in the processes of sublimation that are central
to art. He goes to art for his examples and introduces the anamorphic form in
Holbein's *Ambassadors*, and the arbitrary Lady as figured in the literature of courtly
love, to demonstrate that it is possible for art to produce figures that allude to the
object that stands behind signification, that indicate the gap that would open up in
signification if the intrusion of the Thing were allowed.

The chapters in this book approach the representation of Venus in widely diver-
gent ways, but a number of common features emerge. We find that Venus is invoked
as a powerful entity, is associated with an unbridled erotic force that places her
beauty in a different category from the everyday objects of desire, that her figure
has the potential to encompass extremes of good and evil, of pleasure and pain. We
find that she is the paradigmatic instance for the operations of the aesthetic. These
representations of Venus are produced in the context of the archaeological and
mythographical developments that we have sought to sketch in this introduction.
Venus is understood to inhabit the sundered fragments that connoisseurs and
archaeologists excitedly seek to reassemble, whether the thirteen fragments of the
Venus de' Medici, found in Hadrian's Villa at Tivoli in 1580, or the incomplete
Venus in parts, recovered as we have recounted, from Melos in 1820. Venus, as
potent in pieces as in entirety, functions for Western culture, literally, as the lost
object that was not known to be lost until recovered. All these associations of Venus
indicate that, as a figure, Venus gives access to patterns of response that are highly
distinctive, that lend themselves to discussion in psychoanalytic terms not just in
Kleinian terms, within the scenario of part objects relating to the mother's body,
but, perhaps just as compellingly, in terms of Lacan's elaboration of the object,

which he relates to Freud's lost object, and which he calls, in the seventh seminar, the Thing.

Lacan's formulation is most suggestive in relation to Venus. She seems a far more powerful version of the Lady of courtly love, invoked in her multiple manifestations, yet always recognisably the same. She is wilful and cruel and promises the ultimate reward of satisfied love, but actually exercises her devotees in the frightful realm which goes beyond the purposes of the pleasure principle. Unlike the Lady of courtly romance, Venus is encountered, sometimes most enthrallingly, in fragments. These talismanic remnants are the dramatic correlates of the psyche's lost object. Cultural authority is arrayed around the figure of Venus, whether the antique sculpture in the national museum or the modern rendering on canvas to be exhibited or collected. Venus has remained central to the discourse and institutional structures of art throughout the period we address. And yet, if we understand the figure as standing in for the gaping hole in the structure of signification, in a way that draws attention to that rupture, then we can begin to understand the frightful, ecstatic and destabilising effects of Venus that pull in the opposite direction from the purposes of the artworld and its moral authority. One of the findings of this book on manifestations of Venus is that the beauty offered by art's Venuses is not soft and reassuring, but often terrifying and with the potential to annihilate the spectator.

Lacan posits the signifier as the fundamental cultural artefact. Its making is necessary to the formation of the subject. He sees it as a human creation that negotiates the disjuncture between the real and the realm of language and desire. All language and all art can be understood to hinge on this function. Exceptionally an artefact dramatises this location and allows some inkling of the real in the realm of signification. Arguably this is the effect of Venus in Western art.

Desire and pleasure

The figuring of Venus raises other problems than does the depiction of generic eroticised female figures. The depiction of the female body and the positioning of female figures in representation have been subjects for sustained and productive analysis by feminists since the 1970s. Sophisticated accounts of fetishistic representation, and of the operation of the gaze have permitted gender politics to inform visual analysis.[62] The Oedipal fixing on an object, classically aligned with the person of the mother, is thwarted in the case of Venus, and the chapters in this book are not primarily concerned with that problematic and the issue of the objectification of the female body. It seems that Venus does not normally feature in the Oedipal drama as one of the actors, because her power as the energetic force of love is envisioned, rather, as something that moves between actors. Consequently she is not primarily the object of desire. This is another finding of the book which is somewhat surprising, since the female form, the beauty and the erotic context would lead one to expect Venus to be positioned as object. There are exceptions to

this, and the fetishistic narratives of masochism are shown by Caroline Arscott and Tag Gronberg (drawing on Deleuze's presentation of masochism) to permit Venus to take up the role of the mother. In these cases we see a variant on the Oedipal drama in which the father has abdicated or been destroyed by the power of the mother. But these are exceptions in which the parameters of desire are deliberately reconfigured.

Venus herself is a shape-shifter, and we see that her identity does not preclude masculine traits, nor is it unavailable for appropriation by male figures, as Sarah Wilson shows in her chapter concerning Michel Journiac. Monsieur Venus is a paradoxical but not impossible formulation. Venus represents sheer libidinal force: a sort of hydraulic or electrical energy, subject to cathexes, in Freud's terms. She has an *alter ego*, in Cupid or Eros. We might see Cupid as a Master/Monsieur Venus. Katie Scott's chapter shows the figure of Cupid standing in for Venus in certain ways, acting out his Venus-envy. Cupid is an embodiment of the quality of Love and a deity whose flying arrows dispense love; love energises the field rather than reposing in a single figure.[63] This makes Venus a potent figure for the energies and attractions of the modern urban environment. In modern Paris, for example, as Tag Gronberg shows, consumerism and modernity can be presented in terms of energy and erotic charge through the figure of Venus. In this case the logic associated with Venus is the logic of multiplication, not the binary logic associated with desire.

We argue that Venus can withstand the division into pieces. Her beauty is not skin deep nor even conditional on keeping her frame intact. Again, contrary to the body in pieces logic that has been associated with fetishism and the bolstering of male identity in conditions of modernity, the partitioning of Venus's body seems to go beyond the phallic investment of the portion.[64] The value of the piece and of the whole, equally, do not seem to depend on the dualistic logic of endowment and castration.

Pagan echoes

We see that Venus as pagan goddess can function in an area that is somewhat apart from the binary good and evil of Christian morality. Within the delimited timescale of this book we are not talking about classical mythology proper (pre-Christian traditions in all their diversity), but about the way that the traditions are bundled together and, no doubt, confused into the figure of Venus in early modern and modern times. Venus is, we find, repeatedly invoked, but there is that curious shortfall in credence that is characteristic of the mobilisation of mythologies. The figure is and is not believed in, is and is not attributed with supernatural powers. Classical mythology is domesticated in Christian Europe; it offers a treasury of stories to amaze and entertain. These constitute at times so familiar a set of references that the myths threaten to pass back from learned fable to folk tradition.[65] Of course, were it actually to go through the barrier, back into theology, it would go wild, lose its mild fictive character, and it was never remotely possible that the conditions for a revival of ancient beliefs would recur. At any time, though, the

domesticated creature could show its teeth. In literature and art the deities of Olympus act out and embody primal urges and energies for fundamentally sceptical Christian audiences. The scepticism cannot be experienced as absolutely secure, condescending distance, though. It is compromised by the near-canonical status of the myths. Consequently the representations of the classical are almost as unstable as the fierce and quarrelsome gods. Images hover between secure containment in the realm of fiction and frightening trespass on the actual.

This may be as much as to say that the suspension of disbelief grants the deities a permanent status that escapes both the fictive and the real. Even when an allegory is not consciously elaborated their representational status approximates to the allegorical. Classical gods are not so much metaphors, in early modern and modern culture, as signs of metaphoricity itself. This is doubly so in the case of Venus because she is aligned, through a notion of beauty, with art, and perhaps because she is aligned, through a notion of sexual congress, with reproduction.

Morality

In the case of Venus we see that the goddess as a non-Christian motif functions alongside, indeed in annexation to, Christian theology.[66] Pat Rubin's and Joanna Woodall's chapters, both in different ways, show how the figure of Venus is deployed in overlapping fashion with Biblical figures of Eve and the Virgin, in the elaboration of complex moral schemata, which acknowledge different kinds of worth. In Christian morality a familiar presentation of physical beauty is of the beautiful exterior that hides a corrupt and hideous interior, the mortal shell and the sinful nature. The introduction of Venus offers a different way of approaching physical beauty. Instead of beauty as deceptive surface Venus is understood as substantive beauty, her beauty is not just surface or illusion, it is not subject to decay. Famous for her arbitrary nature, her cruel tricks and wiles, she is also a figure of substantive deception.[67] The deception does not undo the beauty. In this respect she is a counterpart to Christ, the outstanding exception to the general frailty of flesh, who can also be seen to conjoin the embodied-beautiful with the non-corruptible, but is just and true.[68] The classical figure can therefore provide an important variant on the logic of Christian morality and its associated modes of figuration. The continuing appeal of the classical motif could perhaps be accounted for, not so much for the opportunities it gives to celebrate the erotic (potentially escaping the censorship of religious authorities), as by its potential to expand the repertoire of tropes, to reconfigure the relationship between beauty, truth and embodiment.

Venus as allegory

We might say that the bracketed credence that is involved in investing in a pagan deity in a post-pagan world renders Venus permanently allegorical. She is not quite

fictive nor is she literally real. It is helpful to consider the general account of the allegorical that is developed by Joel Fineman.[69] Fineman's account of allegory draws attention to the way it can operate as the recuperative version of authoritative texts 'whose literalism has failed'.[70] He characterises as allegorical the procedure of re-presenting and reinterpreting texts whose authority have faded, for instance classical myths, and he gives as an example the retelling of Ovid, *Ovid Moralisée*, which is very much to the point for our investigation of the survival of Venus. He argues that allegorical re-presentation reaches back to the disappearing past and 'heals the gap', between the present and the past. In an intricate argument that draws on classical rhetoric, structuralist poetics, post-structuralist theory and psychoanalytic terminology he describes the 'reaching through', considered to be allegorical, that happens in poetic form. This is not so much a reaching through from the present to the past as a linking of the synchronic metaphorical to the diachronic metonymic, in other words a linking of the instantaneous structure (which can be conceived of as a set of spatial relationships) to the sequential narrative aspect of a work (relationships in time). He argues that each affects the other when one is projected on to the other in this way, so that, in allegory, structure turns into time and time turns into structure, or in terms of Jakobson's structuralist categories, you get metaphoric metonymy and metonymic metaphor. This discussion of modes of poetic presentation is one that attends to the underlying structures of literary forms and produces a general account which employs an array of rather specialist and technical languages. It is worthwhile following the intricacies and technical distinctions, though, because its attention to the demonstrative manifestation of the aesthetic in poetry is most suggestive in relation to this book's project of understanding what is at stake in the parading of the aesthetic in Venus's appearances. We are arguing that Venus flaunts her charms just as poetry shows off its formal devices.

Fineman is very much concerned with the way that the binary oppositions that characterise structuralist poetics are modulated by the link between levels that occurs in allegory. Structuralism can be described as diacritical because it attends to the oppositional terms, those pairs of either/or terms, that produce meaning. Allegory undoes the polarisations of this diacritical method. When this is argued through in detail it appears that allegory takes the single opposition that underpins a metaphor (two different things compared, a synchronous operation) and builds a whole system of metaphors, extending one opposition into a series (giving a diachronic series), or creating layers of such series in a multiplex symbolism. Fineman argues that allegory can come to stand for the foregrounding of artistic form, for the systematicity of literary or artistic structure, which pays no heed to any single opposition that serves to anchor meaning. Systematic form is enjoyed in its own right as the elaborate shapeliness of the work is developed.

We might then think of Venus as doubly allegorical, in the way she allows a revisiting of the pagan and in the way she is the substantial presence of the aesthetic. Her shapely presence might be said to sum up the formal felicities of art, its plastic

achievements and allure. If literary form allows the systematic shape to be experienced as poetic sensuousness, then Venus's shape could be understood to be the marker and instance of the system of art. Fineman asks what happens to the simple metaphorical opposition when it is built into an allegorical system and concludes that the logic of the metaphor is effaced by allegory. It seems that the diacritical either/or has been abolished by the power of the larger structure. The effect of allegory, then, is apparently to abolish difference, as the metaphor is superseded. Crucially though, this allegorical system is fed by metaphor, and thematises the difference that has been abolished. This is an important twist in the argument made by Fineman. He says 'the diacriticality affected by literary structure emerges as a theme in the register of loss'.[71] Allegory's structure affects that diacritical either/or, seeming to erase difference. Ultimately though the production of allegory cannot be seen as a straightforward replacement of metaphor with the metonymic, or of space with time, the vertical with the horizontal, because there is a melancholy thematisation of the suppressed term.

What, then, are the implications of this for our understanding of Venus and her traits? If we consider the recurrent motif of Venus and her bodily beauty not just as a customary way of alluding to the aesthetic but as the allegorical instantiation of art's system, then we have to take notice of Fineman's argument about the seeming erasure of difference in allegory. Certainly the perplexing lack of fixity of Venus seems to thwart our expectations of standard binary distinctions. It may be possible to give an account of the compelling power of the divisible figure of Venus in terms of the effacement of difference. We do not encounter her as surface nor as depth. She is not available as objectified beauty, not the object to our subject. She is divided into the twin terms of her self and her progeny or accomplice Cupid, but neither term is stabilised by fixed gender attributes. In this way gender difference is subverted. Her body seems to be infinitely divisible, but the process of fragmentation does not tally with the psychoanalytic patterns associated with endowment, castration and fetishistic disavowal. The evasion of binary reference points (inner/outer, masculine/feminine) takes us away from the psychic territory of repression and its associated operations of denial and repudiation which, in Freud, represent the workings of the mind to control the forces of the unconscious. What we find is that, working with different psychoanalytic models (considering Klein and Lacan as well as Freud), the unruly and contradictory nature of Venus in her absolute enthralling beauty seems to indicate psychic territory that cannot easily be contained in the scope of object-centred desire or the logic of eros. Paradoxically our encounter with a goddess of the erotic and of pleasure takes us beyond the pleasure principle, and beyond eros to the realm Freud designated thanatos, or the death drive. Pleasure in terms of eros, then, corresponds to the metaphoric mode that has been supplanted by allegory but has a residual presence as melancholy theme. It is, incidentally, worth noting that this conclusion differs somewhat from Fineman's conclusion with respect to the role of desire in allegory. Our argument about Venus would only allow for the registration of desire within that supplanted

metaphoric mode. Fineman, by contrast, locates desire in the diachronic systems of allegory.

To give an account of Venus is to give an account of the authority and the seductiveness of art. What we have found is that Venus does not just correspond to the sweet enticements of aesthetic pleasure. Those dulcet aspects are confusingly conjoined with stern authority, wild abandon and a body that breaks up into fragments. In the passages we have cited from Lacan we find an account of the fragmented objects derived from the maternal body. Lacan sees them as terrifying in themselves but claims that they play a role for us in culture; inserted into the fabric of consciousness they are said to act as indicators of the governing framework of absolutes: ethical, counter-ethical or, appropriately for Venus, aesthetic.

Finding the lost Venus, repeatedly

We started this introduction by giving an account of the finding of the *Venus de Milo*. In conclusion we glance at a fictional account of the finding of a statue, in Nathaniel Hawthorne's *The Marble Faun*, published in 1860. In this novel in which characters find echoes of the magical pagan world in the prosaic modern one, surely experiencing the allegorical resonances of the layering of past and present as loss, Hawthorne imagines his hero, the artist Kenyon, finding a Venus in the *campagna*. He arrives early for an assignation in a ruined villa, hoping to meet Hilda who has unaccountably disappeared. A gleam of sunshine strikes on a piece of marble in the crumbling earth. Something about it catches his artist's eye and he starts to dig. He finds the fragments of a Venus: torso, arms, hands with slender fingers, and, finally, head.

> In the corner of the excavation, lay a small, round block of stone, much incrusted with earth that had dried and hardened upon it. So, at least, you would have described this object, until the sculptor lifted it, turned it hither and thither, in his hands, brushed off the clinging soil, and finally placed it on the slender neck of the newly discovered statue. The effect was magical. It immediately lighted up and vivified the whole figure, endowing it with personality, soul, and intelligence. The beautiful Idea at once asserted its immortality, and converted that heap of forlorn fragments into a whole, as perfect to the mind, if not to the eye, as when the new marble gleamed with snowy lustre; nor was the impression marred by the earth that still hung upon the exquisitely graceful limbs, and even filled the lovely crevice of the lips.[72]

Kenyon has found a superior prototype of the *Venus de' Medici*. The disgust of the earth blocking the mouth, or encrusted round a broken-off head give way to a supernatural gleaming, as Venus shines through history and accidents and asserts her fascinating power. The layering of past and present that characterises the novel is intensified around this Venus. The finding is a re-enactment of the historical discovery of the *Venus de' Medici*, the reassembly a re-enactment of the making of the original. In an extraordinary twist, we are told, in the next chapter, that Kenyon's

friends had already found, assembled, and then disassembled and reburied the Venus, in order to give him the pleasure of finding it. The allegorical effect of Venus acts to destabilise the logical forward movement of narrative. The attempt to access the past is caught in a magical switchback between part and whole, so that restoration can never be definitive but always promises the fresh thrill of finding the fragment in the filth once again. This fictional moment speaks of the efforts of all the artists encompassed in *Manifestations of Venus*. They and their publics are accessing the past through the figure of Venus, recomposing the goddess, but the magical moment at which her exquisite form appears cannot stave off the recurrent dissolution, nor deprive the next-comer of the joy of finding the lost Venus once again.

2

The seductions of antiquity

Patricia Rubin

In his *Souvenirs d'Italie par un catholique* (1839), Louis de Beauffort distinguished between medieval and Renaissance painting, praising the former as 'that primitive painting [which] is the faithful expression of simple faith, of the unsullied faith of that period, when it had not been altered, when Christian art had not committed adultery with pagan beauty'.[1] On first inspection the stiffly positioned Eve in the *Virgin and Child* attributed to the Master of the Straus Madonna and the gracefully assured Venus in Sandro Botticelli's *Venus and Mars* could be taken as embodiments of de Beauffort's words (Figures 8 and 9). The former seems totally innocent of any form of dalliance with pagan beauty. Although given the attributes of sexual attraction, with her breasts visible beneath her diaphanous dress and her long blonde hair unbound, Eve bears little resemblance to figures fashioned according to the canons of ancient art. Her gaze and her features repeat those of the assembled saints and angels and like them she directs attention to the Virgin. Not 'unsullied' or 'virgin', she still seems a figure of 'simple faith'. Botticelli's Venus, posed with her exhausted lover Mars, is, by definition, the pagan adulteress. The emphatically sensuous curves and sculptural surfaces of her body signify her physical desirability and use tactics studied from ancient sculpture.[2] Both are fifteenth-century paintings, but, if classified, the first – datable to *c.* 1410 and attributed to an anonymous 'Master' – would be called primitive, late gothic or late medieval and the second – which glories in the name Botticelli and dates from the early 1480s – taken as emblematic of the Renaissance. While a closer look at the pictures might not change their classification, it exposes the complexities of the terms and indicates the way that manifestations of Venus (or of the venereal) figure crucial problems and key moments in the historical understanding of the arts.

De Beauffort's distaste for the perceived degeneracy of Renaissance art was not isolated. In Alexis François Rio's history of Italian art, *De la poésie chrétienne*, published in 1836, for example, the quotient of 'Christian poetry' in any given work become the measure not only of its quality, but of its essential value. He, too, exalted the 'primitives'. Rio's book was greatly appreciated in England and influenced both Lord Lindsay (who wrote his own *Sketches of the History of Christian Art* (1847)) and John Ruskin.[3] Venus plays a telling role in the introduction to the second, enlarged,

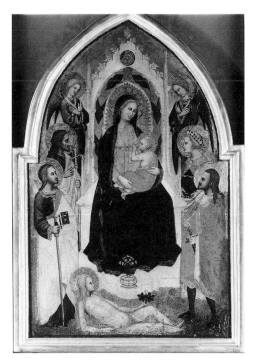

8 Master of the Straus Madonna,
*Virgin and Child Enthroned with Angels and
Saints*, *c.* 1410, tempera and gold on panel.

9 Sandro Botticelli, *Venus and Mars*, *c.* 1483,
tempera and oil on poplar.

edition of Rio's work, which outlines the classical pre-history to Christian art. There she is described as the 'favourite idol of decadent eras' and the progressive sculptural types of the goddess of love trace a 'refinement of corruptions' to the very 'prostitution of art'.[4]

De Beauffort's and Rio's views are representative of a powerful Christian trend in nineteenth-century criticism and historical study, which made the birth of the Renaissance as a term of historical definition a particularly troubled one. Connected to religious debate, political upheaval, moral enquiry and psychological investigation, it was not taken as a neutral period boundary, but used as a key to the development of contemporary society. Seen as an opposition between sacred and secular, Christian and pagan, the revival of antiquity which occurred between the fourteenth and sixteenth centuries was interpreted by some as a battle between true spiritual values and corrupting forces, and by others as a liberating factor related to the emergence of the modern individual.[5]

The seductions of antiquity - the lure of sensuous, naturalistic forms and the fascination of pagan myths - which alternately appalled and thrilled nineteenth-century

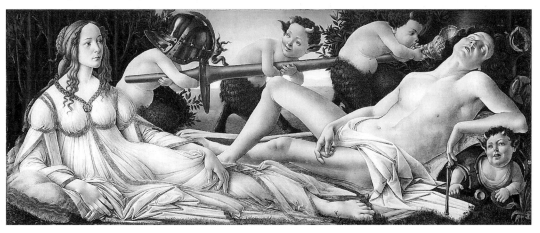

commentators were undeniably inspiring forces in the arts of the earlier period.[6] The purpose here is not to trace, or explain, a multifaceted process of recovery and recognition; instead one instance is used to introduce Venus at a significant moment in her later – that is, post-antique – life, at the beginning of her career as protagonist of this book. It is argued that as re-presented by Botticelli in the fifteenth century, she solicits a form of attention involving the beholder's self-awareness. The engagement with identity allies her with subsequent, rather than previous, eras and raises the problem of the relation of the represented subject to modern subjectivity which is examined in various ways throughout this book. The questions of definition are multiple, and largely unanswerable; for this reason, Venus – the most equivocal of goddesses – is a reliable guide, at once compelling and confounding.

By analysing the forms, the iconography and the functions of the images of Eve and Venus illustrated here (see Figures 8 and 9) it is possible to indicate what Venus had come to mean by the fifteenth century and some of the ways (textual and figurative) that she had survived until then. The paintings are discussed in terms of their similarities, as works that can be related to the social control of sexuality in the fifteenth century, and for their differences as cultural artefacts. A consideration of the latter suggests the intricate ties between history and historiography - between the invention of an image in its time and the subsequent image of that time.

In the devotional panel Eve lies at the foot of the Virgin's throne. The Virgin is at once the majestic queen of Heaven and the humble mother of Christ, nursing the infant who eagerly grasps her breast. His touch both enforces the breast's physicality and protects it from illicit inspection. It is offered to the child, and to the viewer, as an attribute of her special maternity, expressing her role as the nurturing and loving mother of Christ and of mankind.[7] Prayers invoked Mary's breasts as 'little sparks of nourishment/Through which sins are abolished'.[8] Eve's veiled but entirely visible breasts are instead reminders of the shameful condition of humanity after the Fall. Whereas the love that flowed from Mary's body was held to be that of divine charity, that stemming from Eve's was interpreted as the lust of carnal sin. In its simplest sense the juxtaposition of Eve and Mary was that of fall and redemption: the choice in contemplation of their figures was between sin and salvation. But that choice has been complicated here by the fact that Eve has been given a halo and is therefore in some way included among the blessed assembled around the Virgin.

This is one of a small group of paintings that pairs the first and second Eve, the mother of humankind and the mother of God in this way.[9] This dual motherhood not only represents the cycle of salvation and the promise that all the descendants of Eve may regain Paradise at the Last Judgement, but sets it within the genealogical scheme of procreation that leads from Eve to Mary. In all of them Eve is recumbent. This is a pose with significant associations. It neither depicts nor evokes devotion or prayer. It is generically different from the postures taken by attendant or donor figures in religious pictures, which were meant to be imitated by their beholders. Here it categorically separates Eve's spiritually directed gaze from her body, which is positioned in moralising rather than mimetic display.

Figures reclining on their elbows appear frequently in ancient art. One occurs, for example, as a sleeping Fury on an Orestes sarcophagus that stood outside the Florentine cathedral until 1877.[10] There are male and female variants on a Phaeton sarcophagus that became part of a tomb inside the cathedral in the late 1390s (with the relief turned to the wall), but that seems to have been studied and then remembered by Florentine artists (Figure 10).[11] Either or both might have been known to the painter of this panel, who, though inattentive to anatomy, shows an interest in the patterning of drapery over form found in such models. This decorative borrowing does not demonstrate particular understanding of the naturalism of its ancient model, but it is used in a significant way. Reference of this sort stresses the difference between Mary and Eve: relating Eve to a mysterious and alien world while Mary, by contrast, comes from a familiar realm of sanctioned formulas. She bears a reassuring likeness to any number of other Madonnas.

Formally removed from the enthroned and richly dressed Virgin, the recumbent Eve is not, however, totally devoid of marian association. Since the fifth century Mary had been shown reclining after the birth of Christ.[12] This was the formula used by Lorenzo Ghiberti in the Nativity scene on the North Door of the Baptistery, for example, which was composed at about the same time as this panel

10 Phaeton sarcophagus, 2nd century AD, marble.

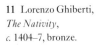

11 Lorenzo Ghiberti,
The Nativity,
c. 1404–7, bronze.

(Figure 11). So, too, she is shown in the late thirteenth-century mosaics inside the Baptistery.[13] Over time the pose had been transferred to other birth scenes, those of the Virgin herself and of John the Baptist. By long tradition, the recumbent woman was a reminder of childbirth and, in the case of Eve, of God's curse for having eaten of the tree of knowledge (*Genesis* 3:16: 'in sorrow thou shalt bring forth children'). The pose had further generative and religious meanings: Adam, for example, was often shown in a similar position at the moment when Eve was pulled from his rib.

Reclining was also the attitude of lasciviousness, associated with *lussuria* and Venus, as she is shown, for example, in the drawing by Pisanello now in Vienna (Figure 12). A useful explanation of the common understanding of the posture is

12 Pisanello, *Venus*,
c. 1425–30, black
chalk, pen and ink and
wash with white
heightening.

given in Boccaccio's gloss of his epic romance, the *Teseida*. In the poem the lovestruck hero Palemone goes the temple of Venus to pray to win the beautiful Emilia. He penetrates its 'most secret part' where he sees the golden-haired goddess 'lying nude'.[14] In glossing these verses Boccaccio says that word *giacere* – to lie – signifies 'the idleness of the voluptuous, and soft living'.[15] He further glosses the beauty of Venus: 'which we know to be a fleeting and frail thing, it means the false judgement of the voluptuous' who are gullible and vain.[16] Her nudity, he adds, signifies 'the [superficial] appearances of things, which attract the minds of those whose powers of reasoning cannot go beyond mere existence'.[17] Her genitals covered by a drapery so thin that 'it hardly hid anything' meant, according to Boccaccio, to 'show the obscured judgement of those fooled by appearances'.[18]

Boccaccio describes Venus as representing man's concupiscent or lustful appetite (*appetito concupiscible*) 'that causes men to desire and to rejoice in having those things which, according to the quality of his judgement – be it rational or corrupt – are pleasing and agreeable'.[19] His extended comments on the temple of Venus demonstrate his own unimpaired judgement. By far the longest explanatory passage in the gloss, it is a textual fixing of the disruptive sexual urges represented by the naked goddess. An essay on Venus, it is not only the key to the underlying moral message of the poem – which ends with a joyous wedding and thankful offerings to Venus – but also to unlock its seeming contradictions, which hinge on the double identity of Venus. One Venus, Boccaccio says, 'can and should be understood as every decent and licit desire, such as to desire to have a wife in order to have children'. The other is the one 'commonly called the goddess of love' who causes lustful things to be desired.[20] They are distant descendants of Plato's two Venuses, as described in *The Symposium* – the terrestrial and the celestial – but as carnal and marital they represent the conversion of Plato's homoerotic philosophy to Christian morality.

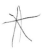

Boccaccio inherited, he did not invent, the Venus of licit and illicit desire. Historically Venus had become the the keeper of 'beauty and virtue and good fame' in the cult of Venus Verticordia ('Changer of the Heart').[21] She was worshipped in the late Roman Republic and early Empire as promoting marriage and childbirth, a fertility goddess of family values. There was a temple dedicated to Venus Genetrix in the forum, where she was venerated as the mother of Aeneas, and therefore of all Romans. The Epicurean philosopher Lucretius invoked her partnership, as 'nurturing Venus' in composing his work *De Rerum Natura*, since 'you alone govern the nature of things … without you nothing comes forth into the shining borders of light, nothing joyous and lovely is made'.[22] These were late, but far from the last, variants of Venus's contrary existence, which Boccaccio and others explained by her multiple origins, including one as the daughter of Sky and Day, another as the daughter of Zeus or Jupiter and the nereid Dione and another as born from the castration of Uranus.[23] According to Boccaccio in his book on the genealogy of the gods, the first, *Venere magna*, was the planetary divinity who presided over love, friendship, fecundity and the season of spring.[24] The second was Plato's *Pandemus*, the earthly Aphrodite. The third, the Venus who emerged from the foam whipped

up by the testicles of Uranus as they were cast into the sea was for Plato the heavenly Aphrodite, 'sprung from no mother's womb but from the heavens themselves'.[25] Plato's discussion of the double nature of Venus was elaborated in the fifteenth century by the Neoplatonist Marsilio Ficino in his discussion of the twin Venuses, one 'Heavenly' (born of Uranus), the other 'Vulgar' (born of Jupiter and Dione). The first was 'that intellect ... located in the Angelic Mind ... entranced by an innate love for understanding the beauty of god', the other 'the power of procreation attributed to the World Soul', entranced by 'her love for procreating that same beauty in bodies'; for Ficino 'each love is virtuous and praiseworthy, for each follows a divine image'.[26] Instead, for Boccaccio, the daughter of Uranus was the symbol of erotic desire, the humour or mood of coitus and of a lascivious life totally given over to lust and lewdness. Nudity is her sign, because sexual sins are committed while nude and their shame cannot be hidden.[27]

Ficino's fifteenth-century interpretations were philosophical, Boccaccio's were mythographic. Earlier (by over a century), Boccaccio's were no less scholarly than Ficino's and depended upon a recognised and widely diffused tradition of historical and figurative explanation of the ancient myths.[28] Boccaccio's encyclopedic *Geneologie deorum gentilium* was written in order to record what he had found regarding the origins, descent and allegorical meanings of the gods in previous writings going back to ancient authors. His book became an authoritative guide to the subject. Published in 1472, it was among the earliest printed books and it remained a respected source until the seventeenth century.

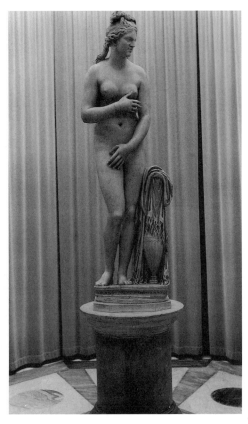

Boccaccio's *Geneologie* demonstrates not only that Venus had survived over the centuries, but that she had thrived in textual memory in her contradictory guises as beneficial love and harmful lust. Nor had she been lost to sight. A statue of Venus, from the Capitol, had also survived and over time was both admired and despised. Her 'exceptional beauty' charmed the twelfth-century visitor, Master Gregory, who was drawn, as though by 'some magic spell' to look at her three times. He related his experience to the myth of Paris and Venus's naked display to the 'thoughtless judge'; he described the wonderful skill of the carving, which made her seem 'more like a living creature than a

13 *Capitoline Venus*, 3rd century AD, marble.

statue; indeed she seems to blush in her nakedness, a reddish tinge colouring her face, and it appears to those who take a close look that blood flows in her snowy complexion.'[29] Other pilgrims, less willing or less able to rationalise her attractions through history and artistry, hung the statue by the neck so that they could throw rocks at her.[30]

This Venus is thought to have been of the Cnidian, or *pudica*, type, similar to, if not the same as, the one now in the Capitoline museum (Figure 13).[31] For Giovanni Pisano a Venus of this sort served as a model for Temperance (Figure 14) on the pulpit for the cathedral in Pisa (completed in 1310 and bearing two long inscriptions praising 'the true God, the creator of all excellent things, who has permitted a man to form figures of such purity').[32] For Masaccio, instead, she signified the shame of Eve at the expulsion (Figure 15). These appearances, and Boccaccio's text, are powerful indications of Venus's resilience and her adaptability – as well as her associations with demonstrations of artistic skill. They further show how the allegorised gods in general and Venus in particular had been assimilated by Christian reasoning and had become part of the lexicon of moral argument.

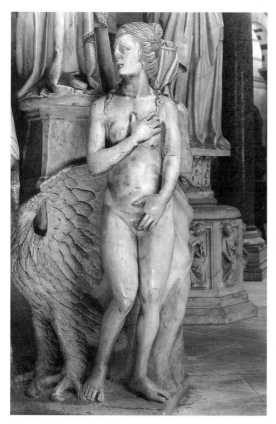

14 Giovanni Pisano, *Temperance*, 1311, marble.

15 Masaccio, *Adam and Eve*, c. 1426–28, fresco.

The recumbent temptress of Boccaccio's poem and the recumbent Eve of the devotional panel literally pose the choice of loving well or loving badly according to the free will of Christian conscience. Within this moral framework, those of corrupt judgement would be seduced by appearances and remain enslaved and condemned by bestial instincts. Those able to exercise their rational faculties could escape the delusion of carnal love and arrive at divine love.

In the fifteenth century this was neither a mere poetical fancy nor a distant theological doctrine. An example of how both this dilemma and this promise were matters of real concern is given by a diary entry written in 1404 by a Florentine merchant, Gregorio Dati. Aged forty and aware of his sinful nature and susceptibility to the 'passions of the body', he invoked his need for God's grace and mercy precisely in order to enlighten his mind and strengthen his will.[33] 'Hoping to advance by degrees along the path of virtue' he resolved to 'keep Friday as a day of total chastity'.[34] Allowing that he might break his promise through forgetfulness, he set up his own system of charitable fines and penitential prayer. Dati fathered a total of twenty-six children, one out of wedlock and the others with three successive wives, one of whom died from an illness following a miscarriage. Dati's resolutions are part of the same life accounting as his lists of the births and deaths of his children in his record book. They were integral to his family history, and therefore his civic and social identity, as well as to the sexual economy of his domestic life.

A similar social dimension structures the spiritual messages of both Boccaccio's poem and the painting (Figure 8). In the first, through the adventures of its protagonists the poem exposes at length the dangers of erotic desire. They are at last safely resolved in the marriage of a chaste and beautiful girl to a valiant lover. Not surprisingly this epic of amorous containment supplied episodes painted on birth trays and wedding chests.[35] While the narrative of salvation that underlies the religious image is very different, its erotic elements argue a similar conclusion. Sexuality may be denied or repressed in chastity; the presence of the virgin martyr St Dorothy is a reminder of this. Its potential to generate violence is symbolised by St Julian, who killed his parents mistakenly thinking that he had found his wife in bed with a lover, and who spent the rest of his life founding hospitals in penance. But sexual desire is also procreative. The generations that bound Eve to Mary and that linked them both to all of humankind depended upon sexual activity, not its renunciation. Motherhood forms the central axis of the panel. Like those of Boccaccio's two Venuses, the carnal pleasures evoked by Eve's body could be those of guilty passion or of legitimately sanctioned desire. Here she seems placed as a reminder of willing submission to the latter. She partakes of the values of the fertile Venus of marital love.

Botticelli's Venus is her companion in this. In general terms the subject is a commonplace, given as such, for example, by Boccaccio in another of his love stories, in a discussion of the different types of love. One of the interlocutors describes the type that

should be followed by whoever desires to come to a glorious end, as something which increases virtue … This love … achieves this in human hearts as a result of disposing the soul to the thing that has been found pleasing: it strips the heart of all pride and all ferocity, making it humble in every act, as obviously appears in Mars, whom we find turning from a fierce and cruel battle leader into a humble and pleasant lover as result of falling in love with Venus.[36]

As a panel that formed part of household decoration it necessarily observed household decorum. Not directly concerned with spiritual well-being, such a painting could not neglect the moral well-being of its viewers. It was a 'private' image, which in fifteenth-century terms meant that it belonged to the realm of the family. Its shape and size identify it as a *spalliera* panel, that is a painting set over a chest or large daybed or above a cornice in one of the principal living rooms, a *camera*, of a patrician palace. It has been associated with the furnishing of such a chamber at the time of a marriage.[37] *Camere* were often decorated when the household was reorganised to accommodate a new alliance and to give designated spaces to the new family unit, but it is misguided to make the messages of their decorations too occasional. They were meant to give long-term pleasure and durable instruction. Venus is here necessarily implicated in family management – *il governo della famiglia* – which allowed for beautiful objects and required the domestication of desire.[38]

One mid-fifteenth-century writer on the subject, Matteo Palmieri, wrote that sex, or the 'generative act', was the aim or purpose of matrimony, and necessary to the welfare of the human species, but it was in itself a 'bestial game'.[39] Both the future and the honour of the family – which defined the basic unit of society – depended upon the 'honesty' and fertility of its wives and the chastity and desirability of its daughters. The *Venus and Mars* and the Madonna (Figure 8) can be interpreted as serving to enforce this erotic regime in their respective spheres of domestic and devotional life. They are comparable as social artefacts. In both the sexuality of the recumbent women is implicitly directed towards procreation, while acting as a reminder of fornication. Passive, their calm demeanour does not show signs of 'unbridled lust', however much their bodies might stimulate carnal appetites.[40] Eve is exposed, but seemingly unaware of her shameful condition. Venus is alluring, but dressed, and has a distant gaze. As examples of figures of contained or controlled desire they are related to the reclining nudes painted on the inside lids of marriage chests (Figure 16): hidden from general view and associated with dower goods, their role was to elicit the legitimate pleasures of conjugal sex.

The paintings also operate in a dialectic with danger. In Christian teaching and Christian symbolism Eve was not only the cause, but became the embodiment of the fallen condition of mankind. The ascendancy of Venus over Mars, as shown here, could literally unman him. Mythographic tradition consistently affirmed that the adultery of Mars and Venus showed how 'valour corrupted by lust is shamefully held in the fetterlike grip of its ardour'.[41] Here Mars is not only nearly naked, but he is being stripped of the signs of his virility, his armour and, with it, his capacity to act.

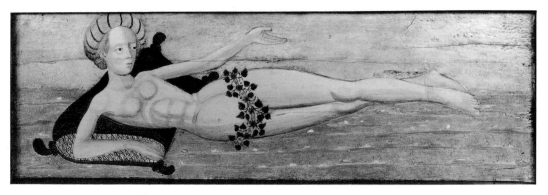

16 Florentine school, *Reclining Nude, c.* 1465–70, tempera on panel.

A social history of art could happily put these two fifteenth-century paintings in the same chapter, just as related devotional and decorative panels were unproblem-atically placed in the same patrician *camere* at the time. But their separation is demanded by cultural and stylistic histories, dating at least from Giorgio Vasari's association of the visual arts with the notions of rebirth and progress in his *Lives of the Artists* (1550). To the question of what differentiates the beauty of a painting like the Madonna from Botticelli's Venus, Vasari's answer might be 'the endeavour to reproduce nature' – achieving a perfection in art that derived from imitation of ancient models.[42] To the question of what separates Botticelli's 'amorous visions' – his Venus or Venuses – from Boccaccio's, comes the answer, the Renaissance. Botticelli has been credited with being 'the initiator of pagan subjects in art, the first painter of a nude Venus and the mouthpiece of the pagan revival which was so often associated with the Florence of Lorenzo de' Medici'.[43] Whereas Boccaccio's Venuses, naked or draped, were to be seen through a poetic veil (as he defined it), which modern scholarship recognises as Christian allegory, Botticelli's have come to be viewed as poetic exercises in classical philology and Neoplatonic philos-ophy.[44] Following Erwin Panofsky's influential arguments, they are products of the detachment that 'deprived antiquity of its realness' and therefore its menace, allowing classical form to be united with classical content.[45] According to this for-mulation pagan myth did not supply typological parallels as in Boccaccio, but 'direct manifestation[s] of religious truth' – not only was Venus a 'holy goddess', but the Virgin herself could be invoked as Venus.[46] As such the goddess manifests herself as a part of the 'nostalgic vision [of classical antiquity] born of estrangement as well as a sense of affinity – which is the very essence of the Renaissance'.[47] She is, if this definition is followed to its Freudian as well as Panofskian conclusions, a figure of desire itself – desire that is played out not in personal psychology but in the very configuration of civilisation since the Renaissance.[48]

What follows will examine some of the ways that this uneasy situation, as announced by the title of Freud's essay on cultural malaise (*Das Unbehagen in der*

Kultur, translated as *Civilisation and its Discontents*), is present in Botticelli's rendering of Venus. An analysis of the disturbing forces so gracefully combined in his painting reveals the tensions underlying its contested interpretation and its status as a cultural paradigm. Venus might not offer the solution to what has more than once been called the 'problem of the Renaissance', but she can certainly be taken as emblematic of what is problematic about the Renaissance as a concept.[49]

Botticelli's painting does not illustrate a given story. No fable, myth or poem - ancient or modern - explains the scene shown on the panel. Its identification as *Venus and Mars* dates from the nineteenth century; it could also be called 'Nymph and Sleeping Knight'.[50] Amorous and sexual, it is certainly venereal, and a moralising tradition, based on the planetary gods and their influence allowed that Venus could tame Mars. As explained by Ficino, for example, in the conjunction of Mars and Venus, 'Venus dominates', she masters, shackling his malignancy, suppressing the vice of temper, though not impeding the 'greatness of soul' or the 'virtue of magnaminity given by Mars'.[51]

Many texts have been adduced to gloss separate elements of the composition, but only one provides a source for any of its episodes. It is a description by the second-century rhetorician Lucian of a picture displayed at the Olympian games. The quality of the work was such that one of the judges gave the painter, Aëtion, his daughter in marriage. The painting itself was of the marriage of Roxanna and Alexander. The scene included cupids or loves (*erotes*) 'playing among Alexander's armour; two of them are carrying his spear, pretending to be labourers burdened under a beam … another has gone inside the corslet, which is lying breast-up on the ground – he seems to be lying in ambush to frighten the others when they drag the shield past him'.[52] With rhetorical flourish – and rhetorical skill is the actual subject of the passage – Lucian also notes the connection between a 'marriage of the imagination' and a 'real-life marriage'.[53] Botticelli adopted, or was asked to adopt, this motif, which not only reinforced the matrimonial significance of his painting, but placed it in direct comparison with a praised work by an ancient painter, a form of latter-day entry in an Olympian competition. It gave the painting the glamour, or authority, of learned influence, with the rhetorician's artifice matched by the painter's own inventiveness.

In the picture Mars's spear is being stolen away, not by *erotes* as in the text, but satyrs – 'laughing, bantering' woodland creatures from the train of Bacchus.[54] One tries to rouse him with a blast through a conch shell: Venus's attribute. There is an obvious phallic inversion as the erect weapon and its ejaculation (of sound) are in the power of Venus. The painting, which is constructed around a symmetrical contrast of female and male, has at its centre - emphasised by Mars's bent knee - a leering satyr, fondly clutching the spear shaft, while turning back towards Venus, directing a laughing gaze at her and providing direction for the viewer's gaze. The rational geometries of spatial construction have been given over to (if not subverted by) more playful dynamics of viewing. 'Little goat-footed satyrs', are listed by Angelo Poliziano among the companions of Pan, Silenus and followers of Priapus

in his poem *Rusticus*, an imitation of ancient pastorals written in 1483, close to the likely date of Botticelli's painting and probably addressing a similar circle of patrons. The satyrs are among the antic band of rustic deities, passing companions of a sleeping shepherd, who rests in a fertile realm of love and pleasure, far removed from city cares.[55] The tone of such poetry is light-hearted as is that of the painting, but the change from the cupids of Lucian's description to the satyrs depicted by Botticelli also has serious implications. It locates the love between Venus and Mars in an erotic region that is at the very boundaries of the rational or perhaps beyond, in a world of amorous dreaming. The benign influence of Venus – the love that should reign supreme between a married couple – is placed dangerously close to the disruptive animal forces of lust.

The spectacle of the male body, passive, naked and lacking all consciousness – an object, if not emblem, of *lussuria*, is a further inversion of sexual orthodoxies. Moral philosophy and theological teaching defined the female as the agent of carnality, exciting lust and unleashing the sensual forces that could render men, or mankind, animal, corrupt and condemned. The male represented instead the rational soul, the active forces of reason whose exercise lead to redemption and differentiated humanity from mere brutish animal existence.[56] In a narrative sense, Mars is shown in a blissful state of sexual exhaustion, but as represented he also evokes a perilous confusion of sexual roles and gender identity.

The dangers suggested by Mars's nakedness are to a degree offset by Venus's dress and demeanour. She is shown in perfect accord with contemporary poetic descriptions of nymphs and nymph-like beauties, descendants of Petrarch's Laura and distant cousins of the nymphs of ancient poetry. However troubling to the hearts of men, they are not depraved women or demonic apparitions, but ennobling visions. So in Poliziano's *Stanze*, when Simonetta appears as a nymph and captures the arrogant, fierce and valiant Giuliano de' Medici for Love, she is like Botticelli's figure, 'fair-skinned, unblemished white, and white is her garment … the ringlets of her golden hair descend on a forehead humbly proud'.[57] She has flashing eyes, and 'wherever she turns those amorous eyes, the air about her becomes serene'.[58] In Poliziano's poem, she is the embodiment of transforming love. Although love 'steals away every masculine thought', it could also inflame the heart and inspire 'lofty victory'.[59]

Such imagery of chivalric love became increasingly fashionable in Florence during the ascendancy of Lorenzo de' Medici. It was a powerful component of the golden age mythology so adroitly cultivated by Lorenzo, who was himself the author of a sonnet sequence and commentary. He justified giving his time to a seemingly frivolous activity because

> in mankind love is not only not reprehensible, but an almost necessary and very true test of nobility and greatness of soul. And above all [love is] the cause that leads men to worthy and excellent endeavors, and leads them to practice and to turn into action those virtues that are potentially in our soul. Therefore, whoever diligently seeks the true definition of love, finds it to be nothing other than an appetite for beauty.[60]

This appetite is stimulated by seeing. The Neoplatonic concepts of love underlying the interpretations of the sonnets gave vision or viewing a key role in the life of the spirit, the search for the highest good and the betterment of humanity. Love was kindled through the eyes: through the power of the eyes of the beautiful lady and through the intense gazing ('mirare fiso') of the lover.[61] As is explained in the commentary, the 'lady's eyes and her beauty' are the 'object' of the lover's eyes; the heart, 'the seat and the location of the concupiscible spirits', is 'nourished' and made noble by means of sight.[62] 'The eyes must be understood to mean the operation of our soul, which works through the eyes.'[63] In this construction, appearances are not deceptive (as they were for Boccaccio), but are potentially revealing of higher truths.

The nymph, or Venus, of the painting can be construed as a specific type of viewing object: her beauty provokes a gaze which inspires the desire for love. The concupiscence of this sort of love is not lust but a spiritually ennobling force. As seen, and as seeing (and hence the importance of her open eyes and steady gaze) she has the potential to influence the subjectivity of her beholder. Conversely, the viewer's subjectivity is constructed by the nature of the gaze: if lustful and carnal, it is bestial; if loving and enlightened, it is human or humane. This would be the case whether the actual spectator were a man or a woman. What was a matter of conscience in the religious painting is staged as a matter of consciousness in the secular image. The symbolic closed circuit represented by the venereal Eve in the Virgin and Child painting has become an open-ended question. The monumental display of the contrasted figures invites attention to their forms as beautiful objects. The meaning of those forms is not absolute. Calling into play the mechanisms of love, the question of sexuality – as a human or animal appetite – is phrased so as to force elegantly but insistently a choice on the viewer, who must decide between responding as beast or civilised being.

In the philosophical and poetic discourse of love that provides the context for this painting, the impulse to resolve its libidinal quandary in favour of a spiritualised love was explained as a longing for perfection. This form of desire could turn each cue to sense, or sensual appetite, towards reason. Within this system aesthetic values were a filter for moral reasoning and privilege was given to sight or vision. In the visual arts one result of the diffusion of this cult of beauty was a change from a mimetic to a sympathetic orientation, whereby the contact between image and viewer became that of an individual, or individuated, response to an object of desire.[64] The language of love supplied conventions or codes of appreciation for this erotics of viewing which made the aestheticised body a legitimate focus for the amorous gaze. One consequence of this was to make the body produced by art synonymous with art itself. So Vasari wrote of Michelangelo's 'refusal to paint anything but the human body in its best proportioned and most perfect forms and in the greatest variety of attitudes', thereby opening 'the way to facility in this art in its principal province, which is the human form'.[65] In painting and sculpture as in poetry, reference to antiquity rendered this love licit, legitimate and honourable,

while at the same time reinforcing the mechanisms of desire through nostalgic allusion to loss and recovery.[66]

The modern term for such longing – the diversion of sexual impulses to spiritual aims – is sublimation. And, at least since the eighteenth century, the triumph of the rational over the primitive has been known as civilisation.[67] Whether or not modern civilisation and the modern individual were born sometime between 1300 and 1500 – a much debated issue in modern literature – the persistent and troublesome connection made between that period and its definition as a civilisation did originate in the time. The anxiety surrounding Renaissance as a historical concept is inherent in its emergence as a cultural construct. The idealised *humanitas* of the period is relentlessly shadowed by the repressed forces of primitive urges, of *feritas*. The critical anxiety surrounding the interpretation not only of Botticelli's mythological paintings, but of almost all pictures of Venus from the period is similarly explained by their structural ambivalence. Even without lascivious satyrs as her companions, the dual appeal of Venus to sense and sensibility is destabilising and disturbs a single explanation. As a manifestation of the Renaissance, Venus reborn as Botticelli's graceful nymph or a voluptuous nude by Titian, is an apt emblem for the delights and the dangers of engaging with its ideals.

3

Wtewael's *Perseus and Andromeda*: looking for love in early seventeenth-century Dutch painting

Joanna Woodall

My quest for a historical form of love has as its immediate object a scene from the story of Perseus and Andromeda pictured in 1611 by the Utrecht artist Joachim Wtewael (Figure 17).[1] But I have an ulterior motive. I am especially interested in the spectacular figure of Andromeda as a manifestation of Venus because I think she can help to satisfy a broader and deeper desire: to restore an erotic dimension to perception of the types of Dutch imagery which have come to be described as realist, in the crude sense of corresponding in some respects to a neutral perception of an objective, external world. The kinds of pictures I mean are the still lifes, flower paintings, native landscapes and scenes involving local, generic figures which moved from the margins to the centre of Dutch visual culture at the beginning of the seventeenth century. Balthasar van der Ast's *Still Life with Shells* (Figure 18) is one example of this range of imagery, which has traditionally been opposed to the mannerist style with which Wtewael's work is identified.[2]

By liberating the symbolic figure of Andromeda in Wtewael's painting, I shall show that during the dawn of the Dutch 'Golden Age' the relationship between an ideal, masculine subject and a feminised realm of specificity and diversity was capable of being viewed both in terms of a life-giving union with a powerful and potentially responsive alter ego, and as the need for the conquest of a potentially murderous, material body. I shall suggest that this complex fantasy of Venus was rooted in an understanding of Nature, the world available to the senses, as *both* a potent, active partner *and* a site of suppression and exploitation. It was held together by faith in the possibility of an erotic interweaving of the heavenly realm of the spirit with the earthly, material body. Taking this possibility to heart in my argument, I shall try to bring the ideal, classical vocabulary of Wtewael's painting into dialogue with the material specificities characteristic of Dutch vernacular pictures.

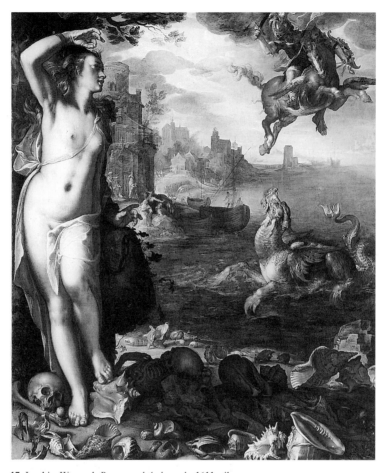

17 Joachim Wtewael, *Perseus and Andromeda*, 1611, oil on canvas.

18 Balthasar van der Ast, *Still Life with Shells*, between 1632 and 1657, oil on panel.

The picture

To begin with, it is rewarding to look closely at Wtewael's *Perseus and Andromeda*, bearing the original story in mind.[3] Iridescent and translucent, the picture is both luminous and dusky, coloured in marble, ivory, coral, bronze, silver and mother of pearl, the precious materials of nature and sculpture. Andromeda, an Ethiopian princess, has been prepared for sacrifice to appease Poseidon for her mother's boast that she, or her daughter, was more beautiful than any of the Nereides.[4] Light skinned[5] and almost as large as life, her loosely fettered body is linked to the unarticulated rock through its relaxed, frontal aspect and cut-out contours. It acquires substance and torsion from the taut twist of the neck, the shaded crook of the raised arm, the projection of one knee and the diaphanous fabric, spiralling round the form between the breasts and across the groin.

Warm, deep shadow shapes breast, abdomen and belly, pooling into the navel. The pearly white, pale gold and rose pink of the revealing draperies are reiterated in the face and the extremities, and the figure is most intensely expressive here. The parted lips, gaze and the large, minutely rendered hands gesture across the pictorial and narrative space to the mounted, embattled Perseus, a leaping, colourful figure which mirrors the monstrous adversary below. Andromeda's feet are directed towards the observer, one of them poised beside a skull teething a thigh bone, the other lightly placed on a shell whose vibrant, seductive interior provides a startlingly direct route of entry into the figure, as if her concealed genitalia have been exposed in their displacement.

The proliferation of exotic, faithfully observed, almost tangible shells turns Wtewael's sea-shore into a still life, presenting nature in all her diversity and particularity (compare Figure 18).[6] In conjunction with a nude female figure, these shells are likely to have been recognised by educated contemporaries of Wtewael as an allusion to Venus, the goddess of love. Although Venus is now often assumed to have been born from the sea on a *scallop* shell, there was a noticeable degree of licence in Dutch representations of her attribute. As Eric-Jan Sluijter has pointed out, the Haarlem artist and writer Karel van Mander, who published his magisterial *Schilder-boeck* in 1603-4, stated in its explanation of Ovid's *Metamorphoses* merely that 'She [Venus] should be represented with mother of pearl or a shell in her hand'[7] and Van Mander's colleague Hendrick Goltzius depicted a Venus holding a naturalistic *nautilus* shell (Figure 19).[8] These two men were certainly known to their contemporary Wtewael, at least through their works,[9] and in his own 1615 *Judgement of Paris* (Figure 20) Wtewael himself explicitly linked the victorious Venus with two shells which are strikingly similar to the most prominent shells in his earlier *Perseus and Andromeda*.[10] Considered as a pair and in relation to two pictorial narratives concerned with the dangers inherent in the quest for perfect beauty/love, one of these shells provides a smooth passage, while the lips of the other are barred by alarming teeth.[11]

Andromeda's loveliness is thus a manifestation of her association with love, a love which can be seen to have a positive and a negative aspect. The shells further

19 Hendrik Goltzius,
Venus-Pictura, after
1604, oil on panel.

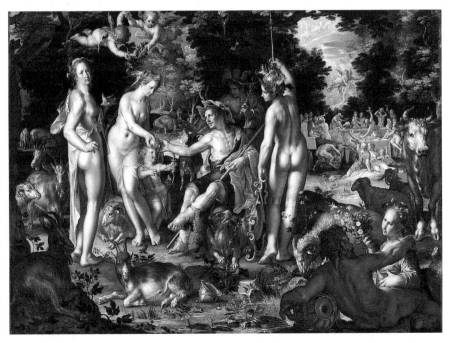

20 Joachim Wtewael, *The Judgement of Paris*, 1615, oil on panel.

enrich her as a symbolic figure in that the Nereides, the sea-nymphs whose divine beauty she was claimed to equal, are said to have lived in coastal grottoes adorned with shells. Their homes were also shaded by branches of vines, like the vegetation which encircles and shelters Andromeda's rock. This constitutes a visual equivalent to the myth's substitution of Andromeda for the Nereides as a model of beauty, the transgression of the boundary between terrestrial mortals and the divine powers of the sea which originates the drama of Perseus. In this view, the flat-topped grey structure to the extreme right of Wtewael's painting, beneath the monster's tail, evokes not only the altars at which Perseus sacrificed to the gods in thanksgiving for his victory, but also sacrificial altars to the Nereides, who could calm the dangerous waters across which travellers must journey to reach their destination.[12]

Besides the abundance of shells, which is not intimated by Ovid's text, the presence of human bones on the shore departs from the classical story, in which Andromeda is the sole victim.[13] Although their inclusion is not particularly unusual, neither is there any classical authorisation for the towering profile of a city directly behind Andromeda, or the depiction of Perseus mounted on a winged horse.[14] These embroideries to the tale bring the picture into semantic contact with adjacent myths, such as that of St George, a legendary Christian knight who slew the pagan monster threatening the walls of a port-city in order to rescue its king's innocent daughter, the ultimate of many sacrifices. The loose chain of allusion could extend to the Christian maiden Angelica, liberated by the Saracen knight Ruggiero in Ariosto's well-known epic poem, *Orlando Furioso*, first published in 1516.[15]

Stories such as these frequently allegorised the fight to protect a virtuous, Christian territory from pagan evil and Wtewael's representation of Perseus and Andromeda was amenable to a political reading in the Netherlands at the beginning of the seventeenth century.[16] Perseus was identifiable with the heroic Princes of Orange, who had rescued the Netherlands from a devilish, sea-borne enemy in the form of Habsburg sovereignty. The manacled figure of Andromeda stood for the captive Low Countries in imminent hope of liberation. As a figure of love, she was thus capable of uniting a specific geographic and historical position with a general, abstract ideal of beauty. She was, in effect, a Dutch Venus, a classical vision of the Dutch Maid.[17]

In her role as the innocent maiden preserved by a heroic knight, Wtewael's figure of Andromeda is a cipher for all virtuous, lovely women, from Plato's Celestial Venus[18] to the Virgin Mary. This range of reference is made explicit in Wtewael's *Venus and Cupid* of 1628, which closely resembles a half-length Virgin and Child (Figure 21).[19] However, Anne Lowenthal has also plausibly suggested that the figures in this painting were modelled upon Wtewael's daughter Antonietta and her little son Hendrick,[20] allying the personal and particular to the divine ideal. Likewise, Andromeda's venereal attribute, the shell, simultaneously identifies her as Plato's Earthly Venus, a personification of the desires instilled by

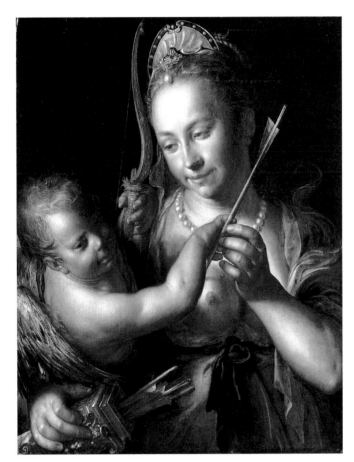

21 Joachim Wtewael,
Venus and Cupid, 1628,
oil on panel.

the material world in all its specificity, variety and artfulness.[21] A nude female
figure, set outdoors, was traditionally associated with Nature, whose unlaboured
fertility is here visible in the plethora of exotic shells – an appropriate symbolic har-
vest for the Netherlands, whose wealth derived in large part from the sea and,
increasingly, a foreign empire.[22] The incorporation of a city, which was convention-
ally personified by an upright maiden,[23] implicitly includes human culture, labour
and exchange within the compass of earthly beauty/love. The material point is
underlined by a subtle relationship between Andromeda and Danäe, another virgin
princess. Andromeda's juxtaposition to a defensive tower, and particularly the way
in which her yearning profile is aligned with the windows of its elevated chamber,
recalls Ovid's text, in which Perseus introduced himself to Andromeda as 'the son
of Jupiter and of Danäe, whom Jupiter made pregnant with his fertile gold, and that
though she was imprisoned in a tower'.[24] Perseus's own experience of love implic-
itly imitates that of a divine father who was capable of transformation into the
essence of material value.

In spanning the physical space between the shells at her feet and the port-scape behind her head and upper torso, Wtewael's Andromeda links the material fertility of nature with the material site of human culture, a union in love especially becoming to a highly urbanised, trading economy such as the Netherlands.[25] Through her gaze and the gestures of her hands, she also suggests that the gap between herself and the noble Perseus-Pegasus motif will finally be closed. Her visually and manually expressed desire thus implies the possibility of ultimately traversing the space between the material world at her feet and an elevated, semi-divine realm. In terms of her symbolic function within Wtewael's picture, the figure of Andromeda is thus not disengaged or even abstracted from the material diversity and specificity of nature, but serves rather to suggest its ideal *connection* with the material and ultimately spiritual worlds of human culture and endeavour. As an offspring of Venus, she can begin to unite the explicit eroticism of the sea-shell at her feet with the sublimated, abstract desire implicit in her gaze.

In this respect, Wtewael's picture of beauty/love rejects the tendency to sepa-rate matter from spirit characteristic of Italian and Italianate art theory of this period, although it certainly deploys a Platonic hierarchy rising from material specifics to the divine, abstract form or prototype and presents a gap between them.[26] At the same time as acknowledging the difference between material, mechanical execution and the spiritual/ intellectual *Idea*, it constructs through Andromeda an eroticised trajectory whereby these dimensions can be brought into loving intercourse with one another. It presents a beautiful ideal of love through which earth, in the form of a shell still life, and heaven, in the form of the classical *historia* of Perseus, can be linked.

Beyond iconography, this marrying of distinct entities is evident in formal qual-ities of the image. As Lowenthal has noted, there is quite a striking difference between the meticulous, naturalistic depiction of the various sea-shells and the more abstract, generalised treatment of much of the remainder of the composition. Lowenthal relates this to Wtewael's mastery of the two recognised pictorial modes in the Netherlands at the beginning of the seventeenth century: 'realist' depiction *naer het leven* (from the life) and 'ideal' imitation *uyt den geest* (from the spirit or intellect).[27] These two modes are normally respectively associated with 'low' sub-jects, such as Wtewael's *Fruit and Vegetable Market* of about 1618 (Figure 22),[28] and 'elevated' histories. However, their use within one picture, as in *Perseus and Andromeda*, was a persistent feature of Wtewael's oeuvre (compare, for example, Figures 20 and 28).[29] Their propinquity within a single field of representation, and particularly the way in which the treatment of Andromeda's very body gradually metamorphoses from almost tangible, shell-like toes up to an abstract, classical vision, suggests that these two modes – and the different genres of painting with which they are primarily identified – were not absolutely separate and opposed. The body of love could encompass both.

Lowenthal has also suggested that the emphasis upon the shells in Wtewael's pic-ture implies that its patron may have been a shell-collector.[30] It seems equally likely

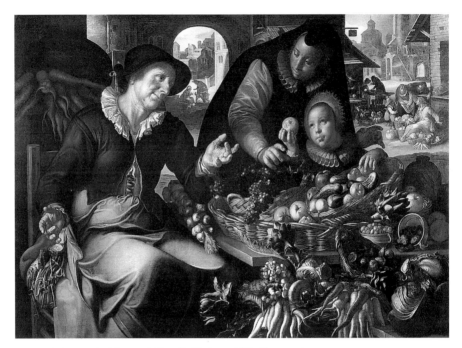

22 Joachim Wtewael, *A Fruit and Vegetable Market*, *c*. 1618, oil on canvas.

that Wtewael himself was the proud owner of these rare and valuable objects since, as
we have seen, two of the same shells appear elsewhere in his oeuvre and, as we shall see,
the picture may well have remained within the artist's own collection.[31] Nevertheless,
Lowenthal's idea usefully invokes the *kunstkamer* as a frame of reference for the
painting because the combination of rare, exotic shells and works of art was typical of
such collections (compare Figure 27). The conceptual categories structuring this
kind of assemblage assume a relationship between nature and art, and implicitly
matter and spirit, comparable to Wtewael's Andromeda. Within a *kunstkamer*, shells
belonged to the category of *naturalia*, manifesting the range, beauty and value of
God's loving, fertile creation, alongside *artificialia*, the wonderful and varied prod-
ucts of human creativity. Works of nature and of art are both products of an animating
force whereby base, dead matter is transformed into beauty.[32]

In Wtewael's painting this creative process is nominally characterised as mascu-
line: heroic and dangerous. Perseus's battle with the half-submerged sea-creature
can be seen as a fight with sensuality, with desire inverted into lustful consumption
of a purely material, inanimate world. For this is how such a monster sees the
lovely, life-giving Andromeda, chained to the rock on the sea-shore. Even the sen-
sory route to living beauty invited by Andromeda's shell is a narrow passage
through death, represented by the human bones to either side. These skeletal
remains, besides stretching the narrative to evoke previous feminine victims of the
sea-monster,[33] seem to allude to masculine agents rendered impotent and ossified

by their engagement with the matter of desire. To the right of Andromeda's feet, the empty eye sockets of the skull gnawing on a femur stare out of the image in a dreadful, conflated parody of the figures in Alberti's description of the *historia* which mediate positively or negatively between the viewer and the story.[34] To the left, a skull and bony torso reclines against a rock gazing eternally up at Andromeda. Its head is propped upon what seems to be another femur in a debased imitation of the conventional melancholic pose of head on hand, while its left hand is drawn across the remains of its breast in an empty gesture of love, an eerie parallel to the orientation of the girl's own hands towards Perseus.[35] The skeleton's heart is eaten away, the dull ribs encircling its hollow chest a distorted echo of the sparkling, coiled shell beside it. As a fixated, prostrate reflection of Andromeda's upright, living perfection, this narcissistic skeleton implicitly attributes deadly power to beauty herself. She casts a shadow over him.

The image here engages with the other side of desire: the material world not just as the beautiful product and symbol of regulated work and skill (human and divine), but as the basic, raw matter of creation – and degeneration. One way of gaining access to this dimension is through the figure of Medusa: the feminine as obscene, horrific, uncontained matter.[36] Perseus was, of course, responsible for her decapitation and in Wtewael's painting her snaky tresses are just visible on his shield. His battle with the monstrous sea-dragon can be seen as a repetition of his struggle with Medusa, and her indirect but essential presence is reiterated by the unauthorised inclusion of the winged horse Pegasus, who is said to have sprung from her blood.[37] More abstractly, the muddy-coloured, strangely unarticulated part of the sea-shore in which there is a confusion of sand, rocks, human bones, shells and even cloth[38] seems Medusan in character. The area looks unfinished, like 'dead-colouring'- the messy, material debris of the painter's studio which literally lay behind pictorial beauty.[39]

Here, however, it is arguable that Wtewael's painting renders even the scatological aspect of the material world susceptible to redemption and transformation into perpetual life and ultimately beauty by means of creative love. In some versions of the story of Perseus and Andromeda, the power of Medusa's severed head is ultimately used by the hero, motivated by love, to petrify the monster,[40] thus controlling and ordering the very danger that the Gorgon had previously manifested. This potential of the appropriated grotesque body to contain and transform its own threat into frozen effigies is evident in the strikingly sculptural qualities of the painting.[41] The intensely tactile shells, in which arbitrary deformation is subject to coiled perfection, look as if they have been generated by a divine sculptor from the surrounding, chaotic matter. Their predominant orange-pink hue is reminiscent of the coral which purportedly originated from a heap of seaweed upon which Perseus laid down Medusa's head after rescuing Andromeda.[42] The possibility of producing something precious, artful and talismanic from a meaningless pile of degenerating debris seems likely to have appealed to a visual culture distinguished by its representation of 'low-life' subjects which could be characterised, in classical terms, as base.[43]

In Andromeda herself the dark, deadly power of Medusa has been utterly harnessed and transformed into the proportions, *contrapposto* and burnished sheen of a beautiful statue. Emerging from the shadowy rock, she evokes the classical sculpture which Van Mander, following Italian theorists such as Ludovico Dolce, proposed as the closest approach to the divine *Idea* whereby artists refined, ordered and animated base matter.[44] Wtewael was familiar with this positive view of sculpture. His contemporary Aernout van Buchell, a Utrecht lawyer and antiquarian, noted that, 'beside the fact that [he] makes paintings, [Wtewael] excels so much in sculpture that for it he has long since won the highest praise from the greatest and highest intellects'.[45]

With the help of the heroic artist, Andromeda is even endowed with the potential to produce life. She has become the paragon of beauty which Perseus, in the Ovidian story, initially took for a marble statue and then, Pygmalion-like, freed from the inanimate rock, enabling her to take on the vibrant pigment of passionate love.[46] Incoherent matter is thus transformed, via the principled articulation of classical sculpture, into the fertile, flesh-and-blood beauty which is Painting. The carnal aspect of Pictura is evident in Andromeda's clear debt to Venetian versions of the same theme (compare Figure 23),[47] so that in the terms of reference established by Vasari, she acknowledges the parentage of both 'intellectual' *disegno* (antique sculpture) and 'sensual' *colore* (the Venetian tradition).[48]

The use of the story of Perseus and Andromeda as an allegory of painting in the Netherlands during the first third of the seventeenth century has been demonstrated by Jeffrey Muller in relation to the external decoration of Rubens's house.[49] My reading of Wtewael's picture in a similar way is supported by the long-standing

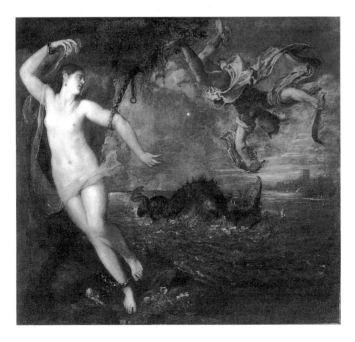

23 Tiziano Vecelli, *Perseus and Andromeda*, 1554–56, oil on canvas.

analogy between the artist and a noble, conquering hero such as Perseus.[50] A metaphor of martial yet bloodless conquest was crucial to Van Mander's representation of the artist, complementing a view of Pictura as epitomising the fruitful benefits of peace. As Celeste Brusati notes, he concluded the preface to the *Schilder-boeck* with a general's appeal to the soldiering painter to 'try his utmost to reach for and achieve the greatest possible dominion over our art, which one can attain without any danger of battle or bloodshed if one only commends oneself seriously and with diligence to bountiful nature'.[51] Perseus in particular was known to have been armed by Mercury and Minerva, the principal governing deities of painting.[52] For Dutch-speaking viewers his defining attribute, his mirror-like shield with its Gorgon head, is likely to have evoked the term *schilder*, the word for painter deriving from the decoration of knight's *shields* by medieval craftsmen.[53] Similarly, Andromeda's association with Venus (which is explicit in her shell and implicit in her powerful capacity for fusion, for marrying distinct entities), placed her in the symbolic realm of Pictura, the externalised, 'natural' form of the painter's desire. As Eric-Jan Sluijter has shown, the image of Venus with the *nautilus* shell by Goltzius (see Figure 19) is at the same time a representation of Pictura. Her right hand grasps a paintbrush, while the proffered shell, her feminine attribute, traditionally contained the paint.[54]

A historically-sanctioned, iconographical reading of Wtewael's picture as an allegory of painting has also been independently proposed by Colette Natival in an important recent article devoted to the work.[55] Her argument is based on the way in which the picture epitomised Van Mander's idea of history painting's universality in its inclusion of still life, landscape and narrative. It is clinched by a verse in which Andromeda is directly compared with the art of painting from Van Mander's *Den Grondt der edel vry schilder-const* (The foundations of the noble, free art of painting), a didactic poem which constitutes the first volume of the *Schilder-boeck*. The sense of this passage is that painters should be concerned with representing the content of histories, but nevertheless enjoy their freedom and not remain bound to the rock (of literal meaning) like Andromeda because painters, following Horace, have as much power as poets in all that they undertake or intend.[56] Wtewael may have been aware of this text; certainly he seems to have taken Van Mander's advice directly to heart in soliciting Andromeda's liberation from her mortal confines in the narrative plot.

A loving engagement with Andromeda transforms her into Venus in both her spiritual and material aspects; into a Dutch Nature in which the fruitfulness of the sea and the city are united; into Netherlandish Painting, an art in which dark, base matter can be transfigured into eternal life and beauty by her faithful devotees. As such, Wtewael's *Perseus and Andromeda* is of relevance to a broader understanding of Netherlandish visual culture in the early seventeenth century.

The erotic polysemy discernible in the picture was authorised within the Christian tradition by the canonical *Song of Solomon* whose heroine Shulamith, black and irresistible like Andromeda, spawned a multiplicity of allegorical

readings.[57] Such readings were also an established means of enjoying yet moralising classical myth and would have been agreeable in principle to Van Mander, whose preface to his explanation of the *Metamorphoses* distinguished three ways of interpreting Ovid's tales, leading to an ethical understanding.[58] In this broad Christian tradition of exegesis, the fleshly female form has typically been understood as a transparent metaphor for a pure, spiritual love which, paradoxically, stands in opposition to the flesh and its material desires.[59] Yet Wtewael's painting makes a specific claim, within and through this tradition, for forms of love and of painting in which material and spiritual existence (and activity) are ideally connected. His Andromeda bears witness to a desire in the early seventeenth-century Netherlands to traverse the boundaries between and unite positions separated by an absolute division between tangible matter and abstract spirit.

Another instance of this inclusivity is the title page of one of Jacob Cats's hugely popular emblem books in which a figure of Cupid presides over heaven and earth: the elevated ideal and grounded specificity (Figure 24). First published in 1618, the

24 Frontispiece to Jacob Cats, *Proteus, Ofie Minne-Beelden Verandert in Sinne-Beelden* (*Proteus, Or Love Images Transformed into Meaningful Images*), Rotterdam, 1627, engraving.

book is entitled *Proteus, Ofte Minne-Beelden Verandert in Sinne-Beelden* (Proteus, or Love-Images Transformed into Meaningful Images).[60] To make a play on language that may well have been appreciated by Cats's original readers, for whom the chain of displacements characteristic of the Pun still spoke as forcefully as the severed dualism of the Word, love is central to met*amor*phosis.[61] In the following sections I shall suggest that the ideological use of love helped to reconcile the Netherlands to the profound changes secured by the revolt against Habsburg and Catholic hegemony[62] by enabling the discerning citizen of the Low Countries to distinguish (his) 'lowliness' from baseness and to recognise both a categorical difference and a meaningful connection between the low and that which was agreed to be socially and spiritually elevated.

The frame

In order to explore in historical terms the fields of desire in which *Perseus and Andromeda* situated its primary viewers, I am now going to use Derrida's concept of the *parergon* or frame as the means whereby an entity is both separated from and connected to a defining other.[63] In the domain of Venus, this capacity might be understood in relation to Georges Bataille's fundamental definition of eroticism as the yearning of 'discontinuous' or separate beings for 'continuity' or union with another entity.[64] I shall begin by setting the picture in the context of its initial conditions of production and reception, placing it within a space of display which addressed a privileged, masculine circle of artists and the amateurs known in Dutch as *liefhebbers*. I shall suggest that this elite group espoused an eroticised relationship to the pictorial image which can be understood as a conservative response to the challenge to established regimes of representation articulated in the recent iconoclastic revolution against Catholic and Hapsburg sovereignty. It involved an attempt to retain visual representation's traditional, sacred function of connecting the material and the spiritual realms whilst simultaneously acknowledging the difference, the distance, which iconoclasm had forcefully asserted between them. The result was an important shift in the location of the capacity to marry body and spirit away from qualities perceived to be intrinsic to the image and towards performative competences and responsibilities exercised by this aspirant group of artists and viewers.

Perseus and Andromeda was no ordinary, run-of-the-mill production, participating in a realm of exchange dominated by material values. Rather, Wtewael seems to have been placed it at one remove from such open market forces, in a zone connecting a domestic sphere of display with the traditional, explicitly sacred space of the altar. Although such an ambitious work clearly involved considerable expenditure of time and effort, the immediate rewards reaped by the painter do not seem to have been monetary, since the picture apparently remained in the possession of his family. It is very likely identifiable with 'a large Perseus and Andromeda by Joachim Wtewael' valued at one hundred and twenty-five guilders which was documented

in the inventory of Wtewael's granddaughter and her husband in 1669. This picture was recorded within a substantial category of 'paintings and mirrors' and located in the *voorkamer*, the main reception room of the house. It was listed between a nativity and a market scene by the same artist, constituting a frame of an 'elevated' history and a 'low' subject which seems to respond to the marriage between spirit and matter thematised by *Perseus and Andromeda*.[65]

Initially, the work was probably hung in the artist's own large house on the Oudegracht, Utrecht's principal canal, which seems to have contained a considerable number of paintings by the master and other artists.[66] The exotic shells which appear in both *The Judgement of Paris* and *Perseus and Andromeda* were perhaps also on display. While such a collection undoubtedly provided Wtewael with personal pleasure and a good advertisement for his skills,[67] it is thus tempting to imagine *Perseus and Andromeda* within a space permeated by the concept of the *kunstkamer* or cabinet of curiosities, where it would have been the focus of admiration of a cultivated circle.[68] A sophisticated audience of this kind would conform with Van Mander's contemporary statement that 'Having returned home [from Italy and France] [...] [Wtewael] has made many pieces, small and large, which are owned by art lovers [*liefhebbers*] in many places and are deservedly appreciated'.[69]

The etymology of the term *liefhebber*, 'those who have love', places this kind of viewer within the realm of Venus.[70] This is acknowledged visually in Hendrick Goltzius's 1603 portrait of the renowned Haarlem art lover Jan Govertsz. (Figure 25),[71] which represents him surrounded by exquisite shells and holding a *nautilus* in a way comparable to the same artist's depiction of *Venus-Pictura* (see Figure 19). Typically highly educated members of urban elites rather than offspring of the great old noble families, *liefhebbers*[72] emerged in the Netherlands towards the end of the sixteenth century as a distinct group spanning the confessional divide between Catholicism and Protestantism. Although often collectors, they defined themselves by their passionate interest in the objects of their affection, rather than by material possession of them.[73] They were also identifiable by their claim that well-directed sensory experience of such objects was a means of attaining an elevated goal. As Zirka Filipczak has discussed with reference to Antwerp, the *liefhebber*'s commitment to empirical knowledge was regarded as the worldly path to divine wisdom and ultimately to faith.[74] It thus justified membership of a spiritual elect. Even a Protestant *liefhebber* might in this sense feel closer to God, closer to immortality, than the ordinary viewer whose material interest constituted an end in itself. As I have argued elsewhere, the ideology of love, conceived as an engagement with the world motivated by and directed to the elevated goal of virtue, also enabled non-noble elites to claim a status in society superior to that of the ordinary citizen and different but equal to that of the hereditary aristocracy.[75]

Within these citizen elites, the ambitions and vision of the *liefhebber* were closely aligned with those of the artist. In Counter-Reformation Antwerp, for example, some *liefhebbers* became members of the guild of Saint Luke and in the paintings of gallery interiors or *kunstkamers* which became a city speciality, the

25 Hendrik Goltzius, *Portrait of Jan Govertsz.*, 1603, oil on canvas.

figures depicted contemplating works of art often included painters alongside such amateurs.[76] Within these surroundings they perceived Pictura in the same way, cognisant of her specific and sensible characteristics as a fertile, life-enhancing manifestation of knowledge, virtue and ultimately divine love, rather than as superficial, ephemeral distractions. Art lovers also rubbed shoulders with artists in *alba amicorum* and as consumers of art literature. Van Mander's *Schilder-boeck*, for example, was aimed at an aspirant community encompassing both producers and viewers of painting.[77] It thus seems likely that not only the practising artist but also the *liefhebber* were included within an important claim in contemporary art literature, registered by Van Mander, that love prevailed over honour and profit as the highest motive for art.[78] This bond between the artist and the *liefhebber* was not just a marriage of convenience; the two figures had something profound in common. They shared a commitment to sensory experience, including the work of the hand, as a respectable route to spiritual fulfilment: a corporeal engagement in the absorbing quest not for Pictura's material body *per se* but for the virtue invested in her substance.

In Utrecht, the close identification between the love-inspired viewer and the elite artist is reflected in the initial reception of *Perseus and Andromeda*. This was apparently centred upon Joachim Wtewael himself, as both the maker and the principal viewer of the work. Wtewael was also not just a learned artist but an 'amateur' in the sense that he did not rely on painting (or sculpture) for his principal income. He made most of his considerable fortune from trading in flax and from investments in property and the East India Company. Although his father was a glass-painter, he could also lay claim to a gentlemanly character as a member of a respected and politically active Utrecht family.[79] His artistic pursuits could thus be represented as motivated by all-encompassing love, rather than just a narrow desire for social honour or need for monetary profit.

In 1611, Wtewael was instrumental in founding a new guild of Saint Luke in Utrecht.[80] *Perseus and Andromeda*, which is dated the same year and is susceptible to interpretation as an allegory which intimates the liberation of Pictura, seems likely to have been of interest to his fellow founding members. This is because, besides its traditional function of economic and social protection, the new institutional body of Pictura enabled the younger generation of the city's artists formally to emancipate themselves from the old Saddlers' guild, whose heterogeneous membership had originally been determined by the skills necessary to produce a knight's armour. In distancing themselves from a category of craftsmen defined by its function within a traditional feudal hierarchy, members of the new guild implicitly aligned themselves with free practitioners and lovers of the liberal arts. They were led by a group of leading Utrecht painters, but it is notable that the first membership roll also listed thirteen sculptors and twelve painters of linen wall hangings – a constituency to which I shall return later.[81]

In the heightened atmosphere surrounding the formation of the new guild, a monumental work which addressed the origins and nature of painting would have invited comparison with depictions of Saint Luke painting the Virgin, the Christian allegory which since medieval times had adorned the altars of painters' guilds, especially in the Netherlands.[82] Saint Luke was also a progenitor of the identification between the *liefhebber* and the aspirant artist in that he is supposed to have been a medical doctor, an educated man whose miraculous visual encounter with the Virgin inspired him to immortalise her in paint, an act of devotion which secured his own salvation.[83] Such devotional images had been banished from ecclesiastical space by the onset of Protestant iconoclasm in the second half of the sixteenth century. In *Perseus and Andromeda*, contemporary viewers could have seen a visual representation with similar concerns and objectives translated into a classical narrative and an aestheticised domestic space.

Recently, Hans Belting and Victor Stoichita have fruitfully emphasised the historical *disjunction*, a rupture associated with iconoclasm, between the devotional image and paintings as works of art intended for a gallery setting.[84] Here I want to use a comparison between an altarpiece depicting Saint Luke painting the Virgin and *Perseus and Andromeda* to initiate a consideration of some *continuities* between

'sacred' and 'gallery' space, not in order finally to deny a decisive change in the conception of pictures but to try to characterise more precisely the emergent, new engagement with Pictura exemplified by Wtewael's work. The confessional climate in Utrecht, which had been the ecclesiastical capital of the Netherlands before the Reformation and remained a centre of Catholic influence within the United Provinces, seems likely to have favoured the appreciation of such continuities.[85]

At the heart of this sense of continuity lies the conceptual space of the *kunstkamer*, a 'gallery setting' specific to this period which, I have suggested, permeated not only the physical location of *Perseus and Andromeda* and its reception by *liefhebbers* but also the relationship between nature and art *within* the picture.[86] It is therefore worthwhile emphasising how close the sacramental space of Saint Luke painting the Virgin had come to the space of the *kunstkamer* by the outbreak of iconoclasm in 1566. From the mid-fifteenth century the artist-evangelist was increasingly depicted in a domestic space, and in an example painted by the renowned Haarlem master Maarten van Heemskerck probably in the late 1550s (Figure 26)[87] this space has become dedicated to the production and consumption of cultivated knowledge. The palatial setting in which are displayed classicising statues including a figure reminiscent of the Virgin, was modelled on a specific 'domestic' space: the courtyard of the Casa Sassi in Rome. In the foreground, an illustrated anatomical text is placed so as to inform not only the work of Saint Luke as *pictor doctus* but the knowledgeable viewer's appreciation of God's loving design as embodied in humanity.[88] Statues and learned books, as well as the sphere, vase of flowers and the inset back room (here on the gallery) in which male figures are gathered around a table, were all to become standard features of Antwerp '*kunstkamer*' paintings, such as that produced around 1636 by Frans Francken the younger (Figure 27).[89]

Just as Van Heemskerck's altarpiece anticipates the world of the *kunstkamer*, so memories of the devotional realm of Saint Luke persist in Francken's 'cabinet picture'. Whereas the Virgin herself is not actually present in the scene, she is highlighted and again replicated in representation. And if Saint Luke is no longer directly visible either, the presence of this devout viewer and artist is arguably evoked by the *liefhebber* who was, ideally, positioned in front of this kind of picture.[90] His association with Saint Luke is implicit in the juxtaposition between the medallion portrait of a contemporary gentleman and the picture of the garlanded Virgin and Child which dominates the centre of Francken's work. This relationship, which is immediately reminiscent of that between the donor of an altarpiece and the central, devotional image, can be seen in terms of the devout viewer's ideal engagement with Christian Pictura. For the Virgin, as an embodiment of love and the mirror without stain,[91] was the perfect device whereby man might see a reflection of God within a feminine, natural world of beauty.

Heemskerck's altarpiece of Saint Luke and Francken's gallery painting frame *Perseus and Andromeda* chronologically. They distinguish a historical space in which the devout artist-evangelist and the love-inspired artist-viewer still mingled

26 Maarten van
Heemskerck, *St Luke
Painting the Virgin and
Child*, late 1550s, oil on
panel.

together in the realization of Pictura, and through her a state of grace. Both figures
were engaged in a quest to attain enhanced status and eternal bliss in and through
well-directed sensory experience of beauty, the perfect corporeal mirror of divine
virtue. If Wtewael's allegory is situated within this space, a place still permeated by
desires traditionally invested in the Virgin Mary, Andromeda becomes under-
standable as another embodiment of the Marian ideal: a fertile yet eternally pure
body, accessible to the senses, which provides the desirous 'consumer'[92] with an
intercessory route between earth and heaven. Indeed, Wtewael's Andromeda is
actually recognisable as the symbolic daughter of the Virgin. In the background of
his painting, the distraught figure identifiable as her mother, dressed in blue and
highlighted immediately to the right of her offspring's pointing finger, is strikingly

reminiscent of a mourning Mary. In view of the established association between the Virgin and the Church, it is also noticeable that the shape and colour of this figure are echoed in the three bluish churches silhouetted on the horizon.[93]

Having established the likeness between Andromeda and the Virgin, and between the figure of the *liefhebber* and his ancestor Saint Luke, it becomes possible to identify some crucial dissimilarities between them. Wtewael's *Perseus and Andromeda* differs from any depiction of Saint Luke painting the Virgin in the sense of crisis surrounding Pictura. Following the Reformation and iconoclasm, it seems that it was no longer possible to exclude the fatal risks of beauty, and the work involved in their suppression, from the perfect picture. Whereas for Saint Luke the immortalising engagement with the Virgin had been an unselfconscious and direct engagement with the embodiment of divine love in the world, for his descendents, shaped by the trauma of iconoclasm, it became an explicitly eroticised yet profoundly apprehensive attempt to negotiate a dangerous and broken path to spiritual virtue via sensory experience of material beauty.

In Heemskerck's image (see Figure 26) the distinction between earth and heaven is miraculously overcome, whereas in Wtewael's work Andromeda remains bound to earthly rock, presently divided from Perseus's heroic activity in the elevated, airy heights. Heemskerck's painting is a statement of faith in the virtue of both the artist and the Madonna in that it places them on equal terms in an intimate

27 Frans Francken II, *Cabinet of Curiosity*, 1636, oil on panel.

and immediate encounter. Indeed, in the process of transforming the material pigments on his palette into the perfect image of the Virgin, the artist is even allowed to touch 'her' with his brush, to mirror her position as an agent of incarnation, the embodiment of divine love in the world.[94] A parrot eating out of the infant Christ's hand symbolises the subordination of the deceitful sin of Eve to the true, faithful imitation which is love.[95] By this means subject and object, material sign and divine prototype are, ideally, united. In Wtewael's work, on the other hand, Heemskerck's tame bird has grown into a winged serpent, a gorgeous but lethal creature which breaks the calm surface of the water, the mirror without stain.

The unperturbed confidence in the power and virtue of imitation evinced by Heemskerck's altarpiece is understandable in the context of the traditional, Catholic conception of the mass as a means of attaining the mortal worshipper's ultimate union with a God of love through the ritual replication of Christ's sacrifice.[96] The oral consumption of Christ's body and blood in the form of bread and wine which lay at the heart of this ritual implicitly defined such mimesis in terms of penetration of the perceived boundary between two separate entities: the mortal communicant and divine virtue. Saint Luke's visual absorption of the Madonna and Child as a condition of producing their perfect, living likeness was thus analogous to the ideal relationship between the communicant and the host in that loving assimilation of an embodiment of divine love was a prerequisite for the faithful reproduction of an immortalising miracle. For the communicant this was the personal redemption achieved by emulation of Christ's sacrifice, while for Saint Luke it was the to-the-life imitation of the Virgin and Child. The painted altarpiece was similar to the host in that it was a material object which could marvellously render the power of divine love sensibly present to the devotee. Communion, which was a primary route to immortality, entailed faith in the possibility of transcending the distinctions between object and subject, material sign and divine prototype, femininity and masculinity, life and death.

The unselfconscious espousal of such a position was no longer possible in the aftermath of the Protestant Reformation, which reduced the Eucharist from the repetition of an immortalising act of sacrifice to a sign, a symbolic commemoration of the distant historical occurrence of the Last Supper.[97] The gap asserted between the material sign and its divine referent deferred transcendence of difference into an ideal future and explained its restriction to all except an elite few, comprising those justified by faith. The Virgin, as the feminine epitome of the traditional concept of visual representation as incarnation, was especially charged by iconoclasts with tempting men to idolatory, to a fatal confusion between a seductive material artefact and the immaculate human mother of God. Rather than a smooth, brilliant mirror which connected the natural world with divine reality, Mary now became capable of evoking a fractured and laboured realm which emphasised the pain of separation. From this critical perspective the association in Wtewael's painting between Mary and Andromeda was a potential liability, her threatened sacrifice to the marauding monster understandable in relation to the menace to the existence of painting implied by iconoclasm.

One response to this challenge to the virtue of Pictura was to situate her within a scene which characterised her as an innocent, passive victim whose fate was dependent upon divine intervention. She is rendered as such in Van Mander's interpretation of the story of Perseus and Andromeda in the commentary on Ovid's *Metamorphoses* which was included in the *Schilder-boeck*: 'The innocent Andromeda delivered by Perseus shows us that the devout, often in extreme need, are redeemed in an unforeseen way by the merciful decree of God.'[98] Such a reading is compatible with the Ovidian myth's political interpretation as an allegory of the providential liberation of the righteous, distressed United Provinces from Catholic, Habsburg exploitation. Within a broader Christian purview, the thematics of the interpretation are also close to the angel Gabriel's annunciation to the righteous, distressed young Virgin. *Perseus and Andromeda* thus evokes an innocent, passive Marian ancestry which allows the Netherlandish Maid and Pictura to continue to be defined as sisters, perhaps even identical twins.[99]

Another, contradictory, response to the threat to Andromeda as Pictura was to emphasise her intrinsic power by according her the attributes of the painter as active agent as well as painting as material object. In Wtewael's work, Andromeda's erect stance, gestures and gaze, together with the visual transition between matter and spirit accomplished through her body, render her an *instrument* of the union between earth and heaven, as well as the passive *recipient* of an eroticised engagement. A similar combination of receptivity and activity is recognisable in the allegory of Pictura in the centre-right background of Frans Francken's *Cabinet of Curiosity* (see Figure 27), in which the seated female figure receiving divine inspiration from an angel resembles both an annunciate and a muscular painter occupied at the easel. Goltzius's *Venus-Pictura* (see Figure 19) articulates the same idea through the attributes of the inert 'feminine' shell and the wielded 'masculine' brush. Looking at Wtewael's picture with this iconography in mind, the shell lying at Andromeda's feet can be seen to counterpoint the smooth, columnar body whose head of chestnut hair, energised by a breeze, registers on a visual and symbolic continuum with Pegasus's flailing tail.

In terms of her Marian heritage, a potent vision of Andromeda bears less resemblance to the innocent and terrified victim of the annunciation than to the triumphant queen of heaven, whose quasi-divine capacity to intercede between earth and heaven derived from her bodily production and possession of the redeeming Christ child.[100] Thus the combination of human virtue and divine power which had traditionally been *successively* invested in the Virgin as a narrative figure was maintained in Andromeda only at the expense of a contradiction, a split, in a feminine figure of desire who had now become *simultaneously* victim and dominatrix.

Indeed, in Wtewael's painting, the preservation of the Marian ideal of Pictura as a means of connecting earth with heaven entails a paradoxical splitting, both between and within, the protagonists in the scene. The virtuous Andromeda still provides a sensory route leading towards salvation, but she is hemmed in by objectified risks and there remains a physical gap between her and Perseus, the focus of

her yearning gaze. And unlike Saint Luke's combination of visual assimilation and physical (manual) activity, the loving engagement necessary to liberate Andromeda's miraculous potential has become so difficult and dangerous that the task has been divided between the 'artist' Perseus, labouring heroically behind Pictura, and the *liefhebber* in front of the picture, who must visually negotiate a perilous and diminishing sensory passage towards immortality.

Furthermore, the point of view of the masculine subject in search of virtue is divided between the viewer's devoted abasement before Andromeda as his ideal *alter ego*, and Perseus's sword-wielding superiority towards the serpent, an inverse, grotesque reflection of himself. At the same time, this cavorting, horizontally-oriented monster can be seen as the antithesis of the bound, upright figure of Andromeda – notice the horizontal alignment between her deep, enlarged navel and the monster's mouth.[101] Yet despite Perseus and Andromeda's shared self-definition by reference to the same terrible, threatening other, and despite Andromeda's visible desire to join her lover, the two figures occupy spatially separate realms.

This obsessive splitting is understandable as a means of acknowledging yet evading the anxieties about Pictura articulated by the trauma of iconoclasm, a physical and theoretical attack on visual representation which sought to separate body from spirit, to distance and indeed cut off the deceitful, sensual, material sign from the true, heavenly signified.[102] At its most extreme, this meant the obliteration of the image as a technique of devotion. However, many people, most obviously Catholics and painters, had everything to gain – both materially and spiritually – from acknowledging the mortal dangers surrounding Pictura whilst preserving her as a sacred site in which, for the elite inspired by love rather than lust, the world available to the senses could still provide a way of reaching, or reaching towards, divine virtue. This entailed maintaining the traditional ideal of continuity between worldly matter and heavenly spirit but at the same time recognising a real discontinuity between them. The result was an intense concern to define and contain different realms of experience while simultaneously providing, through the picture, a means whereby the self-aware artist or *liefhebber* could gain personal access to immortalising virtue, the locus of his desire.

The function of establishing the boundaries of difference while indicating the possibility of continuity is recognisable as a *parergon*, a means simultaneously to separate and connect distinct but adjacent fields. Stoichita has recently discussed gallery pictures such as that by Frans Francken (see Figure 27) as an assemblage of framed motifs[103] and I want to look at the way in which the structure of this 'realist' work conditions the response of the viewer as a prelude to a similar consideration of Wtewael's 'classical allegory'. A comparison between these two works from different confessions is justified by the *liefhebber*'s transcendence of the official divide between Catholics and Protestants, and by the similarity between Utrecht, with its strong Catholic tradition, and Antwerp, with its recent history of religious heterogeneity and iconoclastic attacks. The latter's Counter-Reformation can be seen to have responded to the Protestant critique of the naïve identification of the material

sign with signified reality, while continuing to promote the cult of the Virgin Mary, her celebrated patron saint.

In Francken's painting, techniques of juxtaposition and overlap allow the envisaged viewer – the *liefhebber* – to negotiate a path between physically separate but symbolically connected elements of the image. The pivotal instance is the relationship between the central depiction of the garlanded Virgin and the two principal visual fields above it: the well-lit scholars' study and the shadowy depiction of Pictura. The direction in which the profile medallion portrait 'looks', and the diagonal axis created by motifs in the composition of the garlanded Virgin, such as the baby's pointing arm, the tilt of his mother's head and the highlighted leaf ornament in the upper right corner of the frame, subtly direct the aspiring viewer's search for virtue towards (the) scholarly study in the upper right corner. The *liefhebber*'s quest can also be seen to be fulfilled through his identification with the divinely inspired artist, whose image is placed directly above the representation of the Virgin and pointedly indicated by the white elements on its frame.

The central image of the garlanded Virgin is thus recognisable as the device *in* or *through* which the perceptive viewer/artist can attain the virtues of wordly knowledge and divine inspiration which are situated behind and above it. Its brilliant surfaces and frontal alignment underline the established Marian symbolism of the mirror without stain, whereby the virtuous subject can grasp divine perfection, the focus of his desire. In fact this doubly framed Virgin and Child, might be regarded as the perfect representation of the hierarchy of sensible beauties which provide 'step by step' access, through a process of reflection, to the two more abstract realms of virtue. (There is a progression from the 'tangible' frame of inanimate grotesques to the painted flowers, natural symbols of the Virgin,[104] and on to the sacred image.) However, in contrast to Heemskerck's altarpiece, in which such virtues were embodied in the Virgin and Child, these realms are now represented as separate and distinct, and it is up to the viewer to observe the more or less subtly signposted routes towards them.

He can also choose a less virtuous path. While as 'Pictura' Francken's Virgin leads to fields of abstract virtue, as 'Scultura' she is liable to be absorbed into the predominantly material value(s) by which she is arbitrarily surrounded. The shell at the depicted sculpture's foot, so strikingly reminiscent of that touched by Andromeda's toes, in this context functions as a seductive path to a *relatively* inferior end. In Wtewael's work, by contrast, sculpture has been shown to be incorporated within a virtuous Pictura. This difference seems to articulate not only dissimilar positions within the ongoing debate between painting and sculpture in art theory but the distinct institutional and personal relationships between practitioners of the two media in Antwerp and Utrecht. Whereas Antwerp was characterised by institutional tension and individual separation between those who employed the brush and chiselled in stone, in Utrecht sculptors were included within the new guild of Saint Luke and Wtewael himself was apparently skilled in both techniques.[105]

There are no explicit frames in *Perseus and Andromeda*, but its compositional structure of a distinct foreground, middle ground and background can be seen to function in a similar way to the formally contained visual fields in Francken's work: enabling the astute viewer simultaneously to connect and sever a hierarchy of conceptual realms. The layered juxtaposition of these three areas brings them together, while their distinctive iconography and treatment elicit a sense of separateness. The viewer's gaze is immediately confronted by the *naer het leven* specificity of the 'still life' materials on the sea-shore, then encouraged to move onwards and upwards to the tower with generalised, gesticulating figures, a scene more reminiscent of a 'history painting' created *uyt den geest*. In the remote background he finally reaches an 'abstract' realm of ecclesiastical architecture bathed in ethereal light.[106]

Perseus and Andromeda, the two virtuous protagonists in this drama, are placed and rendered in such a way as to suggest a capacity to *transcend* these three domains. Meanwhile the monster in the middle distance, whose colouring and meticulous rendering relates to the items on the sea-shore, can be seen to *transgress* its proper place amongst these subordinate objects, just as it breaches the surface of the sea. Thus, while a discerning figure engaged with (the) painting would recognise the wonderful 'still life' of shells as an attractive and valuable device through which access can be gained to the disciplined, virtuous way up a socio-spiritual hierarchy personified by beautiful Andromeda, his ordinary cousin would be liable to be distracted from this path by the dangerous characteristics which the shells share with the serpent: their colourful but unregulated novelty and variety.

The distinction between earth and heaven in Wtewael's painting is more pointed than in Francken's picture, in accordance with reformed theology's insistence on the separation of these two spheres.[107] There is, for example, an emphatic frontier between the sea monster and Perseus-Pegasus, whose flailing hind hooves are separated from the creature's open mouth by the highlighted section of horizon between two of the churches. A discerning artist or *liefhebber* who observed this line could here constitute for himself an impenetrable boundary of representation because an awareness of the surface of Narcissus's pool was a natural protection against falling into the gaping trap of unenlightened, uncontrolled consumption. The differentiation between neat (*net*) and rough (*rouw*) finish which is such a feature of Dutch art and art discourse for most of the seventeenth century assumes the development of precisely such a consciousness of 'surface': the limit of visual representation.[108]

The separation of the figures of Perseus and Andromeda seems to confine to the narrative future the possibility of a blissful union between a heroic masculinity presently elevated to divine status and a nominally feminine figure chained to a rock. This possibility is also dependent upon the capacity of virtuous desire to traverse the evanescent, abstract configuration of sunlight and clouds which the artist has created between them. Perhaps this is all that could be explicitly articulated in a reformed, fractured universe. In the following section, however, I shall question

whether all elite, self-aware subjects were completely satisfied with this deferred and aestheticised promise.

The support

An ability to differentiate between the 'surface' of a picture as part of the material world and its 'depths' as the locus of intellectual and spiritual fulfilment can thus be seen to have protected the astute viewer and artist from base materialism and enabled him to pursue his claim to virtue. Hubert Damisch has explored the way in which the split between surface and depth functioned as a mechanism of desire, and in conclusion I want to consider that which he terms the 'underneaths of painting' with reference to *Perseus and Andromeda*.[109] In a meditation on Balzac's *Le Chef d'oeuvre inconnu*, Damisch reveals the passion of the artist-viewer as the compulsion to gain access to the living subject/object of desire which has been buried by the unlimited ambition and labour of an old master beneath 'a wall of paint':

> they saw, in a corner of the canvas, the tip of a foot emerging from this chaos of colours, tones, indecisive nuances, a kind of undefined mist; but a delectable foot, a living foot. They remained petrified before this fragment escaped from a formidable, a slow, progressive, destruction. This foot appeared like the torso of a Venus of Parian marble rising amongst the ruins of a burnt city. – 'There is a woman under there', [one of them] cried ...[110]

Andromeda is, by contrast, in some respects perfectly accessible to an appreciative gaze, the appeal of her own delectable foot enhanced by its proximity to the shell. I want to suggest that, at the historical moment of production and initial reception of this pictorial, marmoreal figure, its 'underneath' could be perceived to comprise *both* an intangible yet living reality *and* 'a wall of paint'. Visual penetration from the 'low', 'still life' foreground to the 'elevated', 'abstract' background of the picture enabled viewers to grasp the allegorical character of the work, the 'hidden' or 'invisible' meaning which remains one of the goals and foundations of art historical discourse.[111] At the same time, the way in which muddy underlayers of the painted canvas were allowed to constitute part of the picture[112] subverted a separation between matter and spirit, and argued for

> a regulated exchange of positions; an exchange equivalent to a manner of plaiting with the threads moving up and down alternatively, each individual thread passing now under, now over, constantly evading the univocal sign: an exchange inherent to the texture if not to the very principle of painting ...[113]

The appreciation of Pictura's hidden, spiritual depths can be described as 'insight', drawing upon Van Mander's use of the term *insien* to characterise a compositional organisation and a mode of looking structured by 'distances'.[114] In my discussion of Francken's *Cabinet of Curiosities* towards the end of the preceding section, the concept of looking *through*, *into* or *beyond* immediate experience was

proposed as the means whereby the desirous artist-viewer could forge a semiotic connection between the substantial image of the Virgin in the flower garland and the separate, shadowy allegory of Pictura which is situated beyond it. This way of ordering and perceiving a work of art is precisely the process whereby Andromeda was liberated from the rock of literal meaning, realising her rich fertility as the embodiment and agent of love. Her identification, through Pictura and Scultura, with feminine archetypes starting with Venus and moving on to the Virgin Mary, satisfied a need to reach towards the vital heart of the matter.

The initial analogy between Andromeda and Venus was located in a perceptible, objective realm: an observable likeness between two lovely female nudes with shells at their feet. However, the invocation of the Virgin was a more exclusive and interiorised process, dependent upon a discerning viewer's capacity and desire to recognise the shadowy, *invisible* prototype within the distant, abstract zone to which he was directed by a series of interlocking 'frames' both external and internal to the picture. No longer permitted to be grasped openly and immediately, the ultimate feminine figure of the faithful, virtuous, immortalising love which constituted Christian Pictura became a conceptual site only attainable by a qualified elite.[115]

Yet, as Lynn Federle Orr has noticed, Andromeda was also modelled upon a *male* figure, that of the saint in Wtewael's *Sebastian Bound* of 1600 (Figure 28).[116] The artist's borrowing of Sebastian's pose for Andromeda is explicit in an elaborate pen and wash drawing which is very probably a preparatory study for the 1611 painting.[117] In the finished picture, Andromeda still strongly recalls Sebastian: a monumental nude in *contrapposto*, with one arm crooked over the head and eyes raised towards a winged embodiment of liberating love depicted from a low, revealing angle.[118] Although the early provenance of *Sebastian Bound* is unknown, it seems quite possible that the connection between the two figures was recognisable to the local, knowledgeable viewers to which *Perseus and Andromeda* was initially addressed. Both pictures were, after all, recent major works by a fellow artist and citizen. But what function, if any, did an appreciation of this resemblance serve in an attempt to probe into the work for its essential, infinitely desirable truth?

For some, then as now, it would probably be sufficient to explain the visual connection between Andromeda and Saint Sebastian in practical terms. Female life-models were rare at this period and this was an efficient reuse of studio material. For others, the ability to make reference to such an artistic source distinguished them as a cultured and talented elite from those whose ignorance limited them to a superficial, material understanding. It implied participation in a broadly based, ideological regime founded upon the recognition and imitation of authoritative models or precedents. This system of meaning can be defined as aristocratic in that the value of a pictorial figure such as Andromeda was supposed to be derived from the prototypes situated 'behind' it, just as the descendents of noble ancestors were supposed to inherit their virtue. However, the transposition of these genealogical principles into the domain of 'art'[119] can be identified primarily with non-hereditary elites because the links within this discursive field were not forged

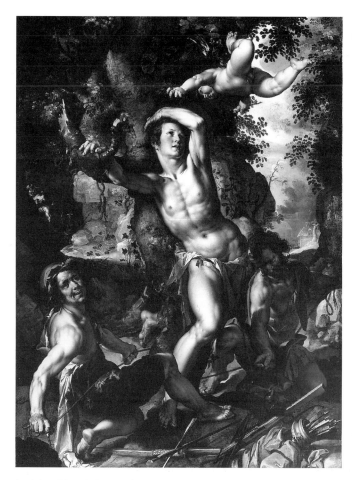

28 Joachim Wtewael,
St Sebastian Bound,
1600, oil on canvas.

by blue blood, but rather by the circulation of an exclusive, shared pool of knowledge and skill.

I have suggested, however, that the true devotee's quest for virtue extended beyond worldly honour to the remote, normally inaccessible realms of the spirit. For such a person, a concept of mimesis as a way of communing with and capturing the ultimate, unattainable reality of undying love was a means of ascending from earth to heaven, defying the representational barrier constituted by death. From this perspective the visual resemblance between Andromeda and Sebastian can be seen to articulate a more profound bond between them. To paraphrase Van Mander's gloss on Andromeda, Saint Sebastian was a devout, captive figure in extreme need, redeemed in an unforeseen way by the merciful decree of a loving God.[120] An officer in the Roman army condemned to be killed with arrows for his Christian belief, he was left for dead but nursed to recovery by the saintly widow Irene.[121]

Moreover, beyond Sebastian, the devout and desirous viewer might recognise the crucified Christ, an incarnation of faithful, redeeming love even more potent

than the Virgin and Child and similarly capable of interpretation as a figure for
visual representation. In His case, however, immortality is attained not through a
process of mirroring and reflection but by arresting and nailing down the living
subject. All saints enter into martyrdom in faithful imitation of Christ's supreme
sacrifice and the naked, erect figure of Sebastian, bound to a tree ready to be pierced
to the point of death, bears a striking resemblance to his model.[122] In Wtewael's
Perseus and Andromeda, traces of this heritage are discernible in the skull at
Andromeda's feet, the tree behind her and the mourning 'mother' in the middle
ground which, together with the other little figures, resembles traditional group-
ings at the foot of the cross.

The devotee's identification of Andromeda with Sebastian and the crucified
Christ is erotic in the sense described by Georges Bataille: a means of attaining life
through a willingness to experience a moment of suspension, of death, in which
'masculinity' and 'femininity' are no longer separate.[123] Recognition of this tran-
scendent position as Andromeda's ultimate foundation and support suggests that,
whatever might be asserted in words about the distinction between sign and ref-
erent, the power of Pictura, and visual representation more generally, still depends
upon implicit faith in the possibility of imaginatively crossing boundaries not just
between established notions of gender but between categories such as presence and
representation, subject and object, meaning and matter, life and death.

Such traversals are also elicited by the sketchy, dung-coloured areas of paint in
the foreground of *Perseus and Andromeda*. Besides the sand, rocks, shells and bones
lying on the sea-shore, this 'unfinished' rendering produces the object upon which
the beautiful Andromeda – visual representation herself – rests her behind. This
object is obviously the rock to which Andromeda is secured by Ovid's narrative,
but the flared shape and scalloped edges of the grimy area indicate that it is, sur-
prisingly, covered by a cloth. It is also noticeable that the chain which binds
Andromeda to this earth(l)y matter is attached to or through this textile. Wtewael
chose to inscribe his own signature next to this spot, recalling Perseus's initial
words to Andromeda in the Ovid's text: 'Oh! Those are not the chains you deserve
to wear, but rather those that link fond lovers together.'[124]

The obscure, impure, yet evidently significant stuff behind Andromeda evokes
the material support upon which virtuous Pictura rests in ways which deny any
categorical distinction between matter and meaning. First, as I pointed out much
earlier,[125] it refers visually to the underpaint and canvas which physically underlie
the pictorial illusion, thus positing a necessary connection in artistic creation
between low realities and elevated ideals. Second, just as Scultura has been shown
to be incorporated into Wtewael's Pictura, the resemblance between the cloth cov-
ering of the rock and stained canvas may acknowledge the interest in the social body
of Painting of the *kleerschrijvers*, the painters of linen wall hangings who were
included into the new Utrecht guild of Saint Luke in 1611.[126] It is notable here that,
whereas some of the motifs in *Perseus and Andromeda* are strikingly sculptural in
effect, the pastel hues, decorative detail and composition of the picture create an

overall impression reminiscent of contemporary tapestry.[127] Third, the (re)presentation of 'filthy' canvas can be related to Wtewael's personal, lucrative involvement with trading in flax – the fibre from which linen canvas is made – which supported his activity as an elite, virtue-inspired artist and viewer.

Such dependence upon a separate, material trade as the foundation of artistic pursuits impelled by the highest motives was apparently controversial in the Netherlands in the early seventeenth century. Van Mander's biography of Wtewael in *Het Schilder-boeck*, published in 1603-4, suggests that some people considered such a subject's claim to virtue to be threatened by his profitable activity as a textile merchant. The opening passage asserts Wtewael's credentials to elite status in eroticised terms, deploying a metaphor of natural upward growth which brings to mind the ascent subsequently accomplished through the body of Andromeda, aligned as it is to a tree:

> The noble talent for painting will, where it is placed or planted by Nature in an art-sustaining and desiring heart, remain suppressed with difficulty but tends to climb up step by step to the highest level of our art and ascend to the highest perfection therein – as generally all fertile plants tend to grow upwards. Thus it happened with Joachim Wtewael, painter of Utrecht, born there in 1566.[128]

Yet, after having reiterated Wtewael's claim to inclusion amongst a Netherlandish cultural elite, Van Mander concludes the biography with a sting in the tail worthy of the serpent in *Perseus and Andromeda*:

> [It] is astonishing how our Pictura is so well-disposed and loving towards him, given that she is held or exercised by him only in second place, whenever commerce, which comes first, tolerates it or allows him the time. For some say it is to be feared that he might sometime be transformed by the Art of painting into flax (in which he trades), just as Arachne became stuck and entangled in her web through the wrath of Minerva. He is now, in 1604, 38 years old.[129]

Wtewael could well have known this passage and it seems quite possible that the way in which matter and material are woven into the symbolic fabric of *Perseus and Andromeda* was in part a witty visual riposte to Van Mander's critical words. This may be another reason why the artist chose to identify himself verbally beside the chain which connects a classical, narrative subject of pictorial beauty and significance with a lowly, inarticulate, even scatological object. Here, then, looking 'behind' Andromeda produces not an erotic fantasy of ultimate union with a separate, abstract realm of virtue but direct contact with Pictura's material support and the 'dirty' trade or intercourse between them.[130]

Thus in *Perseus and Andromeda* the domain of love seems to be extended over the established trinity of inducements to art: the highest spiritual aspiration, the desire for worldly honour and the need for material support.[131] In such a vision the most lowly thing was capable of being affiliated to virtue, not because of any intrinsic resemblance between them but by means of the way in which this matter was

regarded. For Wtewael and the many others like him in the Low Countries who saw the acquisition of wealth through trade as the foundation of the freedom to assume a more 'noble' position, 'base' commodities were a necessary means to higher ends. They were, in Damisch's terms, exchangeable. *Perseus and Andromeda* suggests that, as long as they saw themselves as inspired and justified by divine love, such people could afford to benefit and take pleasure from the specificity, richness and variety of the world, both in reality and in representation, because they were able to appreciate both the separation and the connection between mundane matters and virtue. Others, exemplified here by Van Mander,[132] stressed the absolute distinction between 'low' subjects, objects and activities and their lofty idea(l)s. For them, the fertility of nature and the artificial generation of wealth could be accommodated within a world governed by the highest motives only as a desirable outcome of elevated, 'noble' deeds, which had come to include virtue-inspired artistic production and writing. Direct involvement with aspects of the world regarded as humble and base, epitomised by Dame Commerce, was liable to trap their vulnerable hearts in inanimate yet ensnaring fibres, a superficial material net which would prevent them from reaching their distant, elevated and self-reflexive goal. Love can so very easily be confused with lust.

Under the sign of Venus: the making and meaning of Bouchardon's *L'Amour* in the age of the French rococo

Katie Scott

Bouchardon's just under life-size, winged, marble statue of Cupid (Figures 29–32) stands high on a pedestal in that section of the sculpture galleries at the Louvre dedicated to the accomplishments of eighteenth-century France. Arguably one of the most important and certainly one of the Crown's most expensive sculptural commissions of the first half of the century, *L'Amour se faisant un arc de la massue d'Hercule*[1] (1750) represents the god of Love, alone, in the midst of carving his bow from Hercules's club. More fully, we see Cupid testing the strength and flexibility of a bow in mid-production, his tool – Mars's sword – temporarily laid aside. This narrative is articulated round about the figure thus requiring of the spectator a mazy, turning motion in search of meaning and satisfaction. Head, arms, torso and legs present the graduated angles of a gently twisting curve. This semi-circular movement is reinforced, tightened and completed by the more or less even distribution of significant detail – wood chips, bow string, quiver and arrows, sword, scabbard, shield, helmet, hide – about the 360-degree revolution, and by the perfect, almost uncanny, quality of the finish throughout. Support for the figure and a measure of countervailing stasis is provided by a tree-stump over which is cast the hide of the Nemean lion. The tail slides rather disturbingly between Cupid's feet to protrude over the edge of the base. This detail is matched by the similarly projecting looped end of the bow-string. While in one sense these subtle incursions into the spectator's realm challenge the boundary between art and life, advancing the figure as within reach, in another sense, viewed rather as cancellation marks raised across the continuous pattern around the base, they serve momentarily to fix a privileged angle of vision. But from here *Cupid* is far from symmetrically posed: his legs face left, his head right; the asymmetrical slope of the shoulders is echoed and exaggerated by the unbalance of wings behind. Moreover, Cupid's attention has strayed. He looks away, towards another. Disappointed but still expectant, the spectator is thus once

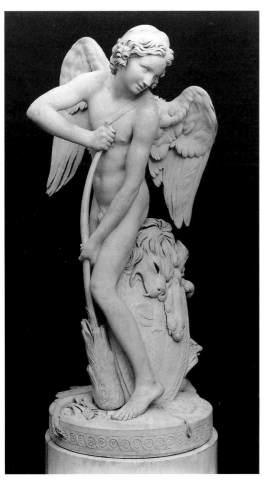

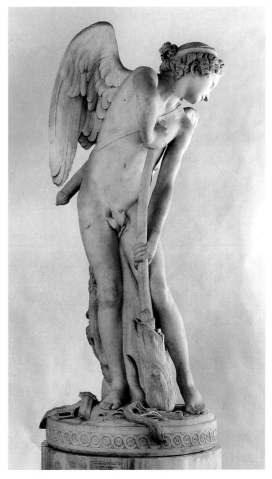

29 Edmé Bouchardon, *L'Amour se faisant un arc de la massue d'Hercule*, 1750, marble.

30 Edmé Bouchardon, *L'Amour se faisant un arc de la massue d'Hercule*, 1750, marble.

more set in motion, adjusting or shifting position to achieve a less obstructed view of the body, to recover a balance of parts, to intercept the look.

Two things immediately occur from this description. The first relates to the subject, the second to its form. Taking them in turn, we remember that according to myth Cupid had, to all intents and purposes, no father. He was rather his mother's son. Indeed, representations of him commonly invoke her presence if they do not actually include her.[2] Bouchardon's *Amour* by contrast, is conspicuously independent. Venus's attributes are nowhere to be seen. Instead of a presiding female deity, the action and attributes invoke male attendants. Such freedom from parental influence invariably bespoke danger. In a pair of drawings from the 1730s Bouchardon had earlier explored the theme of Cupid's escape from maternal

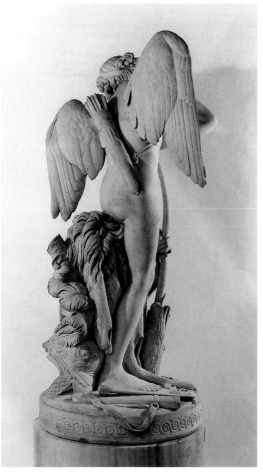

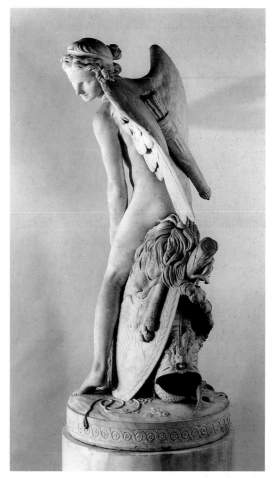

31 Edmé Bouchardon, *L'Amour se faisant un arc de la massue d'Hercule*, 1750, marble.

32 Edmé Bouchardon, *L'Amour se faisant un arc de la massue d'Hercule*, 1750, marble.

control and his subsequent physical chastisement upon recapture.[3] By implication Cupid alone was not only fatherless but Fatherless, that is to say without law, his actions following no rhyme or reason. Significantly, one of the tales that can be told of this *Love* is of an impulse to provide him with a complementary and stabilising female term, to reinstate the mother.[4] But in the absence of such physical and figural reference to Venus how was the goddess's power of love made manifest? Cupid, in Bouchardon's representation was, I shall argue, both a mask for her and an extension of her: an active, phallic Venus.

The form of the sculpture, meanwhile, seems to present something of a paradox. On the one hand, such sculpture in the round lays claim to an elevated artistic status by virtue of its figural autonomy, its internal boundedness. It is in

this sense no mere ornament. However, the circularity which on the one hand yokes the attention of the viewer to the work, on the other withholds a fixed viewing point from which the ambitiousness of the design may be fully and finally admired. In what follows I hope convincingly to suggest that that instability, that shiftiness, far from being simply a by-product of *L'Amour*'s formal composition, partook of the character of desire and was thus textually significant. However, for the present the difficulty of determining a satisfactory and satisfying point of view *vis-à-vis* the sculpture usefully serves as a metaphor for the difficulties of interpreting the work. Doubt about where to look from leads unavoidably to misgivings about what to look for.

Moreover, the uncertainties and ambiguities of the work's formal articulation are reiterated in the history of its display and reception in the eighteenth century. Commissioned by the *Bâtiments du roi* – or the office of the king's works – in the late 1730s,[5] *L'Amour* was delivered to the château de Versailles on Wednesday, 19 August 1750 and displayed in the *salon de la guerre*, an ante-room to the *galerie des glaces* situated at one extremity of Louis XIV's formal apartment.[6] Sometime later, it was transferred to the *salon d'Hercule*, a more recently decorated room leading to the chapel and located at the other end of the *grande enfilade*. However, after no more than four years the statue was removed once more, this time demoted to the *orangerie* at the château de Choisy,[7] one of Louis's minor residences, where it idled until 1778 when finally recalled to Paris to await eventual and prestigious display in the *grande galerie* at the musée du Louvre.[8] Given that under absolutism the formal decoration of the sovereign's palaces and the incorporation of works of art within it tended towards conservatism, remaining notably and symbolically constant across generations,[9] the repeated resitings of Bouchardon's *Cupid* seem to betray anxiety about the statue and its troubling tale of love. The extended search for a *proper* place for *Love* which these resitings describe prompts at least two reflections. First, that we should perhaps view the changes in location as purposeful, as variously more or less successful attempts to bind the semantic and sensual energies of the figure by putting them to some serviceable and seemly end. Second, and consequently, that the success of this enterprise depended on dissipating the perceived threat from within the figure by displacement on to a context or frame without.

In an effort to recount this story of containment and domestication without becoming a party to it, this essay is structured as a series of turns about the statue,[10] the changing angles framing different parts of the body and conjuring up different contexts of signification. Keeping the body so directly in focus and attending in detail to the manner in which its various parts – skin, eyes, sex, elbows, hands and feet – were fashioned and made meaningful is a pursuit of priorities largely alien to the hierarchies of eighteenth-century French criticism.[11] However, it is undertaken in the hope that by such indirect circling of the work we may better realise our aim to understand historically the relationship between art and sexuality.

Looking behind

The tour starts from behind (see Figure 31): *Cupid's* legs, buttocks, wings and retreating back come into view, his left leg largely obscured by Mars's helmet and the lion's skin; the mane apparently teasing his flesh as it hides it. At his feet lies Mars's sword, loose from its scabbard. The sash carries along its ribbon-like length Bouchardon's name, place of birth and the date of statue's execution.[12] Thus despite the fact that Bouchardon's *Cupid* frustrates absolute hierarchies of front and back, looking at the sculpture from behind focuses attention on origins thereby lending it a certain priority. For not only is it here that Bouchardon is most literally, scripturally present, but it is also from here that his sources are most clearly acknowledged and the genealogy of the image revealed. Furthermore, and speaking figuratively, the rear view encourages a 'behind the scenes' account of the gestation of the work with particular attention to the discourses of love alive in the studio.

Philippe de Chennevières first identified the primary source of Bouchardon's figure, not as one might perhaps suppose in Hellenistic sculpture (though a statue of *Eros* by Lysippus may have played its part) but in Parmigianino's famous *Amor* (1531–34), a copy of which was in the eighteenth-century in the Orléans collection attributed to Correggio[13] but which Bouchardon as likely knew from the reproductive engraving by Franciscus van der Steen (Figure 33).[14] The aetiology of Bouchardon's *Cupid* having been established, so to speak, a number of crude propositions suggest themselves: that Cupid's behind was in fact his unofficial front; that the early modern erotic was visually experienced as pose (most famously in Aretino's *modi* or postures); and that *L'Amour* was the beloved of male fantasy, in the first instance that of his creator. However, not only were early eighteenth-century connoisseurs seemingly blind to the erotic, arguably homoerotic, content of the painting,[15] but eighteenth-century accounts

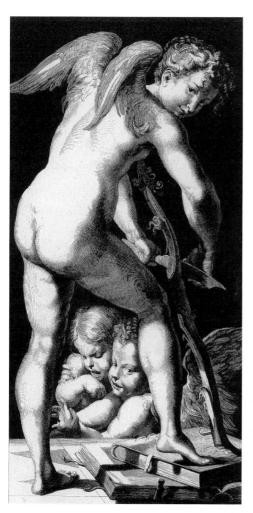

33 Franciscus van der Steen after Parmigianino, *Amor, c.* 1660, engraving.

of Bouchardon's statue were utterly silent as to its source.[16] Pierre-Jean Mariette acknowledged only the antique as a potential model, then immediately dismissed its relevance: the extreme youthfulness of Bouchardon's *Amour* had, apparently, precluded the sculptor having had recourse to any famed antiquities because their subjects – Hercules, Apollo, Antinous, Venus – were invariably of too mature proportion.[17] In this instance, Mariette tells us, Bouchardon emulated not the works but the practice of the ancients.[18] Like them the sculptor studied from the life, and he and his biographers took pains to situate his art and works as firmly within a discourse on nature as within that on the antique. An important facet of understanding the work's meaning thus seems bound up with the deliberate overlooking of quotation in favour of mimesis.

Bouchardon's only statement concerning the *Cupid* took the form of an invoice submitted to the *Bâtiments du roi* in 1752 in defence of the high price he set by his work.[19] Dry and functional though it certainly is, this surprisingly long and detailed text can nevertheless be construed as an autobiographical fragment: it puts into play a particular construction of the artist and plots the stages of one of his creations. Thus unfolds the story of two years of preparations followed by four years and two months of intensive realisation. The central themes are those of imitation and craftsmanship. We learn that having selected a subject Bouchardon set about making 'a large number of drawings after nature and after several models'.[20] The sanguine life drawings that have survived (Figure 34) relate in fact to a single model. They bespeak a double concern: for surface – the soft graininess of the red chalk on white paper rehearses in the colours of flesh the feel of the marble; and for outline – the model, bending over a whip-like stave, is captured from nine different angles, the changing relationship between figure and ground explored at every turn.[21] Renowned for his ability to draw the graceful lines of the human figure in a single, uninterrupted stroke, Bouchardon's technique evoked the gentle passage of a seeing hand across the forms themselves rather than the distanced, alienated, manufacture of their appearance on paper.[22] This prelude in chalk was then supplemented by study of the body's parts in plaster: 'casts were ... made from living bodies, of arms, legs etc'.[23] Thus, a seemingly tactile knowledge of the body gave way to an actual laying on of hands; the model was thereby detained indefinitely in the studio, the imprint of his fleshly forms serving as a memorandum of the real, readily available within a hand's grasp.

These preparations having been finally completed Bouchardon turned to the realisation of the marble. He allowed his pupil to block out the figure but no more. From that moment onwards, he took possession of his work and 'did not relinquish it until it was finished'.[24] In so many words, he jealously kept for himself those strokes of the saw most susceptible to lending animation to the statue, as well as the lengthy and tedious business of sanding and polishing the stone in order to give it a tender texture. Moreover, he specifically mentioned the additional labour of love occasioned by the statue's radical three-dimensionality and the necessity of working 'a fonds et au plus fini' the behind as well as the front.[25] Thus, for years his hands were

34 Edmé Bouchardon,
Life drawing, c. 1742,
red chalk on paper.

continuously and variously upon the *Cupid*, refashioning the preliminary forms completely.

By contrast to this detailed description of the manual aspect of the work, little is said about the idea, that is about the intellectual labour. Bouchardon merely refers to having 'filled himself up' with his subject before, presumably, spilling himself out in his work.[26] However, the sculptor's figure of speech is arresting. In the manner of the archetypal lover described by poets, Bouchardon overflows with love for his *Love*. In this sense the metaphor was designed to impress by the depth and completeness of the knowledge and commitment that it implied. But by characterising the creative mind as a vessel or mould it also lent to the very 'idea' of the *Cupid* an inherently sculptural shape, one which corresponded particularly closely to the responsive, malleable technologies of the terracotta sketch-model, the *première pensée*, which preceded and anticipated the final realisation in marble. Thus one might say that in Bouchardon's invoice the manner of thinking love was assimilated to the manner of making love through a prioritisation of the haptic.

The precise accounting of acts of imitation and craftsmanship at the expense of the processes of the creative imagination may easily be explained by the sculptor's purpose to itemise and thereby cost artistic work. The eroticisation of the narrative of making through the recurrent motif of touch, though conspicuous with hindsight, was almost certainly accidental – a Freudian slip, if you like. However, rather than pursue the desire thus betrayed, I want at this juncture to draw attention to the striking similarity which obtained between Bouchardon's estimation and characterisation of his own practice and that of his contemporary biographers. Caylus and Diderot, for example, in a rare instance of agreement, insisted that Bouchardon's attachment to nature was exceptional and central to his art.[27] It was not simply that from a tender age the sculptor had made a habit of drawing from the life-model;[28] it was, more importantly, that, according to Caylus, 'when he worked after Nature, he became heated, he became inflamed, he saw only her', and moreover, he saw her with that 'enthusiasm' and that 'fire' that the Ancients believed divine.[29] Clearly, for Caylus the creative impulse was linked to the sexual drive. Thus, Pygmalion-like, Bouchardon's inflamed genius was constituted of equal measures of the divine, the creative and the erotic.[30] However, unlike Pygmalion, the source of the sculptor's enthusiasm was exterior to the self, located in nature and not in the imagination. Diderot – who also contributed to the debate about enthusiasm, though not specifically in relation to Bouchardon – made this point doubly emphatic by comparing Bouchardon to that other famous model of his oeuvre, the horse, 'the astonishing beast', who posed for the equestrian statue of Louis XV. The *philosophe* collapsed the artist and his model into a single sign of nature maintaining of each that he was, 'gentle at rest; proud, noble, full of fire and life in action'.[31] Once again the passionate, libidinal thrust of the language suggests that Nature, Love and Art, or to put it differently the horse, Cupid and Bouchardon, were at times being read through, and in terms of, one another, thus establishing an intimate similitude between the three. That the resemblance was deeply figured (and not just a sleight of hand) was borne out, moreover, in the arrangement of Bouchardon's hundreds of drawings in portfolios in the studio, within which those of the model for *Cupid* monogamously cohabited with those of the horse.[32]

In so far as the 'natural' was construed positively by the critics, it was identified above all with the tooled finish of the *Cupid*, with the textures of the piece. Mariette, for instance, wrote at some length of the pleasures to be savoured in the contrasts of light, floating helmet plumes, rough, bristling lion's mane, and stiff and strong godly wings, two of the three only visible, or fully visible, from the rear.[33] Sight here takes on the capabilities of touch.[34] Moreover, like Charles de Brosses before the Borghese *Hermaphrodite* who 'touched' the mattress Bernini made for the figure as a skin, in lieu of the figure's actual skin,[35] so we may say that Mariette displaces fantasies about touching the softness (skin), springiness (hair), torsion (muscle) of *Cupid* on to the inanimate objects at the god's feet. This is not to say that response to the textures of the figure itself was repressed. On the contrary, the debris of Mars and Hercules serves merely to rehearse sensitivities for the refined pleasures to come.[36] Thus

Mariette held ecstatic praise in reserve for *Cupid*'s skin, arguing that the figure came alive via its surface: 'it is flesh itself ... making visible all the expressions of skin and all the accuracy of the muscles and tendons'.[37] So described, the surface is 'profound', drawing attention to itself as plane yet intimating and provoking desire for depth, an interiority imagined as both physiological (the muscles and tendons) and as psychic (love).[38] That excessive attention to the sensual surface could give rise to danger was acknowledged much later by Charles-Nicolas Cochin. In his reminiscences on the art of his contemporaries, Cochin maintained that once Bouchardon took hold of the marble 'his extreme passion for finish' led him astray.[39] Cochin, it must be noted, had public monuments such as the equestrian statue of Louis XV primarily in mind – works where distanced viewing and exposure to the elements rendered attention to surface misplaced, a breach of *convenance*; but the talk of passion, and the intimations of loss of control and judgement, nevertheless serve to elide the appetite for finish with the temptations of the flesh in such a way that the marble surface becomes the scene of the sexual.

The disturbing confusion of categories (art/life, plane/depth, interior/exterior) on the surface or 'skin' of the statue had, of course, long been a trope of tales of love in the studio. In the legends of the Corinthian Maid and Apelles and Campaspe, for instance, the artist's obsession, or gathering fascination, with a single, 'real' model (as opposed to an ideal figure synthesised from multiple examples) gives rise to dangerously commingled loves: of the object *and* of its representation. Analogously Cochin tells of Bouchardon's quest for inspiration for the *Cupid*:

> Rumour has it that Mr Bouchardon was the subject of a disagreeable and ridiculous scene. [...] looking at the young boys bathing on the banks of the river in search of a beautiful model of the appropriate age for the figure he wanted to represent, he found one who struck him as such. He suggested to the boy that he should come home with him. This young man took it into his head to imagine that Mr Bouchardon had completely other intentions and insulted him. I even think that he called the police and that Mr Bouchardon was obliged to declare his name and explain his motives.[40]

As a story, Cochin's salacious gossip functions both as a reprise of earlier tales of beloved models and as a transformation of it by the substitution of a male for a female object.[41] That it is a transformation and not a transference of the narrative is registered in Cochin's text by the tension that arises from his simultaneously raising the spectre of the exploitative sexual interests artists reputedly had in their models,[42] and dispelling it by insisting on its absurdity in this case.

Bouchardon's reputation for continence, both sexual and social, was securely established long before Cochin recorded his tale of misread motives.[43] His studio was, apparently, a place apart, offset from the libertine commerce of *salon* society.[44] It was a place of scholarly study, not sensual pleasure. Such unyielding, chilly self-restraint no doubt sat well on the shoulders of a sculptor aspiring to public works, but the carver of love needed to be moved himself for his statue to move in its turn.[45] It seems possible, therefore, that Cochin was prompted to give this particular

version of Bouchardon's search for a model not in order to quell gossip but to incite it; to promote the idea of an erotic interest, a stirring of love in the breast of a sculptor whose name otherwise stood for self-denial and the rational pursuits of the mind. Thus the anxiety which surfaces in the anecdote is perhaps less rooted in matters of sexual choice than in fear of frigidity: of the marble and of those who work it. Maintaining *enthousiasm*, the rushing, creative heat of genius, in the physically demanding, deliberate and constraining labour of sculpture was recognised as a serious difficulty.[46] Cochin's tale thus saves Bouchardon and his statue from failure, from death, by refiguring the sculptor as an oxymoron of virile chastity.

Viewing the sculpture from behind has revealed a number of things: first, the role of the figure as the beloved; created in love and fashioned with love. Second, that the silence surrounding *Cupid*'s homoerotic source was the consequence not of ignorance or repression but rather of the setting aside of the 'cultural' in favour of the 'natural' as the more persuasive and eloquent trope in art's language of love. Imitation (not emulation) was here libidinally freighted. So much so indeed that the marble surface, that contrived boundary between life and matter, became the primary locus of pleasure. Finally, that the gossip about Bouchardon's aims on the quai de la Seine, though roundly refuted, nevertheless cast a much needed sexual aura over the work of one who by the time of the *Cupid's* completion was increasingly associated with the anti-rococo, and with the revival of a chaste and masculine classicism.

Looking in front

The narratives suggested by going behind were not those represented by the statue but rather those prompted by a fantasy of its creation. By contrast, from the front (see Figure 29) the identity of the figure and his action are more fully legible. Cupid stands, his head in virtual profile, gently bent over the half-formed, possessively held bow. The bow's tip appears to come to rest, if only momentarily, on the delicate strap of the quiver, thus calling to mind the arrows which the Herculean arc will eventually unleash. From this angle, too, we see the hide of the Nemean lion and Mars's shield; however, only the blade of the latter's mighty sword is discernable, the tip leading back behind to the god of war's ostentatiously plumed helmet. Strewn about the base, above the continuous ornamental frieze, are the wood-chippings whittled away by Cupid's effortful attempts at transformation.

Mariette, connoisseur and friend of the sculptor, wrote, in the form of a letter to the *Mercure de France* (1750), the most extended critique of the *Amour*, having been sufficiently privileged to see the finished marble in the studio before its despatch to Versailles.[47] According to him, Bouchardon's aim had been, 'to represent Love who, already conqueror of the gods, among them Mars and Hercules, has taken hold of their weapons and is attempting to change the latter's club into a formidable bow against which no heart will be safe'.[48] Of the sculptor's success Mariette noted three things: first, that the statue was ambitious and rich, worthy of admiration for the condensed meanings packed into a hostile medium;[49] second, that the type of

Cupid depicted was not so much Venus's son as Psyche's lover; third, that the moment chosen, when the wooden weapon was exactly mid-most between club and bow was precisely that which comprehensibility demanded. That the sculpture in fact has much to say is largely a matter of assertion, because Mariette does nothing to elaborate upon the epigrammatical conceit, the beginning and end of which are, as he notes, neatly captured at either extremity of the disturbingly hybrid thing in *Cupid*'s hands. The matter of Cupid's age, meanwhile, relates to the genre of the statue. As the infant personification of Love, *Cupid* belonged to allegory; as the adolescent lover of Psyche he was a character of fable. Thus, as neither one nor the other, but with characteristics of both, he to whom the hands that held the bow-club belonged was no less hybrid than the weapon itself.

These matters of hybridity and meaning were related, though not as cause and effect. Rather, they had a common context in allegory.[50] The apparent contradiction involved in Mariette's claims for the *Cupid*'s semantic plenitude on the one hand and his failure to give it voice on the other may thus in part be explained by the values of concision and brevity that attached to allegorical figures and by their visual rather than verbal character. Sensitivity to Bouchardon's innovations in the treatment of the *Cupid* should likewise be read with an ear to the highly conventionalised language of allegory which dictated that in the case of personified concepts the appearance, the physical form and bearing of the figure, should perfectly match its essence and was not therefore subject to change. By eighteenth-century dictionary definition Love was a child by lack of reason, had wings by virtue of flightiness, was blind because indiscriminate and armed because he inflicted suffering even unto death.[51] Bouchardon's *Amour* worked both to confirm and to break down this figuration. The arrows, Cupid's primary attribute, may not have been visible from the front, for example, but their power was transferred to and made more explicitly phallic in the bow which both covers and stands in for Cupid's sex.[52] Likewise, though not portrayed blindfolded, *Cupid's* blank gaze, and the juxtaposition of his empty eyes – rendered *all'antica* – with the empty sockets of the Nemean lion's flayed head, articulated his sightlessness no less clearly. Moreover, this blindness, by virtue of being of the body (a cataract) rather than temporarily assumed (a blindfold), recalls attention to the surface precisely there where an opening to depth is conventionally expected (the windows of the soul).[53] Thus, while continuing to signify the arbitrariness of Love's conquests, blindness also expresses *Cupid's* loveless self-sufficiency, his existence as pure surface, an 'other' to feeling and interiority. To return then to the anomaly of *Cupid's* age, though his physical maturity, at one level, certainly banished his status as infant, that status was simultaneously reinstated by his superficiality, by his blithe and pitiless blindness to the attractions and feelings of others.[54]

L'Amour as Bouchardon represents him, is not, however, utterly divine: a timeless, perfectly contained and self-referring figure. By his actions seen and implied, he enters into an unfolding narrative of worldly historical dimension.[55] He interferes in the mucky destiny of heroes. Fully to see the part played by *Love* requires shifting the

scene from Paris to Versailles and briefly rehearsing the facts concerning the history of the commission and the display of the statue. The work was ordered by the *Bâtiments du roi* some time prior to 1739, apparently in substitution for a statue of Louis XIV ordered for the cathedral of Notre-Dame but unaccountably abandoned.[56] According to Caylus, Bouchardon selected his own subject, but there is good reason to think that his choice was directed from the start by the anticipated destination of the *salon d'Hercule*, presumably with the consent of the then *Directeur des bâtiments*, Philibert Orry. From the late 1730s the newly completed Hercules drawing-room was a showcase for the arts of the new reign: Pierre Le Pautre's pompous articulation of the walls in a revetment of coloured marble and giant Corinthian pilasters had been enriched by the gorged fulsomeness of Antoine Vassé's bronze mounts which provided capitals for the pilasters and ornament for the cornice, chimney-mantle and picture frames. The room was crowned in 1737 by François Le Moyne's *Apotheosis of Hercules*, a ceiling painting of unprecedented complexity and perspectival daring.[57] An ambitious sculptor could hardly have failed to covet the space at the centre of the room and the opportunity to represent sculpture in a paragone of the arts and a contest of talents. That Bouchardon was one such sculptor is evident in the *Cupid's* allusions to Hercules and is implicit in the invoice for 24,000 *livres* which he submitted for payment of the statue, a sum closely comparable to that which Le Moyne had demanded for the ceiling: an underlining of willed comparisons and keenly felt rivalry perhaps more usually associated with the more competitive and adversarial culture of the 1780s.[58]

In formal terms there is always a difficulty in reading painting and sculpture together because of the different constraints and possibilities imposed by the respective media. In most instances, as here with Vassé's array of palms, cornucopia, helmets, shields, masks, etc., eighteenth-century sculpture functioned as a supplement to, or ornamental envelope for, painting's story. Bouchardon's *Amour*, however, was and did much more than echo Le Moyne's Cupid (Figure 35), depicted standing at his mother's knee, looking over *his* left shoulder at Hercules. Indeed *L'Amour*'s adolescent body sets him apart from Venus's son. In body-type his kin are rather the likes of Hymen, depicted to the right of Jupiter leading Hebe forward, and, more significantly, of the figure which the 1736 *explication* of the ceiling identifies as 'L'Amour de la Vertu'. It is this love, the love of the good, which is both the beginning and the end of Hercules's story. It is that which motivates heroic deeds, lifting man, 'raising him above himself and making him equal to the most difficult and dangerous tasks'. And it is its own reward, figured as immortality, a life after death.[59]

To start to understand the interplay between Bouchardon's tale of love and Le Moyne's apotheosis we can note the different ways in which the two Loves wear their laurels. Predictably, Love-of-virtue's conspicuously crown his head. *Love*, meanwhile, sports his as a convenient *cache-sexe* (see Figure 30).[60] In one sense, the contrast of sites merely gives explicit bodily place to the different registers of Agape and Eros or, to put it differently, of spiritual and sexual aims. Thus the *Cupid*

35 François Le Moyne, *Apotheosis of Hercules*, 1737, oil on plaster.

could be said to constitute a kind of foreground for the painted apotheosis, symbol-
ising the fallen and contingent world of men against which the heavens and the
transcendent hero are dramatically juxtaposed. In another sense, however, the
placing of *Cupid*, Venus's son, centrally beneath the ceiling reinstated Hercules's
choice at the crossroads, articulated vertically as one between the low road of plea-
sure and the high way to heaven. But Hercules, as *L'Amour* implies, was in one
notable instance undone by earthly passion. According to Ovid, Hercules was sold
into slavery in expiation of a crime. Bought by Omphale, the queen of Lydia, he
spent a year so much in sexual thrall to her that he surrendered his own identity for
hers, allegedly wearing her clothes and spinning with her maids.[61] She, meanwhile,
assumed his club and skin. Returning to Bouchardon's statue, it is clear that Cupid
stands in relation to Hercules's attribute as Omphale does to the hero in the *Fasti*,
and that he exercises an analogously revolutionary and refining power over it: the
crude club becomes an elegant bow just as the lion-skin was traded for cloth of
gold. Taking Hercules's club as standing for him we can say that Bouchardon's
statue was organised around the same reversal of power differentials – those of
youth and maturity, beauty and strength, submission and domination, femininity
and masculinity – that structures the fable, and which was typically depicted in
visual representations of the theme by a parallel alienation of Hercules from his
attributes reconfigured as the playthings of an-Other. Thus, love's effect, as
embodied by *Cupid*, amounted to more than the simple diversion of the hero from
his end; *Cupid* troubled gender difference, setting up a perpetual oscillation

between masculine and feminine, the club and the bow, so that each was potentially the attribute of the other.

Viewing the *salon* as an ensemble, Bouchardon's *Amour* operated as a sub-plot in Le Moyne's master-narrative of Herculean glory. It introduced a delay, a turning back in Hercules's otherwise untrammelled drive towards apotheosis. It both represented the pleasures of the improper path and constituted the pleasures of the postponed or deferred end. Or to put it another way, the figure depicted pleasure and created bliss by providing a kind of narrative foreplay that endlessly delayed the resolution of Le Moyne's design.[62] As such it is an 'ancient' story of the mutually destructive forces of flesh and the ideal. But what of the 'modern' story? Of the particular way the myth, and this visual interpretation of it, signified in 1750? We know it was not the resounding success the sculptor anticipated and that by 1752 Louis XV was insisting on its removal.[63] What was its offence? Though, as we shall see later, reservations were expressed about the formal qualities of the work these alone seem insufficient to have warranted the statue's hasty expulsion. More likely, by 1750 love and its softening, deleterious effects on Hercules even in the context of self-mastery regained had become politically problematic.

Since the end of the sixteenth century the Bourbons had routinely raided classical myth to fill the gap between the ideal of absolute monarchy and the realities of individual rule. And indeed, the circumstances of the *Cupid's* inauguration at Versailles suggest that from the outset it elicited a political gloss. In a curious repetition of the circumstances of the commission – to recapitulate, *Love* arose out of and in place of a statue of Louis XIV – *L'Amour* was 'unveiled' in the *salon de la guerre* to be read against, over, perhaps even as an erasure of, Antoine Coysevox's heroic equestrian bas-relief of *Louis Auguste*. Since childhood Louis XV had routinely been compared to Love. At the time of his accession, the lawyer and diarist, Matthieu Marais, had observed with rare poetry that 'On his long golden curls, on his Hyacinth's hair, the crown dazzles ... He resembles Love'.[64] Not only Hyacinthe, but Cupid too was known for his fine, feminine locks. Significantly, early portraits of Louis XV make much of his hair. Jean Du Vivier, in the profile head of Louis *à l'antique* devised for the king's coins and medals, dressed the monarch's hair *à la meche*, that is with ringlets falling in front as well as behind the ears, in a manner entirely comparable to Bouchardon's treatment of *Cupid's* hair.[65] Assimilating Louis to Love would have represented just the latest manifestation of a tradition in which the ancient moralisations of the tale of Hercules and Omphale were inverted and modern praise heaped upon the transgressively effeminate hero for his capacity to incarnate feminine virtues – love, beauty, peace – as well as masculine ones.[66] Thus, in this place it must have seemed as if with *Cupid*/Louis XV a perpetual dominion of love had arrived to consign to the past the rule of conquest and the force of arms.[67]

Such an irenic interpretation of the statue which might have passed unquestioned in the 1730s at the time of the first sketch-model, was scarcely credible by 1750 and impossible in the *salon d'Hercule* where the ceiling not the statue promised eternal bliss, and where Hercules's life story, not Love's, was advanced as

the exemplary masterplot for repetition. Though, according to the *explication* that officially made sense of the ceiling, Hercules represented the ideal subject,[68] a much longer, more venerable and thus more powerful tradition likened Hercules to the kings of France.[69] It was a tradition to which Louis XV was no stranger. At the height of the War of the Austrian Succession (1741–48), a virile and active Hercules had regularly featured on the *jettons* or tokens of the Ministry of War.[70] Moreover, a medal designed by Bouchardon and struck in 1748–49 to commemorate the negotiations for the Peace of Aix-la-Chapelle (1748) had depicted Louis as Hercules choosing Peace over Victory (Figure 36). Louis is shown with his club still firmly in one hand reaching with the other for an olive branch proffered by gentle Peace, his hand interlaces with hers in a gesture that evokes both the twining touch of love and the consenting clasp of the handshake. The dynamic, vigorous figure of Victory, brandishing three laurel crowns is, meanwhile, pointedly ignored by the monarch though she lays an urgent hand upon him.

The events of the war and the negotiations for peace were, however, open to other interpretations. Indeed, in the years immediately following the declaration of peace, Versailles fairly echoed with the whisperings of discontented courtiers and snatches of satiric song which spoke of national humiliation. The king was accused of seeking 'easy glory' in love and wine, of impotence in allowing himself

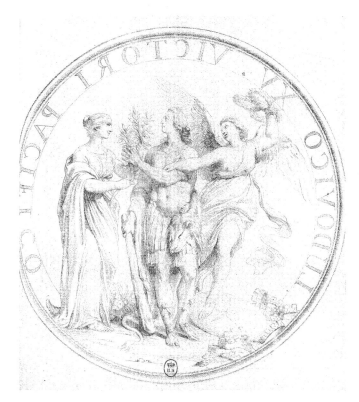

36 Edmé Bouchardon, *Louis XV between Peace and Victory*, 1748, red chalk counter-proof on white paper.

to be 'enslaved' by love, and of 'dropping' his club-sceptre into other hands.[71] In such mouths peace was not the outcome of virtue but the consequence of shameful weakness. According to Jacques-Bénigne Bossuet's classic defence of absolutism, the *Politique tirée des propres paroles de l'Ecriture Sainte* (1709), such softness was always the 'enemy of government'. Bossuet equated it with slothfulness, with inaction of exactly the kind that Louis later stood accused of in pursuing his pleasure at the expense of the rigours of rule.[72] Drawing from and glossing passages from the book of *Proverbs* Bossuet arranged a host of similes to characterise the weak hand under tribute. Particularly evocative in the context of Bouchardon's figure is the analogic description of the dynamic of softness quoted from *Proverbs*, 'As the door turneth upon its hinges, so doth the slothful upon his bed'. Bossuet commented: 'Plenty of movement and no action'.[73] The same could be said of the turnings of love, both of the spiralling, non-reproductive energies of fornication and of the soft inward curl of Bouchardon's portrayal of it, which leads the viewer in a continuous retracing of his or her steps.

The hinge or fulcrum of all that movement without action was widely held to be the king's official mistress, the marquise de Pompadour. Significantly, Diderot later remembered the statue as hers.[74] Indeed, by listing the *Cupid* among her remains, alongside her ashes, he implied that it was, in some senses, *of* her. Thus projecting a common face on to *Cupid* made public the real source of power at court, stripping royal authority of that mystery and dignity upon which it depended for its legitimacy and effectiveness. Louis 'le bien aimé' was, by implication, not so much beloved as sexually replete.[75] So prominent a reminder of the excoriating humiliations of the sexual, of the slippage of laurels from reason to arousal, occurring as it did in the *grands appartements* at Versailles, on the king's daily path to the royal chapel for celebration of the host which he could not in his state of unrepentant sin receive must surely have been an irritant beyond endurance. *Love* was discharged, exiled to a country retreat, reassigned a place in royal pastoral, a genre, as we shall see later, more tolerant of lapse. However, before attending *Cupid* at his last resort under Louis XV a fuller account needs to be taken of the response of the critics of whom the monarch was only one.

Back to front: the contrary view of the critics

Up to now the interpretation of *Cupid* has depended on our point of view. Looking back at the vistas reconstructed behind and before the work in the context of current theories of allegory suggests, however, that modes of reading may describe these critical perspectives equally well.[76] This is to note that looking behind primarily involved consideration of the literal sense of the figure, of its 'real' properties, while looking in front focused attention on the metaphorical or 'proper' meanings of the work. A doubling of the image occurs; one reading overlays and implicitly supersedes the other. The boy carving a bow is given a name and to his manual work is added the surplus labour of preparing an assault on the heart of mankind. While it

has suited my purposes to present these readings as different and equally valid views of the *Cupid*, eighteenth-century critics and commentators were concerned with the relationship between these two modes of signification, or, in this case, with the conspicuous lack of it. According to Cochin, the 'petites maitresses' and 'talons rouges' at court, on first sight of the work, exclaimed, 'What? is that Love? [...] It's Love the manual labourer then; [...] how very disagreeable'.[77] Though Cochin was clearly intent on proving the court Philistine, the response he reported no more than exaggerates that expressed elsewhere. In 1739, at the time of the work's inception, Voltaire had warned of the dangers of representing love '[en] garçon charpentier' or more accurately as *L'Amour sculpteur*, for it must seem that, unable to imagine Love on the upper rungs of Plato's ladder, Bouchardon was bringing Love low to consort with trade in the dust of the workshop.[78] Likewise confronted by the finished plaster at the Salon of 1746, La Font de Saint-Yenne noted the near impossibility of finding 'a noble, appealing and convincing moment' in this literally 'mechanical labour' of transformation.[79] Finally, Diderot's insight was blocked by vision of the enormity of the practical task facing Bouchardon's *Cupid*; he admitted to shock at the very idea of the real time and effort it presupposed.[80] He saw not the loving metamorphosis of Hercules but the prospect of a Herculean task transforming *L'Amour*.

The subject of the artisan Cupid was neither new nor rare. To take an example familiar to Bouchardon, the second scene of Francesco Albani's famous mythological series, *Venus and Adonis* (1621; Figure 37),[81] depicted some sixteen *amorini* busily fashioning, sharpening and testing their weapons in a near sequential illustration of the processes of arms production.[82] Aesthetic sensibility was not offended, however, because the putti's tasks were self-evidently symbolic; the infants merely at play in the world of the workshop. However, the metaphorical value of such work was

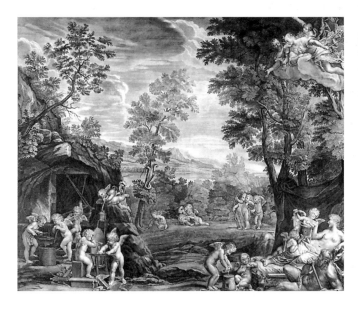

37 Etienne Baudet after Francesco Albani, *The Forge of Venus*, 1672, engraving.

profoundly challenged when Bouchardon made his Cupid *vraissemblable*, that is to say, actually, physically, up to the job he is shown performing. In this, *L'Amour* invited comparison with Bouchardon's etched depictions of the urban trades, the *Cris de Paris* (1737–42), and not the allegories at Versailles from whose anticipated support and reinforcing influence the figure was, in any event, separated at the Salons of 1739 and 1746. Like the *Scieur de bois* (Figure 38), *Cupid* inclines to his task; he is physically and mentally disposed to it. More particularly, *Cupid's* elbow, like the carpenter's, juts out under productive pressure, from some angles intrusively, impolitely. So much so indeed that it may have nudged into consciousness figurative as well as literal definitions of *coude*, thus signifying not only elbow but also 'acute angles' or joints in workmanship, and 'complexly jointed tools' used by woodworkers and others.[83] The literal or informational reading of the *Cupid* thus had the potential for being almost as layered and as richly allusive as the metaphorical one. Indeed, so compelling was the descriptive envelope, that, according to the evidence of eighteenth-century criticism, it effected a reversal of the figure's internal structure and,

38 Comte de Caylus after Edmé Bouchardon, *Le Scieur de bois* from *Cris de Paris*, 1738, etching.

Scieur de Bois.

back to front, the meaning proper to the literal (boy carving a bow) all but displaced the intention of allegory (Love victorious).

The failure of *Love's* labour as a labour of love and thus of *Cupid* to transcend his human form troubled the relationship between love and beauty. The adolescent Cupid, Psyche's lover, inspired love as well as personifying it, or rather, personified love precisely by virtue of inspiring it. Beauty, love's first cause, was thus an intrinsic part of its signification, of what Barthes would have called its 'obvious meaning'.[84] However, according to Cochin, *Cupid*'s beauty was not obvious at Versailles. The court, he claimed, had wanted Love in its own image – a 'fréluquet musqué', a fop. Not finding him, they turned from the marble in disgust.[85] The capital likewise found *Cupid* deficient in beauty. However, if Bouchardon's clearly defensive description of the 1746 plaster as 'plus épuré', more refined,[86] than the maligned 1739 terracotta suggests that the capital initially anticipated the court in finding *Cupid* coarse, Saint-Yves contended that others found *Cupid* insufficiently rather than excessively muscular for his task.[87] All, however, noted the vulgar size of *Cupid's* feet[88] and, for the less imaginative, Voltaire conjured up the horror of the god's calloused caress from the mere sight of his working hands.[89] While anxious not to overstate the case – for Cochin's satire was clearly aimed at the court not the statue, and critics and connoisseurs such as La Font de Saint-Yenne, Saint-Yves and Mariette found much to praise in the *Cupid* as ideal, as well as errors to condemn as vulgar – it nevertheless seems that commentary on *L'Amour* was marked by a general tendency to elide narratives of the working body, of *Cupid*'s literal task, with actual or fantasised details of the working-class body.[90] Thus, under the gaze of the critics, *Love's* carefully observed and persuasively rendered parts – the hunched shoulders, the acutely flexed elbow, the hands hardened and disfigured in action, the clod-hopping feet[91] – were assigned a ruinous power which jeopardised the appearance of ideal beauty, of totality, of unbroken surface or skin, so necessary to the metaphorical body.[92] A Love so dismembered, so depleted in loveliness, barely counted as love at all.

With a touch too much of nature Bouchardon had, it seems, unbalanced the dynamic antimony at the heart of his allegory of Love. The obtrusive materiality of the model overturned the capacity of the figure to represent love and beauty and thereby exiled desire from the realm of metaphor. Its return as an inverted, tertiary meaning, distinct from both the literal and the metaphoric, was darkly evident, however, in the court's disgust. The political callousness which sexual love had long betokened in political discourse thus found its edgy erotic correspondence in Voltaire's fantasy of Cupid's abrasive touch.

In the round: pastoral resolution

In one sense the anxieties that Bouchardon's *Cupid* raised concerning the nature and consequences of love were solved at a stroke by the statue's removal to the *orangerie* at the château de Choisy in 1754 because it was thereby withdrawn from

public view and critical debate. Unlike the spaces of the studio, the palace or the Salon, an *orangerie* was not a place for the sustained interpretation of works of art. On the contrary sculpture there served merely to accent the natural world. The things in *Cupid*'s hands and at his feet, real or symbolic, might easily be lost to meaning in the glare of summer tulips or among the orange trees in winter.[93] The garden more likely awakened interest in other details and qualities of the statue: in the shy presence of flowers naturally rendered among the accoutrements of fame (see Figure 32) or conventionally carved in a continuous frieze about the base, in the roughly knotted bark of the club, and perhaps even in the elemental power of the lion's virtually twitching tail. Thus, the natural (sometimes rustic, sometimes exotic) context of the orangerie, invoked by its Tuscan order and by a *menagerie* and flower garden nearby, did more than simply cover up the problematics of Bouchardon's allegory of love. It served, as we shall see, positively to bring about a change in the statue's standing.

Venus, before losing her identity in Aphrodite, was the Roman spirit of gardens. This mixed origin, her doubled nature, was never entirely forgotten. An anonymous short story of 1752 told of Venus's conquest of the île de France, the spot where the country estate of Choisy-le-roi was situated, comparing its velvet hills and mysterious valleys to the contours of 'a beautiful, naked woman'.[94] Courtiers of the period sang of the delights of the *château* – scene of sexual licence and unbounded pleasure.[95] Finally, the guidebook writer, Dézallier d'Argenville, on describing in detail the wonders of the park and gardens, remarked that such were the attentions lavished upon the place that it resembled nothing so much as a beloved mistress.[96] Love was thus lovingly woven into the forms and function of the *château* marking it as a perfect sight for *Cupid*, returned, you might say, to the realm of his mother.

Vale of Venus, bower of bliss: such alliterations in pastoral discourse advertise the conjunctive nature of the relationships between place and passion, figure and ground, the literal and the metaphorical. At Versailles, *Cupid* intruded on an alien domain of valour. The statue was read against, even in knowing contradiction of the message of its context. Louis Augustus's triumph and Hercules's apotheosis were threatened by *Cupid*'s darts; *Louis XIV* and *Hercules* in turn threatened love with their sublime contempt. By contrast, the relationship between *L'Amour* and the garden at Choisy, Venus's milieu, was one of mutual affirmation, of intimate connection. *Cupid* echoed with the genius of the place. Moreover, just as Nature put an end to the hostilities between figure and ground it also served to reconcile the literal and the metaphoric within the figure itself. Synthesis was established because pastoral is not a genre of ideal bodies but rather of artifice and masquerade. Pastoral routinely has the crook, the rake and the spade idling in 'aristocratic' hands; the noble located precisely in the seemingly ignoble. Thus, *Cupid*'s stoop, curved, according to the critics, by labour, commitment and care, seemingly relaxed into play, his art of sculpture reconfigured as a harmless charade, a charming game.[97] The blind, mutually destructive opposition of sacred and

profane, ideal and real, beauty and horror, high and low which had so troubled the critics dissolved in the natural artifice of the garden. In a counter-intuitive move, the allegorical appears, at Choisy, to have become 'distorted' into the symbolic.

To talk about *Cupid* in its final setting during the *ancien régime* as having been made over as a symbol of love is to suggest changes in the relationship between the figure and its temporal and syntactic meanings. Unlike allegory, the symbol has a single, universal sense and as such is not subject to contingencies. Thus, in being lifted out of time and removed from history, the symbolic *Cupid*, forswore its powers of commentary. It no longer generated a critique of the morals of monarchy or the qualities of kings by means of a modern gloss on an ancient myth, or to be more accurate, of a reading of politics *through* the literary. The closure or containment thereby forced upon the figure may also be understood in terms of *Cupid*'s loss of semantic slipperiness. The symbolic mode halted the tendency of *Love*, in its desire for meaning, to cross over into its opposite – into impotence in the studio, into the feminine in relation to Hercules, into the effeminate in connection with Louis XV, into an exaggerated masculinity in the literal context of the action. The result was a stilling of the statue. Looking at *Cupid* with an eye for its allegorical content – *making his bow from Hercules's club with Mars's sword* – involved and involves a restless turning about the figure in search of a perpetually deferred satisfaction: the moment of fully perceived, fully grasped comprehension. Looking at *L'Amour Adolescent* (as he was referred to in a memorandum in 1773) on the other hand, made possible pleasure in formal relationships devoid of figurative intent. We discover a balance between *Cupid's* (see Figure 29) right arm and left wing, a less obvious stability in the left arm and right wing. We see the way in which the angle of the crooked elbow is mirrored on a smaller scale by the conjunction of foot and calf, the lifting of the heel following the lifting of the elbow; and the way the curve of the bow finds its counter-curve in the outer rim of the shield. The phallic power, the 'insatiable desire' of allegory, most appropriately of an allegory of love, thus gave way at Choisy to the fullness of symbol, to the pre-Oedipal and apolitical pleasures of a thoroughly feminine realm of Venus.

The figure of Venus:
rhetoric of the ideal and the Salon of 1863

Jennifer Shaw

> Now if we examine the properties of fluids, we note that this 'real' may well include, and in large measure, *a physical reality* that continues to resist adequate symbolization and/or that signifies the powerlessness of logic to incorporate in its writing all the characteristic features of nature. And it has often been found necessary to minimize certain of these features of nature, to envisage them, and it, only in light of an ideal status, so as to keep it/them from jamming the works of the theoretical machine.
>
> (Luce Irigaray)[1]

The Paris Salon of 1863 was filled with paintings of Venus. So many Venuses graced the walls of the Palais de l'Industrie that the critic Théophile Gautier gave the Salon a special name: 'The Salon of Venuses.'[2] Alexandre Cabanel's *The Birth of Venus* (Figure 39) and Paul Baudry's *The Pearl and the Wave* (Figure 40) were the main attractions of the Salon, with a *Birth of Venus* by Amaury-Duval (Figure 41) running a close third.[3] These paintings – celebrated by many and derided by a few critics – were invariably a focus of attention for reviewers.[4] Why this preoccupation with Venus? Was she a mythological subject like all the rest? Might the critics not have been equally interested in any other mythic goddess the artists had chosen to paint? The answer, I will argue, is that there was something quite particular about the figure of Venus in France in the mid-nineteenth century that demanded the attention of the critics.

Images of Venus were, of course, paintings of the female nude.[5] The relative success or failure of high art in the France at the mid-century was often gauged by the quality of its nudes.[6] The nude was the ultimate genre for the creation of 'the ideal' in art and Venus was the exemplary subject. She presented the greatest challenge to artists searching to portray 'the ideal'. A goddess of love, she encompassed that which was most threatening because most unrepresentable – sexuality, productivity and desire. Furthermore, Venus's association with the sea from which she was born played an important role in linking her myth to common conceptions of women and femininity. In the nineteenth century the sea was itself a metaphor for the

39 Alexandre Cabanel, *The Birth of Venus*, 1863, oil on canvas.

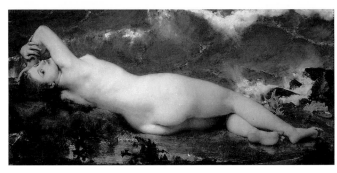

40 Paul Baudry, *The Pearl and the Wave*, 1863, oil on canvas.

uncontainable ebbs and flows of female reproduction – and specifically for the taboo subject, menstruation.[7] Idealising the female body to make a successful image of Venus meant transforming it – elevating it to repress and contain these associations. When painted successfully, Venus was meant to be an idealised figure in which female sexuality and the productivity of the female body were brought under control. The figure of Venus thus posed the ultimate challenge to the male artist wishing to display his transformative power or mastery. However, Venus always threatened to signify more than herself, to outstrip the bounds of her mythological story, to break the boundaries of ideal form and to say something about the nitty-gritty of sexuality and desire, or to show, in the places where her representation broke down, that some things were ultimately beyond representation.

If Venus was the perfect vehicle for the expression of 'the ideal' in art, her representation also brought with it anxieties about the power of masculine creativity. There was a worry, in the Salon of 1863, that even the best paintings of Venus were not doing the job expected of high art.[8] The female body was central to mid-nineteenth-century academic art. Earlier types of history painting predicated on a depiction of the heroic male nude had by this time been largely eclipsed by depictions of the female nude. Yet the female body, and especially Venus, carried such important and wide-ranging implications for the demonstration of male mastery

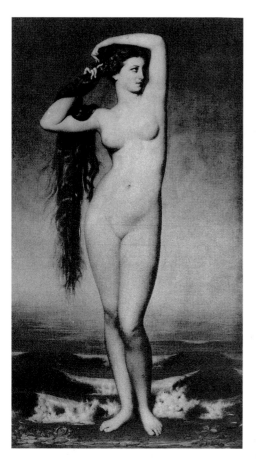

41 Eugène-Emmanuel Amaury-Duval, *The Birth of Venus*, 1863, oil on canvas.

that its representation was fraught with difficulty, and its failed representations came to symbolise most forcefully the 'effeminacy' of the French School of painting. Thus, in 1863, Théophile Thoré explicitly connected the paintings of Venus with a sense of pessimism about the future of French painting:

> It is notable that all the articles on the Salon in all the papers are extremely sad. There is something elegiac in the critics' tone, even when they celebrate the birth of Venus … One doesn't have a good time when one declines. All decadence is gloomy.[9]

As we shall see by looking more closely at the rhetoric of the ideal across a range of cultural discourses, the crisis of the nude as it crystallised around these paintings of Venus resulted less from internal stresses and contradictions in codes of representation than it did from conflicting discourses about the status of woman as a social and sexual agent and from the nature and terms of man's relation to and control of the feminine. The critical preoccupation with Venus in the Salon of 1863 was, in fact, symptomatic of a need to assert the primacy of masculine creativity and control, both of which were perceived – consciously or not – as under threat.

The figure of Venus

Second Empire definitions of Venus encompassed the notion of the fully controlled or ideal body as well as the unregulated female body. Thus representations of Venus served as a locus through which man's control of woman's body, or his lack thereof, could be variously articulated. Venus could represent ideal beauty and chaste love or, alternatively, she could be the goddess of sensual love and ruler of courtesans, a goddess to whom virgins were sacrificed in temples. French culture took its definitions of Venus from mythologies in which her role ranged between these extremes. Thus she effectively mirrored contemporary constructions of woman, serving to incarnate either Madonna or whore.

The *Grand Dictionnaire universel* devoted no less than ten pages to Venus.[10] Most interestingly, the shifting definitions of Venus seem to revolve at least in part

around the issue of her generative power. The *Dictionnaire* began its consideration
of Venus by describing her as, 'the same as Syrian Astarte, goddess of beauty,
mother of Love, queen of Nymphs and Graces', who 'presided over all feminine
charms, for which she possessed the secret ...'[11] However, within a few paragraphs,
the description of Venus as an ideal of woman had to be modified to include her
generative power:

> This is how Venus is represented most often; but if one returns to the origin of her
> myth, one is brought to see in her a divinity of production. The Hellenic peoples per-
> sonified the principle of female generativity by Aphrodite.[12]

Significantly, when Venus as symbol of generative power is brought into play she
comes to represent a fallen form of womanhood:

> The powerful goddess of generation ... becomes the goddess of courtesans, the per-
> sonification of *la vie galante* , the patroness of dissolute pleasures. She falls to the level
> of flirts of the lowest order, introducing into Olympia bad habits and debauching all
> the gods. [13]

Through her reproductive power, Celestial Aphrodite constantly threatens to fall
from a divine form of 'the goddess of generation' into a 'coquette'. Thus the text
suggests the threat of the powerful and productive woman who possesses the ability
to participate in the creation of living beings rather than simply functioning as a
vessel for that which is produced by man. This threat is expressed by the imme-
diate slippage of the goddess of generation to the goddess of prostitutes.[14]

When the *Grand Dictionnaire* turns to a description of popular usage of the word
Venus, we learn that her name was used to signify the sexual act ('the pleasures of
Venus'), colloquially to refer to venereal disease ('a kick from Venus') and in med-
ical terminology to signify the female genitalia ('the mountain of Venus'). The
many variations on the word 'Venus' which appear in Alfred Delvau's *Dictionnaire
érotique moderne* (1864) as descriptions for the sexual act demonstrate the extent to
which she was equated in popular usage with sensual pleasure. Delvau's language
also reflects the aspect of Venus as courtesan. For example, an entry on 'common
Venus' has as its definition 'the girl of the street, who only asks two francs for a
voyage to Cythera'.[15]

In their reviews of the Salon of 1863, critics prefaced their treatments of the
Venus paintings by Amaury-Duval, Baudry and Cabanel with more general discus-
sions of the mythological figure and like the *Grand Dictionnaire*, attempted to con-
trol and limit her definitions. For example, Maxime Du Camp gave a history of
Venus which demonstrated the importance of containing the productive female
body in order to construct an ideal femininity:

> That from the bearded Venus of Cyprus, primordial type of male and female fecun-
> dity, androgynous goddess born from the sea, symbolizing the generative action of
> the sun on the water, would emerge Homer's Venus, a weak being of perfect beauty, is
> easily conceivable, because each attribute of the primitive gods ... became a divinity.

Venus, keeping beauty for herself, gave fecundity to Ceres, agility to Diana, multiplicity to Amphitrite: she remained then and has arrived to us as a prototype of woman made divine by the beauty of forms. [16]

Du Camp imagined Venus's transformation from a monster embodying both male and female attributes, to a goddess of female beauty alone. The hermaphrodite, containing within itself complete generative power, became a woman, who depended on her conjunction with man for her power. Here, Venus's definition involved fixing her attributes and removing her access to the power of fecundity, defined as male. Yet there remains a tension in Du Camp's text between this Venus of the ideal, and the unidealised goddess who still embodied fecundity, agility and multiplicity.

Another critic, Olivier Merson, discussed a similar range of meanings:

Aphrodite signified above all the Universal Cause; everything that breathed in the sky, on the earth, at the depths of the ocean passed for her work. But men's ideas became quickly troubled and she became queen of Cythera ... and of a thousand other places still, she was and remained ... the divinity of courtesans.[17]

In contrast to Du Camp, Merson describes Venus's initial state as an ideal one, attributing her 'fall' to male desire. Perhaps this passage also speaks of the impossibility of maintaining this image of female power and fecundity in a culture predicated on male creative supremacy. Thus the 'divinity of courtesans' remained the predominant conception of Venus for nineteenth-century art critics.

Gender and creativity

The association of Venus with primordial fecundity and her identification with the sea imagined as unceasingly productive and uncontrollable, constructed her as a palimpsest upon which anxieties about male creativity and control could be projected. These anxieties were instanced in the redefinition of generative Venus as *fille publique*. Significantly, these definitions of Venus were written at the very moment when major shifts in the conception of the female body were entering the popular imagination. As Thomas Laqueur has shown, during the eighteenth century and early nineteenth century the conception of woman in relation to man shifted:

The old model, in which men and women were arrayed according to their degree of metaphysical perfection, their vital heat, along an axis whose telos was male, gave way by the late eighteenth century to a new model of difference, of biological divergence. An anatomy and physiology of incommensurability replaced a metaphysics of hierarchy in the representation of women in relation to men.[18]

Laqueur emphasises that this biology of incommensurability did not follow simply from scientific advances, but was part of a more general cultural reconstruction of 'woman'. If evidence for sexual difference could be gleaned from biology, it was in the realm of culture that concepts of woman's complete alterity and the inferiority

of her difference were instantiated. Thus the old hierarchy, which saw women as defective versions of men, was replaced by a new one. While men and women were now constructed as biologically different creatures, the superiority of man over woman was maintained. Throughout the nineteenth century, the discursive production of sexual difference fabricated in fields as diverse as medicine, philosophy and art naturalised a hierarchy of gender, one of whose loci concerned the capacity for original creativity understood as necessarily male.

The notion that men were solely responsible for original creativity was staunchly maintained across a range of discourses, even in the face of the first scientific evidence that women's bodies played an active role in the process of human conception.[19] In 1840 the physiologist Raciborski contrasted the old belief in a male-controlled form of conception with the possibilities suggested by recent scientific findings: 'As for reproduction, until recently we had foolishly believed that the sperm, battling against the laws of impenetrability, passed across the thick envelope of the ovaries in order to enter the reservoir of eggs and choose one according to its own liking.'[20] While it had previously been thought that ovulation in mammals occurred in reaction to sexual intercourse, in the nineteenth century it was shown that mammals ovulate spontaneously during regularly recurring periods of heat, a process occurring independently of intercourse with a male.[21] The scientific discoveries of ovology and embriology thus revealed that men were not the sole instigators of human generation but that conception depended as much on female ovulation as on insemination.[22]

This was never merely a scientific debate on the mechanics of fertilisation and conception. Rather, it called into question deeply rooted assumptions about the supremacy of men in the generation of the species that were linked to more general beliefs about the power of creation. The consequences of this debate for the prevalent conception of male creation were voiced by Ernest Legouvé, member of the *Académie Française*, professor at the *Collège de France* and author of numerous books and lectures on French women of the nineteenth century: 'For four thousand years, that is to say until our century, Science has refused to give woman the title of creator; the scholars have pretended that the *mother* was not a mother.'[23] Acknowledging this new model of the female body's role in the production of human life, it thus became necessary to define the status of the male body with relation to the conception and development of the foetus. In the entry 'Mother', for the *Larousse du XIX siècle*, the anatomist Antoine Serres described the new understanding of the female body's role in reproduction. He suggested a competition between male and female in the creation of life, and attempted to substantiate the pre-eminence of the male's role through elevating the importance of men in the initial conception. After mentioning the previously held 'theory of the superiority of the father', Serres continued:

> It is not he alone who creates the child, since the child is not yet created as a man when the paternal action ceases. Reproduction still demands a second agent, that is to say the mother; the mother who assists the child in the acquisition of each of his

organs; … The mother, then, contrary to the old oriental doctrine, plays a part *at least equal* to that of the father in the creation of his posterity. The first impetus, it is true, comes from him but from her comes the real formation.[24][my italics]

In Serres's discussion, the importance of the female body in the development of the foetus after conception is acknowledged (barely), while the significance of the male role in the initial conception is stressed. The secondary importance of the material process of development and growth in the womb is signalled by the ancillary role of the mother. This has interesting parallels with artistic debates about the relationship between the ideal and the material, in which the definition of genius in art depended upon an emphasis on the initial conception of a work, and a corresponding de-emphasis of the material execution or *métier*, a schema which, of course, goes back to the ancient distinction between *techné* and *physis*.

The figure of woman

Jules Michelet entered publicly into debates about generation in his book *L'Amour* (1858), one of the mid-nineteenth century's most widely circulated works of popular medicine and morality.[25] In *L'Amour*, Michelet presented the theory of spontaneous ovulation in humans to the layperson.[26] This in itself was a pro-science and anti-clerical move. Yet in taking this position, Michelet was forced to negotiate a potential crisis in the notion of male supremacy in procreation. One of the central purposes of his book was, therefore, to reinforce the notion of male creation and man's corresponding control over women's personal and reproductive lives. *L'Amour*, then, stands as an important landmark, weaving together biological 'knowledge' of the female reproductive system and common sense advice for men in their intimate relations with women with questions of male creativity.

According to Michelet 'woman, the miracle of divine contradiction' holds within herself 'a battle of opposite qualities' – a battle between an ideal femininity and a physical state ruled by nature.[27] Yet woman is more subject to the natural and uncontrollable ebbs and flows of her own body, and specifically of her menstrual period:

> Elevated by her beauty, her poetry, her lively intuition, her power of prediction, she is no less held in a servitude of weakness and suffering by Nature. She takes flight each month, our poor, dear Sibyl, and each month Nature warns her with a pain, and with a terrible crisis, throws her back into the hands of love.[28]

Michelet's obsessive focus on the debilitating effects of the female reproductive cycle, and specifically the menstrual period, was part of a more general trend in which descriptions of social and physical phenomena couched in the language of biological knowledge naturalised oppressive hierarchies as objective truth. Michelet begins the chapter 'Woman is sick' by explicitly comparing the battle of opposite qualities innate to woman with the sea:

> Very often, seated and thinking in front of the deep sea, I sensed the first agitation, at first muffled, then perceptible, then getting louder, dreadful, that called the wave to the shore. I was dominated, absorbed with the immense electricity that floated on the arms of the waves where the foam shimmered.
>
> But with how much more emotion, with what religion, what tender respect, I took note of the first signs, sweet, delicate, contained, then painful, violent, the nervous impressions that periodically announce the flux and reflux of that other ocean, Woman![29]

This association of woman with the sea is ostensibly rooted in the realities of her biological make-up. On the most basic level, the sea represents the eternal change which Michelet describes as the source both of man's fascination for woman and of woman's ultimate inferiority. Yet the metaphor of the sea also becomes the source for Michelet's description of man's proper relation to her. For though uncontrollable by women, the female body is, in Michelet's model, controllable by men. The comparison between woman and the sea is transformed from a description of the uncontrollable forces of nature into the ebb and flow of the menstrual cycle, deemed to be both the basic cause of her changeability and the symptom of her weakness and man's control over her. The menstrual period is described as of a cycle of wounding, scarring, and healing, only to be wounded again:

> She is generally ill at least one week in four. The week that precedes that of the crisis is already troubled. And in the eight or ten days that follow this painful week, there continues a languor, a weakness, that one does not know how to define … It's the scarring of an interior wound, that, fundamentally, causes this drama. Such that in reality, 15 or 20 days in 28 (one could say almost always) woman is not only a sick person but a wounded person. She incessantly suffers the eternal wound of love.[30]

Throughout Michelet's text it is clear that the wound is in some sense inflicted by her male partner and related to intercourse. When speaking of the first months of pregnancy, for example, Michelet describes woman's relationship to 'he who has wounded her, for whom she suffers, and whom she loves the more for it'.[31] Michelet's vision of a man sitting by the chaotic sea is, above all, a metaphor for sexual desire, and represents a fantasy of control of woman's body through the sexual act which, in this metaphorical schema, turns the sea from chaos to the 'flux and reflux' of a cycle. The uncontrollable sea submits itself to a controlled cycle just as the woman submits herself to the 'wound' which man metaphorically inflicts upon her through sexual intercourse. What I want to highlight here is the 'transformation' of the woman's body by man through sex and the importance of the sea metaphor in this vision of the relations of man and woman.

Male responsibility for the cycle is put into play through equivocation in defining the wound. On the one hand, it seems to be defined as the product of intercourse and the blood as that of a virgin. On the other, Michelet ascribes the wounding to spontaneous ovulation, which many theorists believed was the source of menstrual blood.[32] Although the evidence for spontaneous ovulation in humans

was still ambiguous, numerous clinical reports based on autopsy material claimed that cicatrices were found on the ovaries of virgins left by the release of an ovum without intercourse.[33] Michelet's conflation of these two wounds – the wound of intercourse and the wound of the ovum bursting from the ovary – functioned in part to negate the role of the female body in spontaneous ovulation by rhetorically delegating the responsibility for the conflated wounds to men.

In an endnote entitled 'Woman rehabilitated and made innocent by science', Michelet argues that the notion of the menstrual period as wound redeems woman by replacing the biblical idea that menstruation is a sign of constitutional impurity (hence 'curse'), with its medical redefinition as a sign of violence imposed on her in 'the sacred wound of love through which our mothers conceived us'.[34] Yet this revision was hardly liberating. For the female body was still constructed to legitimise the inferiority of woman and her constant need of man's healing and support. Within the bourgeois family structure, woman's role as wife and mother was rationalised by her 'sick' nature which both required a husband's protection and prevented her from working outside the home. Woman's sickness made her unfit for prolonged and concentrated mental or physical activity. Such a construction of femininity rationalised the exclusion of middle-class women from the workforce: 'Woman, so sickly and so often interrupted is a very bad worker. Her mobile constitution, the renewal of which constitutes the depth of her being, prevents her from applying herself for long periods of time.'[35] In addition, the quality of changeability was supposed to maintain male interest.

Furthermore, woman's defective nature guaranteed man's creative power, necessitating his transformation of her. In Michelet's chapter, 'You must create your woman (wife.) Nothing would give her greater pleasure', man is said to create woman at her request: 'You must want what she wants, and take her at her word, remake her, renew her, *create* her.'[36] Michelet describes the contemporary male desire for woman as a 'modern passion for a progressive being, for a lively and loving work, which we make hour by hour, for a beauty truly ours, elastic in proportion to our own power ...'.[37] The constant cycle of change Michelet described in woman's body is constructed as the very sign of man's creative power. Accordingly, those same characteristics which he designated to signal woman's lack of control over her own body, were, in this move, reconstructed as produced by men.

There is a direct relationship between this linkage of the menstrual cycle to male creativity and contemporary myths about pregnancy and its effect upon women. Several times throughout his text Michelet refers to the notion that the impregnation of a virgin actually changes her constitution, imprinting it with the characteristics of her first male partner:

> Double marvel, the birth of the child and the transformation of the mother. The impregnated spouse becomes a man. Invaded by the male force that has taken hold of her, she yields nearer and nearer to it. The man will win, will penetrate her. She will be *him* more and more.[38]

In a footnote Michelet elaborates medical 'evidence' that the impression of the husband is 'the physical outcome of a modification of the organism'.[39] The idea that the female body was transformed by man through sexual intercourse functioned to negate the impact of recent discoveries about the productive role that female bodies actually played in the conception and development of the foetus. Michelet suggests that even the development of the foetus – a process that is clearly dependent upon the female body – has its ultimate cause not in the female body, but in the male power to transform a woman into a surrogate for himself.

Michelet's notion of men 'creating' women was adapted by writers on art and theorised as significant to artistic practice. A discussion of the menstrual period in terms similar to Michelet's crops up in a set of articles published in *L'Artiste* called 'Woman from the point of view of beauty'.[40] The somewhat startling inclusion of such a discussion in an article about woman and the beautiful becomes less so once we realise that medical discourse, Michelet's popularised version of medical theory, and theories of the ideal in art were interlinked cultural discourses aimed at enforcing the difference between the sexes and the superiority of men. Like Michelet, the author of these articles, Charles Beaurin, believed changeability to be the essential aspect of woman, a quality he called 'undulability'. In Beaurin's essay, water and the sea are employed as metaphors for woman's essence and, as in Michelet, are directly related to the 'wounding' and 'healing' of menstruation:

> The physiological law of germinative renewal, which is the privilege of the feminine nature, submits the monthly fire of life within her to a periodicity similar to the flux and reflux of the sea. It is a retreat and return of forces that leaves woman in a state of complete openness only a third of the month, but it is a high vital tide. The course of her debilitation, of her preparation, and of her reparation is only the work of a surplus of the life that she is destined to give to her child.[41]

According to Beaurin, 'this alternation of strength and weakness determines in woman a daily state of inequality…'.[42] Throughout his account of woman's body described part by part, female inferiority is deduced through reference to physiognomy and contrasted to man's superiority. For example describing the forehead, Beaurin states that,

> Her forehead is less developed in her than in man. It is less moulded by the interior workings of the brain. Reflection presides over the formation of the virile forehead, spontaneity over that of the feminine forehead … . when the feminine forehead is developed it is always at the expense of her breast.[43]

Mental activity on a woman's part thus reduces her femininity. For Beaurin as for Michelet, rational thought is, by definition, a male characteristic antithetical to woman, whose chronic instability causes her to make intuitive and impulsive decisions, 'always through a feeling of propulsion or revulsion'.[44]

Like Michelet, Beaurin stressed man's creative role in relation to women. Woman's *ondulabilité* is metaphorically read from (among other things) the curves

which make up the surface of her figure. 'This essential mobility of the feminine nature', says Beaurin, 'carries in the species and in the individual an indefinite variation, a profound susceptibility to modifications, to transformations, to metamorphoses …'.[45] Man is 'the king of creation' while woman is 'the elite being of preference'.[46] Woman 'has been created for love, to prove it, to inspire it' and therefore, according to Beaurin, 'the essential condition of their accord is the ascendancy of man'. *Ondulabilité* is ultimately a sign of woman's natural place in the heterosexual reproductive economy – a product of woman's 'need for harmony with the child that she must raise and with the man to whom she must be the helpmate'.[47] All of this is significant to artistic practice because, according to Beaurin, love 'carries with it the intuition of Beauty' which is the basis of the ideal.[48] Beaurin's text provides an important example of the way common conceptions of feminine essence, based on medical 'knowledge' intersected and in part structured the artistic discourse on the ideal.

Rhetoric of the ideal

There is perhaps no better example of the discourse on the ideal than the writings of Charles Blanc. Like Michelet, whose works formed a cornerstone of literary and popular culture in mid-nineteenth-century France, Charles Blanc was, in the artistic sphere, a theorist who exerted a profound impact. His *Grammaire des arts du dessin* (1867) is most commonly referred to by art historians for its importance as an educational text for artistic practice.[49] Yet its description of the origins and purposes of art codified the general structures that would be commonly employed in art criticism in the second half of the nineteenth century. Blanc's text illustrates the extent to which the notion of the ideal in academic discourse was not only dependent on gender, but was also fundamentally about male power. Blanc appeals to God and to nature to justify a hierarchy among different representational and cognitive modes. The extent to which his description depends upon a 'natural' and gendered inequality between men and women shows how reliant discourses on art already were upon discourses on sexuality.

In the first chapter of the book, for example, Blanc formulates the general principles of art which are said to derive from the primordial experiences of man. He describes man in the Garden of Eden, newly put upon the earth and surrounded only by beauty, quintessentially represented by woman (Eve).[50] However, if woman is initially the representative of beauty, by tasting the apple she 'pours upon the earth all miseries. Beauty disappears then, or obscures itself'.[51] Thus woman is the cause of all that is ugly and foul, her original sin compelling man to transform what she has defiled into 'the beautiful'. Although woman has caused beauty to be obscured, man may still retrieve his paradise lost since 'nature still shows, here and there, across the sombre veil that covers her, a few traces of her original beauty'. Says Blanc, 'we carry with us from birth a secret intuition of "the beautiful" which is the ideal'.[52] The ideal, then, is a category which depends, at its very inception, on

gender. The purpose of all creative endeavour is to reclaim what the feminine has lost for man: 'Thus humanity, guided by a star that is the memory of its past grandeur and the hope of its future grandeur, will march to the conquest of Paradise lost, that is to say the true, the good, and the beautiful.'[53]

The terms of Blanc's definition of artistic endeavour are themselves derived from Victor Cousin's *Du Vrai, du beau et du bien*, of 1817 (republished in 1853).[54] However, Blanc takes Cousin's christianised version of platonic idealism a step further by making explicit not only female responsibility for the Fall, but also the necessity of male creativity in the face of a world ruined by woman. Cousin's rhetoric of man's search for the ideal was widely employed in discussions of woman and art, especially in the Catholic press. For example, writing for *L'Union*, in a review of the 1863 Salon, Du Bosc de Pesquidoux proposed a definition of art which reiterated that of Blanc: 'Art is the representation of the beautiful in order to produce the good; or rather, art is a speech which must express the beautiful, the good, the true.'[55]

In Blanc's terms, the purpose of art is to recognise in nature those qualities which are manifestations of beauty and to use them as a guide for depiction. In keeping with academic theory, this does not involve copying nature, but, rather, idealising by seeing through her veil what she once was and could again become.[56] Thus Blanc defines art: 'ART IS THE INTERPRETATION OF NATURE'.[57] Though everyone bears within themselves an intuition of 'the ideal', not everyone is born with the same ability to conceptualise it: 'Among the majority of men it is obscure, latent and sleeping.' However, there are some who 'carry this idea of the beautiful within them in a state of light, and cannot take a step in life without embellishing everything they see, without enlightening with their looks everything they meet'.[58] This is the definition of a great artist.[59] An unequal relationship between those who can recognise the ideal and those who cannot is thereby constructed.[60] In Blanc, as in Cousin, this special ability of intellection is presumed to be a male attribute and not a female one. On the contrary, women are themselves part of the veiled nature through which men can reach truth. As the being whose uncontrolled act caused the need for art in the first place, woman becomes the very site of transformation back to the original state of grace. For this reason the female nude is the ultimate genre for the representation of the ideal. Far from being a neutral aesthetic concept, the ideal is both based on, and supportive of, an underlying hierarchy of creativity and intellection, which is, before anything else, gendered.

Various aspects of artistic practice are similarly defined by Blanc. He gives an explicitly gendered account of the inferiority of colour to drawing taken from seventeenth-century academic theory: 'Drawing is the masculine sex of art, colour is its feminine one. Of the three great arts, architecture, sculpture and painting, there is only one in which colour is necessary; but drawing is so essential to all of them, that one properly calls them the *arts of drawing*.'[61] Thus colour, the feminine aspect of art, is both inferior and supplementary to drawing, the masculine one. All

the arts are consequently defined in terms of their relation to the masculine, to *dessin*. In painting Blanc admits that 'colour ... is essential', but qualifies this by stating that 'it takes second place'. He compares this unequal relationship with the reproductive relationship between man and woman:

> The union of drawing and colour is necessary for engendering painting, just as the union between man and woman is for engendering humanity; but it is necessary that drawing keep its preponderance over colour. If it is otherwise, painting courts its ruin: it will be lost by colour like humanity was lost by Eve.[62]

In other words, Blanc sets up a hierarchy within painterly practice that parallels the one described by Michelet for human generation.

Like Michelet, Blanc justifies this structure through an appeal to the natural. He describes the superiority of line over colour as 'written in the very laws of nature', because objects can be recognised exclusively by their line and shape but not by their colour alone. Furthermore, while drawing produces form, which is absolute and unchanging, a 'project of mind', colours are relative and 'vary according to the environment in which they exist'. They are tied to the vicissitudes of the body and the material world.[63] Blanc's hierarchy is thus built on oppositions between masculine and feminine characteristics: 'Colour plays in art the feminine role, the role of sentiment; subjected to drawing like sentiment must be subjected to reason, colour adds charm, expression and grace.'[64] Drawing is essential, while colour is supplementary and superficial; drawing is aligned with reason and thought while colour is associated with emotion and physical sensation. Drawing is masculine, while colour is feminine.

According to Blanc, the artist must give his works the 'imprints of life' which he can only find 'in the individuals created by nature'. The task is not to create an abstract vision of the ideal but to transform nature into the ideal. The ideal depiction of the female body must allude to its rootedness in nature while at the same time demonstrating that it is the product of artistic transformation and thus does not reproduce nature's imperfections.[65] Blanc follows Cousin in his emphasis on transformation. Cousin warns the artist to avoid 'a lifeless ideal' which results from 'working from the mind alone' as well as 'the absence of the ideal' that comes from copying the model. According to Cousin: 'Genius is a ready and sure perception of the right proportion in which the ideal and the natural, form and thought, ought to be united. This union is the perfection of art.'[66]

What sets Blanc apart from Cousin is the explicit introduction of sexuality and gender into his description. Both Michelet's and Blanc's descriptions of the ideal are, I would argue, part of the same deployment of a definition of sexuality under control.[67] Significantly, Blanc does not call for a sexless art, but a modest one: 'Modesty ... it is the inverse of naiveté, because where innocence finishes modesty begins. Eve only blushed at her nudity in the earthly Paradise when, having touched the tree of science, she knew good and evil' ...[68] Blanc uses a marital relationship reminiscent of Michelet's as a metaphor for artistic practice. To produce a

masterpiece, says Blanc, the artist must make nature his own in much the same way that Michelet advises his readers to 'create' their wives:

> these two beings are forever inseparable: the type, which is the product of thought, the individual that is the child of life. Let the artist marry nature, then; let him marry her without marrying below his station, but unite with her in an indissoluble union.[69]

'Uniting' with nature, the artist metaphorically makes nature his wife. Nature/woman becomes the property of the artist, and is transformed by him into art through a process of possession which, as in Michelet and Beaurin, can be aligned with heterosexuality.[70]

An analogous notion of transformation formed the central thematic structuring many discussions of the paintings of Venus in the 1863 Salon. Claude Vignon's review for *Le Correspondant* provides an example of how a rhetoric of the controlled body overlapped with a language of art when critics attempted to demonstrate the aesthetic success or failure of the Venuses.[71] Vignon described Cabanel's *Venus* as a perfect transformation of the female body, one which spoke of male creative mastery. The eye, said Vignon, was at once 'pulled by a shimmer of tender colours' (notice that it is colour, the feminine side of art, that exerts its pull upon the viewer). Then it became active again, following the lines demarcated by the artist's hand over the body constructed in its ideal form. Finally, 'it pause[d], captivated by an unexpected charm, by a singular harmony of contours and nuances'.[72] Like Blanc, Vignon, defined the perfect Venus as a balance of the physical and the ideal. Thus she said of Cabanel's Venus: 'This is not at all a beautiful woman, it is ideal beauty incarnated in woman.'[73] This balance between the active and the passive, between the physical and the ideal, through which the body was metaphorically mastered, made the painting so successful that, 'one can remain a long time in front of M. Cabanel's Venus; nothing wounds there'.[74] With the evocation of the wound, Vignon implied that the female body, in its untransformed physicality, would have been ugly, even painful, to the eye. Cabanel's Venus had a body which had been transformed away from the vulgarities of the everyday – a body not subject to the 'wound' of intercourse and menstruation, not bound enough to the physical world to provoke male sexual desire. Yet this choice of vocabulary seems to indicate an overcompensation for, and denial of, the erotic elements of the painting.

According to Vignon, unlike the idealised Venus of Cabanel, Baudry's Venus took up a pose 'more overelaborate than well executed'. With her 'badly attached feet' she had 'an awkward and provocative *je ne sais quoi*'.[75] Here, as in Blanc's formulation, physical imperfections, which according to academic theory are signs of specificity, were seen to detract from the ideality of the figure. Vignon was not the only one to hold such a view of Baudry's painting. The critic Jules Castagnary pointed to the figure's 'appearance of a Parisian milliner,' a sign of contemporaneity that prevented her from being a goddess.[76] Writing for the *Gazette des Beaux-Arts*, Paul Mantz noted that the mortality of Baudry's Venus was indicated by her imperfections which were specifically linked to failure of the artist's drawing technique:

'She is nude like a goddess, but it's a mortal, as one sees a bit too well in the imper-
fections of her form, the inadequate way in which the loins attach to the hips, the
smallness of the chimerically drawn feet.'[77] Georges Lafenestre also complained in
the *Revue contemporaine* that Baudry failed to transform 'these blushes of a
deformed torso ... this narrowness of contemporary feet' with the result that, 'we
are still in Paris, only in Paris; the artist hasn't been able to transport us further
away'.[78] According to these critics, Baudry had failed to achieve the balance of the
ideal/real, mind/body which would serve as the sign of a body transformed and
mastered, the body of high art.

Many other critics gave similar descriptions of the two paintings. Those, like
Vignon, who wished to praise Cabanel, pointed to the superior transformatory
power of his drawing and modelling. H. Francingues, the critic for the *Revue des
races latines*, noted that Cabanel's Venus was perfectly drawn and that 'everything
the imagination could dream up' was graciously accomplished in her form, and
contrasted this to Baudry's complete lack of modelling in the figure.[79] Writing for
La Gazette de France, the critic 'Un Bourgeois de Paris' suggested that 'Cabanel's
Venus has a soul', while Baudry's 'has only a body' and related the untransformed
body of Baudry's Venus to the artist's inferior powers of idealisation. He noted that
Baudry's drawing was much less harmonious than Cabanel's. Finally, the critic
concluded: 'The more I look at this Venus, the less I recognise a goddess there: I see
the painter's hand, and do not sense at all the soul of the artist.'[80]

Taken together, the three Venuses offered a range of the body and its mastery.
Vignon described Cabanel's as a perfect illustration of mastery, and Baudry's as an
example of the constant threat to that mastery provoked by the female body.
Amaury-Duval's Venus, on the other hand, was an example of painting which
failed even to address that purpose of mastery through transformation and thus
presented the viewer with what Cousin had called a 'lifeless ideal'. Amaury-
Duval's Venus showed thought alone, not thought applied to and in control of
nature. Said Vignon: 'He suppresses or absolutely neglects charm, and, making an
abstraction of the eye's pleasure, conceives of beauty by thought alone.'[81] Amaury-
Duval's abstract Venus presented an example less threatening than Baudry's of an
artist's failure to fulfil the aims which had been constructed for Art and prompted
Vignon to conclude: 'If Venus is not beauty that charms, then what will she be? A
neoplatonic conception that bores us?'[82]

The negative relationship of the 'ideal' Venus to the physical was elaborated in a
caricature by Bertall in the *Journal amusant* (Figure 42) which constructed the
paintings in terms of the physical reactions they provoked in their male viewers.[83]
Furthest left, the 'Amaury-Duvalistes' stand to the side of a painting and point at it
with reserve, noting its solidity and good drawing. In the centre are the
'Cabanellistes', a more agitated crowd of men, who describe the painting as caress-
able cotton. Furthest right, from the crowd of 'Baudrystes', a disembodied hand
reaches up from below the canvas and grabs hold of the scribble that stands for
Baudry's Venus. The Venuses' excessive rootedness in the physical world, signalled

by a lack of idealisation (be it in the quality of facture, or colour, or in the depiction of the detail) implied the varying degrees to which they appeared as products of the artists' and viewers' sexual, rather than spiritual, interactions with the works. An overtly sexual tone signals the engagement of body rather than mind. Lest one miss the point, Bertall includes a reference to prostitution in the title: 'quartier Breda'[84] emphasising that these women are viewed as sexual objects in a public space, and further implying that the Salon is not only an exhibition space, but also a market place.

Bertall's caricature further mocks a philistine viewing public lacking the ability to 'grasp the ideal' and appreciate high art, who instead take pleasure in the physical, sexual and material aspects of the paintings. Hence, the caricature reflects and reinforces two of the hierarchies implicit in the ideal which we have already observed in Blanc's analysis. First, woman is formulated in terms of male desire, and contrasting degrees of man's control over both his and her body are presented with the less idealised female bodies provoking a more intense male desire. Second, an implicit hierarchy among the viewing public is described, by which the bourgeois viewers who are the butt of the joke are shown as unable to appreciate high art, while the implied reader/viewer, who can laugh at their philistinism and lack of taste, is by default constructed as the possessor of the power to recognise the ideal or lack of it. At the same time, the caricature mocks the very notion that the ideal precludes sexual desire in the service of disinterested beauty.

2 JOURNAL AMUSANT. N° 387.

LE SALON DE 1863 ET SON SOUS-SOL, — dépeints par BERTALL.
QUARTIER DES VÉNUS DE 1863 (quartier Breda).
LES AMATEURS DE VÉNUS SE PARTAGENT EN TROIS BOUDOIRS : LES BAUDRYSTES, LES CABANELLISTES, LES AMAURY-DUVALISTES.
Jugements des Pâris de 1863.

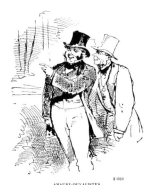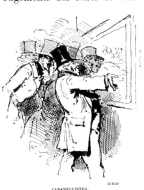

AMAURY-DUVALISTES.
— Moi, je préfère la Vénus d'Amaury-Duval. Bon dessin ! et puis, c'est de la peinture solide : fer-blanc de première qualité!

CABANELLISTES.
— Moi, c'est Cabanel qui est mon homme. Jamais on n'a travaillé le coton comme ça !

BAUDRYSTES.
— Quant à moi, je donne la pomme à la Vénus de Baudry. Au moins c'est de la chair, ça vous dit quelque chose....
— O éloquence de la chair !...

42 *Quartier de Vénus 1863 (quartier Breda)*, in *Journal amusant*, 1863, wood engraving.

Maxime Du Camp's discussion of the 1863 Venuses for the *Revue des deux mondes* provides an example of the role Venus played in critical laments about the 'decadence' of the French School. Like Charles Blanc, Du Camp stressed the importance of 'conception' in art, and the need for the artist to render in a superior form what he can only glimpse in nature.[85] Bemoaning the decline of French art, Du Camp said the capacity for 'interpretation' (the term Blanc used for artistic transformation into the ideal) had been lost.[86] In Du Camp's account, both Cabanel and Baudry were condemned for painting 'decoratively'. The decorative was linked to the feminine, the superficial, the material, and signalled the decadence of French art: 'In a word, the exclusive cult of matter in all its manifestations.'[87] In Du Camp's analysis, as in Bertall's caricature, the preoccupation with the material or physical (as opposed to the spiritual) aspects of art ranged from the decorative and largely innocuous to the sexual and immoral.

Like Blanc, Du Camp elaborated a hierarchy of artistic talent, in which some artists were more capable of sensing the ideal than others. Du Camp believed Cabanel to be capable of depicting the ideal. His Venus was, he said, 'very strongly painted, with a knowing brush'. Yet Du Camp could not overlook the overt eroticism of Cabanel's figure. Cabanel had produced 'an ensemble that would be successful, if it didn't have certain intentional exaggerations that it is not at all convenient to indicate'.[88] Du Camp politely avoided the issue of sexuality with this phrase, but he returned to it soon enough. Here is more of Du Camp's description of Cabanel's Venus:

> One reproach in passing: his Venus is not in the process of being born, rather she awakens. Lying on a wave where the whitened swell of the froth serves as a pillow, she is stretched out in a manner which makes the contour of her hips and her chest more prominent; from her barely opened eyes, she seems to solicit the admiration of the viewer and say to him: 'See how beautiful I am! look, I am there for you to contemplate at your ease; the sea is a pretext, my name a blank cheque I am a woman, nothing more but nothing less, and if the old king David had only seen me he would have preferred me to the young Abigail!' It's too much, all this discussion is useless, and this Venus doesn't say anything else.[89]

Deliberately positioned so that her hips and chest are prominently laid out for display, surrounded by brushstrokes of sea foam that metaphorically caress her body, the eroticism of this Venus is Cabanel's choice, rather than his failure. This emphasis on the erotic is amplified by Du Camp's claim that the woman awakens – perhaps from a sleep with illicit dreams judging from her orgasmic expression – rather than being born in a state of innocence.[90] Cabanel's *Birth of Venus* represented not the failure to capture the ideal, but the refusal to do so.

Baudry's painting, on the other hand, was an example of an artist's failure to sense the ideal and interpret the model. If *The Pearl and the Wave* crossed the line of propriety, it was because Baudry was incapable of making his work transcend the physical and sexual meanings of the female body. Baudry's painting thus served as a

moral example for artists and viewers: 'Perhaps it is sometimes good for one to see where one can end up when, looking only for grace, one does not know how to contain it within the limits beyond which it changes its name.'[91] Du Camp contrasted Baudry, an artist facile with colour, the 'feminine' side of art, with Cabanel whose control of the image was indicated by firm modelling and defining line, the 'masculine' side of art.[92] Baudry's painting failed in all areas associated with the 'masculine' side of art. It was characterised by the absence of composition and 'crude' modelling and 'incomplete' drawing. While Du Camp admitted that Baudry excelled in the realm of colour, he described this aspect of Baudry's painterly practice in passive terms. Baudry's use of colour was owed not to artistic mastery, but 'to nature'. Indeed, Baudry's failure to take control of the process of painting was so complete that 'one would say that the model takes the pose which suits her and that M. Baudry contents himself to copy her … as one can convince oneself upon seeing his Wave'.[93]

Interestingly, Baudry himself struggled with the subject matter of his painting:

> I had at first thought of the Wave for the title, that is to say of the movement of undulating curves, of the ephemeral and pure freshness of the foam; all that was very feminine. But, however, the transposition of the idea of water to a living being is a bit too much of an abstraction. It appeared to me simpler to make the wave the jewel box and the figure the Pearl, the pearl lifting itself to the light on the azure jewel box of the wave. Venus Aphrodite has the same origin.[94]

This explanation of the inspiration for the painting brings together the discourse of femininity as 'undulability' with the depiction of Venus. On the one hand, it attests to Baudry's desire to treat the Venus theme. The shift in conceptualising the subject of the painting from wave to pearl and from pearl to Venus manifests Baudry's sense that his role was to transform the 'feminine' into a pearl of high art. On the other hand, it makes clear the impetus behind such transformation – to make the female body legible, predictable, controllable at the same time as 'femininity' is defined as the opposite of these.

Had Du Camp found Baudry's painting to be successful, he might have described the figure as the pearl – a figure, hard edged and solid, transformed and elevated from the physicality of nature by a masculine and controlling line. But instead, Du Camp described of the woman as 'the wave' with its constant movement and change, the very essence of 'the feminine' as it was constructed in nineteenth-century discourse. Yet at the same time, too, he acknowledged the impossibility of depicting the wave and thus of fixing femininity: 'To allegorise a wave', said Du Camp, 'is not an easy thing. What is a wave? Disquiet, depth, treachery, instability.'[95] Here the ambivalent nature of nineteenth-century discourses on femininity is manifest. The female body was associated with the mobility and instability that justified exclusion of women from the realms of power. But those very same forces were also what made it both unrepresentable and threatening.

In Du Camp's account, the preponderance of the 'feminine' side of art goes hand in hand with the depiction of the female body at its most material. Without the powers of reason and interpretation to keep the material side of painting in check, 'one enters more and more into a materialism that brings art to be nothing more than a *métier*'.[96] While the different forms of the 'cult of matter' that the paintings by Baudry and Cabanel were said to represent were not identical, they were related and mutually reinforcing. Furthermore, each of them played into an unequal hierarchy where the material, the inferior term, was represented as and by the feminine. Thus it was only natural for Du Camp to refer to 'decadent' modern art like the Venuses as 'effeminate and vulgarly sensual art'.[97] For Du Camp, this meant an art fostered by 'this French society that no longer seems to follow anything, alas! but the special and rapid interest of the moment'.[98]

We have seen that across a variety of discourses, woman was constructed in these terms, as ruled by the physical, and constantly changing. Thus 'effeminate' was not simply a synonym for 'weak'. It had implications, as did these paintings, for a more general construction of the feminine. Furthermore, descriptions of creativity in the realm of art had important parallels with descriptions of human reproduction. Remembering our discussion of the crisis of male creativity in the context of bio-medical theories of the female body's active role in the conception and birth of children, it becomes apparent that a parallel structure is operating here in the demotion of 'the feminine' in art.

The hierarchies of power and knowledge that constructed the categories embodying the feminine as inferior operated politically to instantiate modes of cognition through which woman and the feminine could only be negative terms. A vocabulary of mastery and control of the female body accompanied a characterisation of women as out of control of their own bodies, as debilitated, sick and mutilated. This definition of woman functioned across a variety of discourses for both the subjection of women and the promotion of male creative mastery. Woman's debility had to be maintained by patriarchy especially when the definition of her sexuality shifted from a defective sameness to a sexual difference with the potential for power of its own. As the productive role of the female body in human generation was scientifically demonstrated, woman's complete alterity had to be established as both otherness and inferiority in order to affirm male creative and procreative superiority. As we have seen, discussions of Venus played a crucial role in the production and reproduction of this discursive structure. For the figure of Venus marked the place where contemporary definitions of the female body and female sexuality most powerfully intersected with the theories of the ideal in which male creativity was codified. It was perhaps there, in the discourses of art and the ideal, that the integral part these constructions of woman were meant to play in the preservation of male creative supremacy was most dramatically exhibited. But it was also there, in the attempts of critics to account for the failure of artists to attain 'the ideal' when depicting the female body, that the desperation and fragility of that discourse emerged.

Venus as dominatrix: nineteenth-century artists and their creations

Caroline Arscott

This chapter addresses the question of artistic creativity in the mid-nineteenth century. Through an examination of a series of paintings about an artwork (the series by Edward Burne-Jones, 1868–78) and an artist's life (Elizabeth Eastlake's life of the sculptor John Gibson, published in 1870) it looks at the erotic drama associated with the creative process.

In each case the artist is situated in relation to a Venus. The goddess Venus animates Pygmalion's sculpture, at his request. The artist Gibson is seen to have a special relationship to his own sculpture of Venus. Venus, and various female figures who take on her attributes, relegate the artist to a position of submissive adoration and dependence. The male artist is seen as a wild and virile genius who can only access the realm of the law, language and culture through the favour of this powerful goddess. The familiar gendering of the terms nature and culture as female and male is reversed in this construction of genius. Sexual continence and total enthralment are required and the fantasy of intense involvement with the goddess can be seen to conform to the narrative structure of masochism.

The chapter concludes that, at this moment in the mid-nineteenth century, notions of artistic identity were reworked to produce a specifically perverse subject position for the male artist. This has interesting implications for our understanding of the phenomenon of art for art's sake and the claims for the autonomy of art in the modern period.

Tone and emotion in Burne-Jones's *Pygmalion and the Image*

One century on from the exhibition of *Pygmalion and the Image* Burne-Jones's critical reputation had fallen to a low ebb. A monographic exhibition was mounted by the Arts Council in 1975–76 and the catalogue comments on the Pygmalion series were particularly damning. The catalogue entry reads: 'These well known pictures were shown with no. 136 [*The Annunciation*] at the Grosvenor Gallery in 1879. Their rather mawkish sentiment and chalky tones perhaps make them the hardest of all

Burne-Jones's works for the modern taste to accept. They are based on designs made for [William Morris's] *The Earthly Paradise* in 1867'.[1] The sentimentality and chalkiness are taken as faults, but comparison with the much fuller comments published in the *Athenaeum*, nearly a hundred years before, shows that the manipulation of these characteristics could be taken as fundamental to the pictures' effects. The very same characteristics are the focus of the reviewer's attention: the matt surface and soft tone, and the sentiment, are alluded to by the critic (almost certainly William Michael Rossetti) who says: 'The colour of this picture is lovely in its wealth of deep purple-like hues and harmonies of purple and rose tints; the effect is soft and diffused, and, like all the paintings before us, this one is low and tender in tone.'[2]

Particular effects of light, colour and mood are picked out in sequence as the review considers the four paintings of the series. In the first canvas *The Heart Desires* (Figure 43) we are told 'The picture shows the young study-worn Pygmalion standing before and gazing intently on an unfinished group of the Graces carved in marble and placed on a pedestal in his chamber which is filled

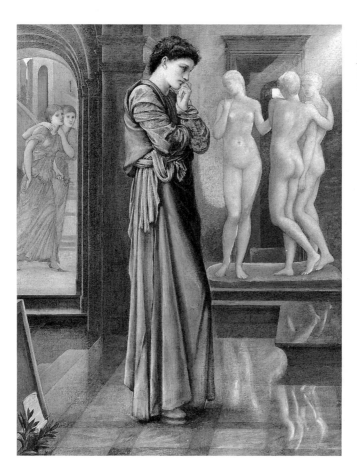

43 Edward Burne-Jones, *The Heart Desires*, 1875–78, oil on canvas.

with a cool, chaste light, so that the statues look grey and solemn.' We are told that Pygmalion himself is thoughtful. He is intent, desirous, but not passionate: 'There is more of studious force than of amorous fire in his look, and a patient will to create beauty beyond that which has been already expressed by the typical group before him. The heart of the sculptor desires but it has not concentrated itself.'[2]

These comments, that put diffused light and unfocused desire together, offer a fascinating way of thinking about technical effects and sentiment. Dim light renders shapes in near-monotone and the lack of colour and a correlative lack of warmth keeps amorousness at bay. Chastity and solemnity are conveyed but nonetheless we are conscious of a colloidal libido. In the second canvas, *The Hand Refrains* (Figure 44), the reviewer notices the subtle increase in warmth of the tones. Before the sculptor stands a statue which represents his effort to move beyond the 'impersonal, purely aesthetic' charm of the Graces. This, we are told, has been made from a 'warmer tinted marble' than that of the Graces while the picture is lit with 'rosier illumination'. Yet roses are lacking in the statue that stands

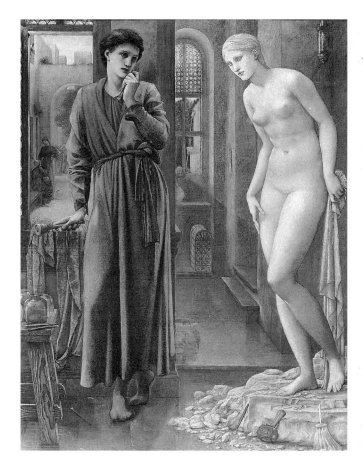

44 Edward Burne-Jones, *The Hand Refrains*, 1875–78, oil on canvas.

'soulless and without a blush' for all its beauty. In its intimation of warmth it may be 'Venus-like' and yet it is still cool and 'virginal'. The review pairs these two terms. Pygmalion, meanwhile, has grown noticeably thin and wan, and is at the point of despair as he yearns for an access of human sympathy to this marble figure.

The third and fourth canvases show the intervention of Venus and its result. The *Athenaeum* describes the light effects associated with the figure of Venus in *The Godhead Fires* (Figure 45).[3]

> In the third picture she has descended, clad in a softly shining diaphanous robe of white, which emits a silvery lustre and is instinct with the rose-tints of the pearl; a robe which is pressed to her form, as on an azure filmy cloudlet she drifts through the air.

All these lustrous effects relate to diffused and variegated gleaming rather than direct radiance. The emotional state of the two is seen to be similarly muted. Nothing as direct as joy or excitement is discerned. The newly-animated statue leans forward for support from Venus.

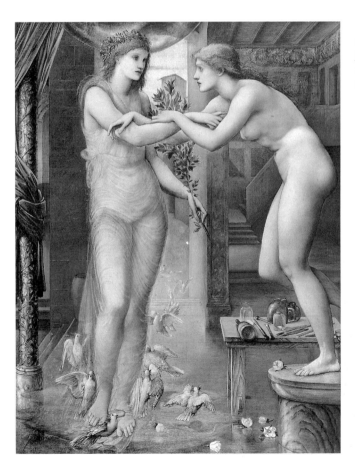

45 Edward Burne-Jones, *The Godhead Fires*, 1875–78, oil on canvas.

> Nearly lost in wondering unconsciousness, it bent forward with outstretched lithe arms, twined those arms on the arm of Venus for support, and gazed with eyes that are wistful into the serious eyes of the goddess.

An account has been given of a move from the gloomy and fretful, to the somewhat rosier yearning despair, to a luminous and pearly, half-conscious wistfulness.

In the fourth canvas the warmth of light is said to be greater: 'The light of the chamber is full of warmth'. The colour-values in the now-living statue are noted as brighter: 'All her forms are filled with carnation tints and golden inner hues'. The joy and warmth in this final scene, *The Soul Attains* (Figure 46), is asserted. The very close reading of light and colour effects and the differentiation in states of desire, longing and wonderment has seen a progression in the series, and yet in this attentive and insightful reading we are left with an acknowledgement that, at the conclusion of the series, 'the image' still retains vestiges of the statue–state.

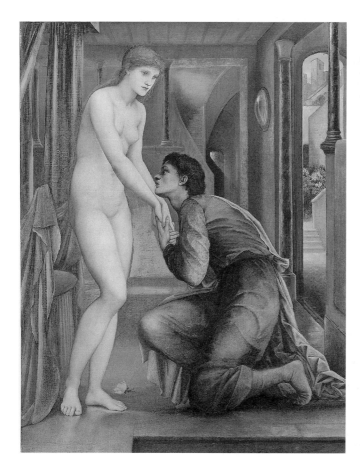

46 Edward Burne-Jones, *The Soul Attains*, 1875–78, oil on canvas.

> The naked figure has not yet quite parted with the stillness of its statue-state, and is bending, full of wonder at the adoration and joy of the lover who, enraptured, kneels before her, twining her long fingers with his own, and in thought, at least, lies bound with her arms. There is speculation now in her eyes, hardly yet moved by passion. The light of the chamber is full of warmth. The legend is nearly complete.

In this account we finish with incompletion. Pygmalion may imagine himself embracing the newly-living statue, but he does not. He kneels and so they are both still. That imagined embrace is formulated as a motionless binding in any case. The statue's state, 'full of wonder', and Pygmalion's, 'enraptured', render them both inactive. 'Enraptured' with the adjoining terms, 'twining' and 'bound' attest to a disabling captivity that contradicts the indications of change and development in this series. The reviewer spoke early on of the entire series being 'low and tender in tone'. This relates to the quality of light, and, just as forcefully, to the emotional atmosphere of the entire set from first to last. At the same time there is a recognition of a highly charged eroticism, alluded to in a mention of the 'super-sensuous' beauty (rather than sensuous) that is favoured and presented in Burne-Jones's works. My interest is in this eroticised murky dimness and in the implications of developing a low-toned narrative around the story of Pygmalion. I take the *Athenaeum* account as an example of the kind of response possible for a sympathetic insider in 1870s Aestheticism. It registers the highly charged atmosphere and follows the ebb and flow of warmth while acknowledging the diffuse and misty tone of the whole series. This account does not see sentimentality and chalkiness as faults of taste and technique. Following the lead of the *Athenaeum* reviewer we should take the uniformity of the series seriously and consider the implications of a narrative about artistic creation that suppresses narrative development. The sequence of scenes might lead us to expect a developmental narrative, and we are, indeed, given the stages of a story. However, there is a patterning in the series that undermines the idea of narrative movement. I will go on to show that Burne-Jones uses repetition and symmetry to lend a decorative stasis to the set of images. In the context of 1870s Aestheticism the leeching away of narrative and its replacement with, first, a strongly accented mood and, second, an emphasis on formal patterning within the composition was a common characteristic of vanguard work. In *Pymalion and the Image* Burne-Jones makes that move from narrative towards mood and decoration. He elaborates a set of themes that link the low-toned optical harmonies, and the repetitious format, to an emotional register of quivering fear and exquisite pain.

Literary versions of the myth

The Pygmalion story itself can be told in many different ways.[4] In Robert Keningdale Cook's 'Pygmalion', a poem dated May 1866 (published in *Purpose and Passion: Being Pygmalion and Other Poems of 1870*), the artist prays to assorted powers of nature and, full of hope, 'throbbing', embraces the chaste marble statue.

His passion brings it to life, in metaphors of infusion of blood, thawing of ice, rushing of foamy rivers, and ripening of fruit.

> His arms he wound – ah! not reluctantly –
> About the chasteness of the marble pale;
> Close pressing on the lips yet unawaked
> A fervent touch of fire, the while his soul
> Its spirit-whispered hope gave forth in throbs.
> And not for nought, for through the moved air
> There rushed swift ardours at the touch; heaven-bid
> Ambrosial fragrance thrilled around the pair,
> The man and marble maid; and fountain-loosed
> The frozen life-spring of her heart became
> A river billowing crimson foam to swell
> Full many a blue-tinged marble vein with life.[5]

He is the ultimate phallic figure, penetrating the female natural, arousing the demure statue to a passionate state in which she matches his engorged and effusive body. Like Venus she is born out of his spermatic foam, and their mutual swelling and spending leads to her fruiting. Thomas Woolner gives us another phallic Pygmalion in his verse work of 1881.[6] Here the retiring and moody artist, a worry to his widowed mother, gives a spark of life to his work only when he experiences desire for Ianthe, one of his mother's handmaidens. The key moment of transformation is when he kisses Ianthe and her pallor turns to a rosy glow. The bringing to life of the statue of Hebe is only metaphorical, but scandalous reports present it as literal, saying that he has brought a statue to life by necromancy: mixing blood with clay. Consequently he has to overcome hostility and attacks on his person by carrying a sword, strapped on at the behest of his new wife. It is easy to see this as a mark of his new phallic prowess. Ultimately he assumes a full masculine identity by vanquishing his personal assailants and taking up his father's role as leader of the Cypriot armed forces. As victor he is crowned King. The pursuit of art is exactly parallel to the manly pursuit of life. His mother told him to pursue his art whatever the danger, saying 'charge with all your strength/The fairest death is death in victory'[7] and the goddess told him of the parallel between art and battle: 'These high Olympian gifts are yours to hold/ Braced must you be to battle for your own'.[8] Each of these tales gives us an active and amorous Pygmalion who could utter the words of the character in William Brough's burlesque play of 1867.

> *Pygmalion*: My beautiful – my own! (embracing her)
> *Statue*: Oh! don't, sir, please
> I'm sure I'm much too soft to stand a squeeze.
> *Pygmalion*: Too soft! What mean you?
> *Statue*: Nay I hardly know,
> I was so firm and hard an hour ago;
> Suddenly I grew soft –

> *Pygmalion:* Nay speak no farder,
> You getting softer but renews my (h)ardour;
> Unrivalled maid![9]

The trade-off between the hardening of the male sculptor and the softening of the stone maiden is neatly put in this ribald dialogue.

Morris's version of the myth

Burne-Jones's paintings derive from a project to illustrate Morris's tale in *The Earthly Paradise*, which is yet another telling of the tale.[10] Several pencil drawings and rough engravings survive from 1866–67. A first painted series was developed from four of these designs in the years 1868–70 and the large-scale works that are the focus of this essay are a further development of the theme, dating from 1879.[11] Each version inflects the story in different ways and in no case does Burne-Jones's logic tally precisely with the scheme of Morris's poem.

In Morris's poem the sculptor Pygmalion is given a wide range of emotional states, while, for the bulk of the story, the statue is fixed in a grave stance of painless half-knowledge of love – seeming to have an inkling of love, but at one remove, as if in a dream.

> Naked it was, its unbound locks were laid
> Over the lovely shoulders; with one hand
> Reached out, as to a lover, did it stand,
> The other held a fair rose over-blown;
> No smile was on the parted lips, the eyes
> Seemed as if even now great love had shown
> Unto them something of its sweet surprise,
> Yet saddened them with half-seen mysteries
> And still midst passion maiden-like she seemed
> As though of love unchanged for aye, she dreamed.[12]

The anaesthetised timelessness of the statue is set off against dynamic states of engagement on Pygmalion's part. He feels the bitterness and disgust of world-weariness, the frenzy of thwarted desire, the agitation of nameless hope, the agony of presumed loss, the momentary chill and calm of abandoned hope and then the renewed pain of rekindled desire. It is only in the closing section of the poem that the statue participates in this kind of vivid experience. Speaking to Pygmalion she cries out at the pangs of love that she feels for the first time. The inverse relationship between pleasured or numbed timelessness and the intensity of love and loss is a major theme of the poem as a whole. The enjoyment of magical trance-like states repeatedly gives way, in a switchback, to mortality, memory and the inevitable regret of lost illusion. In Burne-Jones's (1879) *Pygmalion and the Image* there is no such contrast. If anything, Pygmalion, the statue and Venus all seem to inhabit the timeless zone occupied by Morris's statue. But this is not the beatific region

explored in Morris's romance. It is a world where loss is not allowed to figure, where pleasure comes packaged with pain.[13]

Burne-Jones's Pygmalion

In this presentation of the story, the supreme artistic achievement of producing a desirable object brings with it the promise of consummating that desire. The artist's skill and passion unite to make possible the ultimate act of creativity – the creation of life. The art object is identified both with the object of passion: the sexual partner, and with the result of passion: the new life engendered. This solipsism is emphasised in the series which presents an interaction which is entirely non-interactive in that there is no outside term that comes in to challenge the potency of the male creator. He does not love anything that represents an other because the object of his passion, though gendered female is something that derives only from him, all his own work. He does not rely on a living model like Woolner's Pygmalion or the forces of nature like Cook's artist. If we think of desire as being organised around difference and unattainability we see that this narrative isn't really concerned with desire but with pleasure and possession, in a fantasy situation where the encounter offers a replication of the phallic self rather than a threat of castration. Difference is referenced in the first canvas where the looks of passing women and the sculpted group paralyse the sculptor. There is a shattering of form in the broken reflections in the marble floor. But subsequently the emphasis is on perfect mirroring and homogeneity.

The story does not develop but seems to repeat, as the paired vertical figures recur. There is no decisive action or culminating episode. The thick turgid atmosphere seems to inhibit action. The puddled 'azure filmy cloudlet' and the spray of doves and roses in the third canvas seem to be a reprise of the array of scattered stone around the base of the statue in the previous scene. If we read this as a motif of pleasurable bodily emission, we hesitate to see it as a climactic effusion because it remains constant and seems just part of the erotically charged particular soup surrounding the figures. The misty quality of the light reduces the palpable reality of the objects depicted, so that everything seems at one remove and dreamlike, yet at the same time it intensifies sensory experience for the viewer because it seems that vision itself has become tactile. We might think about this as the diffusion of sensuality in that there is a transfer of effect from the object to the visual medium.

The hammer, chisel and brush along the base of the plinth allude to touch and penetration, though no contact between artist and statue is shown. Indeed there is a very profound equivocation about the making of this sculpture. We see a transition from marble to living flesh, but the pots of water, the clammy atmosphere and the wrapping cloths over the windowsill, also to some extent the suggestion of wrapping and unwrapping in the sculpture itself, drapery held aside and the overlapping, bandage-like forms of the sculpted hair, suggest the modelling of clay.[14] This introduces a powerful motif which brings death into question, and we recall the libellous suggestion of the mixing of blood and clay in the Woolner poem. Marble

to flesh is a one-way narrative, based on opposition. Clay to flesh is part of a circular story (dust to dust), based on supposed identity of substance. And it brings in an element which may be one reason that this series is so compelling: that of the unwrapping of a corpse. I would suggest that this theme of the corpse as ready-made sculpture, sculpture as ready-made consort, acts to preclude penetrative union between sculptor and artwork. Instead we are given a kind of celibate adoration. Furthermore it works against the notion of the cutting of the female form and associated intimations of castration. The important thing here is the integral form which offers such a comforting aid to disavowal.

We might think of the two middle paintings as statements of the equivalence between eroticised creation and miraculous procreation, and then see the first and final paintings of the series as affirmations of the enclosed circularity of this satisfactory identity of functions. The pictorial sequence, like a sculpture, is in the round. The composition is reversed to produce symmetrical enclosure, the open door to the world outside is moved left to right, the sculptor now faces in the other direction. Centrally the figure of the sculptor and that of the sculpture mirror each other, their eyes almost meet in the second canvas. They are matched in size, in orientation, in an erosion of marks of sexual differentiation. It is a curiously androgynous presentation of virility – and the substitution of the goddess for the sculptor, and/or sculpture, seems quite logical. We have a love of self which verges on narcissism, androgyny which does not necessarily move into homoeroticism.

Masochism

The looping of narrative is one feature picked out by Deleuze in an essay of 1967 on masochism.[15] Deleuze argues that a hold-all notion of sadomasochism should be abandoned. In this essay, entitled 'Coldness and cruelty', he is concerned to show that masochism is a distinct phenomenon. He investigates the characters, subject positions and narrative devices in the fiction of Von Sacher-Masoch and contrasts them to those in De Sade. De Sade's novels deal with characters in pursuit of an anarchic primary nature, beyond the real, and of absolute negativity. They offer obscene descriptions of violent scenarios that are multiplied and accelerated. Von Sacher-Masoch deals with characters who operate within the structures of disavowal, rather than seeking universal negation. In these fantasies of masochism repetition does not drive the narrative forward but suspends it in a time-loop. Instead of a drive to actualisation, a dream-like state is produced in which the real can be disavowed. For the masochist pleasure is infinitely deferred and pain is accepted as the condition for this future promise. There is a repetition of scenarios where action is frozen, so that the immobilised victim is caught at the moment of anticipation – seeing the raised whip – or the threatening stance of a torturer frozen like a statue. The theme of coldness refers to this freezing of action but also to the emotional temperature. There is no frenzy in masochistic fantasy but an impassive dispensing of punishment by the torturer, and a relinquishment or postponement

of pleasure on the part of the subject. This is a mark of the strategy of disavowal that is fundamental to masochism. The disavowal of castration proceeds by the investment of the female figure with a compensatory phallus. Deleuze argues that the structure of disavowal carries through into the disavowal of pleasure itself. Hence the subject feels pleasure but relinquishes it. There is also a corresponding disavowal of the (male) subject's own masculinity. Deleuze identifies the theme of the androgyny or hermaphroditism of the subject and explains this as the suspension of the self's virility in disavowal.

Gibson's patrons

At this point my discussion shifts to another formulation of artistic identity – one that emerges in the biographical and autobiographical writings concerning the sculptor John Gibson. I am drawing on a biography by Lady Elizabeth Eastlake, published in 1870 and a later work of 1911 by Thomas Matthews.[16] Both were based on autobiographical fragments left by Gibson. For the sake of brevity I will draw these sources together; they were both in agreement that Gibson had genius.

Gibson's genius was projected as a wild and untamed force at odds with the modern world and polite society. My focus here is one particular aspect of this, not his brusqueness with important patrons, nor his inability to interpret railway timetables, but the gendering of artistic creativity and the erotics of art making as they appear in the life or lives of Gibson. Gibson's inner force is connected with his virility: he is represented as amorous and yet continent. Rome is a reservoir of the erotic for him. He verges on passion in relationships with a series of powerful women, starting with the haughty female models in Rome and then with a string of lady patrons: Mrs Huskisson, Mrs Sandbach, Mrs Robinson, Queen Victoria and Elizabeth Eastlake herself. All these patrons offer close friendship, worldly wisdom and access to cultivated society and cultural matters. His own background was humble. His father was a market gardener and Gibson originally only spoke Welsh. Originally unlettered, Gibson never became fully cultivated. When he came to write his autobiography he depended on friends to take it down from dictation or to correct the syntax and phrasing of his own rough jottings.

The pattern in the biography is unmistakable. We are presented with a series of relationships which are all more or less eroticised. The female figures are locked into a relationship of beneficent domination *vis-à-vis* the sculptor. The erotic undercurrents are at their plainest in the edition of Gibson's life published in 1911, assembled by Thomas Matthews. He includes a number of incidents and friendships that are omitted in Eastlake's work of 1870. In particular there is an intimate friendship with the patron Emily Robinson. A passage from one of her letters describes a relationship where the term 'purity' signals non-consummation, but the special closeness is said to exceed even that between a mother and son. Gibson's account of his first meeting with her dwells on her beauty and the perfect Grecian cast of her nose and chin. He says 'the moment I was in her presence I felt as if I

were fixed to the ground and she stood still as a statue, beautiful and noble. In silence she advanced putting forth both hands; so did I.'[17] There is a response bordering on religious worship for female beauty; the women take on the aspect of Gibson's own sculpted goddesses. The moment of rapt contemplation renders both Gibson and his object of worship immobile, and then there is a dream-like moment of symmetrical movement. In his correspondence with Mrs Robinson, we are told, Gibson's handwriting came to resemble hers so closely that their scripts were eventually indistinguishable. Again the theme is one of symmetry, and that of the sculptor being lent the words, or the culture, of the woman, here very literally in the form of the handwriting. There might even be a form of symmetry at work in the blush remarked upon by Mrs Robinson in her comment on their first meeting: 'I did observe your emotion very soon, for when you spoke to me you changed colour.'[18] She surely resembles Venus, a goddess later to be most notorious in Gibson's oeuvre when he colours his statue, the *Tinted Venus* (Figure 47), a faint shade of pink. Here the sculptor's blush anticipates the tinting of his Venus.

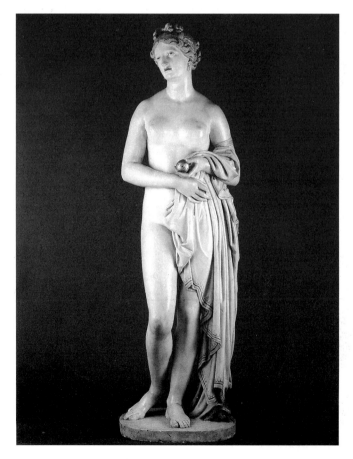

47 John Gibson, *Tinted Venus, c.* 1850, marble.

Gibson's statues

Gibson took on the young American sculptor Harriet Hosmer as a pupil. Eastlake`s comment on Harriet Hosmer, that in her Gibson 'may justly be said to have raised a monument to himself',[19] takes on an added significance if we consider the powerful females in his life to function both as his own sculptural creations, and as the classical goddesses imaged in his sculpture. This takes us back to a third category of female figures inhabiting the biography, after the passionate models and the intense women patrons. Gibson is set up in opposition to the figures he sculpts, and to some extent to the ancient sculptures he admires. In his own work he is shown as having a special rapport with the figures of Venus and Cupid. Venus and Cupid are modelled together and separately. Cupid is sometimes a winged curly-headed baby, at other times an adolescent or pre-adolescent boy. An important project was *Love Disguised as a Shepherd* (Figure 48). Eastlake refers to an imaginary conversation that Gibson had with Eros while contemplating this statue, but considers that it 'draws too much on the marvellous' for insertion. The interview is recorded in the Matthews volume, however, and the first and most striking feature of the passage is the infusion of desire into Gibson's prayer.

> Oh Eros canst thou disguise thy celestial countenance, or conceal thy ambrosial locks which wave luxuriantly round thy feminine shoulders? Thy little hands are too delicate for a shepherd, and so are those lovely limbs – will not thy god-like steps betray thee?[20]

Desire is evidently conceivable in relation to this feminised male figure, but I would suggest that there is so strong an identification between Gibson and Cupid that this is a kind of thrilling to the eroticised self rather than a straightforwardly homoerotic alternative to the fixation we see elsewhere on powerful female figures – because of course the coercive figure of Venus is not far away.[21] The interchangeability of the gender identity of the self is conditional on the subordination to a specially endowed female. In the imaginary conversation with Cupid the

48 John Gibson, *Cupid in Disguise / Love Disguised as a Shepherd*, c. 1840, marble.

theme of androgyny is quite explicitly addressed. Cupid tells Gibson, 'No sculptor should presume to represent me without being aware of the peculiarity of my nature and form which is androgynous'. Cupid calls on Gibson to colour the statue rather than leaving it in white marble as it is: 'when the Graces tie up my little top-knot which they, as well as my mother always make me wear they will never suffer those white locks'. The curling hair does seem to be an indicator of the identification set up between Gibson and Cupid. Venus is said to be looking for him, and has offered a kiss as a reward for anyone who finds him, but Cupid is inclined to be rebellious and runs off to meet Gannymede. He thinks that Venus might increase the number of kisses on offer. The goddess is benign but he acknowledges that punishment is as likely an outcome as reward. This rather extraordinary conversation, with its invocation of the option of male–male sexual love and its overriding consciousness of a controlling mother is perhaps easier to interpret in the light of the sections of the biography dealing with the *Tinted Venus*.

Gibson claimed that he wanted to give his Venus 'purity, sweetness, dignity and grace'. Rather than produce a monotonous cold object he decides to colour the stone, thus bringing her a little closer to life. This makes it possible for him to fantasise that she really is the goddess and that she has appeared to him.

> Here is a little nearer approach to life – it is therefore more impressive – yes indeed she seems an ethereal being with her blue eyes fixed upon me. At moments I forgot that I was gazing at my own production: there I sat before her, long and often. How was I ever to part from her?

The long-drawn-out, enraptured contemplation might be said to extend to four years, during which Gibson kept the statue in his studio in Rome and failed to deliver it to the Prestons of Liverpool who had commissioned it. The ire of Mrs Preston was provoked, producing a response from Gibson that aligns the statue and this angry lady patron: 'the truth is I cannot screw up my courage to send away my Goddess. It is almost as difficult for me to part with her as it would be for Mr. Preston to part with you.'[22] Gibson is fixed in a guilty and enamoured stance of worship. Time stands still and reality is suspended as he plays Cupid to his Venus. We recall his forceful mother who, in the early pages of Eastlake's biography, beat him for not telling the truth and insisted that he believe in his dream of going to Rome. We recall his total commitment to posterity in whose favour he will sacrifice everything else in life, and for whose approval he waits with something akin to anticipation: 'that praise which I most pant for is that which I am never destined to hear, for it is that which posterity may give'.[23]

Passion and law

In their efforts to give us Gibson the genius his biographers, in collusion with Gibson himself, show us a subject in erotic thrall to overlapping female entities, all of whom stand for art and beauty. Hovering between marble and flesh, earth and

heaven, coldness and warmth, dispensers of punishment and reward, these muse-like females operate as phallic mothers in relation to a gender-ambivalent son. They play the role of dominatrix to his masochist. I think it is clear that patterns emerging within Gibson's biography point to a specifically perverted form of erotic fantasy. We can recognise instances throughout the history of artistic biography of the use of a rudimentary notion of sublimation in which the artist's passionate nature is contained and channelled into his work to produce work that is more intense. Here we have a version in which that curbing of passion is thematised in terms of domination and submission. In the process there is a reversal of gender roles. The phallic mother comes to stand for law and culture within Gibson's life or lives. She stands for truth and for the discipline of classical form, and for the power of language. I would like to quote a passage from Deleuze.

> It is therefore surprising that even the most enlightened psychoanalytic writers link the emergence of a symbolic order with 'the name of the father'. This is surely to cling to the singularly unanalytic conception of the mother as the representative of nature and the father as the sole principle and representative of culture and law. The masochist experiences the symbolic order as an intermaternal order in which the mother represents the law under certain prescribed conditions. She generates the symbolism through which the masochist expresses himself. [24]

This is to say that within the particular conditions of masochistic fantasy the symbolic is associated not with the father but with the mother, and this is because the father has been expelled or expunged as a reference point.

The links with the peculiar temporal structure of the Burne-Jones work should be apparent. The symmetry which places decoration above narrative, and which produces an ambivalent gender identity for the artist/subject seems to be the symmetry of masochistic disavowal. The pleasures of this fantasy, then, are not those of realisation, of the grasp of the object, of destructive penetration, but of the regressive movement to the oral satisfactions of the pre-Oedipal moment. But this is an oral mother who also takes on the punishing functions exercised within the Oedipal regime. The subject can be reborn as lover and child of the mother only if the Oedipal power to punish by castration is taken from the father and exercised against the father, or as Deleuze argues against the representative of the father in the masochist's self. This makes possible a fantasy of the prospect of being at once reborn to the mother and achieving incestual union with her. This is not to say that submission and subordination are thematised in this fable of a chaste but libidinal artist in quite the way they are in the life of Gibson. However, Burne-Jones's Pygmalion is trapped in a stifling atmosphere, mesmerised and rendered incapable of action. Themes of birth and conjugal union are confusingly overlaid. These motifs find an echo in some more explicitly violent imagery that we see elsewhere in Burne-Jones's oeuvre. *The Wheel of Fortune*, from 1875–83, has a circular motion in which the male subject is the half-languid, half-ecstatic subject of punishment. *The Depths of the Sea* of 1886 is interesting in terms of the airlessness and the claustrophobia of the Pygmalion series.

Burne-Jones's remark about it when trying to borrow a tank with rocks from another artist is somehow revealing of the preoccupation with a subordinated male subjectivity: 'My picture isn't to be Rhine maidens – it's a chap in a pickle but I lack the pickle jar'.[25]

Gibson and the corpse

The question of the corpse-like coldness of the dominatrix is one that allows us to follow themes across from Burne-Jones's series to Gibson's life. I have spoken about the indications that Galatea, zombie-like, is a resurrected corpse. This ties in with an incident in Gibson's life, omitted by Eastlake, but included in Matthews's, where as a student Gibson was the sleep-in studio assistant to a sculptor. One night a cadaver for study was left in the upstairs studio and he slept in the room below. He gives a long account of the terror he felt. The corpse was female, and middle-aged, with streaming dark hair, half-open eyes, and a relaxed jaw showing her teeth. As he lay in his bed he imagined that the corpse had come to life, and started to think that he heard her moving around upstairs. He describes his sleeplessness and the turmoil of feelings that he experienced: 'feelings which I could not account for – fear – no – no, no fear'.[26]

The description of the set of features is repeated item for item at the end of this account, hair, eyes, open mouth, teeth, and brings to mind the features of his most celebrated sculpture the *Tinted Venus* and Gibson's own description of her blue eyes fixed upon him. The tinting is what brings the dead classical to life in Gibson's view of his work, and the faint glow might be thought partially to warm the chilly marble. Von Sacher-Masoch's paradigmatic dominatrix is a Venus in Furs. Southern and northern, classical and medieval, enveloped in fur to warm her marble-like chilliness she encompasses a number of contradictions. The Pre-Raphaelite Burne-Jones, working in an era of classical revival, self-consciously codes his work as simultaneously medieval and classical. The indeterminate space of fantasy is an impossible magical past, where contradictions are suspended. For Gibson the magic is in the transformation of the classical by the infusion of colour. My contention is that in both cases the magic depends on the elaboration of masochistic fantasy.

This chapter has juxtaposed two mid-nineteenth-century discussions of artistic creativity. Burne-Jones, the painter, chooses to present the sculptor Pygmalion, while Gibson, the sculptor, and his editors/biographers seek to explain his decision to add colour to the sculpted figure, to stray into the territory of painting; in each case there is a contradiction betweeen painting and sculpture that is suspended. In his powdery, claustrophobic interior scenes Burne-Jones lends painted narrative the fixity of stone while Gibson is seen to encounter inanimate forms (of classical sculpture, of his own sculpture and of the cadaver) and to effect a partial reanimation through the apprehension of colour. I have identified a number of ways in which these presentations of the artist work around the suspension of contradiction. The

contradictory qualities of the media are suspended, as are the contradictory time-frames of past and present, and the contradictory associations of medieval and classical. In the wake of these matters of style and allusion come the questions of psychic positioning, as we see the suspension of the contradictions between pleasure and pain, and life and death, and the possibility of gender ambivalence in the artist himself. The absolute that remains is the dominatrix: the mother with switch in hand, Venus, posterity or art itself. I started by referring to the 1870s Aesthetic Movement context of Burne-Jones's experiments with mood and the suppression of narrative. My argument has been that there is a masochistic inflection to his engagement with the decorative. Similar traits are evident in the biographical presentations of Gibson that were produced, published and reworked over a much longer historical period, one that spans the greater part of the nineteenth century. The subject position adopted by Burne-Jones (in his surrogate Pygmalion) is neither unique to himself nor solely characteristic of late Pre-Raphaelite, or Aesthetic Movement work. However, I think this example does give us terms in which to assess the claims for the autonomy of art in the modern period. The development of the aesthetic philosophy of 'art for art's sake' in the latter half of the nineteenth century could be seen to provide a cultural home for the specifically perverse formation that I have been tracing.

Veiling Venus: gender and painterly abstraction in early German modernism

Shulamith Behr

In a previously unpublished watercolour and gouache of a *Life Class c.* 1906–14 (Figure 49), the Russian-born artist Marianne Werefkin gave some insight into her attitude to the practice of painting or drawing from life.[1] Within a windowed, light-filled studio, an exotic array of creatures – among them a secretary bird, a lion and a monkey – are depicted on an elevated dais, a location traditionally reserved for unimpeded viewing of a nude model, whether male or female. A woman artist, seated in the lower right corner, is portrayed in action focusing on this spectacle. Her status as an artist appears to be questioned, as the gaze of the viewer objectifies the curvacious body. Werefkin distances herself from this dilettante, the so-called *Malweib* (female painter), whose increasing presence in the public sphere was so unfairly caricatured in magazines of the time.[2] Yet, while bordering on parody, the sketch deserves further scrutiny. The dangers of mimesis are alluded to by the inclusion of a serpent in the foreground, separated from the illusory sphere of Eden. The monkey, too, offering the fruit (a knowledge of good and evil), is a loaded signifier. While the artist is tempted to 'ape' or mimic nature, such an indulgence is invested with carnal and erotic associations. For Werefkin, the denigration of vision was crucial to the pursuit of an abstracted, inner world of art. Her theoretical renunciation of the body also signalled a certain discomfort in engaging in the staged scenario of female nudity, a subject of equal significance in academic, secessionist and avant-garde circles in the early twentieth century.

The tropes of avant-garde practice – the male artist, the studio and the nude model – have been the substance of immense critical scrutiny. The implied domination or control of the model as the object of the male gaze has been central to understanding the historical role of the male artist within the hegemonic structures of patriarchy.[3] While an emphasis on the overt sexuality of their models may have transgressed social mores, the vanguard's aligning of images of women with nature and the 'primitive Other' suggests that contemporary discourses on gender and colonialism converged in the study of the nude.[4] Yet, in early twentieth-century Germany, the promotion of bodily revitalisation through nudity had its reformist

elements.[5] This theme was central to the thematic orientation of the *Künstlergruppe Brücke* (Artists' Group Bridge), founded in Dresden in 1905.

In his *Chronik KG Brücke*, or *Chronicle of the Artists' Group Brücke* written in 1913, the artist Ernst Ludwig Kirchner characterised the early years of their studio practice as follows:

> Here [in the studio] there existed the opportunity to study the nude, the foundation of all pictorial art, in free and natural motion. From our drawings according to this foundation there developed a communal sense that we should derive the inspiration for our work from life itself and should subordinate [ourselves] to its direct experience.[6]

The significance associated with the study of the female nude as the 'foundation of pictorial art' and as the 'matter' that bound the group in communal practice can be corroborated by the predominance of the motif within their respective oeuvres.[7] Their attempt to create an art of directness and authenticity pointed to an informed

49 Marianne Werefkin, *Life Class*, *c.* 1906–14, gouache on paper.

rejection of academicism. As architectural students at the Technical College in Dresden, as Peter Lasko has shown, the *Brücke* would have had the benefit both of exposure to traditional artistic values and of the changes triggered by educational reform in the visual and environmental arts during this period.[8] Moreover, the town's expanding network of sanatoriums and health resorts as centres for outdoor bathing and natural medicine meant that it was not surprising that they developed their subversive ideas about uninhibited and anti-bourgeois lifestyles within this environment.[9]

This introduction serves to highlight the discrepant views held on the relevance of traditional studio practice in early German modernism. Whereas for members of the *Brücke* drawing from the model constituted an affirmation of their attempt to unite the praxis of art and life, for Werefkin, though academically trained, the process had become unnatural and yet alluring. While attempting to dispense with the physical motif of the nude, she nonetheless negotiated the issue of eroticism central to avant-garde practice. The excursus above, moreover, raises the problem of gendered authorship in depicting the eroticised female body – paradigmatically the figure of Venus within an academic tradition. However, this chapter follows a less familiar path in accounts of early German modernism by focusing on theories of expression pertaining to the body among those artists who aspired to abstraction. This was more apparent in the circle of the *Neue Künstlervereinigung München* (NKV), or the New Artists' Association of Munich, an exhibiting society formed in 1909, and the *Blaue Reiter* group founded in late 1911. The Russian Wassily Kandinsky, his partner Gabriele Münter, the expatriate Russian woman artist Marianne Werefkin and her companion Alexej Jawlensky, were among the members of this Association, which was founded at Werefkin's residence in Schwabing, the artists' and intellectuals' quarter of Munich. The membership of the group was drawn from the performing, literary and visual arts, testifying to the make-up of the social milieu.[10]

Of these four artists, Kandinsky and Werefkin were the most vocal in proclaiming their dedication to a form of spiritual abstraction in their theoretical treatises. Indeed, Werefkin's largely unpublished journals *Lettres à un Inconnu* (*Letters to an Unknown*), written between 1901 and 1905, predated the publication of Kandinsky's text *Über das Geistige in der Kunst* (*On the Spiritual in Art*) in 1912.[11] In their writings, both artists showed themselves to be imbued with the legacies of Romanticism, either directly through their reading of Goethe's *Farbenlehre* (*Colour Theories*, 1810), for instance, or indirectly, via their acquaintance with symbolist aesthetic theory, be it French, German or Russian. They both embraced philosophical idealism, proclaiming the superiority of art over the phenomenological, and employed in their writings the rhythms and cycles of nature as metaphors for the organic and yet autonomous laws of art. In seeking abstraction, the notion of boundlessness, the desire to transcend physical and spatial containment had its correlative in their differing emphases on denying the body. Clearly, their suspicion of scientific positivism meant that traditional canons of beauty or anatomical proportion would have been anathema to them.

'Veiling Venus', the theme of this chapter, serves as a frame in which to explore a range of gendered subjectivities in light of the hypothesised relationship between Expressionist painterly abstraction and male sexual fantasy. My choice of the infinitives 'to veil', 'to mask' or 'to hide' introduces relativist terms that span a variety of metaphoric substitutions for the body in representation. In turn, this secretive language references authorship, not only in relation to genealogy and to traditional practice, but also in relation to the body of the artist. As will be shown, in his approach towards abstraction, Kandinsky's theorisation of the erotic relied on the binary oppositions of the male and female terms and a stabilisation of the masculine creative self. For Werefkin, however, this pursuit resulted in a destabilisation of her persona and an exploration of the double-gendered self. Such were the risks for the dedicated woman artist that 'to take the veil' or to declare celibacy seemed to be a necessary prerequisite in order to preserve her integrity. In both instances, their representations of the body involved a projection of sexual fantasy on to the 'Other', be it a 'primitivist' or orientalist conception of the female nude in Kandinsky's representations or, in the case of Werefkin, a focus on the androgyne.

Before considering selected examples from their oeuvres, however, it is instructive to examine the perceived status of the avant-garde artist in late Wilhelmine Germany, at a time when both official reaction and critical reception viewed the modern art world as a foreign element and an attack on the social body. The ideas of the physician and dilettante art historian Max Nordau were well publicised through frequent reissues of his well-known book *Entartung* (*Degeneracy*), published in two volumes between 1892 and 1893.[12] In this text, he employed terminology evolved within the legal and medical disciplines, equating modern stylistic tendencies with criminality and hysteria. Indeed, in dedicating his book to the Turin-based anthropologist and psychiatrist Cesare Lombroso, Nordau declared that 'degenerates are not always criminals, prostitutes, anarchists and pronounced lunatics; they are often authors and artists'.[13]

The deviant body of the modern artist

As the artists' and students' quarter of Munich, the Schwabing area had its own Bohemia. Within the censorious milieu of a Roman Catholic majority, the Dionysian rituals pursued within the circle of the writers Karl Wolfskehl and Stefan George achieved notoriety. Apparently, the promiscuous lifestyle of the token woman in this group, the writer and artist Franziska zu Reventlov, went unmolested by the police only by virtue of her aristocratic descent.[14] The *Lex Heinze*, a law that ratified state control over prostitution, and which came into effect in 1900, was equally repressive in its censorship of art and the press.[15] According to Peter Jelavich, in the early 1890s, the police, under Catholic pressure, forced a Munich art dealer to remove a reproduction of the Venus de Milo from his display window.[16]

The divergent responses to these elements of social fragmentation were
debated in the proliferating journals and magazines aimed at specific factions
within the bourgeoisie. In one such publication dedicated to topical events and
cultural intervention, the broadsheet *Simplicissimus*, the illustrator Thomas
Theodore Heine commented on the cliquishness of the decadent *Moderne Dichter*
(*Modern Poets*) in Munich (Figure 50): 'We can't associate with him because he
doesn't have a hereditary disease.' Heine's wit lambasted the intellectuals' self-
conceit as well as the gluttonous Philistine in the foreground. Wearing long coats
with narrow waists, the bodies of the male poets were feminised and stereotyped.
The language of the new sciences of eugenics and sexology, while increasing an
understanding of sexuality and the body, was readily accepted by popular culture
as a vehicle for stigmatisation.[17]

Similarly, in a vignette in the journal *Jugend* (*Youth*) (Figure 51), Countess
Otolia Kraszewska seized on the deviancy of modern creative women in her carica-
ture *Das dritte Geschlecht* (*The Third Sex*). The salon hostess asks: 'What are you
currently writing, Miss Lillienstiel?' She replies 'A novel' – 'What is it called?' –
'Messalina' – 'Historical then?' – 'No, hysterical'. Within the cosy domesticity of

50 Thomas Theodore
Heine, *Modern Poets*,
in *Simplicissimus*, 6,
1901–2

Frauenkultur, afternoon tea in the proverbial salon, the illustrator satirised the manliness of the female novelist, the promiscuity of the loose woman and the primness of high society women.

Evidently, the 'constitutive constraints' on modern artistic identity in Germany were applicable to both genders; however, societal constructions of the terms 'woman' and 'artist' were mutually exclusive. According to the art historian and critic Karl Scheffler in his treatise *Die Frau und die Kunst* (*Woman and Art*), published in 1908, 'atrophy, sickliness or hypertrophy of sexual feelings, perversion or impotence' resulted from women's rejection of their biological destiny.[18] In seeking to become original artists, they turned into a defeminised 'third sex':

> If she forces herself to be artistically creative, then she immediately becomes mannish. That is to say: she cripples her sex, sacrifices her harmony and with that surrenders out of hand every possibility of being original ... Therefore, since woman cannot be original, she can only attach herself to men's art. She is the imitatrix par excellence, the empathizer who sentimentalises and disguises manly art forms ... She is the born dilettante. [19]

The norms of masculinity and femininity which operated as regulatory practices set up a binary opposition in which sexual identity could be 'performed' only in relation to heterosexuality. Such dualities plagued Werefkin sufficiently for her to have invented a third self, as she noted in her journal in 1905:

51 Otolia Gräfin Kraszewska, *The Third Sex*, in *Jugend*, 31, 1900.

> I am not cowardly and I keep my word. I am faithful to myself, ferocious to myself and indulgent to others. That is I, the man. I love the song of love – that is I, the woman. I consciously create for myself illusions and dreams, that is I the artist … I am much more a man than a woman. The desire to please and to pity alone make me a woman. I hear and I take note … I am neither man nor woman – I am I.[20]

Significantly, this resolution coincided with her resumption of painting in 1906 following a ten-year period of non-production.

As in the case of Werefkin, Kandinsky arrived in Munich in 1896. Aged thirty at the time, he turned down the offer of an academic appointment in Russia in order to pursue an artistic career. Yet Kandinsky's specialist training in Russian peasant law and ethnography was to prove of enduring significance to his artistic development. He therefore spoke with some authority when, in 1901, he wrote one of his first essays on art criticism 'Critique of the critics'. Written for a Russian audience, the review inveighed against the vogue inspired by Nordau:

> I would point out that in the irresponsible and ignorant hands of Max Nordau, 'art' reviews are being engulfed by references to the sickness of the modern school in art, to the psychological derangement of contemporary artists, whom our critics cleverly propose placing in *Kunstkammern* (*curio cabinets*), panopticons and lunatic asylums.[21]

Kandinsky obviously found it unacceptable to apply the language of criminal anthropology to contemporary artists. However, this was only a preview of what was to follow.

By 1910, in view of the pronounced abstraction in his works, critics branded Kandinsky's exhibits 'decadent', considering them the result of pathological madness. Furthermore, the reviewer G. J. Wolf stated that he would have fewer objections if Kandinsky's *Composition 2* were labelled a '"Colour sketch for a Modern Carpet" … on a par with "designers"'.[22] In aligning his works with applied art, critics drew attention to their 'lesser' feminine, craft-like associations, an accusation that Kandinsky repeatedly attempted to counteract in his theoretical writings. Evidently, societal expectations of masculinity were adequately surveillant to compel the modern artist into a rhetoric or facade of manliness. It is therefore interesting to consider whether Kandinsky's abstraction and dematerialisation of the body can be construed as an attempt to subvert the mastering or controlling gaze, an observation that will be evaluated in the next section.

Kandinsky and 'veiling' the body

In Munich, Kandinsky studied art for two years in the private studio of the Slovenian painter, Anton Ažbè. Subsequently, his strenuous efforts to gain entrance to the Academy strike one as rather surprising, given the circumstances of his age and aspirations. Though he failed in this attempt at first, he was eventually accepted by Franz von Stuck for his masterclass in painting at the Academy. While extremely gracious in praising his tutors, Kandinsky was dismissive of the

academic practice of drawing from the model. In his *Reminiscences* of 1913, he recalled this aspect of his training in the studio of Ažbè as a 'constraint' upon his freedom that turned him into a 'slave' and he continued:

> I arrived in Munich with the sense of being born anew ... but I quickly encountered a constraint upon my freedom that turned me into a slave, even if only temporarily in a new guise – studying from the model. Two or three models 'sat for heads' or 'posed nude'. Students of both sexes and from various countries thronged around these smelly, apathetic, expressionless, characterless natural phenomena, who were paid fifty to seventy pfennigs an hour. They drew carefully on paper or canvas trying to represent exactly the anatomy, structure and character of these people who were of no concern to them ... and they spent not one second thinking about art.[23]

The references to feeling enslaved by the model constitute an ironic inversion of academic artist's mastery or control over the human body. This is accompanied by an unconcealed aversion to the model, the purity of art having little to do with this routine activity in the confines of the studio.

It is understandable therefore why, apart from in his student sketchbooks, portraiture or paintings of the nude are rare occurrences in Kandinsky's oeuvre. Where they do occur, as in his *Nude* of 1911, the figure, which is set against a landscape, is rendered featureless, weightless and transparent, a mere cipher without substance.[24] Rather than depict the body naturalistically, Kandinsky proposed to hide its physical aspects through the combination of what he termed 'veiling' and 'stripping'.[25] Veiling entailed an unexpected blurring of the image while stripping involved reducing the body to a partial outline. Peg Weiss's suggestion that the figure derives from Kandinsky's knowledge of Russian folklore is compelling.[26] Apparently the female image could have had its origins in Rusalka, one of the animating spirits of nature who, according to various legends, is endowed with incredible sensuality and danger. She is said to lure men into her sphere and often to tickle them to death.

Yet viewed in the context of its display at the *Neue Secession* in Berlin in November 1911, the work could be considered a counter-statement to the avant-garde discourse on the eroticised female nude. Though it shared in the primitivist aesthetic of the women/nature paradigm, its lack of legibility contrasted forcefully with the canvases of the *Brücke* group, who also contributed works to this venue. 'Veiling' the body, then, was feasibly a means of ameliorating the artist's discomfort in being controlled by its presence. Kandinsky admitted as much when he evaluated his development in light of contemporary practice:

> I always found it unpleasant, however, and often distasteful, to allow the figures to remain within the bounds of physiological laws and at the same time to indulge in compositional distortions. It seemed to me that if one physical realm is destroyed for the sake of pictorial necessity, then the artist has the artistic right to negate the other physical realms as well. I saw with displeasure in other people's pictures elongations that contradicted the structure of the body, or anatomical distortions, and knew well

that this would not and could not be for me the solution to the question of representation. Thus, objects began gradually to dissolve more and more in my pictures. This can be seen in nearly all the pictures of 1910.[27]

While dispensing with the figural element, Kandinsky still retained the subject as a means of theorising the process of representation. This is clarified in an unpublished essay that annotates the theme of the painting *Arabisches III* (Arabs III), also subtitled *Schöne Orientalin* (Beautiful Oriental Woman), of 1911:[28]

> Here I wanted to inform myself of the trivial: two Arabs (a young one and a villain) fight over a beautiful woman. Their movements are trivial. The beautiful woman is trivial. Nearby the beautiful woman a water-jug is placed.[29]

Notwithstanding Kandinsky's efforts to diminish its importance, the subject of villainous Arabs battling over a lustful, reclining woman, reminiscent of an odalisque, is saturated with colonial discourses on the exoticism of the Orient.

As Kandinsky would have it, though, the spectator should not respond to this 'veiled' narrative, but to the pictorial elements as an expression of abstract content – the independence of line from colour and the saturated accents that cause the eye to move across and into the purity of the white, primed surface. Here Kandinsky used the control over the female body as a metaphor for his encounter with the canvas. Turning again to his *Reminiscences*, we find his description of this 'struggle':

> I learnt to struggle with the canvas, to recognize it as an entity opposed to my wishes and to force it to submit to those wishes. At first, it stands there like a pure, chaste maiden, with clear gaze and heavenly joy – this pure canvas that is itself as beautiful as a picture. And then comes the imperious brush, conquering it gradually, first here, then there, employing all its native energy, like a European colonist who with axe, spade, saw penetrates the virgin jungle where no human foot has trod, bending it to conform to his will.[30]

Typical of sexual fantasy, this passage seeks not only to summon imaginary objects of desire but also to stage its primal *mise-en-scène* in no uncertain terms.[31] Dismissal of or contempt for the relevance of the body is accompanied by unwitting acknowledgement of its fascination and attraction as a source of lost pleasure.[32] We are aware that the painting *Schöne Orientalin* was one of those precious paintings which accompanied Kandinsky on his return to Russia in 1915 and which was hung in his apartment in Moscow until his departure in 1921.[33]

This description of the intuitive creative process locates Kandinsky's practice within Expressionist theory. In this gender-specific rhetoric, the victory of 'spirit' over female 'matter' was viewed in utopian terms. Barbara Wright has interpreted this conceptual framework as the Expressionist response to German feminism. Faced with the threat of social upheaval, the 'new man' literally demanded the 'eternal' woman as his complementary opposite.[34] The polarisation is suitably conveyed in Paul Hatvani's essay 'Spracherotik' (Erotic language/speech): 'And there

the artist exists after all in eternal opposition to the matter, this female matter is the source of the Expressionist artist's higher masculinity.'[35] Manipulation of this 'female matter' – be it word, paint or canvas – was used metaphorically to connote the sexually charged fantasy of autonomous creativity.

As Rosemary Betterton has observed, the critical language used to describe the making of abstract painting has come to signify 'a gendered relationship between the active (masculine) painter and the passive (feminine) canvas'.[36] Yet, as mentioned earlier, in aligning Kandinsky's works with applied art, critics drew attention to their feminine associations.[37] His masking, hiding or dissolution of the body harboured the potential to subvert the dominant discourse of patriarchy. Alerted to this possible destabilisation of the symbolic order, Franz Marc, in his defence of the second exhibition of the NKV in September 1910, made a hasty retreat and credited this 'new definition of painting' with the status of high art.[38]

Werefkin and embodying abstraction

Werefkin's theorisation of the erotic can be found in her corpus of treatises written between the years 1901 and 1905. The journals *Lettres à un Inconnu* were written in French, the language of elite circles in Tsarist Russia. These offer an insight into the vicarious nature of her relationship with Jawlensky. He was younger than Werefkin and she provided economic support and intellectual directives for her erring and more intuitive partner. The manner of addressing the inner, unique self acknowledges the impact of Charles Baudelaire's intimate journals *Mon coeur mis à nu* (*My heart laid bare*, 1869), the title itself suggesting that she thought of her diary as an 'altar ego'. It was as if it were a mirror in which she could narcissistically address her 'larger self', her 'beautiful one', her 'unique'. At times she contrasted the disillusionment that she experienced in her one-sided relationship with Jawlensky (referred to as J. in the *Lettres*) with the steadiness and reliability of her inner love:

> I love J. more than ever … but he has so little tenderness for me … My eyes turn towards the other whom I also love so strongly, so tenderly, with such youth, towards that love where there is only us both, where all is so personal, where me, I am me, without any reasonable reason. I listen to the tender words. I see the eyes that adore me, I feel the caress that was never dared to be given. My self is divided in two. My self struggles. And to restore my harmony, I throw myself recklessly into my art.[39]

Werefkin's well-known *Self-Portrait* of *c.* 1910 (Figure 52), appears to draw on the sustenance of this inner rapport in presenting the woman artist as visionary prophet. Here, Werefkin has no need to wear her womanliness as a mask in order to hide the possession of masculinity.[40] The appropriation of the masculine creative force, perceived as her inner love or unique one, was the vehicle through which she was able to explore the autonomy of artistic formation.[41] This subversive agent assisted her efforts in overcoming her marginality, not only in relation to bourgeois

52 Marianne Werefkin, *Self-portrait*,
c. 1908–10, tempera on paper mounted on
board.

society but also as a woman practitioner seeking status in male-dominated avant-garde circles. Evidently, although the depiction of the self-image would appear to be one of the most solitary acts of the creative process, the artist as model, the portrait evinces the most complex interaction between private and public life.[42] In this instance, it is instructive that Werefkin exhibited this work as one of three paintings contributed to the third exhibition of the NKV in 1911.[43]

While the *Self-Portrait* serves to illuminate the limits of Werefkin's homage to painterly abstraction, the critical language used in developing a theory of art making differs substantially from Kandinsky's writings. No longer do we encounter the rhetoric of phallic mastery and penetration but a rapport that speaks of 'caresses' and 'tenderness', almost as though the creative process involves a fantasy of sexual foreplay before the divided self attains unity in the work of art. Though the self-portrait draws on the example of van Gogh in its three-quarter-view pose, summarily cut-off composition and swirling brushstrokes, its crafting is more layered, materially speaking.[44] When Werefkin resumed painting in 1906, she revised her understanding of what constituted high art and abandoned the earthy tonalities of oil painting on canvas. Preferring to use the saturation of colours and the quicker drying processes of a mixed technique on paper or board, she achieves effects of transparency and opaqueness within the limited flexibility of the tempera medium. Impasto-like features are reserved for the areas of most concentrated attention, around the startling red eyes and knitted brow.

In negotiating her public self-image, Werefkin appears to have circumvented the tradition of objectifying the female body. This does not mean that she was unaware of the mastering gaze. Indeed, she commented with insight on this matter in her journals: 'I have caught upon myself, upon my beautiful shoulders, some of the male gazes that call for a slap. I have seen artists treat with the same contempt the naked woman that aided them in their work as what the whites rewarded the Negroes [Sic.]'.[45] Here the discourses on gender, class and colonialism neatly converge in the study of the female nude. But it is in Werefkin's private works, executed in her studio or in her sketchbooks, that one finds nuances of her reservations

in this regard. In her *Portrait of Helena Nesnakomoff*, 1909 (Figure 53), the young Russian woman who served as a domestic and who cohabited with Jawlensky, the artist's discomfort with the theme is apparent. Though Werefkin trained in the Academy in Moscow in 1883 and photographs of her studio in St Petersburg in 1886 reveal that she was adept at painting studies of the nude, here the figure presents an anomaly.[46] The portrayal of the torso possibly evokes the 'body ideal' of the Venus canon and the deliberately unfinished hands and severed feet could be construed as traces of the 'body broken', a play on the fantasy of the damaged Venus.[47] One might also entertain the notion of the 'stunted Venus' in that, even though Helena was twenty-six years old at the time and the mother of Jawlensky's son, Werefkin emphasised the disproportion of the head in relation to the body and the concordant child-like appearance of the woman.

That Werefkin should attempt to de-eroticise the image of Helena could be interpreted in light of the artist's commitment to painterly abstraction. Rather than embodying the sexually active model, Werefkin chose to purify and veil the image in light of her own declaration of celibacy. After describing in detail her experiences

53 Marianne Werefkin, *Portrait of Helena Nesnakomoff*, 1909, gouache on paper mounted on board.

when assisting in a gynaecological examination of a woman after childbirth, Werefkin declared: 'Since then physical love has been a monster to me ... We who love art and who defend it against the public, we will defend love against this filth ... sanctify the chaste love the illusory love of the artist'.[48] While one has no way of verifying whether this disparagement of physical love or frigidity had a basis in actuality, one can ascertain that the metaphor of 'taking the veil', so to speak, served as a vehicle for self-integration of her physical and artistic personae.

54 Marianne Werefkin, *Androgene*, 1908–9, gouache.

Werefkin's pre-1914 sketchbooks reveal her attraction to the enticing interiors of brothels and an exploration of sexual fantasy. Undoubtedly, the impact of her second visit to Paris in 1905 and viewing of the launching exhibition of the *Salon d'automne* was a pivotal experience. Inspired by the works of Lautrec, the Nabis and intimists, she pursued themes of modernity derived from the extremes of social entertainment, from sophisticated salon, ballroom and soirée interiors, to scenes from popular culture – the circus, cabaret and low life. Within the context of the early twentieth century, the role of the *flâneuse* was a distinct possibility for the woman artist in observing the spectacle engendered by urban capitalism.[49] The small-scale sketches are more intuitively handled, as in Figure 54 which constructs an imaginary scenario of the worship of the androgyne, elevated above a kneeling male and female figure. In another drawing from the same sketchbook (Figure 55), the word 'Androgene' surmounts the representation of the body of the third sex, Werefkin signalling her fascination in underscoring the stigmata of the facial features.

The subversive implications of the androgyne enter into Werefkin's portrayals of *Ausdruckstanz* (Expressive Dance) and, in particular, inform her depiction of the Russian Jewish dancer Alexander Sacharoff. As a member of the New Artists' Association circle of artists, performers, musicians and critics, Sacharoff entranced initiated audiences with his choreographic

55 Marianne Werefkin, *Androgene*, 1908–9, graphite.

inventions. Largely the preserve of women dancers like Isadora Duncan, expressive dance rejected conventional ballet and relied on direct communication by means of streamlined bodily movement and gesture. Reviewers of Sacharoff's performances were frustrated by their inability to identify a 'character' as such. Judeaophobia at the time deemed it necessary to unmask the Jew by finding some immutable features of physiognomy, which Sacharoff's varied dance and costume failed to provide. Critics therefore saw the meaning of the performance as lying in the instinctual eroticism of the hermaphrodite figure, attributions of bisexuality to Jewish males invariably linking into the discourse on anti-Semitism.[50] In contravening the norm, Sacharoff was considered to have opened the 'sluice gate of anarchy'.[51]

As seen, Werefkin was drawn to the transgressive celebration of the third sex. Her position as a cultural producer meant that she was not immune to the debates on race and gender in seeking to give fixity to the physiognomic type. In the *Portrait*

56 Marianne Werefkin, *The Dancer Sacharoff*, *c.* 1909, tempera on board.

of Alexander Sacharoff of 1909 (Figure 56), the stereotype of Jewishness is reinforced by an introduction of the oriental dimension, stemming from Werefkin's interest in the Japanese print. As a counterfoil to her *Self-Portrait* (see Figure 52), which appropriated the masculine creative force, the portrait of Sacharoff gives reign to the flexibility of the 'female gaze' in embodying the eroticism of gendered and racial difference.[52] It was in the masquerade of the performance that sexual identity could be interpreted as fluid, and Werefkin laboured this ambiguity. This is apparent when we compare the alluring 'otherness' of Sacharoff with the masculinity of the posed studio photograph (Figure 57). Here, possibly the experience of dance (Figure 58) matched Werefkin's fantasies, the freedom of movement liberating the body from the regulatory constraints of the social and cultural discourse on gender identity and sexuality.

In tracing Werefkin's discrediting of traditional and avant-garde discourses on representations of the body – from the dematerialisation of the model in the *Life*

Class (see Figure 49), to the masquerade of the dance – it becomes evident that Expressionist painterly abstraction is not inherently the prerogative of male sexual fantasy. It is only the critical framework of modernism that has inscribed the woman practitioner as outside the realm of cultural practice. The nuanced veiling of the images, in particular that of the androgyne, operate as a 'reverse discourse' in demanding legitimacy or 'naturality'.[53] Notwithstanding Kandinsky's veiling of the human body, he nonetheless adopted theories of colour and form that sublimated but nevertheless reinscribed traditional metaphoric oppositions of masculinity and femininity. Although his process of abstraction can be construed as introducing strategies of resistance to the dominant discourse on figure-based painting, such counter-discourses themselves constituted new powers, knowledge and truths. Some measure of the success of Kandinsky's

57 *Alexander Sacharoff as Daphnis, c.* 1910, photograph.

agenda is the manner in which the rhetoric of the spiritual and the abstract have mystified and dominated modernist narratives over the century. The necessity for Werefkin to invent an imaginary realm of freedom in abstraction that would serve to integrate her conflicting personae have given voice to some of the most compelling reasons for reclaiming the territory of painterly abstraction for the woman artist in early modernism.

58 Marianne Werefkin, *The Dancer Sacharoff in Front of a Red Stage and Head, c.* 1909, gouache and graphite.

Deco Venus

Tag Gronberg

Goddess of beauty and of love, Venus appears in many guises; references to the classical goddess are confined neither to the past nor to the realm of high art. Whether in the form of a direct representation, or more elusively, almost as a vestigial after-image, traces of her presence can be found throughout visual culture. Operating sometimes as the idealisation of desire, sometimes as an alluring and destabilising force, Venus oscillates between the reassuring and the alarming. Indeed perhaps part of her compulsive appeal is that she can never be entirely the one without the other. It is the instability of Venus as well as her disruptive potential that I wish to invoke here by considering an instance where Venus emerges in a juxtaposition of painting with *art décoratif*, a confrontation of art with consumerist culture. What are the consequences of Venus stepping out from the ideal world of oil painting into the real world of the modern city? What happens when Venus presents beauty as both the timeless and the fashionable? In this chapter, Venus constitutes the means as much as the object of speculation. Her figure will, I hope, enable me to explore an instance of artistic identity or, rather, of two interrelated artistic identities, identities negotiated both in terms of gender difference and through art's complex relation to consumerism.

I focus my exploration on a photograph taken in 1925, an image which clearly bears the marks of fashion photography (Figure 59). Here two carefully posed mannequins show off the boldly patterned coats in which they are clad. The model on the left gazes directly out at the viewer and is positioned three-quarters frontally. The right-hand figure is seen from the back, but her gaze is similarly relayed to the viewer as a mirror reflection. The viewer is able to scrutinise the coats from the front, back and (thanks to the full-length mirror reflection) in profile. This concern with showing off clothing to best effect, as well as the models' evident awareness of their fashionably dressed bodies being put on (and putting on a) display, are symptomatic of fashion photography. However, this photographic *mise-en-scène* with its showcasing of chic clothing involves more than the pose and configuration of the mannequins. These three views of the coats are framed, put into parentheses almost, by two paintings. On the left we see a large (almost larger than life-size) painting of a female nude, standing on a bridge in front of the Eiffel

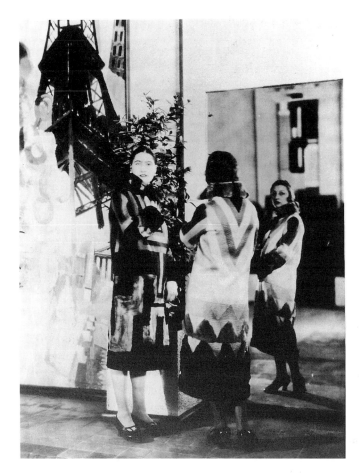

59 Models in coats designed by Sonia Delaunay posing in Robert Mallet-Stevens's entrance hall of the French Embassy at the 1925 Paris *Exposition internationale des arts décoratifs et industriels modernes*, photograph.

Tower; on the right (in mirror reflection) a vertical abstract panel. Painting, it seems, has been put at the service of *la couture*: the zig-zag struts of the Eiffel Tower and the rectangular forms of the abstract panel function to emphasise the geometric patterning of the coats. These references to engineering technology and to abstraction, we might infer, underscore the modernity, the up-to-date quality, of the fashion designs.

This is a fairly complex photograph, then, in its knowing play with mirror reflections and in its juxtaposition of high art with fashion. It is complex and suggestive too in the way that the devices of fashion photography intersect with artistic iconography. Here the mannequins appear in a three graces configuration, or alternatively (in the iconographically related theme), as the three goddesses – Juno, Minerva and Venus – who figure in the *Judgment of Paris*.[1] The three goddesses motif puts the viewer in the position of the shepherd boy Paris, the position of choosing; aesthetic judgement is thus elided with consumer choice. The suggestion of a 'judgment of Paris' is reinforced, at the level of a pun, by the depiction of

the Eiffel Tower, emblem of the city of Paris. This might lead one to reconsider the painting as a kind of urban birth of Venus, with the goddess of love newly washed into existence by the waters of the Seine. There are hints of Venus here, but are these anything more than the arch and witty play of fashion promotion? Can such allusions to Venus help us to understand the significance of this confrontation between high art and consumer culture?

In order to formulate an answer, it is necessary to identify the components of the photograph in somewhat more detail. The coats, designed by Sonia Delaunay, formed part of her exhibit at the 1925 Paris *Exposition Internationale des Arts Décoratifs et Industriels Modernes* where she shared a stand with the couturier and furrier Jacques Heim. The photograph of mannequins modelling Delaunay coats was taken in one of the exhibition's major displays, the group project organised under the auspices of the *Société des Arts Décoratifs* to design a sequence of rooms for

60 Robert Delaunay, *Ville de Paris. La Femme et la Tour*, 1925, as exhibited in the French Embassy at the 1925 Paris Exhibition, photograph.

a French Embassy.[2] Each of the embassy rooms was under the supervision of a different architect, who was responsible for choosing furnishings as well as suitable works of art. The Delaunay mannequins are shown in the Embassy's entrance hall, a room designed by the architect Robert Mallet-Stevens and adorned with two paintings: Robert Delaunay's *Ville de Paris. La Femme et la Tour* (Figure 60) and a non-figurative panel by Fernand Léger.[3] (Although the choice of Robert Delaunay's painting, with its dominating image of the Eiffel Tower, seems perfectly in keeping with the embassy theme, the effective 'Frenchness' of this work is a subject to which I shall return.) This was one of a number of photographs of Delaunay's fashions taken in the Exhibition grounds, several of which involved displays designed by the same architect. There are photographs of mannequins in dresses made up in Delaunay textiles modelling in Mallet-Stevens's exhibition garden, with its bizarre abstract concrete trees (made by the Martel brothers), while others show Delaunay's geometrically decorated car and fashionable *automobilistes* posed outside Mallet-Stevens's *Pavillon du Tourisme*.

It is important to realise, however, that such showcasing of women's clothing

through exhibition architecture and design was not merely in the interests of fashion photography. Women's fashion played a significant role in the ambition of the 1925 *Exposition des Arts Décoratifs* to project an image of a specifically French modern decorative art.[4] The discourse of fashion – by which I mean journalistic writing, but also photography and other modes of promotion and advertising – could be used strategically: particularly the insistence on the up-to-date quality of French *haute couture* as well as the long-standing reputation of Paris as world leader in women's fashion. Femininity, and in particular the public display of well-dressed women, was thus accorded a crucial role in the definition of a 1920s modernity. In this context, the women's outfits and accessories designed by Sonia Delaunay played an important role. Trained as an artist, Delaunay had turned to textile and fashion design during the First World War as a means of supplementing the family income.[5] By the mid-1920s she was well known as a designer and her work was covered in upmarket journals such as *Vogue*. At the 1925 Exhibition, Heim and Delaunay presented their joint display in the form of a 'Boutique Simultanée' – a shop, but an exclusive one which derived its name from the Parisian artistic avant-garde. This reference to fine art practice validated Heim's fashions, reaffirming the 'high' status of *haute couture* and its difference from the world of mass production.

The displays and photographs of Delaunay's fashions and accessories at the 1925 Exhibition clearly signalled a connection between luxury commodities and artistic practice, but the precise nature and function of this connection warrants further scrutiny. Claims that the fashion designs of her *Atelier* were somehow inspired or influenced by avant-garde painting were undoubtedly useful at the level of marketing, as was the case for example with Raoul Dufy's textile designs. However, deploying the term *Simultanée* in the 1920s as a brand name for such goods raises a number of issues, particularly around the question of artistic identity. The Delaunays often represented their practices in terms of a joint venture, the product of two symbiotically related yet clearly differentiated temperaments.[6] In one of Sonia Delaunay's retrospective accounts, this relationship is described – or perhaps better, symbolised – through one of Robert's paintings of the Eiffel Tower. Here the painting marks a betrothal, promise of the imminent consumation of love and desire, but also (given that the gift is recollected retrospectively) the threshold of a shared artistic venture. Sonia Delaunay claimed: 'I brought him the light of the Orient, he burned with all the stars of the New World.' By 1913 the Delaunays were using a letterhead incorporating the image of the Eiffel Tower, a reference undoubtedly to the importance of this motif in their work – recurring in Robert Delaunay's paintings, and prominent in Sonia Delaunay's illustrations (executed in 1913) to Blaise Cendrars's poem, *La Prose du Transsibérien*.

Certainly for Robert Delaunay, the Eiffel Tower, more than any other motif or subject matter functioned as a kind of marker for the different stages of his artistic development. Sonia Delaunay's story of the engagement present concludes: 'He showed me the *Ville de Paris* and said "This marks the end of an era"'.[7] The large-scale *Ville de Paris* (Figure 61), exhibited at the 1912 *Salon des Indépendants*,

61 Robert Delaunay, *La Ville de Paris*, 1912, oil on canvas.

juxtaposes the Eiffel Tower with a group of female nudes configured as a Three
Graces group. This juxtaposition, the significance of which has been variously inter-
preted, can operate at different levels.[8] The pieced-together quality of the picture,
incorporating a range of motifs and styles from Delaunay's earlier work, suggests a
kind of self-reflexive consideration of the artist's own practice (as evidenced by his
dating of the work on the canvas, 1910–11–12). At the same time, the drawn-back
curtain at the top left (a recurring device in Delaunay's work) further underscores
the nature of painting as representation. This might help explain to some extent, the
(for some commentators) incongruous insertion of the Three Graces into a modern
cityscape. My concern here, however, is not with correct iconographical interpreta-
tion, whether in connection with the female nudes, the Eiffel Tower or the painting
as a whole. I am interested rather in what, in the case of the Delaunays, such imagery
might reveal concerning issues of desire and artistic identity.

 For those close to Robert Delaunay, it was not unusual to use references to the
Eiffel Tower as a means of signifying his practice in terms of desire. Sonia Delaunay
declared that 'The *Tower* was his emancipating muse, his Eve future.'[9] Here the
Tower signifies a conflation of artistic muse with Eve, of inspiration with seduction,
artistic idealisation with fall from grace. Of course Eve as 'Eve future' is a particu-
larly modern permutation. Like the Biblical Eve this is Woman produced for man, a
female figure who fulfils the (male) fantasy of bypassing maternal procreation. But
'Eve future' evades even divine intervention, being a mechanical product manufac-
tured by one man for another. Unlike the unruly earlier Eve, 'Eve future' was

programmed for thought and speech according to the desires of her owner. But in the end even this tamed and modernised version proved alarming: her master finds that the desire aroused by 'Eve future' exceeds, is not contained by, his awareness of her mechanical origins.[10] Given the Eiffel Tower's associations with invention and modernity, it is perhaps not surprising to find the Parisian monument cast as 'Eve future'; the effect is, at one level, to underscore the avant-gardism of Delaunay's work. I leave as an open question, for the moment, the implications of identifying an artistic practice in relation to a desire so inextricably bound up with anxiety.

Another femininising of the Tower occurs in Blaise Cendrars's 1924 essay 'The Eiffel Tower'.[11] Dedicated to Sonia Delaunay, this recounts Robert's fascination with the subject which became so closely identified with his practice. Set in the years 1910 to 1911, this is a story of a shared exploration, poet and painter stalking their prey. It begins with a visual pursuit. Cendrars recovering from a broken leg lies in a hotel room with his leg in traction. Cendrars and Delaunay (who apparently visited each day) had the city delivered to them by the hotel window as a ready-made picture, a still life. This ostensible domestification of the cityscape, however, proved fraught – at least for the painter. Cendrars describes Delaunay 'always haunted' by the Tower, grappling in sketches with the new subject matter in order to 'subdue it'. Avant-garde artistic endeavour is characterised not only as 'advanced' but as a kind of battle against 'silence and oblivion'.[12] As it develops, the whole tenor of this narrative changes; Cendrars's leg heals and he goes off with Delaunay on a series of urban excursions. The Tower, described as having 'a unique attraction for all kinds of people', particularly lovers (who ascended its heights in order to be alone) and honeymooners from the provinces and abroad, is explicitly eroticised. No longer a struggle with oblivion, the artistic confrontation with the Tower now takes the form of an extended flirtation. However visually elusive – stiff and perpendicular viewed from one position, a corkscrew from another – we know from Cendrars's claim that this 'flirtatious' encounter will end in the painter's mastery. Such descriptions of the act of painting in terms of a male eroticised gaze and conquest were nothing new, traditional even. What is striking in Cendrars's account (as in Sonia Delaunay's allusion to *Eve future*) is the implicit connection of such eroticism with a fight against loss of control ('death') as well as the equation of the Tower's visual enticement with feminine allure.

The 1920s, when Cendrars's piece was written, was a problematic period for Robert Delaunay. There were financial problems (one of the reasons for Sonia Delaunay's design practice), but also the difficulty of defining a distinctive position within the post-war Parisian avant-garde.[13] Robert Delaunay's work at this time included portraits and a number of paintings which explicitly recapitulated themes from his pre-war oeuvre (the 1925 *Femme à la Tour*, for example, was dated 1910–25).[14] This 'return' to figurative painting (already begun during the war) was of course not unusual at the time of the *rappel à l'ordre*. But unlike other artists (such as Picasso, Braque or Léger) Delaunay did not have the security afforded by the financial backing of a dealer.[15] It thus fell to Delaunay himself to find ways to

assert the continued relevance of Simultaneous painting in its post-war manifesta-
tions. Sonia Delaunay's designs were recruited and energetically promoted as
proof of the sustained modernity of Simultaneity. Photography played an impor-
tant part in this attempt to define a post-war artistic identity. Many photographs
were made of Sonia Delaunay's fashions and those showing mannequins posi-
tioned next to paintings by Robert Delaunay were obviously intended to help
market Simultaneous designs internationally as well as in France. The 1925
Ambassade photograph, for example, was published in 'lifestyle' magazines such as
the Australian *The Home* and the German *Das Leben*.[16] But similar images had
already appeared in Parisian art journals. A photograph of three models posed in
Robert Delaunay's studio (Figure 62) was used in a November 1924 issue of the
Galerie Bernheim Jeune's house magazine *Le Bulletin de la vie artistique* as part of
an 'Enquête' (survey) entitled 'Chez les cubistes'.

If Robert Delaunay invested a considerable amount of time and energy in pro-
moting his wife's designs, this was as much in the interest of creating an identity for
his own practice as in procuring sales for her textiles and fashions. The *Bulletin de
la vie artistique* photograph, for example, strategically juxtaposed pre- and post-
war motifs from Robert's oeuvre as the backdrop to the fashion designs.[17] Certain
of Robert's portraits too, such as that of Madame Mandel (1923) (Figure 63), show
a conjunction of what appear to be pre-war paintings with 1920s Simultaneous
designs.[18] Such juxtapositions of fine art with consumer goods (however exclusive)
were far from straightforward or simple. The aim was to demonstrate a desirable
aesthetic continuity between art and design while at the same time avoiding any

62 Robert Delaunay's
studio, 1924,
photograph.

63 Robert Delaunay,
*Portrait of Mme
Mandel*, 1923, oil on
canvas.

implication that Simultaneity now functioned exclusively as decoration or orna-
ment.[19] Of her 1920s textile designs, Sonia Delaunay claimed that: 'For me they
were and remained color scales, which were ultimately the purified conception
underlying our painting.'[20] The quote comes from an interview published in 1967.
Over twenty-five years after the death of Robert, this was a point in Delaunay's
career where she had reasserted her status as a fine artist. But what artistic identi-
ties were possible for her during the 1920s, the period when she was most active as a
designer?

The 1924 *Bulletin de la vie artistique* photograph includes Sonia Delaunay as one
of the three models, draped in a length of Simultaneous fabric, sitting just below the
Eiffel Tower motif in one of her husband's best-known paintings (a version of the
Homage à Blériot). Photographs depicting both 'his' paintings and 'her' textiles, of
Simultaneity displayed on the female body as well as on canvas, had already been
made before the war. Indeed a photograph dated 1913 (Figure 64) shares with that of
1924 both the presence of Sonia Delaunay as model and the (smaller) *Homage à
Blériot*. Whereas the 1924 photograph has Sonia Delaunay gazing out at the viewer,
inviting admiration, the 1913 image shows a much more self-absorbed figure.
Standing before a small table, Delaunay gazes thoughtfully at her reflection in not
just one, but in two superimposed mirrors. This scenario – carefully staged around a
piece of furniture reminiscent of that centrepiece of the feminine toilette, the
dressing table – suggests an intense, almost excessive narcissism. At the same time,
however, it functions as an assertion of artistic identity. Not only the fashionable

64 Sonia Delaunay in the Delaunays' apartment in the rue des Grands-Augustins, Paris, 1913, photograph.

outfit (the collage elements on Delaunay's jacket) but also the collaged bookcovers (visible on the dressing table and mantelpiece) were produced by her. And the verticality of her body is echoed visually by the *Transsibérian*, hanging on the wall behind. Here, her works predominate over his. The *mise-en-scène* of the domestic interior in which Woman admires her fashionable appearance has been translated into the artist's contemplation of herself in and through her works. This photograph does not convey the 'private' realm of the home but rather the woman artist's engagement with the Parisian art world (Simultaneous painting and poetry), an engagement not restricted to the level of decoration (her jacket) but involving also the mind. The bookcovers stand as evidence of artistic and intellectual activity. Delaunay claimed that her Simultaneous book illustrations and covers were always inspired by the literature she admired: 'I rebound books that I loved'.[21] These were not 'frivolous' novels but works by the literary avant-garde.

During the 1920s (and at the time of the 1925 Exhibition) several photographs were published showing Sonia Delaunay clad in a Simultaneous outfit sitting next to *her* easel or worktable (Figure 65). Despite the allusions to female authorship involved with such photographs, the status of the woman artist was not necessarily construed as equivalent to that of the male painter. Similarly, the presence of Sonia Delaunay and/or her designs alongside Robert Delaunay's canvases did not necessarily infer two artists engaged in an equal partnership. Indeed it could be argued (with some justification) that such imagery was no more than either a means of enhancing the cachet of Simultaneous textiles (by emphasising a connection with 'art') or a reference to women's suitability as practitioners of the applied arts. Even the substitution of easel for dressing table might as easily produce a derogatory as a positive validation of the woman artist's work. Women's painting was often dismissed as the product of feminine narcissism; according to one critic for example, women artists worked on a *toile* in the same manner as on their *toilette*.[22]

To get a greater sense of how a woman artist's work might negotiate, and indeed exploit, such characterisations of femininity and the decorative, it is worth considering in a bit more detail the significance of collage in Sonia Delaunay's practice. In a 1956 article on the Delaunays' use of collage, Sonia Delaunay

stressed the importance of collage technique for her post-war fashion and textile designs.[23] Although Delaunay mentions that in 1913 she showed work at an exhibition of Cubism, the examples cited in this article (which included reference to her pre-war bookcovers as well as interior and fashion design) seem a world apart from the Cubist collages produced by Picasso and Braque during 1912 and 1913.[24] In comparison to these with their witty use of the ephemera of urban mass culture and their implicit debunking of craft and artistic skill, Delaunay's various forms of collage risk appearing trivial and conspicuously lacking critical edge. Indeed it is difficult to keep the word 'decorative,' with all its perjorative associations, at bay.

I would argue, however, that it is precisely the reassertion (in an aesthetic context) of collage as decoration which is suggestive. Take for example this little story of 'origins' which Delaunay was fond of recounting:

> About 1911 I had the idea of making for my son, who had just been born, a blanket composed of bits of fabric like those I had seen in the houses of Russian peasants. When it was finished, the arrangement of the pieces of material seemed to me to evoke cubist conceptions and we then tried to apply the same process to other objects and paintings.[25]

Such references to the inspiration of peasant or folk art were of course quite common in various avant-garde artistic circles (particularly in Russia). Nor is my aim to pursue an exploration in terms of the artist's (auto)biography; what I find intriguing here is the association made between collage and motherhood. Considered as a crib cover for a baby, collage takes on a vivid new life. It stands for maternal protection, thus implying aspects of the maternal gaze: pleasure in seeing the traces of the squirming body below, anxiety as the surface is scrutinised for signs of breathing. Other instances of Delaunay's work with collage in the years before the First World War are similarly thought-provoking. For example, the outfits she produced for herself and Robert to wear to the *Bal Bullier* in 1913 (which were, she claimed, made up of fabric remnants procured from Robert's tailor). Delaunay's Simultaneous dress prompted Cendrars's poem 'On her dress she wears a body', revealing in its acknowledgement of the desiring male gaze elicited by this fabric collage, even as it translated into abstraction the dancing female body. The point here is

65 *Un coin de l'atelier de l'artiste*, 1925, photograph in *Les arts plastiques*, May 1925.

that Delaunay displayed Simultaneity on her body not simply for the purposes of male admiration but also (and perhaps primarily) to make an artistic statement to the assembled poets and artists frequenting this dance hall, as well as to others, such as the Italian Futurists.[26] At one level, these *souvenirs* with their focus on motherhood and feminine self-adornment, relegate Delaunay's practice to the category of 'applied arts', as inferior in status (albeit complementary) to that of avant-garde male artists. At the same time, however, reclaimed for art as an overtly decorative practice, collage reveals a potential for the expression of female subjectivity and artistic identity. This concept of a decorative, animated collage is the antithesis of modernist interpretations such as that of Clement Greenberg with its insistence on collage as a means of transcending decoration.[27]

Delaunay's geometrical embroidered coats of the 1920s were a distinctive permutation on the collage technique; no longer made up of 'remnants' they were constructed with pieces of specially produced embroidery, sometimes alternating with sections of fur.[28] These were manifestations of collage produced through explicit reference to the female body, collages in which a sense of luxury and of tactility were paramount. Unlike earlier, pre-war garments such as the 1913 Simultaneous dress worn almost as an aesthetic manifesto or the waistcoats and scarves made for artist friends, such coats were the product of Delaunay's commercial design practice and as such took their place as commodities within the Parisian fashion industry. This status as commodity is confirmed in a striking logo which appeared sometime around the mid-1920s showing Delaunay's name 'Sonia' superimposed on the Eiffel Tower in the form of an undulating female nude (Figure 66). The logo (which formed part of advertisements for Simultaneous fashions) merged the Delaunays' famous Simultaneity trademark with references to Paris as world centre of women's fashion and luxury shopping. The curvaceous typography evoked both the ideal female nude of painting and the female consumer, a meeting of the world of art with the realm of commodification. Potentially effective as a marketing device, such close proximity of the ideal and the venal could nonetheless prove problematic.

This is perhaps the moment to return to the photograph of the entrance hall at the 1925 Exhibition's French Embassy, to its

Sonia Delaunay

19, BOULEVARD MALESHERBES, 19

INTRODUIT L'ART VIVANT
DANS LA VIE QUOTIDIENNE

Comme en son stand SIMULTANÉ
que vous admiriez l'an dernier sur le
pont Alexandre III, naissent, en son
atelier, de ses découvertes picturales

TOUS LES ÉLÉMENTS DU CADRE
MODERNE OU VOUS DÉSIREZ VIVRE

Manteaux Chapeaux
Echarpes Meubles
Sacs Tapis
Robes Etoffes

DELAVNAY

66 Advertisement for Sonia Delaunay's designs and fashions, 1925–26.

staging of Simultaneous painting and fashions – and to Venus. In certain versions of the Judgment of Paris story, the shepherd requests that the goddesses disrobe in order that he may better come to his decision.[29] The whole point of the *Ambassade* photograph, on the other hand, is of course that the models who present themselves for scrutiny are stylishly dressed. Taking a cue from the coats in which the women are clad, let us consider another Venus: Venus in furs. As Julia Emberley has pointed out, during the twentieth century the fur coat has emerged as the quintessential feminine fashion commodity.[30] Already prior to this, however, the fur coat had functioned as privileged symbol of women's self-adornment. Whenever Wanda, the female protagonist of Sacher-Masoch's 1870 novel *Venus in Furs*, drapes herself in fur (whether in the form of a luxuriant coat or jacket) it is as an expression of woman's power as seductress; the fur is described as a fishnet, a means of enticement and capture. The fur is a frame, setting off woman's beauty, but it also takes on some of the tactile and olfactory qualities of that beauty – woman's 'gentle warmth' and 'warm perfume'.[31] Masoch's Venus in furs is a 'cruel' Venus: 'symbol of the tyranny and cruelty common to beautiful women'.[32] His narrative involves a drama of surrogate mastery: woman is powerful only by consent, or rather in acquiescing to the insistence, of her male companion. *Venus in Furs* represents woman powerful 'despite herself'.[33] And this power is easily revoked (as indeed occurs with the novel's conclusion).

At one level Masoch's story functions to assuage male anxieties provoked by the physical attraction of women, the fear that as in the case of Samson, men are somehow always betrayed by the women they love.[34] It plays to the fantasy that however vulnerable to desire, ultimately man can always reassert control. This may explain the novel's frequent references to paintings such as Raphael's *Fornarina* and Titian's *Venus with Mirror*, both of which depict women in fur. Raphael's picture – its sitter traditionally identified as the painter's mistress – suggests not only the evidence but also the idealisation and hence transcendence of the artist's desire for his model. Such connections between fur (and in particular fur-clad women) and the art of painting resonate beyond these narrative confines; indeed the representation of fur has often been invoked as proof of artistic mastery. According to Richard Davey's 1895 *Furs and Fur Garments*, for example, the depiction of fur garments revealed the skill of 'great painters' such as Raphael, Titian, Holbein, Giorgione, Tintoretto, Peter Porbus and Rembrandt. Raphael's 'Violinist' and 'the grand portrait of his mistress, the Fornarina' are 'so marvellously painted that one can examine [them] with a magnifying glass'. As for Rembrandt, 'all know how [...] tenderly he elaborated the shading of every undulation of the surface of his sables'.[35]

The painter's 'tender' elaboration of the canvas surface is again the focus in John Berger's discussion of Rubens's *Hélène Fourment in a Fur Coat*, a depiction of the artist's wife. Berger's writing reveals a telling identification between the desiring male gaze of the critic with that of the painter, a desire expressed not only through reference to the picture's subject (the female body draped in fur) but also by the canvas's painterly surface. In *Ways of Seeing* Berger analyses the painting's

composition in terms of Fourment's 'sexual centre', a centre 'hidden' by her fur drape. But this centre is obscured only to be displaced.[36] A process of displacement necessitated because, as argued by Hubert Damisch in his book *The Judgment of Paris*, the female genitals are 'hardly ever judged to be beautiful' and 'beauty must therefore be attached to certain secondary sexual characteristics',[37] and to feminine adornments such as fur. Given its appearance and its proximity to the female body a 'dark fur coat' is a particularly apt, even obvious, 'metaphor for her sex'.[38] But in the context of painting, this may prove to be a case of one metaphor masking another. After all, not only 'her' coat but also 'his' brush is made of fur and what we are invited to admire are the physical traces of that fur, the 'tender elaboration' of the artist's brush which produces an enticing 'surrounding darkness in the picture'. Masterpieces depicting the fur-clad female nude can thus function as an assertion of male subjectivity, and in particular of a masculinity in control. One of the fascinations of *Venus in Furs* is that however much it accords with such fantasies, the novel also reveals the precarious status of this masculinity. Wanda is represented as unwholesomely narcissistic, enacting love scenes for the mirror's reflection and eventually seducing a young artist in order to compel him to paint her portrait as fur-clad dominatrix. Here even the transcendent power of painting is subsumed to the force of woman's 'cruel' narcissism.

Let us go back again to the *Ambassade* photograph. Shortly before the Exhibition opened, the Embassy was the site of what the press deemed a *scandale*. The authorities had apparently disapproved of the two paintings in Mallet-Stevens's *halle* and insisted on their removal. This provoked some support for Delaunay and Léger and the pictures were eventually reinstated. It is not altogether clear what had proved unacceptable to the authorities. According to one explanation, there were doubts as to whether any form of art associated with Cubism was appropriate as a means of representing France abroad. Others claimed that the nude figure in Delaunay's picture displayed a 'sexe trop visible'.[39] We can probably never know exactly what caused official disapproval and to all extents and purposes, it is not important to know. Nevertheless, the comments on Delaunay's female nude remain provocative; was there, after all, an element of the scandalous involved here? From the *Ambassade* photograph, with its explicit confrontation of art with fashion, we might well infer that the problem lay not with, or in, the painting but rather in its context of display – an exhibition so closely identified both with the decorative and with the female consumer. Such an emphasis on women's fashion threatened to produce an explicitly venal femininity. In an environment dominated by fashion, it was perhaps difficult for the female nude to maintain its status as ideal beauty, as the idealisation of male desire.[40] When Venus in fur brushed against her painted counterpart, it suddenly became possible 'to see her sex'.

Femininity – woman as both artist and consumer – played a crucial role in the Delaunays' joint Simultaneous project, particularly during the post-war period. The potentially destabilising consequences of this lay not merely in the close

conjunction of art with consumerism, but in the possibility of slippage between the two; not only by revealing (high) art's status as commodity but also by presenting the alarming prospect of woman's artistic prowess. The imagery of the Eiffel Tower, emblematic of Simultaneity, is symptomatic of this instability. Apollinaire's poem *Zone* (1913) refers to the Eiffel Tower (symbol of Paris) as a shepherdess, thus hinting at the possibility of a female judge, a femininity capable of aesthetic as well as abstract discernment.[41] In his 1924 essay Cendrars referred to Eiffel's great engineering feat as rising above Paris 'slender as a hatpin', a reminder of the status of Paris as world capital of feminine fashion and women's consumption.[42] The hatpin, part of the Parisienne's arsenal of self-adornment, looms suddenly in all its inherent ambiguity as both decoration and weapon of self-assertion, a startling counterpoint to the painter's brush and the poet's pen. (Prior to its characterisation as a hatpin, the Eiffel Tower had figured in Cendrars's poetry as Robert Delaunay's paintbrush soaked in light.)[43] In the case of the 1925 *Ambassade* photograph, it is again through the realm of fashion, with its evocation of a modernised Venus – a 'Deco Venus' – that we are alerted to the interests at stake (the potential as well as the risks) in Simultaneity's conjunction of *toile* with *toilette*.

The photograph stages a close proximity of painting with decoration, of art with commodity and it is in this proximity that we can locate the threatening aspect of Venus. On the one hand, the viewer of the photograph is invited to take on the role of Paris, in order to choose the most beautiful of these three modern goddesses. At the same time, it is possible to slip into the position of the female consumer, scrutinising her reflection in the mirror. As Anne Hollander has pointed out, the very act of looking into a mirror – an iconography intimately associated with Venus – presupposes the wish to create an image.[44] In this sense it is impossible entirely to disassociate such rituals of 'passive' female narcissism from an active desire for self-representation and authorship, from feminine subjectivity. Feminine narcissism and subjectivity play a part too in the Judgment of Paris scenario; Damisch reminds us that Venus tried to influence the shepherd boy's choice by offering him Helen, a woman judged beautiful in her own – Venus's – terms.[45] Rather than a contradiction of her ideal status as goddess, then, it is perhaps particularly in her venal guise as consumer that the scrutinising (and hence controlling) aspect of Venus is most apparent.[46]

9

Monsieur Venus:
Michel Journiac and love

Sarah Wilson

Greek anthropomorphism is the triumph of the imagination. Those marbles are the figures of the union of the sensible and the intelligible, but their gazes are of stone and blood does not beat in their veins.

(Marcel Pacquet, *Michel Journiac*, 1977)[1]

Man! That is Man!, He has beauty; I fear it. He is indifferent; I tremble. He is contemptible; I admire him! … I shall make him my master and he will twist my soul beneath his body.

(Rachilde, *Monsieur Venus*, 1977)[2]

Venus, the body in allegory, through whom we speak the name of love … Rachilde's *Monsieur Venus* (1882), reappeared in France in a handsome, Art Nouveau-designed paperback edition in 1977. A society that was already perturbed by sexual confusion on various social, literary and artistic fronts rediscovered this gender-twisting text written by the twenty-year-old Marguerite Eymery, self-proclaimed 'man of letters'.[3] In *Monsieur Venus*, the voracious heroine, Raoule de Vénérande, seduces a dimpled young painter, Jacques Silvert. His sister, Raoule's florist, doubles as a lady of the night. Raoule sets Jacques up in a studio with a Venus de Milo in the corner – so voluptuous in its fixtures and fittings he feels compelled to lick the castors of the furniture. Reversing the relations between the contemporary man-about-town and his mistress, Raoule – deliberately dallying with all the gendered elements of the French language – quivers before Silvert's beauty. She voices a shockingly forthright paean of desire for the male, if, at times, Jacques's gender seems ambiguous: even the small of his back is deemed worthy of a Venus Callipyge.[4] The sculptor and performance artist, Michel Journiac, certainly read and admired this narrative;[5] and, as I will argue, Journiac himself may be seen as the Monsieur Venus of 1970s Paris.

Writing on Journiac, Marcel Pacquet declared: 'One shouldn't hurry to castigate the impotence of the decadents, for their convulsions and their inaptitudes are

also our own.'[6] Of course, homosexuality and gender-crossing had preoccupied the Romantics, Symbolists and Decadents: it is, however, the mirroring of nineteenth-century with contemporary preoccupations – the republication of *Monsieur Venus* was symptomatic – which defines this particular moment in French intellectual history. Let us recall that Roland Barthes's famous text 'The death of the author' (1968) opens with the collapse of 'voice' predicated on the cross-dressed castrato of Balzac's *Sarrazine*, of 1830, further explored in Barthes' *S/Z* (1970).[7] In literature a whole new gay scene of writing was emerging; the veteran Jean Genet and powerful younger writers such as Pierre Guyotat created national scandals with their work.[8] Adding the fine arts to literature, publications such as Cecily Beurdeley's *L'Amour Bleu* (1977), illustrated the modes and manners of love from the ancient Greeks to Francis Bacon with arousing literary passages.[9]

Michel Foucault published his exemplary study of Herculine Barbin, the tragic nineteeenth-century hermaphrodite, in 1978, two years after *La Volonté de savoir* was published in Paris.[10] Following this first book on sexuality, he continued his encyclopaedic history of of the subject, despite a delayed publishing programme. It was in 1984 that *L'Usage des Plaisirs*, the second volume appeared, in which *aphrodisia* are defined as 'the works, the arts of Aphrodite' ... 'the aphrodisia are the acts, gestures and contacts that produce a certain form of pleasure'. Foucault concludes: 'Sexual behaviour was constituted, in Greek thought, as a domain of ethical practice in the form of *aphrodisia*, of pleasurable acts situated in an agonistic field of forces difficult to control.'[11] Not only is no sexual differentiation involved – *eros* being developed, of course, among men – but a concept of *aphrodisia* is elaborated which is prior to the personification of Aphrodite-Venus, before the obstacle of the female body, 'autopsied' by Journiac in 1972, and the notion of a third person as female deity presiding over the love encounter.

Already in *Monsieur Venus*, the Venus de Milo plaster cast has become the kitsch attribute of the *fin-de-siècle* studio cum boudoir; during the twentieth century the peculiar power of the armless torso provoked countless artists to homage and parody. In 1968, Gillo Dorflès's pioneering *Kitsch*, placed photographs of $37.50 *Black Aphrodite* and *White Aphrodite* casts and Venus de Milo garden ornaments in close proximity to classic texts on kitsch by Hermann Broch and Clement Greenberg.[12] By 1973, the exhibition 'The Venus de Milo or the dangers of celebrity' saw the apotheosis of Venus as an 'art' genre. Travelling from the 'Ready Museum' in Brussels – a conceptual 'museum without walls' – literally scores of Venuses moved to the Musée des Arts Décoratifs, Pavillon de Marsan, in the purlieus of the Louvre itself.

An exhibition review cited the Venus de Milo sweet-wrappers produced by the state shop in Moscow at the height of revolutionary Russian avant-gardism; the show displayed the classic Venus de Milo variations of Man Ray, Max Ernst and Salvador Dali of the inter-war period. In the catalogue, a photograph of Buster Keaton in drag, posing on a plinth, magnificently embodied the hermaphrodite 'Monsieur Venus'. This publication, almost a trade catalogue of Venuses in their twentieth-century manifestations, illustrated not only the Venus de Milo in advertisements for

Parfums Chantal, a variety of health, beauty and fashion oufits (Monsieur Venuses figured here too), but bras, tartan scarves, stamps (Greece and Paraguay), and more interestingly art packagers. 'Sculpture 2000' courses given with the assistance of the cast studios at the Louvre were also offered. The 'real' Venus de Milo was conspicuous by both her propinquity within the building and her absence from the exhibition. In the catalogue she was again represented through lack: invisibly boxed, concealed and escorted by menacing Japanese motorcycle police, accompanying her to the Tokyo international exhibition of 1964. The problem had become one of non-differentiation: 'Everything is grist to the mill of idols: the fake overwhelms the real which acquiesces or responds. The legend upsets history. In this torment, Venus de Milo ends up looking like Marx or Lenin, Marilyn Monroe like Chairman Mao, and Mona Lisa like the mannekenpis or Général de Gaulle. You can buy them for the same price in the Super Bazar, or win them with fishing rods at fairs.'[13]

A critical interest in kitsch, recalling, and indeed familiar with the vituperations of a Hermann Broch in the 1920s, was reborn in the 1960s. It coincided with the discovery for a new generation of artists of the Duchampian ready-made, *carte blanche* for a permissive age, whose eager response to American Pop Art was tempered with a European cultural and political cynicism. The dominant movement in 1960s Paris, Nouveau Réalisme, from the *bricolage*-based metal assemblages of Jean Tinguely to the sugar-coloured enlargements of contemporary idols or old masters by Martial Raysse, played on irony, recognition and the manifold pleasures of the ersatz. The Louvre again was a constant reference, with Raysse's *Amor and Psyche* after Gérard, Daniel Spoerri's assemblage with the Mona Lisa, or Niki de Saint-Phalle's own Venus de Milo which combined a feminist anger with transatlantic antagonisms, at the height of the Cold War (Figure 67). Niki shot at the Venus, who embodied all the 'old' European cultural values; bullets burst concealed bladders of red, green and brown paint under the goddess's draped plaster surface, in a New York theatrical performance of 1962, *The Construction of Boston*. Venus bled.[14]

Why, then, Journiac's *Venus de Milo Autopsy*, in the Louvre exhibition (Figure 68)? A work equally angry perhaps, but

67 Niki de Saint-Phalle, *Venus de Milo*, 1962, plaster of Paris on chicken wire.

68 Michel Journiac, *Venus de Milo Autopsy*, 1973, plaster Venus, skull, plasticised cloth, table and two stools.

'cold' rather than 'hot': Venus mutilated yet again, sliced off at torso level on a table, head and loins draped in white, acrylicised material, 'white shrouds, figuring what Christian morbidity has conserved from the luminous flesh of Hellenism'.[15] Two stools at her side, one supporting a severed hand, one a skull, transformed the installation into a vision of necrophilic voluptousness in the cell of a penitent saint.

Journiac's story is one of loss, intellectual discovery and religious struggle. It is extra-ordinarily poignant in its complexity, idiosyncracy and its spiritual dimensions, thus distinguishing him from his contemporaries: sculptors, such as Pol Bury or Annette and Patrick Poirier who exhibited in the Venus show, or contemporary performance artists in both France and America. Journiac's importance was recognised as deci-sive from the outset by the promoter of performance art in France, François Pluchart, yet he is absent from the annals of Anglo-American art history; he was French, he was a Catholic and there has been no real market in his works. He was also a homosexual intellectual whose contribution to 1970s debates around gender and psychoanalysis are fascinating; a Monsieur Venus, phallic woman and bride of

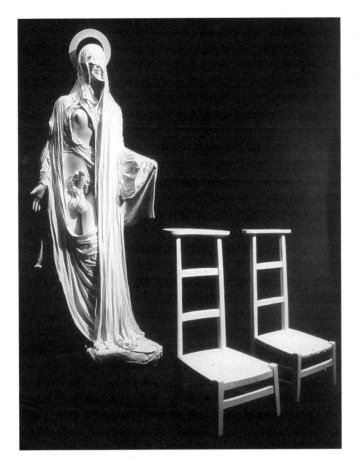

69 Michel Journiac, *Holy Virgin*, 1972, plaster of Paris and two *prie-Dieu*.

Christ. His bisexual sculpture, *Holy Virgin* (*Le Saint-V[i]erge*) (1972), a madonna with an erect penis played on the difference in French between *vierge*, virgin, and *verge*, rod or penis (Figure 69). It was, one could argue, a timely manifestation of the ancient Venus Uranius, the bisexual Venus surrounded with erect phalli.[16] Transcending an initial response of derision, Journiac declared it demonstrated that 'the transvestite is, beyond laughter … in the domain of the sacred'.[17] The sacred history of gender variant priests extends, of course from archaic times to the tradition of the Orphic Christ who fused pagan and Christian in a mystic union, into the modern period with Paul Gauguin's 'berdache' figures in Tahiti, or the avatars and practitioners of 'gay spirituality' today.[18] The dialectic between the kitsch aspects of Journiac's three-dimensional works, the emotional and the sacred in his performances, marks a flouting of categories which, in the wake of a Piero Manzoni in Italy, deserves serious critical attention.[19]

Born in 1935 to a relatively poor family, Journiac studied scholastic philosophy and theology at the Catholic University of Paris and aesthetics at the Sorbonne.[20] His vocation as a seminarist meant that he escaped conscription in the Algerian war,

teaching French literature instead in Damas, Syria. It was here that his calling to the priesthood was irrevocably abandoned. An intense and painfully repetitive letter to his superiors explains the discovery of his homosexuality at the age of seventeen, his discovery of Christ at eighteen. Branded *pédéraste* and *la fille*, he experienced the loss of his boyhood friends; he feared losing his parents' love. The letter is also a spritual and intellectual itinerary: the chance discovery of the writings of André Gide opened up a world of acceptance, a God of love, ratified by François Mauriac's description of an Algerian battered by the crowd as Christ: and hence Christ, the despised and rejected among men, as love itself. Journiac relates his exultation at the discovery of Nietzsche's rejection of the morality of the herd and its commonplace definitions of Good and Evil; Teilhard de Chardin's poems also strengthened his faith, and he was comforted by the existentialist heroes of Sartre and Camus. How disconcerting for him later to discover that these authors were vilified by the Church! The most unsurmountable religious problem was the seminary's emphasis upon Thomism with its exultation of reason beyond and above the individual will. Journiac sensed the impossibility of reconciling his private beliefs and sexual being; he found the discipline and communality of the seminary unbearably constricting compared with his former truant freedoms, roaming the streets of Paris as an unhappy adolescent.

Art was discovered on just such a walk – an exhibition of the works of Georges Rouault, for Journiac an exemplary instance of the transformation of ugliness and vice into beauty. 'Painting confirmed for me what Racine, Villon and Baudelaire had led me to discover. Art appeared to me as a means of salvation, as salvation itself, the only salvation possible. It was the project which could snatch the world and mankind from the absurd, via which the universe took on meaning.'[21] Yet the vanity of artistic, political or social production was manifest. Michel Journiac's art was therefore, first and foremost, a *vanitas*.

While early drawings of 1955-57 exist, the first work to be described at length by a critic was *The Neglected Wound* of 1963, contemporary with his spiritual crisis: a white painting (oil on panel), combined with bas-relief elements of wood and cloth, a white wax candle (penis) and a wound traced in black and coloured: the gash suggesting at once a bite, a bruising and a forest of entrails.[22] Later works of the 1960s, involving similar figures on a white ground seemed constituted of muscles and viscera, the flayed body *écorché à vif*. Here, faces or intimations of a pyschological dimension – valued by Journiac in the paintings of Egon Schiele – were abandoned for raw flesh and crude emotion. These works bore titles such as *The Voyeur* (1963), *Sacrifice* (1963), *Blood Sign* (1966), *Letters for a Blood Alphabet* (1967).[23] Similar works with altar-like, wooden framing devices, were arranged for his first exhibition 'Blood Trap' in the ecclesiastical setting of the Cloîture des Billettes, in 1968.[24]

The same year, the eminent director of the French National Museum of Modern Art, Jean Cassou, prefaced Journiac's first collection of poems, *Le Sang nu* (*Naked Blood*). 'Cruel in the use of his colours, his forms, his preposterous accessories', Journiac's 'bloody and funereal obsessions' contained within themselves the imperative to descend into the 'most profound of our physiological and moral hells', Cassou

declared. While he spoke, innocently it seems, of the 'lucidly accepted vocation' the 'tranquil resolution' of a new generation, it was in fact extraordinarily far-sighted of him to see within Journiac's hysterically bloodied meats an 'invulnerable candour'. [25]

Cassou seemed oblivious to the sexual and autobiographical subtext of Journiac's poems, yet by 1969 a climate of reception already existed for the sexually ambiguous, with homosexual liberation a militant dimension of 1970s debates in Paris. Popular culture, of course, was where the convulsions of society were most visibly situated. In the 1960s, the Beat generation, the Beatles, the hippies, flower power, psychedelia, sexually unconventional heroes such as Timothy Leary, Jack Kerouac and Allen Ginsberg all had their impact in France. Throughout the 1970s, haircuts, fashion and sexual relationships were all profoundly modified thanks to the impact of feminism in conjunction with the new visibility of gay desire. An androgynous wave swept Western Europe and America. While French intellectuals read Foucault, Lacan or Marcuse's *Eros et Civilisation* (translated in 1968), and the international avant-garde shifted its boundaries from painting and sculpture to performance, androgynous rock stars such as Alice Cooper, David Bowie or Marc Bolan dominated the music scene. Indeed in mid-decade, 1974, Jean-Christophe Amman's exhibition '"Transformer": Aspekte der Travestie' which travelled from Lucerne to Graz and Bochum was a hymn to extravagant and beautiful drag artist(e)s, demonstrating that this new androgyny, or what the catalogue called 'Genderfuck dressing, the visible expression of an integrated masculine/feminine consciousness' was indeed an international phenomemon, and reflected an international community in open pursuit of previously hidden pleasures. [26]

The self-appointed theorist of homosexual desire, Guy Hocquenghem, offered a particularly French explanation for the period which he baptised 'l'après-mai des faunes'. [27] This nostalgically Mallarméan pun related to the paradoxical disappearance of an archetypal virile, proletarian, revolutionary, 'red' French male, on the barricades. Symbolically, the posters of the Comité d'Action Pédérastique were the only posters to be torn up and censored by those who occupied the Sorbonne. Hocquenghem prognosticated: 'with the downfall of revolutionary ideals (and this is surely not the least of the effects of May 68), masculinity as a whole as the real, day-to-day bearer of revolution vacillates'. In a state of 'hesitation and fear of feminism' sexual identity had become problematised. 'In some way, all these males have been sodomised. Just at the moment when the *pédés* are discovering short hair and virile facades.' [28] In 1971, Hocquenghem launched the Front Homosexuel d'Action Révolutionnaire (FHAR, pronounced *phare* = beacon) with his manifestos 'Addressed to those who believe they're "normal"' and 'Addressed to those like us'. [29] In January 1972, his confessional life story was published in *Le Nouvel Observateur*; Hocquenghem continued to teach and write through the decade, after the first thrust of the FHAR subsided, with his publication *Race d'Ep!* (1979, Rasdep = Pederast), offering a popular medical and visual history of homosexuality over a century. [30]

Legal, medical and educational practices themselves were changing in this climate. [31] In 1973, the homosexual debate reached seven million television viewers,

and the government introduced sex education in schools, aided by the Librarie Hachette's *Encyclopédie de la vie Sexuelle*. The gay review *Arcadie* organised a Paris congress that year (with further congresses held in Marseilles, Metz and Paris (twice) in 1975, 1977, 1979, 1980). In 1974, with FHAR now succeeded by the more political Groupe de Libération Homosexuel, De Gaulle lowered the age of homosexual consent to eighteen (it was currently fifteen for women!) and the Société Clinique de Sexologie was founded. In politics, local gay 'cells' on the communist model were organised by arrondissements, and in 1978 two 'homosexual difference' candidates were fielded in the legislative elections. As a result of this new liberalisation, a gay sex industry flourished with renewed vigour and visibility, extending from magazines in kiosks and gay saunas to the infiltration of several advertising campaigns with the gay message. Homosexual film festivals were held in Paris in April 1977 and January 1978 (the latter closed by the police with casualties); the Comité d'antirepression homosexuelle was founded in 1979.[32]

Despite the unequivocal Biblical prohibition of the homosexual act, and the institutionalisation of the cycle of sin, shame, guilt and confession and absolution within the Catholic Church, the force for change was unstoppable. A fundamental liberalisation was set in train with Pope Paul VI's Vatican II revisions of 1962–70. An open discussion of the problem of homosexuality within the Church led to the foundation of the group 'David et Jonathan' in January 1972, initially hosted by the review *Arcadie*, and baptised with a group recital of the Paternoster. 'David et Jonathan' became the model for similar discussion groups in the provinces. Inasmuch as the debate between progressives and conservative 'integrists' in the Church was always vigorous, 'David et Jonathan' refused to take sides. Relations with the Vatican were almost non-existent, especially following the unanticipated Papal confirmation of the prohibition of homosexuality, masturbation and pre-marital sex in 1976, which provoked a wave of protests – even suicides – in France.[33] Just as the Catholic Church had been compelled to engage in debates with Marxism and Existentialism in the 1950s, it was now forced to accept the *donnés* of a post-Freudian age, and to embrace the new era. Love conquers all.

Was Michel Journiac's work, then, merely an epiphenomenon of the times? With the rehabilitation of 'psychobiography' in the light of the recent valorisation of testimony and trauma theory, one can say no.[34] To what extent were the liturgical dimensions of the Catholic rite responsible for Journiac's breakthrough from painting and sculpture into the performative, an art which addressed, like a priest, the spectator as participant, and the objects of ritual themselves as possible *pièges* or – traps?

The precursors of performance art in France, Georges Mathieu, Yves Klein, Niki de Saint Phalle were extremely prominent on the 1960s international art scene. While Klein aspired to the spiritual and ritual in works constantly preoccupied with purity, resurrection and angelic flight, Niki de Saint Phalle's bloodied and bullet-riddled altarpieces declared the traumatically inescapable yet politically destitute condition of the Church in France at the time of the Algerian war; a

Church which ceaselessly ratified the monstrous patriarchy and conservatism of the French state. In 1964, Jean-Jacques Lebel introduced the American-style Happening to France, presenting Carolee Schneeman's *Meat Joy* at the 'Free Expression' festival.[35] The greatest Happening – May 1968 itself – would precede Journiac's move into performance-related works.

Already so many fathers! Self-conscious Oedipalism was deployed in Journiac's first, parodic acts. Through hypertrophy and ridicule he both invited and instantly deflated psychoanalytic interpretations of his work: he killed his father figures, stole their styles, mocked their signatures. Officially and commercially speaking, the success story of French art in the 1960s and early 1970s, had been Nouveau Réalisme. Journiac first 'washed the dirty linen' of the Nouveau-Réaliste artists and their friends in public in *The Great Wash*, soaking the clothes – César's pullover, an Oldenberg sock – in white vinyl paint and hanging them, rigid, on a line in the Galerie Daniel Templon in March 1969. Into a linen basket were tossed the clothes of the useless rejects; Chagall, Dali, Mathieu, Picasso, Rosenquist, or the Narrative Figuration movement. In October 1969, the *Trap for a voyeur* placed a naked man in a cage made of neon tubes so bright that the peering public was blinded – the situation of the gaze reversed. An adjunct to the *Trap*, *The Substitute*, used the fairground device of a screen with two naked, photographed bodies and cut-out heads for the public to peer through, appropriating the opposite sex's body if so desired. This surely deliberate citation of Marcel Duchamp's naked pose as Cranach's Adam (with Eve-Brogna Perlmutter's naked Eve in Picabia's 1921 *Ciné-sketch*), invoked the possibility of a quick photographic sex-change.[36]

In 1969, Journiac presided over one of the most powerful and bizarre events of the 1960s, an apotheosis of appropriation as a strategy: *Mass for a body* was celebrated on 6 November in the Galerie Daniel Templon, with the assistance of the art critics Pierre Restany and Catherine Millet. Notionally blasphemous, the mass was conducted by Journiac with great solemnity, in Latin, and took place in an awed silence. Journiac had had his own blood drawn, in the presence of a photographer, in order to make a *boudin*, a blood-sausage which was to be sliced as the host.[37] The portable altars surrounding the main altar bore white sculptures of body parts in their recesses, like so many whited sepulchres. The principles both of literality and reversibility were at stake: the challenge was to nothing less than the doctrine of transubstantiation itself. Christ made man, via Journiac's blood, became man made Christ. The audience partook of the *boudin*, an event which acquired international dimensions when repeated, using a Paris-New York telephone hotline in 1970.[38] The phallicism of Nouveau-Réalisme's moustachioed he-men became Journiac's target in his more sculptural phase of parody. In April 1971, Journiac exhibited at the Galerie Imbert, coinciding with the the first homosexual film festival at the Cinéma d'Olympic, and the newpsaper *Libération*'s day-by-day coverage of events – together with the scandal around Hocquenghem's manifesto number of *Tout*, towards the end of the month.[39] 'Parody of a collection' was a phallic carnival. An ultra-erect, wrapped penis-package, *Christo parody*, mocked the Bulgarian

Nouveau Réaliste; a shiny, flaccid, vinyl 'soft-sculpture' penis, *Oldenberg parody*, mocked the American Pop artist; *Love machine, Tinguely parody*, created an anti-machine with an erect plaster penis placed ridiculously on top of the mechanism.[40] The masquerade of styles and the artefacts of male display in conjunction with the notion of reversibility both of the sexes and of viewer and viewed was funny, cruel, and above all, valedictory.

In October 1971, François Pluchart initiated the performance-focused review *Artitudes* with an issue on 'the material body of art', and international coverage, featuring Dan Graham, Vito Acconci, Denis Oppenheim, Joseph Beuys and Piero Manzoni.[41] International performance art had 'arrived' in Paris.

In March 1972, Journiac created what was arguably his masterpiece: *Homage to Freud. Critical Statement of a Transvestite Mythology*, a serial photopiece, which also existed as a poster, folded and mailed to many acquaintances (Figure 70).[42] Journiac's confessional letter of 1962 had described his reading of Freud, and the horrified discovery that desire was not merely a question of morals – his previous social and religious problem – but of malady. Is human freedom no more than a conscious registering of the biological laws of reproduction, he asked? Why should only proto-reproductive behaviour be defined as normal, even when reproduction is not desired? The great fear of loss of parental love he described in this letter was surely resolved to no small extent in *Homage to Freud*, where, somewhat astonishingly, his parents were co-opted as equal protagonists – the beginning of works based on the notion of a trinity of love.

The photographs which required several takes and all his make-up skills were captioned 'FATHER: Robert Journiac masquerading as Robert Journiac; MOTHER: Renée Journiac masquerading as Renée Journiac; SON: Michel Journiac masquerading as Robert Journiac; SON: Michel Journiac masquerading as Renée Journiac.' Here, one must distinguish in English between 'masquerade' and 'tranvestism': in French the 'travesti en' and 'travestissement' has the sense of both, with a whiff of 'drag' and even of 'travesty', yet not quite the pathological aura of 'transvestism'.[43] Thus 'Michel Journiac travesti en Renée Journiac' may imply 'Michel Journiac in drag as Renée Journiac', while 'Renée Journiac travestie en Renée Journiac' retains more the sense of the female masquerade – the hair, the pearls, the pendant. Is Michel Journiac *in drag* as Robert Journiac? Is this a travesty? For is not Journiac *of the substance* of both his parents, rather than merely participating in a masquerade? The uncanny in these photographs relates as much to the genetic as the genital, while evidently the mug-shot format evokes the institutionalised policing of identity. The striking evidence of Journiac's photographic humour in particular negates both the idea of Freud's *talking* cure, and the body as a whole from the chest downwards: the places of disturbance and sites of lack according to both Freud and Lacan. *Homage to Freud* invites a gazing at a male 'lack' as well as a female one. Finally, reversing the work of Oedipal parody performed upon the Nouveaux Réalistes, appropriation becomes an extraordinary work of acceptance, complicity, desire, certainly 'invulnerable candour' to use Cassou's phrase – and

70 Michel Journiac,
*Homage to Freud:
Critical Statement of a
Transvestite
Mythology*, 1972,
poster.

PERE : Robert Journiac travesti en Robert Journiac FILS : Michel Journiac travesti en Robert Journiac

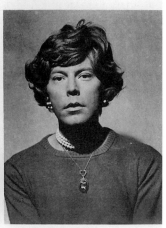

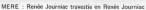

MERE : Renée Journiac travestie en Renée Journiac FILS : Michel Journiac travesti en Renée Journiac

love. While his exegete Marcel Paquet invoked the one-dimensional image of the Moebius strip to describe the relationship between subject and identity, Journiac himself called the work a 'statement of the failure of the ritual magic of psycho-analysis'.[44] And Venus? As embodied in her classical manifestations and narratives, it is clear that the goddess is and was always, pre- or post-Oedipal.

Antipsychiatry, influenced by both R. D. Laing and the 'schizo' as promoted by Gilles Deleuze and Féliz Guattari, was, indeed, one of the liberationist tenets of Journiac's age.[45] In his passionate preface for Guy Hocquenghem's *L'Après-Mai des faunes*, Deleuze elaborates: 'Against psychoanalysis, against the interpretation and reductions of psychoanalyses – homosexuality seen as the relations with the father, with the mother, with Oedipus ... Psychoanalysis has never supported desire. It has always reduced it and made it say something else. Among Freud's most ridiculous pages are those on fellatio ... Interpretation, regression, forced

regression … Maybe there is an Oedipal homosexuality, a *homosexualité-maman*, guilt, paranoia, anything you like'; but this should be challenged, Deleuze declares, by Hocquenghem's notion of the 'specificity and irreducibility of homosexual desire, a flux without an aim or origin, an affair of experimentation, not interpretation'. Homosexuality is lived in the present, it is not a function of the past.[46]

The dichotomy implicitly suggested by Gilles Deleuze is very much evident in Journiac's own manifestations: the 'Oedipal' prim son versus the wild transvestite, and their idiosyncratic combination in his literal parody of the condition of a *homosexualité-maman*. In *Trap for a Transvestite* of June 1972, he created photograph sequences of the dressings and undressings of a professional transvestite, Gérard Castex, transformed first from a man in fashionable garb, to a nude, then into Greta Garbo or Rita Hayworth; a mirror with a star's name at the end of each of the four sequences reflected the viewer, himself or herself, as a *travesti*.[47] The performance was repeated live at the opening. In November 1974, the photograph series, '24 hours in the life of an ordinary woman', while extending Journiac's ideas and procedures in both *Homage to Freud* and *Trap for a transvestite*, conflated his wildest drag dreams with an apotheosis of the *homosexualité-maman* fantasy. Based on the stereotypes promoted by women's magazines such as *Marie-Claire*, the series also makes a parodic yet devastating contribution to feminist debates in France. Journiac, in his mother's guise, was photographed – by a local commercial photographer – going through the rituals of what Henri Lefebvre had glorified in its masculinist form as 'everyday life'. This was the everyday life of a not-too-young, married working woman of the lower middle class:

Series: 'Reality' (photographs by Marcelle Fantel)

Husband wakes up. Housework. Washing, Going out. Arriving at work. Clocking in. Work. Fixing make-up 1. Fixing make-up 2. The midday meal. Coffee. Cigarette. Shopping 1. Shopping 2. The purchase [Tampax]. Cooking. Husband arrives. Evening meal 1. Evening meal 2. Washing up. Television. In bed 1. In bed 2. In bed 3 [no action, the husband reads a newspaper in all three photos]. Dream: waiting 1. Dream: waiting 2. Dream: waiting 3, Dream: lover.

Series: 'Phantasms' (photographs by Marie-Armelle Dussour)

In his arms. Maternity. Suckling the Baby. The Bride. The virtuous young Virgin. The Whore. Giving birth. The Widow. The Rape. The Covergirl. The Feminist. Girl taking mass. Carried away [on a motorbike]. The Queen. The Lesbian, Woman in drag as a Man. Woman in white. The Striptease artist.[48]

'… Women have been condemned', Journiac said to *Marie-Claire*, 'to embody desire. Female fashions, make-up, have no other function. A man is proud of two things. His mind and his phallus. So he locks up art in museums and women in perfectly irrational outfits incarnating a stereotypical desire …'[49] Yet just as the transvestite is sacred, the sacred role of the artist is a form of prostitution. The previous year, Journiac had stated in a discussion on 'sociological art': 'We're prostitutes.

What's important is that we touch others whoever they
are, you find yourself in a position where you don't
choose the partner.'[50] The personal biography Journiac
provides at the end of the publication, *24 heures dans la
vie d'une femme ordinaire*, has a more personal take on
'whoring': genuine photographs of his childhood and
adolescence take their place within the contemporary
genre of 'fake' biographies promoted by artists such as
Christian Boltanksi. But Journiac's captions become
increasingly ironic and judgemental: 'Maternal nest-
building' (Michel and mother in a nest of twigs); 'Jean'
(the dead brother); 'Vagabond paternity' (Michel and
his father); 'Advent of the word' (Michel reading); then
'Whore 1', 'Whore 2' – which show Michel as a young
man, dressed normally, not in drag, the repressed other
of the 'whore' of the fantasm series (Figure 71).

Whoring and loving within or outside the family?
The biographical supplement to *24 heures ...* was the
precursor of *Incest*, March 1975, a work which is per-
haps the ultimate deconstruction of the Venus myth,
and the natural successor to *Homage to Freud*. Journiac,
working again with his parents, posed in 'prim son'
guise, doubling and tripling himself in a series of eight
photographs in which he is always both the lover and the
third person, the excluded one. Artist, art-tart, outcast.
He is both the presiding Monsieur Venus of these love
narratives and the provocative *fils-voyeur*, both son and
voyeur, whose initial Oedipal trauma is generated,
Freud argues, by seeing or overhearing parental coitus
... Eight permutations were offered in a numbered
sequence (Figures 72 and 73):

71 Michel Journiac,
*Phantasms: The Striptease
Artist*, from the series *Twenty-
four Hours in the Life of an
Ordinary Woman*, 1974,
photograph.

1 *Father-as-lover Son-boy-lover Son-voyeur*
2 *Father-as-Lover Son-as-daughter-as-lover
 Son-voyeur* (Journiac doubles as the sister he never
 had, who resembles his mother and who embraces his father)
3 *Mother-as-lover Son-boy-lover Son-voyeur*
4 *Mother-as-lover Son-as-daughter-as-lover Son-voyeur*
5 *Son-as-father-as-lover Son-as-mother-as-lover Son-voyeur*
 (Journiac in his *Homage to Freud* parental disguises fantasises, through pho-
 tomontage, the sexual love, in which, incestuously, he plays both roles)
6 *Son-as-daughter-as-lover Son-boy-lover Son-Voyeur* (Journiac commits
 incest with the sister he never had)

Mother–Lover Son–Boy–Lover *Son–Voyeur*

72 Michel Journiac, *Incest*, 1975, photograph.

Father–Lover Son–Boy–Lover *Son–Voyeur*

73 Michel Journiac, *Incest*, 1975, photograph.

7 *Son-as-daughter-as-lover* *Son-as-daughter-as-lover* *Son as voyeur*
 (Two non-existent daughters [Journiac] have a lesbian affair)
8 *Son-boy-lover* *Son-boy-lover* *Son-voyeur* (two brothers embrace; Journiac, a
 third, looks on jealously)

But perhaps every Oedipal variation is a travesty? Without the guise of 'looking-alike' would we 'feel-alike' as Freud says we must? Artifice and 'horizontality' are emphasised in the *Incest* series. A Deleuzian insistence on the present is guaranteed by the narrative sequential arrangement of the photographs read from left to right, while real 'presence' is attested by the 'veracity' of the photograph itself. Yet the 'here and now' is teased provocatively by the time-based axes of fantasy and repression: 'Freud's uncertainty whether *events* or *fantasies* make up the typical content of the repressed'.[51]

In the April–June 1975 'Indecency' issue of *Artitudes*, Journiac's poem 'Preliminary to Incest' accompanied the startling *Incest* photographs: *Comment dire l'autre si ce n'est par drague ou par mort …?* Death or the lover's encounter (*la drague* = the pick-up) are the sole ways to speak the other. Painful memories conflate the liquid of his dead brother's lumbar puncture with his own sperm and masturbation ritual, 'masquerading as victor, masquerading as victim … parents at the cemetery, at the brother's tomb'.[52] At the origin of his trauma, as declared in his poems of 1968, and the pictorial biography accompanying the *24 heures* drag series, was, always, the death of his brother in 1948. An extraordinary text of late 1981, about the family as 'murderess … an entanglement of bodies from which we cannot escape each other' and the 'necessary murders, son-brother, father-son, mother-son, father-mother' it engenders, complements the love-theme of *L'Inceste*, 1975, with a violent hatred.[53]

Excommunion, a performance held in July 1978, at the Théâtre Oblique, continued the motif of the third, the Other, the witness of the heterosexual relationship this time parodied as a narrative of the exchange of transitional objects: a cigarette, flowers, rings, photographs, at first including Journiac in a 'threesome'. While the couple draw red circles on their arms, Journiac brands himself with a red-hot iron. Finally the young couple rub away their circles, burn their flowers, rings and photos and walk off stage. Journiac is left, looking at their portraits, bearing the sole enduring, burning scar of the relationship, alone. Monsieur Venus, both originator of the performance and voyeur, is also excluded.

Exclusion is concomitant with love. Just as *Trap for a voyeur*, 1969, while putatively reversing the position of victim and voyeur in terms of the gaze could not remove the symbolic bars of the cage, Guy Hocquenghem – as early as July 1972 – described the trap of desire in terms of a similar dialectic: 'We were imprisoned in the game of shame which we transformed into the game of pride. It's never more than gilding the bars of our cage. We are not free homosexuals proud to be gay.'[54] In 1983, Journiac branded himself with the triangle, pink on his wounded skin, which marked out the homosexual in Nazi concentration camps – a highly disturbing action he would repeat in a period of AIDS militancy in 1993.[55]

Finally in these performances which put love to the test, I shall discuss the *Action of the Excluded Body* which took place at the Centre Georges Pompidou in June 1983. Here, Journiac 'gives birth' to a baby bloodied with his own blood and buries it, in front of a couple locked in embrace behind the scene; he picks a fight with the young man, and ends up lying like a *Pietà* in the arms of the naked woman. Again the theme of the third, the inclusions and exclusions of erotic love, the impossible desire to transcend gender in love, and mourning for the dead baby brother are inextricably linked with the postures of Christ.[56] Journiac's performance parodies his own exclusion, from the experience of birth, from his brother's love, from love of a woman, and as a *Pietà* figure, from the love of the Madonna. Or is there not a critical aporia here, in that the performance itself, the bloodying, the cradling, the striking, the lying with, are the transcendent acts of love? Surely the persistence of desire in the present is the complement to memory, with its games of repression and prohibition, the unforgettable brother, the unending 'work', in the Freudian sense, of dream, of mourning, of 'being with' ones' parents.

The persistence of desire ... *Icons of the Present Time*, 1988, presented three series of forty black and white photographs in all, mounted on grounds of gold leaf, brushed with Journiac's own blood: the faces and torsos of eleven delectable male porn stars; an obese, naked mother goddess (paired with an image of a child from Weimar Germany sitting on a pile of banknotes) and twenty-seven mugshots of beautiful men from Franz Kafka and Antonin Artaud to Journiac's friends and lovers, or to contemporary stars such as Michael Jackson (Figure 74). Journiac had always favoured pornography in its most straightforward sense *pour bander* – to arouse desire, as a mode of self-realisation or of reaching the other beyond the accepted conventions of erotic ritual.[57] Indeed, *Icons of the Present Time* may be framed as an exegesis of the *chresis aphrodision*, the use of pleasures, and an eloquent tribute to Foucault's almost contemporary *L'Usage des Plaisirs* of 1984.

Journiac dedicated his *Ritual of Transmutation*, an action in twelve stages extending from 1993 to 1995, when he already knew he was dying of cancer, 'To Jacques Miège, to my friends, to my lovers'.[58] One could argue that Journiac's last performative act was his death. As Julia Hontou has remarked, 'Journiac's whole career was an attempt to put death into the scene of art, to dominate the fear it arouses, while never annihilating its power ... Journiac speaks of his desire to preside over death, to take it upon himself, to organise it, to be at the heart of the action.'[59] Yet here, too the sacred act of love was paramount, from the moving deathbed photograph, taken by Jean-Luc Moulène on 16 October 1995, the day after his death, to Vincent Labaume's moving funeral elegy on 20 October 1995 at Notre Dame de la Gare.[60] An artist and AIDS activist to the last, Journiac died, aged 60, not, in fact, of AIDS but prostate cancer, ironically during the exhibition, 'fémininmasculin' in which his work was present, but not powerfully so. 'Late' in every sense, 'féminimasculin' could have done so much more to explore the use of pleasures, the vagaries of gender in lieu of the presentation of a profusion of sculptural and photographic phalli, 'part objects', slits and slippages, resolutely binary in its conception.[61]

74 Michel Journiac,
Icon of the Present,
1986, photograph
mounted on gold leaf.

Discussing his *Icons of the Present Time*, Journiac spoke of the 'ontological power of the caress' …[62] In 'fémininmasculin', love, and paradoxically sex itself as an epiphanic and ontological, not genital, phenomenon was the lack. In Michel Journiac's art, in contrast, Venus, autopsied, returns both as a form of sacred sexuality and mourning and – before and after AIDS – of transcendant sexual practice.

> Sex is worth dying for. It is in this (strictly historical) sense that sex is indeed imbued with the death instinct. When a long while ago the West discovered love, it bestowed on it a value high enough to make death acceptable; nowadays it is sex that claims that equivalence, the highest of all.
>
> (Michel Foucault, 1976)[63]

Notes

Notes to Chapter 1

1 The archaeological metaphor has of course long since been put to use in psychoanalysis and history by Freud and Foucault respectively. See M. Foucault, *The Archaeology of Knowledge*, trans. A. M. Sheridan (London, 1972) and for Freud see D. Kuspit, 'A mighty metaphor: the analogy of the archaeology and psychoanalysis' in L. Gamwell and R. Wells (eds), *Sigmund Freud and Art. His Personal Collection of Antiquities* (London, 1989) pp. 133–51.

2 For a discussion of the source see J. Aicard, *La Vénus de Milo: recherches sur l'histoire de la découverte* (Paris, 1874).

3 On Marie-Louis-Jean-André-Charles Demartier du Tyrac, comte de Marcellus (1795–1865), see A. Dumaine, *Quelques oubliés de l'autre siècle* (Paris, 1928), pp. 1–64. For a recent discussion of his travel writings, see O. Augustinos, *French Odysseys: Greece in French Travel Literature from the Renaissance to the Romantic Era* (Baltimore, 1994), pp. 228–43.

4 These allegations have most recently been made by Peter Fuller in *Art and Psychoanalysis* (London, 1980), pp. 71–129.

5 Marcellus, *Souvenirs de l'orient*, 2 vols (Paris, 1839), vol. 1, pp. 231–67.

6 M. Bernal, *Black Athena. The Afroasiatic Roots of Classical Civilization*, 2 vols (London, 1991).

7 *Ibid.*, pp. 65–6.

8 The decade that witnessed the recovery of the Melian goddess also witnessed the 'discovery' of the other, Hottentot Venus. See S. Gilman, 'Black bodies, white bodies: towards an iconography of female sexuality in late nineteenth-century art, medicine and literature', *Critical Inquiry*, 12 (1985), pp. 204-42.

9 Marcellus, *Souvenirs*, p. 238.

10 *Ibid.*, pp. 247–8.

11 See *Hesiod, the Homeric Hymns and Homerica*, trans. H. G. Evelyn-White (London and New York, 1929), Homeric Hymn VI, *To Aphrodite*.

12 Marcellus talks, for instance, of his 'faiblesse paternelle' for his idol (*Souvenirs*, p. 234) and later calls her his 'pupille' (p. 258). But between these opening and closing bouts of paternalism he also admits to reciting Homeric verse to Venus (p. 248) and visiting her in the hold of the *Estafette* where his admiration swelled each time the 'voiles grossiers' that covered her were drawn back that he might pay her homage (p. 249). On his tour round the Aegean with the Venus, see *ibid.*, p. 250 and the map of his peregrinations provided drawn up by J. -P. Alaux and published in A. Pasquier, *La Vénus de Milo et les Aphrodites du Louvre* (Paris, 1985), p. 27.

13 Lucretius, *De Reruni Natura*, trans. W. H. D. Rouse (London and New York, 1924), p. 5. Venus as Lucretius portrayed her appeared to Marcellus in an anticipatory and erotic dream. See Marcellus, *Souvenirs*, p. 244.

14 *Ibid.*, pp. 233–4. Le Conte de Lisle in his famous poem on the *Vénus de Milo* apostrophises her in a similar way: 'Allume dans mon sein la sublime étincelle, / N'enferme point ma gloire au tombeau soucieux; / Et fais que ma pensée en rhythmes d'or ruiselle / Comme un divin métal au moule harmonieux.': *Poèmes antiques* (Paris, 1852), p. 124.

15 See Quatremère de Quincy, *Notice sur la statue antique de Vénus découverte dans l'île de Milo en 1820* (Paris, 1821). The keeper of antiquities at the Louvre, the comte de Clarac also initially promoted an attribution to Praxiteles, suggesting in fact that the Melian figure be identified with the Praxiteles's veiled Venus executed according to Pliny for the inhabitants of Cos. See *Description des antiquités du musée royale commencée par feu M. le chevalier Visconti; continuée et augmentée par M. le comte de Clarac* (Paris, 1820), p.10. Later he argued for greater caution in attributions: see *Sur la statue antique de Vénus Victrix découverte dans l'île de Milo en 1820* (Paris, 1821), pp. 16–17.

16 J. J. Winckelmann narrated this transformation of the grand and sublime age of Phidias into the beautiful and flowing style of Praxiteles by analogy to the tale of the majestic goddess Juno's borrowing of graceful Venus's girdle the better to seduce Jupiter. By this argument 'naturalism' is presented as a supplement. See J. J. Winckelmann, *Histoire de l'art chez les anciens*, 2 vols (Amsterdam, 1766), vol. 1, p. 32.

17 For the classical texts see J. J. Pollitt, *The Art of Greece 1400–31 B.C. Sources and Documents* (Englewood Cliffs, 1965), pp. 128–34. For an interpretation of those sources and a discussion of the ways in which they have been used and interpreted down to the present day, see C. M. Havelock, *The Aphrodite of Knidos and her Successors* (Ann Arbor, 1995), pp. 39–54 and *passim*.

18 Sec Pollitt, *The Art of Greece*, pp. 131–2. In the nineteenth century Phryne became in her own right a significant subject for painting and sculpture. Among the most notable examples are: James Pradier, *Phryne* (1845), Jean Léon Gérôme, *The Judgement of Phryne* (1861) and Falquiere, *Phryne* (1861).

19 See Pollitt, *The Art of Greece*, p. 128.

20 See I. Jenkins, *Archaeology and Aesthetics in Sculpture Galleries in the British Museum 1800–1939* (London, 1992), chapter 3.

21 The other Venuses which can be identified from these photographs are versions of the Capitoline Venus, the Crouching Venus and the so-called Venus of Arles. See Pasquier, *La Vénus de Milo*, pp. 43–65.

22 On the lighting and display of antiquities see Jenkins, *Archaeology and Aesthetics*, pp. 41–55.

23 See Quatremère de Quincy, *Notice;* Clarac, *Description des antiquités*, pp. 6–11.

24 On Frederick Barnard see E. de Mare, *The Victorian Woodblock Illustrators* (London, 1980), p. 154.

25 J.-K. Huysmans, *Croquis de Paris* (Paris, 1905), p. 131. For an excellent and full discussion of the essay 'Etiage' in the context of Huysmans's appreciation of sculpture see P. Ward-Jackson, 'Reinvesting the idol: J.-K. Huysmans and sculpture', *Burlington Magazine*, 138 (1996), pp. 801–8, esp. pp. 803–4.

26 Marcellus, *Souvenirs*, pp. 257–8.

27 Marcellus specifically refers to the display of antiquities at the Vatican, but he was also invoking Pliny's account of the Aphrodite of Knidos. See similar comments made by

Clarac in *Sur la statue antique,* p. 3. On the history of the statue's display see E. Michon, 'La Vénus de Milo: son arrivé et son exposition au Louvre', *Revue des études grecques,* 13 (1900), pp. 362–70.

28 See S. Stewart, *On Longing. Narratives of the Miniature, the Gigantic, the Souvenir and the Collection* (Durham and London, 1993), pp. 132–69.

29 Clarac compares her to a new star, one that transformed the aesthetic hierarchy by laying claim to a uniquely celestial status. See Clarac, *Sur la statue antique,* pp. 1, 2.

30 J. J. Bernoulli, *Aphrodite, Ein Banstein zur griechischen Kunstmythologie* (Leipzig, 1873).

31 For a discussion of the various types see F. Haskell and N. Penny, *Taste and the Antique: The Lure of Classical Sculpture, 1500–1900* (New Haven and London, 1981), pp. 316–33; Havelock, *The Aphrodite of Knidos,* pp. 69–101.

32 Clarac, *Description,* p. 8.

33 W Frohner, *Notice de la sculpture antique du musée national du Louvre,* 2 vols (Paris, 1878), p. 170.

34 Winckelmann, *Histoire de l'art,* vol. 1, p. 279.

35 W. Lubke, *History of Sculpture in Italy* (1st pub. 1863), trans. F. E. Bunnett (London, 1872), vol. 1, p. 278.

36 On nineteenth-century mythology, see M. Detienne, *The Creation of Mythology,* trans. M. Cook (Chicago, 1986), esp. pp. 1–21.

37 Le Comte de Lisle, *Poèmes,* pp. 121–2.

38 Lubke's accusation of coquetry rested on Venus's 'apparently modest bearing, seems to challenge the admirer whose attention she is seeking': Lubke, *History of Sculpture,* vol. 1, p. 278.

39 Havelock, *The Aphrodite of Knidos,* pp. 16–37, 78–80.

40 On Daumier's images of *amateurs* and collectors see most recently B. Laughton, *Honoré Daumier* (London and New Haven, 1996), pp. 49–63.

41 Freud's comment about the collector is made in a letter to Wilhelm Fliess, 24 January 1895 (*The Complete Letters of Sigmund Freud to Wilhelm Fliess, 1887–1904,* ed. J. M. Masson (Cambridge, Mass., 1984), p. 110) and is fully discussed by John Forrester in his essay '"Mille e tre": Freud and collecting', in J. Elsner and R. Cardinal (eds), *The Culture of Collecting* (London, 1994), pp. 224–51.

42 *Ibid.*

43 Freud possessed a Roman statuette of Venus with a mirror. See *Sigmund Freud and Art,* p. 112. For the ancient literary tradition see Pollitt, *The Art of Greece,* p. 131; Havelock, *The Aphrodite of Knidos,* p. 21. For the reconstruction of the *Venus de Milo* with a shield see Fuller, *Art and Psychoanalysis,* p. 87

44 M. Bergstein, 'Lonely Aphrodites: on the documentary photography of sculpture', *The Art Bulletin,* LXXIV, 3 (September 1992), pp. 475–98, esp. pp. 487–8.

45 Fuller, *Art and Psychoanalysis,* pp. 71–129.

46 A. Furtwangler, *Masterpieces of Greek Sculptures: A Series of Essays on the History of Art* (London, 1905), p. 383.

47 Fuller has recourse to Hanna Segal's writing as much as Klein's. See Fuller, *Art and Psychoanalysis,* pp. 109–29. See also M. Klein, 'Some theoretical conclusions regarding the emotional life of the infant', in idem, *Envy and Gratitude and Other Works, 1946–1963* (London, 1988), pp. 61–93.

48 Fuller, 'Venus de Milo', p. 125.

49 *Ibid.*, p. 86.

50 Champfleury, *Les bras de la Vénus de Milo,* published along with *Madame Eugenio* (Paris, 1874), pp. 243–4.

51 See Page Dubois's criticisms in 'Archaic bodies-in-pieces', in N. B. Kampen, *Sexuality In Ancient Art* (Cambridge, 1996), p. 58 and J. Stallabrass, 'Success and failure of Peter Fuller', *New Left Review,* 207 (September–October 1994), pp. 87–102. Fuller's deployment of Klein falls in the shadow of the project of Adrian Stokes in the 1950s and 1960s. See R. Wollheim (ed. and intr.), *The Image In Form: Selected Writings of Adrian Stokes* (Harmondsworth, 1972).

52 See for example M. Nixon, 'Bad enough mother', *October,* 71 (1995), pp. 71–92 and J. Phillips and L. Stonebridge, *Reading Melanie Klein* (London and New York, 1998).

53 J. Lacan, *The Ethics of Psychoanalysis, 1959–1960: The Seminar of Jacques Lacan, Book VII,* trans. D. Potter (London and New York, 1992). We are most grateful to Parveen Adams for suggesting this line of enquiry.

54 Though, as a female figure, Venus was never acknowledged as a ruling authority in the academy.

55 He conceives of it both as rent and plug in the fabric of consciousness.

56 Lacan, *The Ethics of Psychoanalysis,* p. 106

57 *Ibid.,* p. 111.

58 *Ibid.,* p. 68.

59 *Ibid.,* p. 58.

60 *Ibid.,* p. 55.

61 *Ibid.,* pp. 80–1,

62 See important contributions in R. Parker and G. Pollock, *Framing Feminism: Art and the Women's Movement* (London and New York, 1987), L. Mulvey, *Visual and Other Pleasures* (Basingstoke, 1989) and T. Garb, *Bodies of Modernity: Figure and Flesh in Fin-de-Siècle France* (London, 1998).

63 In hellenistic sources Eros frequently gave way to a plurality of Erotes, following the logic of love's multiplication. See S. Hornblower and A. Spawforth, *The Oxford Classical Dictionary* (Oxford and New York, 1996), p. 557.

64 Setting Venus apart from the kind of fetishistic strategies described by Linda Nochlin in L. Nochlin, *The Body in Pieces: The Fragment as a Metaphor of Modernity* (London, 1994).

65 On the prevalence and vigour of the classical as a set of references in the pre-Renaissance period see E. Panofsky, *Renaissance and Renascences in Western Art,* (London, 1965).

66 Iconographic readings of Renaissance imagery in terms of Neoplatonic thought: J. Seznec, *Survival of the Pagan Gods* (London, 1940); E. Wind, *Pagan Mysteries in the Renaissance* (1st pub. 1958), (Harmondsworth, 1967); E. H. Gombrich, *Symbolic Images* (1st pub. 1972), (Oxford, 1985).

67 Among her titles are Aphrodite Machinitis, Aphrodite Epistrophia, Aphrodite Praxis and Aphrodite Hetaira: see G. Grigson, *The Goddess of Love* (London, 1978), p. 95, and also Hornblower and Spawforth, *The Oxford Classical Dictionary,* p. 120.

68 In the case of Christ the damaging of the crucified body has very often been used to maintain the familiar duality between spiritual inner beauty and the hideousness of the punished outer shell (e.g. Grünewald); at other times the integral beauty of Christ's body is the guarantee of meaning in the terms that we have suggested.

69 J. Fineman, 'The structure of allegorical desire' (1980), in A. Michelson *et al.* (eds), *October: The First Decade* (Cambridge, Mass. and London, 1987), pp. 373–92. On allegory see W. Benjamin, *The Origin of German Tragic Drama*, trans. J. Osborne (London, 1977) and C. Owens, 'The allegorical impulse: towards a theory of postmodernism', *October*, 12 (1980) 12, pp. 67–86.

70 *Ibid.*, p.375.

71 *Ibid.*, p. 390; see also p. 385.

72 N. Hawthorne, *The Marble Faun* (1st pub. 1860) (London, 1995), p. 336.

Notes to Chapter 2

I would like to thank Adam Free for his assistance in preparing this essay for publication.

1 Louis de Beauffort, *Souvenirs d'Italie par un catholique* (Brussels, 1839), p. 111. Unless otherwise indicated the translations of all primary texts are my own.

2 E. Tietze Conrat, 'Botticelli and the antique', *Burlington Magazine*, xlvii (1925), pp. 124–9, suggested that the poses are based on a Bacchus and Ariadne sarcophagus in the Vatican (no. 173); there is no evidence that this sarcophagus was known at the time, nor was it necessary for Botticelli as a model for his reclining figures, for sources known in Florence, see below, p. 27. J. Dunkerton, S. Foister, D. Gordon and N. Penny, *Giotto to Dürer: Early Renaissance Painting in The National Gallery* (London, 1991), p. 336, note that a statue of a sleeping hermaphrodite, admired in Florence, could have inspired the motif of Mars's foot catching the drapery.

3 For Rio generally, see M. C. Bowe, *François Rio: sa place dans le renouveau catholique en Europe* (Paris, 1938) and J. B. Bullen, *The Myth of the Renaissance in Nineteenth-Century Writing* (Oxford, 1994), pp. 80–90; for Rio's influence in England, see M. Levey, 'Botticelli and nineteenth-century England', *Journal of the Warburg and Courtauld Institutes*, xxiii (1960), p. 295 and R. Lightbown, 'The inspiration of Christian art', in S. Macready and F. H. Thompson (eds), *Influences in Victorian Art and Architecture* (London, 1985), pp. 3–40. See A. M. Ernstrom, '"Why should we always be looking back?" "Christian art" in nineteenth-century historiography in Britain', *Art History*, xxii (1999), pp. 421–35.

4 F. Rio, *De l'Art Chrétienne* (Paris, 1861), vol. i, pp. v, xvii, xviii.

5 Bullen, *The Myth of the Renaissance*, surveys and discusses these conflicting concepts. The most renowned champions of the secular, 'modern', Renaissance are Jules Michelet, who is credited with having made the French word the definitive term in the seventh volume of his *Histoire de France au seizième siècle* dedicated to *La Renaissance* (1855) and Jacob Burckhardt whose *Die Kultur der Renaissance in Italien* (1860) had Michelet's notion that the Renaissance saw 'the discovery of the world, the discovery of man' as one of its central tenets (and the heading of its fourth section).

6 For a wide-ranging consideration of the influence of the antique, with further references, see S. Settis (ed.), *Memoria dell'antico nell'arte italiana*, 3 vols (Turin, 1984–86).

7 For the iconography of the *Madonna del Latte* and its relation to that of the Madonna of Humility, see M. Meiss, *Painting in Florence and Siena after the Black Death* (New York, 1964), pp. 151–2. See further M. Holmes, 'Disrobing the Virgin: the Madonna *Lactans* in fifteenth-century Florentine art', in G. A. Johnson and S. F. Matthews Grieco (ed.), *Picturing Women in Renaissance and Baroque Italy* (Cambridge and New York, 1997), pp. 167–95, for the devotional attitudes and traditions associated with this type and for

the problems inherent in displaying the Virgin's bared breast; also discussed, with different conclusions, by C. W. Bynum, 'The Body of Christ in the later Middle Ages: a reply to Leo Steinberg', *Renaissance Quarterly*, xxxix (1986), p. 407 and M. Miles, 'The Virgin's one bare breast: female nudity and religious meaning in Tuscan early Renaissance culture', in S. Suleiman (ed.), *The Female Body in Western Culture* (Cambridge, Mass., 1986), pp. 193–208.

8 'De uberibus B. Mariae Virginis', quoted from Holmes, 'Disrobing the Virgin', p. 171.

9 For these paintings see M. Quinton Smith, 'The Winter Exhibition at the Royal Academy – I. Paintings of St Fina and of Eve Recumbent', *Burlington Magazine*, civ (1962), pp. 62–6; see also M. T. Filieri (ed.), *Sumptuosa tabula picta. Pittori a Lucca tra gotico e rinascimento*, exhibition, Lucca, Museo Nazionale di Villa Guinigi (Livorno, 1998), pp. 151, 240–1.

10 For this sarcophagus, see L. Becherucci and G. Brunetti, *Il Museo dell'Opera del Duomo* (Florence, n.d.), vol. i, pl. 1, p. 212, no. 2.

11 See R. Krautheimer, *Lorenzo Ghiberti* (Princeton, 1970), vol. ii, pp. 339–40, for this sarcophagus (now in the Museo dell'Opera del Duomo, Florence), which some time after 1395 was incorporated in the tomb of Piero Farnese in the Duomo with the relief facing the wall, but which provided motifs for Ghiberti.

12 G. Schiller, *Iconography of Christian Art* (London, 1971), vol. i, p. 62.

13 See T. Verdon (ed.), *Alla riscoperta di Piazza del Duomo in Firenze*, vol. i, *Dal Battistero al Duomo* (Florence, 1991), p. 34, figure 15, for an illustration of the Baptistery mosaics.

14 G. Boccaccio, 'Teseida', Book 7, verses 63–5, in G. Boccaccio, *Opere Minori in Volgare*, ed. M. Marti (Milan, 1970), vol. ii, p. 467.

15 Boccaccio, 'Chiose al Teseida', in *ibid.*, p. 728.

16 *Ibid.*

17 *Ibid.*

18 Boccaccio, 'Teseida', Book 7, verse 65, p. 467; 'Chiose al Teseida', p. 728.

19 *Ibid.*, p. 708; from the gloss on the visit of Palemone's rival, Arcita, to the temple of Mars (Mars represents the hot-tempered or choleric appetite – the 'appetito irascibile').

20 Ibid., p. 713.

21 For this cult, see Ovid, *Fasti*, trans. J. Frazer (Cambridge and London, 1926), pp. 198–9. See generally R. Schilling, *La Religion romaine de Vénus depuis les origines jusqu'au temps d'Auguste*, 2nd ed. (Paris, 1982). For the fortunes of Venus through the Middle Ages, see F. von Bezold, *Das Fortleben der antiken Götter im mitteralterlichen Humanismus* (Bonn-Leipzig, 1922).

22 *De Rerum Natura*, trans. W. H. D. Rouse, revised by M. F. Smith (Cambridge, Mass. and London, 1982), pp. 2–5; Lucretius died *c.* 55 BC.

23 Cicero, *De Natura Deorum*, trans. H. Rackham (London and New York, 1933), III.xxiii.59, pp. 342–3, lists these, and a fourth, 'conceived of Syria and Cyprus … called Astarte'.

24 G. Boccaccio, *Tutte le opere di Giovanni Boccaccio*, ed. V. Branca (Paris, 1998), vol. vii, *Geneologie deorum gentilium*, Book 3, chapter 22, vol. i, pp. 336–7.

25 Plato, *Symposium*, trans. M. Joyce, in *The Collected Dialogues of Plato*, ed. E. Hamilton and H. Cairns (New York, 1961), pp. 534–5 *(Symposium* 180de).

26 Ficino, *Commentary on Plato's 'Symposium' on Love,* trans. and ed. S. R. Jayne (Dallas, Texas, 1985), Speech 2, chapter 7 ('On the two origins of love and the double Venus'), pp. 53–4; see also Speech 6, chapter 7 ('On the birth of love'), pp. 115–18.

27 Boccaccio, *Geneologie deorum gentilium,* Book 3, chapter 23, pp. 350–9.

28 See J. Chance, *Medieval Mythography: From Roman North Africa to the School of Chartres, A.D. 433–1177* (Gainesville, Florida, 1994), for the development of mythography from its origins in Greek Stoic interpretations of Homer to the time of Boccaccio; see pp. xxxi–xxxvii for a useful chronology of medieval mythographers and commentary authors from the third to the fifteenth centuries.

29 J. Osborne (ed.), *Master Gregorius: The Marvels of Rome* (Toronto, 1987), p. 26. See M. Camille, *The Gothic Idol: Ideology and Image-Making in Medieval Art* (Cambridge and London, 1990), for the distancing mechanism of the 'aesthetic appropriation' of texts and images, with reference to Venus and Master Gregory, pp. 81–5. See below, n. 31, for the identification of the statue.

30 W. Hecksher, 'The *Anadyomene* in the medieval tradition (Pelagia – Cleopatra – Aphrodite). A prelude to Botticelli's "Birth of Venus"', *Nederlands Kunsthistorisch Jaarboek,* vii (1956), p. 33.

31 The name, Cnidian, and the pose are derived from the statue made by the Greek sculptor Praxiteles for the Cnidian sanctuary of Venus on the island of Cos in the fourth century BC. The statue showed Venus nude, at her bath, holding her drapery with her right hand positioned over her breasts, her left over her genitals – hence the later descriptive term *pudica* (modest). Statues of the Cnidian type were known throughout the Middle Ages. See P. P. Bober and R. O. Rubinstein, *Renaissance Artists and Antique Sculpture: A Handbook of Sources* (London, 1989), pp. 59–60 for the 'almost continuous history' of Venus *pudica* types. See N. Salomon, 'The Venus Pudica: uncovering art history's "hidden agendas" and pernicious pedigrees', in G. Pollock (ed.), *Generations and Geographies in the Visual Arts: Feminist Readings* (London and New York, 1996), pp. 69–87, for the canonical status of this form of Aphrodite and its implications for art history

32 LAUDO DEUM VERUM PER QUEM SUNT OPTIMA RERUM\QUI DEDIT HAS PURAS HOMINEM FORMARE FIGURAS. Quoted in full in J. Pope-Hennessy, *Italian Gothic Sculpture* (London and New York, 1972), pp. 177–8.

33 G. Brucker, *Two Memoirs of Renaissance Florence: The Diaries of Buonaccorso Pitti & Gregorio Dati,* trans. J. Martines (New York, 1967), p. 124 (1 January 1404).

34 *Ibid.*

35 For a census see V. Branca, P. Watson and V. Kirkham, 'Boccaccio visualizzato', *Studi sul Boccaccio,* xv (1985–86), pp. 152–3, 156, 158, 162, and E. Callmann, 'Subjects from Boccaccio in Italian painting, 1375–1525', *Studi sul Boccaccio,* xxiii (1995), pp. 37–40. For an analysis of the subjects chosen for illustration and their meanings, see C. Baskins, *'Cassone' Paintings, Humanism, and Gender in Early Modern Italy* (Cambridge and New York, 1998), chapter 1 (*'Le Nozze d'Emilia:* amazons, armed and beautiful'), pp. 26–49. For the moral system of the *Teseida* and Boccaccio's other amorous works, see A. K. Cassell and V. Kirkham, *Diana's Hunt. Caccia di Diana. Boccaccio's First Fiction* (Philadelphia, 1991); V. Kirkham, '"Chiuso parlare" in Boccaccio's *Teseida', Italica,* lxii (1985), pp. 305–51; and R. Hollander, *Boccaccio's Two Venuses* (New York, 1977).

36 *Il Filocolo,* trans. D. Caheney and T. G. Bergin, Garland Library of Medieval Literature, vol. xliii, series B (New York and London, 1985), Book 4, chapter 45, p. 276.

37 Dunkerton *et al., Giotto to Dürer,* p. 336. See further E. H. Gombrich, 'Botticelli's mythologies: a study in the neo-platonic symbolism of his circle', in idem, *Symbolic Images: Studies in the Art of the Renaissance* (London, 1985), pp. 68–9, for this painting as a 'marriage piece' and the question as to whether the wasps (*vespe*) buzzing by Mars's ear might refer to a marriage in the Vespucci family, with the admission of difficulty in finding a Vespucci marriage at a plausible date for this painting (n. 140, p. 216).

38 See for example the treatise by Matteo Palmieri, *Vita civile,* ed. G. Belloni (Florence, 1982), pp. 158–9 (regarding sexual conduct of women) and p. 194 (about well-appointed houses).

39 *Ibid.,* Book 4, p. 159, 'Il fine dell'atto generativo è necessario alla salute delle spezie humane, ma in sé è quanto più può vilissimo, misero et brutto et è certo vilipensione et servitù d'ogni animo degno et giuoco bestiale che merita essere lasciato agli asini'. See also Leon Battista Alberti's discourse on love in Book 2 of his treatise on the family, *I Libri della Famiglia,* ed. R. Romano and A. Tenenti (Turin, 1969), particularly pp. 104–11 for the differences between carnal and conjugal love. Generally regarding sex and gender roles in marriage, see G. Ruggiero, *The Boundaries of Eros: Sex, Crime and Sexuality in Renaissance Venice* (Oxford, 1985), particularly chapters 2 and 3 ('Fornication and then marriage', and 'Adultery: marriage and sex') and M. Rocke, 'Gender and sexual culture in Renaissance Italy', in J. C. Brown and R. C. Davis (ed.), *Gender and Society in Renaissance Italy* (London and New York, 1998), pp. 150–70.

40 For a description of the behaviour provoked by 'la isfrenata voglia della libidine' in a woman, see the story told by the Piovano Arlotto, about his youthful love affair ('diabolically inspired') with a nun of strong carnal appetite, in G. Folena (ed.), *Motti e Facezie del Piovano Arlotto* (Milan and Naples, 1953), no. 75, pp. 116–17. Palmieri, *Vita civile,* p. 159, describes the duty of a wife to avoid any sort of movement that would seem that of a public whore. For such gestural codes, see S. Fermor, 'Movement and gender in sixteenth-century Italian painting', in K. Adler and M. Pointon (ed.), *The Body Imaged: The Human Form and Visual Culture Since the Renaissance* (Cambridge and New York, 1993), pp. 129–46. For the issues of female honesty and family honour, see J. Kirshner, *Pursuing Honor While Avoiding Sin: The Monte delle Doti of Florence* (Milan, 1978).

41 From the *Mitologiae,* II, 7, of Fulgentius (468–533), quoted by K. Heinrichs, *The Myths of Classical Lovers in Medieval Literature* (University Park, Pa. and London, 1990), p. 89, who notes that variants of this formulation are found in every subsequent major medieval mythographer. See also Kirkham, '"Chiuso parlare"', p. 328 and n. 39, pp. 347–8.

42 As in his description of the achievements of the painters of his second age in the Preface to Part 2, *Le Vite de' più eccellenti pittori scultori e architettori nelle redazioni del 1550 e 1568,* ed. R. Bettarini and P. Barocchi, vol. iii (Florence, 1966–87), p. 19 ('cercaron far quel che vedevano nel naturale') and of the artists of the third age in the Preface to Part 3, *ibid.,* vol. iv (1976), pp. 6–7.

43 Gombrich, 'Botticelli's mythologies', pp. 32–3. This opinion of Botticelli and the connection of his works with a vogue for pagan subjects in Laurentian Florence refers to an established tradition see, for example, J. Burckhardt, *Der Cicerone* (Basel, 1855), p. 801 and J. A. Crowe and G. B. Cavalcaselle, *A History of Painting in Italy* (London, 1864), vol. ii, pp. 414, 418–19.

44 For the 'veil of poetry', see Boccaccio, *Geneologie deorum gentilium,* preface and Book 14 (his defence of poetry); Boccaccio's 'poetic tactics', his role as 'poet-allegorist' are discussed by Cassell and Kirkham, *Caccia di Diana,* pp. 63–8. For intepretations of Botticelli, see Gombrich, 'Botticelli's mythologies' and C. Dempsey, *The Portrayal of Love: Botticelli's 'Primavera' and Humanist Culture at the Time of Lorenzo the Magnificent* (Princeton, 1992), pp. 3–19.

45 E. Panofsky, *Renaissance and Renascences in Western Art* (New York, 1972), pp. 111–12.

46 *Ibid.,* pp. 187–8, quoting Boccaccio's *Ameto,* where Venus is addressed as 'Santa Venere' and 'sanctissima dea' and a poem by Lorenzo Buonincontri, one of Ficino's friends.

47 *Ibid.,* p.210.

48 *Ibid.,* p. 113, for the permanence of the Renaissance and its relation to what Panofsky calls 'our civilization'.

49 For this 'problem', see, for example: J. Huizinga, 'Renaissancestudiën, I: Het probleem', *De Gids,* vol. lxxxiv (1920), Part Four, pp. 107–33, 231–55 ('The problem of the Renaissance', in idem, *Men and Ideas: Essays on History, the Middle Ages, the Renaissance,* trans. J. S. Holmes and H. van Marle (New York, 1959), pp. 243–87); W. K. Ferguson, *The Renaisssance* (New York, 1940), p. 2, describing the Renaissance as 'the most intractable problem child of historiography', which he later sought to resolve in his book on *The Renaissance in Historical Thought* (Boston, 1948), not, evidently, to universal satisfaction; D. Cantimori, 'La periodizzazione dell'età del rinascimento' in *Studi di storia* (Turin, 1959), pp. 340–65; W. L. Gundersheimer (ed.), *The Italian Renaissance* (Englewood Cliffs, NJ, 1965); A. Buck (ed.), *Zu Begriff und Problem der Renaissance* (Darmstadt, 1969); M. Ciliberto, *Il Rinascimento. Storia di un dibattito* (Florence, 1975); W. J. Bouwsma, 'The Renaissance and the drama of Western history', *American Historical Review,* lxxxiv (1979), pp. 1–15; D. Hay, 'Historians and the Renaissance during the last twenty-five years', in idem, *Renaissance Essays* (London, 1988), pp. 103–32; P. Findlen and K. Gouwens, 'The persistence of the Renaissance', *American Historical Review,* ciii (1998), pp. 51–4.

50 P. Holberton, 'Botticelli's *Hypnerotomachia* in The National Gallery, London: a problem of the use of classical sources in Renaissance art', *Illinois Classical Studies,* ix (1984), pp. 150–82, particularly pp. 156–7, 180–1, points out and discusses the problems of identification. He interprets the painting as a statement about love, a pictorial caprice (using Vasari's term *capriccio)* 'belonging to a general class of love pictures' (p. 171), not a mythological narrative, but 'a kind of battle in a dream occasioned by love … the 'earliest surviving *fête champêtre'* (pp. 181–2), using classical literary sources but also indebted to the vernacular tradition of love poetry. C. Dempsey, 'Lorenzo's *Ombra*', in G. C. Garfagnini (ed.), *Lorenzo il Magnifico e il suo mondo* (Florence, 1994), pp. 341–55, maintains the protagonists as Mars and Venus, but gives the dream a more sinister tone, as 'a nightmare phantasm of the *ombra'* (p. 355), where Mars, possessed by the nightmare (*ombra*) of Venus, is assailed by a panic terror, a soul lost in a state of sensual confusion and panicky uncertainty' (p. 346). For a digest of sources and of the varying interpretations of the painting, see R. Lightbown, *Sandro Botticelli* (London, 1978), vol. ii, pp. 56–8, and vol. i, pp. 90–5, for his own analysis of the painting as a 'commonplace of connubial gallantry' transmuted into a poetic vision, and 'attempting to re-create or rival lost paintings' from antiquity.

51 Ficino, *Commentary,* Speech 5, chapter 8, p. 97. This passage was specifically related to Botticelli's painting by N. Robb, *Neoplatonism of the Italian Renaissance* (London, 1935), p. 218, and the connection was developed by Gombrich, 'Botticelli's mythologies', pp. 66–9, who discusses the panel as a moralising marriage piece.

52 Lucian, *Herodotus or Aëtion,* in *Lucian,* trans. A. M. Harmen Kilburn (London and Cambridge, Mass., 1959), vol. vi, pp. 147–9

53 *Ibid.,* pp. 148–9.

54 As described by Horace in *The Art of Poetry,* in Horace, *Satires, Epistles and Ars Poetica,* trans. H. R. Fairclough (Cambridge, Mass., 1978), pp. 468–9 (line 226).

55 Poliziano, *Rusticus,* in *Silvae,* ed. F. Bausi (Florence, 1996), lines 320–32, pp. 76–7. The section ends with a description of love, music and scented flowers, as tribute offered to Venus and pleasure – the fount of life – little known to the city ('semper amor, semper cantus et fistula cordi est, semper odorati Venerisque stipendia flores, vitarumque altrix urbi male nota voluptas'). The poem was dedicated to Jacopo Salviati, who, as the dedication notes, was engaged to Lorenzo de' Medici's daughter; it was, according to its concluding verses praising Lorenzo, written at the Medici villa at Fiesole. In the dedication Poliziano describes himself as a 'client and student' ('cliens alumnusque') of Lorenzo. For the 'political-cultural' context of this densely philological poem and its companions in the *Silvae,* which were intended as examples of modern learning and composed and publicly recited at the inaugural lectures of Poliziano's courses at the Florentine university between 1482 and 1486, see Bausi's introduction to his edition, pp. xi–xxxi.

56 For a concise discussion of these traditions, see D. N. Devries, 'Fathers and sons: patristic exegesis and the castration complex', in R. Trexler (ed.), *Gender Rhetorics: Postures of Dominance and Submission in History* (Binghamton, NY 1994), pp. 33–45. For a more extensive consideration of sexual roles and definitions of sexuality, see J. A. Brundage, *Law, Sex and Christian Society in Medieval Europe* (Chicago, 1987).

57 D. Quint (trans.), *The Stanze of Angelo Poliziano* (Amherst, Mass., 1979), Book 1, verse 43, pp. 22–3. The poem was begun in 1475 as a celebration of Giuliano's joust; left unfinished after Giuliano's assassination in the 1478 Pazzi conspiracy, Poliziano revised it sometime after 1479. For these dates and a 'sombre' reading of the *Stanze,* relating the poem to the historical circumstances of its composition, see C. Dempsey, 'Portraits and masks in the art of Lorenzo de' Medici, Botticelli, and Politian's *Stanze per la Giostra',* *Renaissance Quarterly,* lii (1999), pp. 27–39.

58 *Ibid.,* Book 1, verse 44, pp. 22–3.

59 *Ibid.,* Book 1 verse l6, pp. 8–9 and Book 2, verse 46, pp. 90–1.

60 J. W. Cook (ed.), *The Autobiography of Lorenzo de' Medici the Magnificent: A Commentary on My Sonnets* (Binghamton, NY, 1995), pp. 34–5.

61 *Ibid.,* pp. 86–7 (commentary to sonnet 6).

62 *Ibid.,* pp. 98–101 (commentary to sonnet 9) and pp. 120–1 (commentary to sonnet 13).

63 *Ibid.,* pp. 100–1

64 With regard to the circulation of ideas of beauty, see Jayne's remarks on the appeal and influence of Ficino's commentary on Plato's *Symposium,* in Ficino, *Commentary,* pp. 19–23. See also P. Lorenzetti, *La bellezza e l'amore nei trattati del cinquecento* (Pisa, 1922). For an anthology of the contemporary treatises on beauty and love, see M. Pozzi (ed.), *Trattati d'amore del Cinquecento* (Rome and Bari, 1980); for further treatments of

changes in the relationship between beholders and works of art in the Renaissance, see J. Shearman, *'Only Connect …' Art and the Spectator in the Italian Renaissance* (Princeton, 1992) and C. Hulse, *The Rule of Art: Literature and Painting in the Renaissance* (Chicago and London, 1990).

65 Vasari, *Le vite,* vol. vi, p. 69 (translation quoted from G. Du C. de Vere, *Lives of the Most Eminent Painters, Sculptors and Architects by Giorgio Vasari* (London, 1912–15), vol. ix, p. 56). See Adler and Pointon, *The Body Imaged,* for reflections on the long-term results of this process for Western art and art history. With particular reference to the Renaissance Venus as a canonical figure, see T. J. Clark, 'Olympia's choice', in R. Goffen (ed.), *Titian's 'Venus of Urbino'* (Cambridge and New York, 1997), pp. 129–45 and J. Shaw, chapter 5 in this volume.

66 For discussions and instances of this process, see: C. Ginzburg, 'Tiziano, Ovidio e i codici della figurazione erotica nel '500' and D. Rosand, 'Ermeneutica amorosa: observations on the interpretation of Titian's Venuses', both in *Tiziano e Venezia: Convegno Internazionale di Studi, Venezia, 1976* (Venice, 1980), pp. 125–35, 375–81; M. Pardo, 'Artifice as seduction in Titian', in J. G. Turner (ed.), *Sexuality and Gender in Early Modern Europe. Institutions, Texts, Images* (Cambridge and New York, 1993), pp. 55–89; D. Rosand, 'So-and-so reclining on her couch', in Goffen (ed.), *Titian's 'Venus of Urbino'*, pp. 37–62; B. L. Talvacchia, *Taking Positions: On the Erotic in Renaissance Culture* (Princeton, 1999).

67 L. Febvre, 'Civilisation: évolution d'un mot et d'un group d'idées', in idem, *Pour une histoire à part entière* (Paris, 1962), pp. 481–528.

Notes to Chapter 3

A preliminary version of this paper was presented at the conference *Lust en liefde verbeeld* held at the Museum Boymans–van Beuningen in collaboration with the Huizinga Instituut on 3 June 1998. I am most grateful for the comments that I received there. I have also found participation in the Courtauld Institute research group through which this book has been developed enormously helpful. I owe a particular debt to the book's editors, Katie Scott and Caroline Arscott.

1 Paris, Musée du Louvre, inv. no. R.F. 1982–5. Canvas, 180 x 150 cm., signed and dated, on the rock, beside the chain, 'Joachim wte/wael fecit/Anno 1611': A. Lowenthal, *Joachim Wtewael and Dutch Mannerism* (Doornspijk, 1986), pp. 130–1, colour plate XVII.

2 Rotterdam, Museum Boymans–van Beuningen. Panel, 30 x 47 cm., signed below, in the centre, 'B. van der Ast': E. Meijer, *Stillevens uit de Gouden Eeuw. Eigen collectie Museum Boymans–van Beuningen Rotterdam* (Rotterdam, 1989), pp. 52–3, with colour plate. For Wtewael's identification with mannerism, and a nuanced discussion of the style, see Lowenthal, *Wtewael,* p. 55. For a textbook definition in which Dutch mannerism is assimilated to classical idealisation, see S. Slive, *Dutch Painting 1600–1800* (New Haven and London, 1995), p. 7.

3 Ovid, *Metamorphoses* IV, lines 671–765. Loeb Classical Library, *Ovid in Six Volumes. III. Metamorphoses,* trans. F. J. Miller, 3rd ed. revised by G. P. Goold, 2 vols (Cambridge and London, 1977), vol. 1, pp. 225–33 (hereafter Loeb). E.-J. Sluijter, *De 'Heydensche Fabulen' in de Noordnederlandse Schilderkunst, c. 1590–1670* (Enschede, n.d. (1986)) demonstrates that Ovidian myths were very well known to

seventeenth-century artists and viewers. See especially p. 22 and Appendix 1, pp.
295–339 for illustrated vernacular translations of and glosses on the *Metamorphoses.*

4 J. D. Reid, with the assistance of S. Rohmann, *The Oxford Guide to Classical Mythology
in the Arts, 1300–1990s,* 2 vols (Oxford, 1993), vol. 1, p. 875.

5 E. McGrath, 'The black Andromeda', *Journal of the Warburg and Courtauld Institutes*
55, (1992), pp. 1–6, esp. p. 3.

6 S. Segal, 'Shell still life', in exhibition catalogue, *A Prosperous Past. The Sumptuous
Still Life in the Netherlands,* ed. W. Jordan (The Hague, Fort Worth and Cambridge,
Mass., 1988), pp. 77–92. See esp. pp. 78–9 for a 2,000-line didactic poem written by
Philibert van Borsselen in 1611 (the date of *Perseus and Andromeda*) and published in
1614, praising the variety of shells as evidence of the fertility of the creator.

7 K. van Mander, *Het Schilder–boeck* (Haarlem, 1603–4) *Wttelegghingh op den
Metamorphosis Pub. Ovidij Nasonis,* fol. 30r., quoted in E.–J. Sluijter, 'Venus, Visus en
Pictura', *Nederlands Kunsthistorisch Jaarboek,* 42–3 (1991–92), pp. 337–96, p. 365 (my
translation). For shells as attributes of Venus, see G. de Terverant, *Attributs et symbols
dans l'art profane 1450–1600; Dictionnaire d'un langage perdu,* 3 vols (Geneva,
1958–64), vol.1, col. 114.

8 Sluijter, 'Venus', pp. 364–5, figure 270. Panel, lozenge, 69 x 70 cm., Mannheim, collec-
tion Armin Pertsch. This picture, dated by Sluijter after 1604 and before Goltzius's
death in 1617, was roughly contemporary with *Perseus and Andromeda.* As Sluijter
notes, the figure is identified as Venus by the rose at her breast, as well as the shell.

9 C. Natival, 'Andromède aux rivages du Nord: Persée delivrant Andromède de
Joachim Wtewael', in F Siguret and A. Laframboise (eds), *Andromède ou le héros à
l'épreuve de la beauté,* Actes du colloque international organisée au Musée du Louvre
par l'université de Montréal et le Service Culturel du Musée du Louvre les 3 et 4
février 1995 (Paris, 1996), pp. 143–71, figure 10 and A. Lowenthal, in exhibition
catalogue, *Masters of Light: Dutch Painters in Utrecht during the Golden Age* (San
Francisco, Baltimore and London 1997–98), p. 288, independently note similarities
between Wtewael's *Perseus and Andromeda* and a print of the same subject of 1601
by Jan Saenredam after Hendrick Goltzius.

10 London, National Gallery, inv. no. 6334. Panel 59.7 x 79.1 cm., signed and dated 'Jo [in
monogram] wte wael/fecit Ano 1615'. The similarity between the principal shells in the
two paintings was noticed in A. Lowenthal, *The Paintings of Joachim Anthonisz. Wtewael
(1566–1637)* (Ph.D. thesis, Columbia University, 1975, Ann Arbor, 1980), p. 287.

11 The shell at Andromeda's feet seems to be a *Turbo Marmoratus* from the Indian
Archipelago, whilst the other shell is probably a *Nautilus Pompilius.* For contemporary
symbolic use of shells *in bono* and *in malo,* see Segal, *Prosperous Past,* pp. 77–8.

12 For the Nereides, see J. Lemprière, *Lemprière's Classical Dictionary* (London, 1994; 1st
pub. 1788), p. 438, with references to the classical sources. For an interpretation of the
Nereids in antiquity as guides of the soul to immortality, see E. Panofsky, *Tomb
Sculpture. Its Changing Aspects from Ancient Egypt to Bernini* (London, 1964), p. 22,
note 1.

13 See note 6 for contemporary interest in shells. Lowenthal, *Wtewael,* p. 131, suggests
that the bones may be references to the horrors of the recent Dutch war with Spain.

14 The relationship of the iconography to the Ovidian text is also analysed by Natival,
Andromède, pp. 147–8. The identification of the tower with a city is confirmed by the
inclusion of a very similar motif in Wtewael's depiction of *Belgica and Prince Maurice of*

Orange at the City Gates from his series of pen drawings allegorising the History of the Netherlands. Vienna, Graphisehe Sammlung Albertina: Lowenthal, *Wtewael*, plate 135. Cf. E. McGrath, 'A Netherlandish history by Joachim Wtewael', *Journal of the Warburg and Courtauld Institutes*, 37 (1975), pp. 182–217.

15 U. Reinhardt, 'Andromeda und Angelica. Zum Motiv Köningsdocter–Held– Ungeheuer in der literarischen und bildlichen Tradition des Abendlandes', *Die Rezeption der Metamorphozen des Ovid in der Neuzeit: Der Antike Mythos in Text und Bild*, Internationales Symposion de Werner Reimers–Stiftung Bad Hamburg v.d. H 22–25 April 1991 (Berlin, 1995), pp. 193–213, esp. p. 203.

16 Lowenthal, *Wtewael*, p. 131. Sluijter, 'Heydensche Fabulen', p. 48, notes that *Perseus and Andromeda* was the most popular Ovidian subject in Netherlandish prints in the late sixteenth and early seventeenth century, although paintings were relatively rare.

17 For the Dutch Maid, a Marian figure in an enclosed garden which represented the Netherlands, see P. J. van Winter, 'De Hollandse Tuin', *Nederlands Kunsthistorisch Jaarboek*, 8 (1957), pp. 29–121, esp. pp. 59ff.

18 These ideas have been extensively discussed, especially in relation to Titian's so-called *Sacred and Profane Love* (c. 1515). For example, E. Panofsky, *Problems in Titian, Mostly Iconographic* (New York, 1969), pp. 109, 115–19. In summary, Plato in the *Symposium* distinguishes between a celestial and an earthly or 'vulgar' Venus. In 'De Amore', the influential commentary on the *Symposium* by the fifteenth-century Florentine Neo-platonist Marsilio Ficino, celestial Venus is said to have been born from the sea and led to a realm beyond sensory perception, whilst earthly Venus was generated naturally and governed the world accessible to the senses, especially the realm of sight: 'Both Venuses are honourable and praiseworthy, for both pursue the procreation of beauty, though each in her own way.' However, followers of Plato also distinguished a third, negative kind of love, *amor ferinus* or *amor bestiale*, which was confined to the domain of touch: M. Ficino, *In Convivium Platonis Commentarium*, II, 7 and VI, 7, *Opera omnia*, pp. 1326ff. and 1344ff. For knowledge of the two Venuses in the Netherlands, see Van Mander, *Schilder–boeck*, Wttelegghingh, fol. 30r.

19 York, City Art Gallery, inv. no. 902. Panel 71.7 x 55.2 cm., signed and dated 'Jo [in monogram] wte/wael fecit Ano 1628'.

20 Lowenthal, *Wtewael*, p. 157.

21 See note 18.

22 G. Saunders, *The Nude. A New Perspective* (London, 1989), pp. 91–115. Segal, *Prosperous Past*, p. 84, states that tropical shells were brought to Holland from the Far East in the ships of the Dutch East India Company. Lowenthal, *Wtewael*, p. 31, mentions that the artist had shares in this company.

23 A. de Vries, *Dictionary of Symbols and Imagery* (Amsterdam and London, 1974), p. 100, with textual references.

24 Ovid, *Metamorphoses*, IV, lines 697–8. This translation from M. M. Innes (intro, and trans.), *The Metamorphoses of Ovid* (London, 1955), p. 112. The Danäe story was treated at least once by Wtewael, c. 1606–10, Paris, Musée du Louvre, inv. no. R.F. 1979–23.

25 J. L. Van Zanden, *The Rise and Decline of Hollands Economy* (Manchester, 1993), pp. 29–43; J. de Vries, *European Urbanization, 1500–1800* (Cambridge, 1984), pp. 116–18 and 168–71.

26 For a succinct account of the theory of Forms or Ideas propounded in Plato's *Republic*, see R. Gregory (ed.), *The Oxford Companion to the Mind* (Oxford and New York, 1987), p. 629.

27 Lowenthal, *Masters of Light*, pp. 288–9. See also Lowenthal, *Wtewael*, p. 55 and note 9, and C. Swan, *'Ad vivum, naer het leven*, from the life: defining a mode of representation', *Word and Image*, 11, 4 (October–December 1995), pp. 353–72, esp. pp. 354–8, with further references. For seventeenth-century usage of *naer het leven* and *uyt den geest*, see L. de Pauw-de Veen, *De Begrippen 'schilder', 'schilderij' en 'schilderen' in de Zeventeinde Eeuw* (Brussels, 1969), p. 214.

28 Utrecht, Centraal Museum, inv. no. 359. Canvas, 116 x 160 cm., *c.* 1618.

29 See also, Lowenthal, *Wtewael*, colour plate IV, *Lot and his daughters, c.* 1597–1603, Los Angeles County Museum of Art; colour plate XI, *Mars and Venus Surprised by Vulcan, c.* 1606–10, Malibu, John Paul Getty Museum; colour plate XXIII, *Caritas, c.* 1620–28, private collection.

30 Lowenthal, *Masters of Light*, p. 289 and p. 427, note 7.

31 For the shells see p. 41. For the artist's probable ownership of the picture, see p. 52.

32 For the *kunstkamer* in the Netherlands, see especially E. Bergvelt and R. Kistemaker (eds), *De Wereld binnen handbereik: Nederlandse kunst en rariteitenverzamelingen 1585–1735* (Amsterdam, 1992).

33 According to Ovid, Andromeda was the only sacrifice.

34 C. Grayson (ed. intro. transl.), *Leon Battista Alberti on Painting and on Sculpture. The Latin Texts of De Pictura and De Statua* (London, 1972), p. 83, para 42: 'Then I like there to be someone in the *historia* who tells the spectators what is going on, and either beckons them with his hand to look, or with ferocious expression and forbidding glance challenges them not to come near, as if he wished their business to be secret, or point to some danger or remarkable thing in the picture, or by his very gestures invites you to laugh or weep with them.' On knowledge of Alberti's text in early seventeenth-century Netherlands, see W. Melion, *Shaping the Netherlandish Canon. Karel van Mander's Schilder–Boeck* (Chicago and London, 1991), p. 8.

35 R. Klibansky, E. Panofsky and F. Saxl, *Saturn and Melancholy. Studies in the History of Natural Philosophy, Religion and Art* (London, 1964), esp. pp. 286–9; for the head in hand gesture: C. Ripa, *Iconologia, of Uytbeeldinghe des verstants* (Amsterdam, 1644), pp. 499–500, *Malincolia* and p. 398, *Meditatione*. For the hand on heart as a gesture of love: *ibid.*, p. 295, *Amor verso Iddio*. Notice also the resemblance between this figure of the Love of God and *Andromeda*.

36 J. Kristeva, *Powers of Horror. An Essay on Abjection*, trans. L. Roudiez (New York, 1982), pp. 1–18. See also E. Grosz, 'The body of signification', in J. Fletcher and A. Benjamin (eds), *Abjection, Melancholia and Love: The Work of Julia Kristeva* (London, 1990), pp. 80–103, esp. pp. 86–93.

37 On Pegasus's origin, see Ovid, *Metamorphoses* IV, lines 770–86 (Loeb edition, p. 233). On his unauthorised but quite conventional presence in representations of Perseus and Andromeda, see Natival, 'Andromède', pp. 149–50

38 See p. 66.

39 H. Miedema, 'Over kwaliteitsvoorschriften in het St. Lucasgilde; over 'doodverf', *Oud Holland*, 101 (1987), pp. 141–7.

40 Lemprière, *Dictionary*, p. 53, with references to the classical sources.

41 On the significance of sculptural references in the depicted nude, compare L. Nead, *The Female Nude. Art, Obscenity and Sexuality*, (London and New York, 1992), pp. 8–9.

42 Ovid, *Metamorphoses,* IV, lines 743–53 (Loeb edition, p. 231).

43 P. Stallybrass and A. White, *The Politics and Poetics of Transgression* (London, 1986), pp. 1–6.

44 R. Lee, *Ut Pictura Poesis. The Humanistic Theory of Painting* (New York, 1967), p. 11 re Ludovico Dolce. For knowledge of these ideas in the Netherlands, H. Miedema (ed. and comm.), *Karel van Mander. The Lives of the Illustrious Netherlandish and German Painters,* 6 vols (Doornspijk, 1994–), vol.2, pp. 298–9 (commentary on fol. 208r.30–31) and vol. 3, p. 271 (commentary on fol. 334r.36).

45 Lowenthal, *Wtewael,* p. 36, citing G. J. Hoogewerff and J. Q. Regteren Altena, *Arnoldus Buchelius 'Res Pictoriae': aantekeningen over kunstenaars en kunstwerken, 1583–1639* (The Hague, 1928), pp. 75–6.

46 Ovid, *Metamorphoses,* IV, lines 676 and 738–9 (Loeb edition, pp. 227 and 231).

47 London, Wallace collection. Canvas, 183 x 199 cm., documented 1554–6. Lowenthal, *Wtewael,* p. 131, points out that the design of Titian's painting was disseminated in a print by G. B. Fontana, in which the horizontal format has been rendered vertical, like that used by Wtewael for *Perseus and Andromeda.*

48 P. L. Rubin, *Giorgio Vasari: Art and History* (New Haven and London, *c.* 1995), pp. 241–5.

49 J. Muller, 'The Perseus and Andromeda on Rubens's house', *Simiolus,* 12 (1981–82), pp. 131–46, esp. p. 143.

50 In F. de Holanda, *Da Pintura Antiga e Diálogos em Roma* (1549), for example, the king's task of leading his army into battle is compared with the assault on nature mounted by the painter motivated by love in the sense of the satisfaction of his own desire. The military commander 'never slew an enemy harder to overcome than it is for the work of a great painter to correspond to his desire or ideal [...]': Francisco de Holanda, *Four Dialogues on Painting* remained unpublished. It was published in an English translation by A. F. G. Bell (London, 1928). This quotation is from pp. 14–15. For the persistence of this metaphor in sixteenth- and seventeenth-century Netherlands, see Melion, *Van Mander,* p. 176 and C. Brusati, *Artifice and Illusion. The Art and Writing of Samuel van Hoogstraten* (Chicago and London, 1995), pp. 228–30. Compare Natival, 'Andromède', p. 156.

51 Van Mander, *Schilder-boeck,* preface, unpaginated, translated and quoted in Brusati, *Artifice and Illusion,* p. 230.

52 See, for example, Z. Z. Filipczak, *Picturing Art in Antwerp 1530–1700* (Princeton 1987), p. 70.

53 For the etymology of the term *schilder,* see Lowenthal, *Wtemael,* p. 34, and M.-J. Bok, 'Artists at work: their lives and livelihoods', Lowenthal in *Masters of Light,* pp. 86–99, explanation on p. 91. For a summary of the historical analogy between pictures and mirrors, J. Woods-Marsden, *Renaissance Self-Portraiture. The Visual Construction of Identity and the Social Status of the Artist* (New Haven and London, 1998), pp. 31–4. See also the pioneering articles by H. Schwarz, 'The mirror in art', *Art Quarterly,* 15 (1952), pp. 97–118 and 'The mirror of the artist and the mirror of the devout', in *idem, Studies in the History of Art dedicated to William Suida* (London, 1959), pp. 90–105.

54 Compare the shells used by the figure of Marcia painting her own portrait in the fifteenth-century French miniature from Boccaccio, *De Claribus Mulieribus* 1402, MS Fr. 12420 f. 101v. Paris, Bibliothèque Nationale. See also the inclusion of shells, presumably as containers for paints, in plate 14 ('Color Olivi') of the *Nova Reperta c.* 1600.

Shells appear together with paintbrushes in Joris Hoefnagel's miniature, *Hermathena.
Allegorical Scene Dedicated to Abraham Ortelius* 1593, Antwerp, Stedelijk prentenk-abinet, inv. no. 535.

55 Natival, 'Andromède', *passim*. I came across this article after having completed the pre-liminary version of this text and greatly benefited from its observations and erudition.

56 *Ibid.*, p. 154; H. Miedema (ed., trans. and comm.), *Karel van Mander, Den grondt der edel vry schilder–const* 2 vols (Utrecht, 1973), vol. 1, pp. 140–1 (chapter V, *Van der ordi-nanty ende inventy der historien*, fol. 18v., verse 43), vol. 2, p. 482.

57 Natival, 'Andromède', p. 153, also notes polysemy as a striking feature of the painting; A. S. Byatt (intro.), *The Song of Solomon* (Edinburgh, 1998), *passim*. I am grateful to Katie Scott for this reference.

58 Van Mander, *Schilder-boeck, Wttelegghinge, Voor-reden,* unpaginated (pp. 5–6).

59 Byatt, *Solomon*, p. viii.

60 The illustration is from the edition of *Proteus* published in Rotterdam in 1627, pp. 6–7. G. A. Bredero provides a literary instance of this inclusivity. Most famous for his 'vulgar' or 'realist' verse, he ordered his poetic output into humorous, amorous and serious themes: G. A. Bredero, *Boertigh, amoreus, en aendachtigh Groot Lied-boeck* ... (Amsterdam, 1622).

61 On the pun and the word, see Stallybrass and White, *Transgression*, p. 11. The unending darkness and chaos at the heart of this process of change was also acknowl-edged. The frontispiece to Van Mander's *Wtlegghinge* shows two figures not mentioned by Ovid: the serpent biting its tail as a symbol of eternity and Demogorgon, the father of the Gods. According to Spenser in the *Faerie Queen* (1596), II, 47: 'Down in the bottom of the deepe Abysse/where Demogorgon in full darkness pent/Farre from the view of Gods and heaven's blisse/The hideous Chaos keeps, their dreadful dwelling is.' These references from W. L. Strauss (ed.), *The Illustrated Bartsch 3 (Commentary). Netherlandish Artists. Hendrick Goltzius* (New York, 1982), esp. p. 264 (print 0301.238. *The Cave of Eternity*). See also pp. 259–65 for the children of Demogorgon, all alluding to the legend of Proserpine, who spent half the year underground and half above.

62 J. Israel, *The Dutch Republic. Its Rise, Greatness and Fall, 1477–1806* (Oxford, 1995), pp. 328–98.

63 J. Derrida, 'Parergon', in *The Truth in Painting*, trans. G. Bennington and I. McLeod (Chicago and London, 1987), pp. 16–82. See also V. Stoichita, *The Self-Aware Image. An Insight into Early Modern Meta-Painting* (Cambridge, 1997), pp. 17–29.

64 G. Bataille, *Eroticism*, trans. M. Dalwood (London and New York, 1987; 1st pub. 1957), pp. 12–15.

65 Lowenthal, *Wtewael*, p. 131 and pp. 187–8, doc. 95, 'Inventory of jewels, gold and sil-verwork, painting, furniture and so forth, belonging to Jacob Martens and Aletta Pater [the daughter of Wtewael's daughter Antonietta], made January 1669', no. 3. For pos-sible previous provenances of the picture, *ibid.*, pp. 191–2, doc. 121 (1656 inventory of the estate of Antonietta and her husband Johan Pater), no. 2; pp. 193–6, doc. 124 (1661 inventory of the estate of Joachim's son Pieter, who was also a painter), no. 19. *Ibid.*, cat. B–4, plate 139, a variant on *Perseus and Andromeda* attributed to Pieter, also suggests that the original picture may have remained in the family.

66 For a map showing the location of Wtewael's house in Utrecht, see Bok, 'Artists at work', pp. 88–9. The 1661 inventory of the estate of Joachim's son Pieter lists a number of works

which seem likely to have been inherited from his father: see Lowenthal, *Wtewael*, pp. 193–6, doc. 124.

67 J. M. Muller, *Rubens. The Artist as Collector* (Princeton, 1989), pp. 48–63.

68 J. van der Veen, 'Liefhebbers, handelaren en kunstenaars', in Bergvelt and Kistemaker, *De Wereld*, pp. 117–34; H. Coomans, 'Schelpenverzamelingen', in *ibid.*, pp. 192–203; and E. Honig, 'The beholder as work of art: a study in the relocation of value in seventeenth-century Flemish painting', in *Beeld en zelfbeeld in de Nederlandse kunst 1550–1750. Nederlands Kunsthistorisch Jaarboek*, 46 (1995), pp. 253–97, esp. pp. 275–81.

69 Van Mander, *Schilder-boeck*, fol. 296v (trans. Miedema, *Lives*, vol. 1, pp. 444–5).

70 For the relationship between *liefhebber* and *liefde* (love), see M. de Vries and L. Te Winkel *et al.*, *Woordenboek der Nederlandsche Taal*, 29 vols (The Hague, Leiden and Arnhem, 1964–1996), part 8, section 2 (1924) cols. 2103–7 and *Dictionarium Tetraglotton, Sell Voces Latinae Omnes, et Graecae eis respondentes, cum Gallica & Teutonica, quam passim Flandri eam vocant earum interpretatione* (Antwerp (William Silvÿ), 1562). 15v., entries for 'Amator, Amoreus: celui qui aime, Boeler, Vrÿer, Liethebber' 16r., 'Amo … are: Aimer, Liefhebben, Beminnen'. See also A. Madoets *et al.*, *Thesaurus Theutonicae Linguae. Schat der Neder-duytscher spraken* (Antwerp (C. Plantÿn), 1562), unpaginated, entries for 'Liefhebben/lieven: Aimer, avoir cher. Amare, adamare, diligere, aliquem charum habere, operam dare amori', 'Liefhebber: Amateur. Amator, dilector'.

71 Rotterdam, Museum Boymans–van Beuningen, canvas, 107 x 82.7 cm.

72 The term *liefhebber* was used to indicate enthusiasm in a variety of different fields. In the sphere of art, it was generally qualified; for example *liefhebber der schilderijen, konstliefhebber, Constliefdighen Heeren.*

73 Honig, 'Beholder', pp. 275–81; Filipczak, *Picturing Art in Antwerp*, pp. 47–57 and 69–70.

74 *Ibid.*, pp. 69–70.

75 J. Woodall, 'Love is in the air: amor as motivation and message in seventeenth-century Netherlandish painting', *Art History*, 19, 2 (June 1996), pp. 208–64, esp. p. 225.

76 For illustrated examples, see Filipczak, *Picturing Art in Antwerp*, figures 2, 3, 34, 64. *Liefhebbers* were also included in Van Dyck's so-called *Iconography*, a series of portrait prints of elite figures in which the dominant category was Antwerp artists. For seventeenth-century translations of *liefhebber* as *amateur*, see Filipczak, *Picturing Art in Antwerp*, p. 70, note 39.

77 K. Thomassen *et al.*, exhibition catalogue, *Alba Amicorum, Vijf Eeuwen Vriendschap op Papier Gezet: Het Albuni Amicorum en het Poëzie-Album in de Nederlanden* (The Hague, 1990), *passim*. For Van Mander's readership, see Melion, *Van Mander*, p. 14 and p. 203, note 4.

78 Woodall, *Love*, pp. 217–21. The extension of this claim to the *liefhebber* is implicit in a poem on the subject by the painter Cornelis Ketel of Gouda, quoted in *ibid.*, pp. 219–20. The opening lines, 'Three things induce *everyone to learn the arts* most of all [my italics]; the one is money, the second honour and the third love of art …' do not limit the *topos* to the practitioner; all are included within a project defined in terms of the acquisition of knowledge rather than practical mastery. The verse appears in Van Mander, *Schilder-boeck*, fol. 276r. (trans. Miedema, *Lives*, vol. 1, p. 362).

79 In 1628, his elder brother Johan was to become a burgomaster and in 1610, the year preceding *Perseus and Andromeda*, Joachim himself took part in a *coup* staged by a

coalition of Calvinists and Catholics aimed at limiting the hereditary nobility's influence over the government of Utrecht. For Wtewael's biography, see Lowenthal, *Wtewael*, pp. 25–37. See also exhibition catalogues, *Dawn of the Golden Age*, pp. 326-7 and *Masters of Light*, pp. 392–3. Wtewael's income was apparently not derived primarily from the sale of his paintings since a large part of his oeuvre remained in his possession at his death. See exhibition catalogue, *Dawn of the Golden Age*, p. 327 and Lowenthal, *Wtewael*, p. 36.

80 Bok, in 'Artists at work' p. 92. Wtewael's name appears on the guild's first membership roll and Bok suggests that he was one of the men who took the initiative in its establishment, together with Paulus Moreelse and Abraham Willaerts.

81 See p. 66 and S. Muller, 'Utrechtsche schildersvereenigingen', idem, *Oud Holland*, vol. 22 (Princeton, NJ, 1989), pp. 1–11 and 2–3.

82 G. Kraut, *Lukas malt die Madonna: Zeugnisse zum künstlerischen Selbstverstandnis in der Malerei* (Worms, 1986).

83 E. D. Howe, 'Luke', in J. Turner (ed.), *The Dictionary of Art*, 34 vols (London and New York, 1996), 3 vol. 19, p. 787.

84 Stoichita, *Self-Aware Image*, p. xiv and H. Belting, *Likeness and Presence. A History of the Image Before the Era of Art* (Chicago and London, 1995), p. xxi.

85 For a summary, B. J. Kaplan, 'Confessionalism and its limits: religion in Utrecht 1600–1650', in exhibition catalogue, *Masters of Light*, pp. 60–71. See also *idem, Calvinists and Libertines: Confession and Community in Utrecht 1578–1620* (Oxford, 1995). The evidence concerning Wtewael's own religious allegiances is difficult to interpret. In his earlier career he travelled to Italy in the company of a Catholic cleric, Charles de Bourgneuf de Cucé, Bishop of Saint Malo, but by the late 1610s had become, perhaps for political reasons, an adherent of Counter-Remonstrant (strict) Calvinism.

86 See pp. 45–6.

87 Rennes, Musée des Beaux-Arts. Panel, 158 x 144 cm., signed and dated 'M[ar]tinus Heem[…] fecit'. I. Veldman, *Maarten van Heemskerck and Dutch Humanism in the Sixteenth Century* (Maarsen, 1977), chapter 6, pp. 113–21.

88 On the relationship between the background and a drawing of the courtyard made by Heemskerck in Rome, see *ibid.*, p. 115. On the identification of the anatomical text, see *ibid.*, pp. 115–19. The centre left anatomical figure, which is masculine but posed in a similar way to the Virgin above, is splayed out to show the internal organs and, as Veldman, *ibid.*, notes, resembles contemporary illustrations of pregnant women. It seems possible that these features implicitly acknowledge the common origin in love of empirical and sexual knowledge of the human body.

89 Frankfurt am Main, Historisches Museum. Panel, 49 x 64 cm., *c.* 1636. For further illustrations of this kind of painting, see Filipczak, *Picturing Art in Antwerp, passim*.

90 Honig, 'Beholder', pp. 276–81.

91 Schwarz, 'Mirror', p. 98, referring to the seventh chapter of the Apocraphyl Old Testament Book of Wisdom, VII, 26: 'For she [Wisdom] is an effulgence from everlasting light, and an unspotted mirror of the working of God, and an image of his goodness.

92 For the concept of the devout viewer as consumer, see R. Falckenburg, *The Fruit of Devotion: Mysticism and the Imagery of Love in Flemish Paintings of the Virgin and Child* (Amsterdam and Philadelphia, 1994), esp. pp. 18–19.

93 For the identification of the Virgin (or Bride) with the Church, which derives from Christian allegories of the Song of Solomon, see H. Rahner, SJ, *Our Lady and the Church*, trans. S. Bullough (New York, 1961). Natival, 'Andromède', p. 153, also notices the churches in the background in interpreting *Andromeda* as an image of Piety.

94 For the elision of heaven and earth in the setting of the Heemskerck, see Veldman, *Heemskerck*, p. 115, referring to E. K. J. Reznicek, 'De reconstructie van't altaer van S. Lukas van Maerten van Heemskerck', *Oud Holland*, 70 (1955), pp. 233–46. For a discussion of the picture which emphasises the self-awareness of the artist as creator see V. Stoichita, *A Short History of the Shadow* (London, 1997), pp. 89–91, esp. p. 90. For a broader discussion of painting of this period as informed by concepts of incarnation, see Stoichita, *Self-Aware Image*, pp. 3–10.

95 Veldman, *Heemskerck*, p. 115. For the parrot as a symbol of both *imitatio* and the Virgin, see Stoichita, *Self-Aware Image*, p. 82.

96 H. J. Schroeder, *The Canons and Decrees of the Council of Trent* (Rockford, Ill., 1978), pp. 144–5, 149–50; J. Pohle, 'The Eucharist', in *The Catholic Encylopaedia*, 15 vols (New York, 1909), vol. 5, pp. 572–90, esp. p. 573: 'Thus the Trinity, Incarnation and Eucharist are really welded together like a precious chain, which in a wonderful manner links heaven with earth, God and Man, uniting them most intimately and keeping them united', and p. 586: 'The first and principal effect of the Holy Eucharist is union with Christ by love ... Christ himself designated the idea of Communion as a union by love: "He that eateth my flesh and drinketh my blood, abideth in me and I in him" [John, VI, 57]'.

97 Stoichita, *Self-Aware Image*, pp. 92–5 and 184. See also L. Marin, *Etudes semiologiques. Ecritures, peintures* (Paris, 1972), pp. 158–88.

98 Van Mander, *Schilder-boeck, Wtleggingh*, fol. 36v–37r (my translation).

99 See p. 43.

100 M. Warner, *Alone of All Her Sex. The Myth and Cult of the Virgin Mary* (1st pub. 1976, reprinted with new Afterthoughts, London, 1990), pp. 103–17, esp. p. 107 and figure 12, which refers to the eighth-century, six foot high icon of Maria Regina in the Basilica of Sta Maria in Trastevere, Rome. This shows an upright Virgin with an erect Christ Child between her knees and a Pope prostrated before her. It is inscribed (in Latin) 'As God himself made himself from thy womb, the princes among the angels stand by and marvel at thee, who carried in thy womb the Child who is born.' Warner, p. 109, points out, with reference to eighth-century iconoclasm, that the image of the Virgin in triumph asserted the orthodoxy of images *per se*.

101 On the metaphor of the navel as a 'way in' to the body of signification which transcends essentialist concepts of gender, see M. Bal, *Reading 'Rembrandt'. Beyond the Word-Image Opposition* (Cambridge, 1991), pp. 21–3.

102 D. Freedberg, 'Art and iconoclasm, 1525–1580 – The case of the Northern Netherlands', in exhibition catalogue, *Kunst voor de beeldenstorm Nordnederlandse Kunst 1525–1580* (Amsterdam, 1986), pp. 69–105; S. Michalski, *The Reformation and the Visual Arts. The Protestant Image Question in Western and Eastern Europe* (London, 1993); L. Parshall and P. Parshall, *Art and the Reformation. An Annotated Bibliography* (Boston, 1986).

103 Stoichita, *Self-Aware Image*, pp. 67–88, esp. pp. 83–8.

104 For various flowers as symbols of the Virgin, see P. Taylor, *Dutch Flower Painting* (New Haven and London, 1995), pp. 55–6, 60–2 and 69–70.

105 For an interpretation of Francken's picture in terms of the theoretical *paragone* between painting and sculpture, see Stoichita, *Self-Aware Image*, pp. 85–6. For the institutional tensions between painters and stone sculptors in Antwerp, see Filipczak, *Picturing Art in Antwerp*, pp. 15–18. For the position of sculptors in Utrecht, and Wtewael's involvement with the medium, see pp. 98 and 107.

106 Cf. Melion, *Van Mander*, pp. 7–8 on the way in which Van Mander in *Den grondt* relates the compositional structure of landscape to the way in which meaning is generated by the viewer: 'Sight itself, penetrating deep into the landscape, constitutes the history's action, and seeing displaces the story told as history's principal event.' Melion on p. 8 notes the implicitly sexual nature of some of Van Mander's vocabulary and on p. 9 his use of metaphors of natural and commercial consumption (bees buzzing round flowers, a banquet, a pedlar's stall) to characterise the relationship between the ordering of the composition and the movement of the eye.

107 Succinctly stated in C. Eire, *War Against the Idols, the Reformation of Worship from Erasmus to Calvin* (Cambridge, 1986), introduction, pp. 1–7.

108 M.-I. Pousão-Smith, *Concepts of Brushwork in the Northern and Southern Netherlands in the Seventeenth Century* (Ph.D. thesis, London University, Courtauld Institute of Art, 1998), pp. 25–44.

109 H. Damisch, 'The underneaths of painting', trans. F. Pacteau and S. Bann, *Word and Image*, 1, 2 (1985), pp. 197–209. I am grateful to Sheila McTighe for drawing my attention to this article, and to the M.A. group which we taught together in 1998–99 for helping me to appreciate its relevance to my argument.

110 *Ibid.*, p. 197, quoting Balzac.

111 For example, an interest in these regions lies at the heart of the 'iconographic' approach to Dutch realism identified with Eddy de Jongh. See, for example, E. de Jongh, *Zinne- en minnebeelden in de schilderkunst van de zeventiende eeuw* (Amsterdam-Antwerp, 1967); *idem*, 'Realism en schijnrealism in de schilderkunst van de zeventiende eeuw', exhibition catalogue in, *Rembrandt en zijn tijd* (Brussels, 1971); S. Alpers, 'On the emblematic interpretation of Dutch art', in *idem*, *The Art of Describing* (Chicago, 1983), pp. 229–33.

112 See p. 47.

113 Damisch, 'The underneaths of painting', p. 198.

114 Melion, *Van Mander*, pp. 7–8.

115 The importance of this way of looking at pictures may have been enhanced in the aftermath of iconoclasm because the intangible nature of the connection between the specific instance and its authorising exemplar acknowledged the difference which Protestants asserted between matter and spirit, the sign and the prototype.

116 L. Federle Orr, in B. Broos *et al.*, in exhibition catalogue, *Great Dutch Paintings from America* (The Hague and San Francisco, 1990–91), p. 491.

117 Vienna, Graphische Sammlung Albertina, 8133, discussed and illustrated by Lowenthal, *Masters of Light*, p. 288, figure 1.

118 The revealing pose of Sebastian's angel is noted by Lowenthal, *Masters of Light*, p. 137.

119 Belting, *Likeness*, p. xxi.

120 See p. 59 and n. 98.

121 Lowenthal, *Masters of Light*, p. 135. J. Jacobs (ed.), exhibition catalogue, *Sebastiaan, martelaar of mythe* (Bergen op Zoom, The Hague, 1993).

122 *Sebastian Bound's* symbolic links with *Andromeda* and the crucified Christ suggest that it too may have been an allegory of visual representation. As a figure of virtue tied down by vulgar workmen, the saint's situation corresponded to the unsuccessful struggle of elite artists to establish their independence from more humble craftsmen within the Utrecht guild at the turn of the seventeenth century.

123 Bataille, *Eroticism*, pp. 11–25.

124 Ovid, *Metamorphoses*, IV, lines 679–81 (Loeb edition, p. 225).

125 See p. 47.

126 See p. 54. In 1656 the new guild of artists founded in The Hague was actually named the 'Confrerie Pictura'.

127 See, for example, the colour illustrations of tapestries designed by François Spiering in G. Luyten *et al.*, exhibition catalogue, *Dawn of the Golden Age* (Amsterdam, 1993–94), pp. 239, 280–1. For discussion of Dutch tapestry, and further references see *ibid.*, pp. 45–6, 420–5.

128 Van Mander, *Schilder-boeck*, fol. 296v.

129 *Ibid.*, fol.297r.

130 The point is reiterated in more distant and elevated terms by the tower which can be seen to allude to Danäe's impregnation by Jupiter in the form of a shower of gold.

131 Woodall, 'Love is in the air', pp. 217–21.

132 This is not to say that Van Mander personally shared this view; *Het Schilder-boeck* also represents a more liberal position, e.g. the poem by Van Mander's friend Cornelis Ketel (see n. 7).

Notes to Chapter 4

My heartfelt thanks to fellow contributors, participating Courtauld Women Teachers and most especially to Joanna Woodall and Caroline Arscott, who by their sharp criticism and warm encouragement have contributed immeasurably to the improvement of this essay.

1 The title given by Bouchardon at the time of the exhibition of the modello in 1739 and printed in the *livret* was retained thereafter. See J. J. Guiffrey, *Collection des livrets des anciennes expositions depuis 1673 jusqu'en 1800*, 5 vols (Paris, 1869–72), vol. I, *livret, 1739*, p. 23; *livret, 1746*, no. 57. On the invoice submitted by the sculptor to the *Bâtiments* title is given rather differently: 'l'Amour essayant un arc commencé, fait de la massue d'Hercule, la d. figure accompagnée de plusieurs attributs de ce héros, tels que la peau de lion et ses armes, ouvrages fait avec soin extraordinaire'. See 'Edmé Bouchardon. Proposition de payment de sa statue de *L'Amour*', *Archives de art français*, 1 (1851–52), p. 162.

2 For example Etienne-Maurice Falconet's *Seated Cupid* (1757 Paris, musée du Louvre) is represented with roses, a sign of Venus, conspicuously strewn at his feet.

3 The drawings are known from prints, *Vénus retenant l'Amour* and *Vénus fouettant l'Amour*, executed jointly by the comte de Caylus (etching) and Etienne Fessard (engraving). See *Inventaire du fonds français: graveurs du XVIIIe siècle* (Paris, 1940), vol. IV, pp. 60–1, nos 43–4.

4 Most famously the comte d'Angiviller commissioned a pendant from Augustin Pajou, the *Psyche abandoned* finally completed in 1791. See M. Schneider, 'Verlassenwerden-Verlassensein. Zur Darstellung des Liebesschmerzes in der Französischen Skulptur des spaten Ancien Regime', *Pantheon*, 48 (1990), pp. 110–22; K. Krausse, 'Ein

ungleiches Paar. Amor von Edme Bouchardon und Psyche von Augustin Pajou', *Stadel-Jahrbuch*, 14 (1993), pp. 289–302; *Pajou, sculpteur du roi 1730–1809* (Paris, musée du Louvre, 1997–98), pp. 333–46. At an earlier date, *c.* 1755, a reduced marble copy of the *Amour* (Washington, National Gallery) found a companion in Jean-Baptiste Lemoyne's *Flore* (1755). See U. Middeldorf, *Sculptures from the Samuel H. Kress Collection. European Schools XIV–XIX Century* (London, 1976), pp. 102–4 (K1713). Earlier still, Jean-Baptiste Pigalle on displaying the full-scale model of his *Vénus* (1746–47) to the public at his studio and not the Salon owing to the impossibilities of transporting it, apparently commented that '… Vénus a qui j'ai donné l'être, / Au *Salon* ne devoit paroître / Que pour admirer Bouchardon; / Et les *beautés* de son fils *Cupidon.*' See Lieu de Sepmanville, *Réflexions nouvelles d'un amateur des beaux-arts* (n.p. 1747), pp. 40–1. Finally one can note that when *L'Amour* was unveiled in the *salon de la guerre* at Versailles, the antique *Vénus d'Arles*, restored by Girardon in the seventeenth century, was on display in the adjacent *galerie des glaces*. Antique and modern, and actual and imaginary female partners were, it seems, found for *L'Amour.*

5 For the full documentation concerning the commission, see M. Furcy-Raynaud, 'Inventaire des sculptures exécutés au XVIIIe siècle pour la direction des bâtiments du roi', *Archives de l'art français*, 14 (1927), pp. 49–58.

6 See C.-P. d'Albert, duc de Luynes, *Mémoires du duc de Luynes sur la cour de Louis XV, 1735–58*, ed. L. Dussieux and E. Soulié, 17 vols (Paris, 1860–65), vol. X, p. 314.

7 It is clear from the documents published by Furcy-Raynaud that moves were afoot to have the statue removed by November 1752. (See 'Inventaire des sculptures', pp. 52–3.) However, according to the duc de Luynes's memoirs *L'Amour* was not finally dispatched until 19 August 1754. (See Luynes, *Mémoires*, vol. XIII, p. 314.)

8 *L'Amour* was apparently recalled in order that a full-scale copy could be made for the gardens at the Petit Trianon. Simultaneously d'Angiviller commissioned a pendant from Pajou which has been the subject of two recent and important studies: Schneider, 'Verlassenwerden-Verlassenssein'; and Krausse, 'Em ungleiches Paar'. A drawing by Charles de Wailly published by Krausse suggests that the two figures were intended to frame the entrance to the long gallery and introduce the display of d'Angiviller's *grands hommes.*

9 For the decoration of the grands appartements at Versailles, for instance, see C. Constant, 'Les Tableaux du grand appartement du roi', *Revue du Louvre*, 26 (1976), pp. 157–64.

10 The structure was prompted by the Lacanian argument that the drive can only attain its aim *en faisant la tour*, an argument suggestively applied by Hubert Damisch to representations of Venus generally and Rubens's treatment of her specifically. See H. Damisch, *The Judgement of Paris*, trans. J. Goodman (London and Chicago, 1992), pp. 276–9 and *passim.*

11 Classically exemplified by Pierre-Jean Mariette's account of the statue, see 'Lettre a M.***' in the *Mercure de France* (September 1750), reprinted with A. C. R de Tubière de Grimoard de Pestels de Levis, comte de Caylus's *Vie d'Edmé Bouchardon, sculpteur de roi* (Paris, 1772).

12 'PAR EDME BOUCHARDON DE CHAUMONT en Bassigni. FAIT en 1750'.

13 Krausse attributes the copy which entered the Orleans collection around 1722 and is currently at Bridgewater House, London, to Joseph Heintz. See Krauss, 'Ein ungleiches Paar', p. 292.

14 Bouchardon was an enthusiastic collector of prints. At the sale of his collection François Basan catalogued several loose prints after Correggio though none of the *Amor*, and also volumes of prints after Italian sixteenth-century artists including Correggio but without detailed itemisation. (See *Catalogue des tableaux, desseins, estampes, livres ..., modèles en cire et plâtre, laissés après le décès de M. Bouchardon, sculpteur de Roi*, November 1762.) It is thus unclear whether Bouchardon knew the composition via an oil or an engraved copy. On the print, see *Hollstein's Dutch and Flemish Etchings, Engravings and Woodcuts ca.1450–1700*, 53 vols (1949–99), vol. XXVIII, 'van der Steen' no. 23.

15 Dubois de Saint-Gelais in the first published catalogue of the collection described the painting as follows: 'Il [L'Amour] est représenté par un jeune Garçon ailé, âgé d'environ quinze ans, on lui voit le visage, quoiqu'il ait le corps presque entièrement tourné, & qu'il soit courbé dans l'attitude d'un homme qui travaille à un Ouvrage rude.' (*Description des tableaux du palais royal* (Paris, 1727), p. 56). However, nearly a hundred years later Charles Dupaty described in more suggestive terms another copy of the composition in Florence, insisting as follows on the phallic nature of the artist's brush: 'Quelle heureuse idée, tendre Corrège t'est venue au bout de ton pinceau! Car "c'est au bout de ton pinceau, disait-tu, que tes idées venaient". Ton pinceau prenait pour ainsi dire du sentiment dans ton coeur, comme il prenait de la couleur dans la nature.' See C. Dupaty, *Lettres d'Italie*, 2 vols (Paris, 1822), vol. I, p. 109.

16 Both Mariette and Caylus were involved in Pierre Crozat's *Receuil* or publication of the Italian paintings in the royal and Orléans collections and would have known the painting even though it was not among those engraved and catalogued. Moreover, Mariette later noted in his entry on Bouchardon in the *Abecedario* that in the case of the *Amour* the sculptor 'a sçu bien allier les graces du Corrège avec la pureté de dessein de l'Antique'. See P.-J. Mariette, *Abecedario*, (ed.), P. de Chennevières and A. de Montaiglon, 6 vols (Paris, 1851–60), vol. I, p. 163.

17 See Mariette, 'Lettre a M. ***', p. 127.

18 *Ibid.*, p. 129. Bouchardon's studio in the Louvre was, however, hung with the large chalk drawings that he had made after the antique in Rome. See Caylus, *La Vie d'Edmé Bouchardon*, p. 13. See also a letter from Bouchardon to the duc d'Antin (10 July 1732) in which the sculptor requests additional funds from the *Bâtiments* to defray the costs of bringing the drawings back to Paris thereby testifying to the importance they had for him. The letter is in the manuscript collection of the Fondation Custodia: Ms. 8734.

19 See 'Bouchardon. Proposition de payement', pp. 162–8.

20 *Ibid.*, p. 163. It is generally thought that Bouchardon followed his usual practice and that these drawings actually came after an initial sketch model (musée Bonnat, Bayonne). They are therefore dated between 1739 and 1746, that is between the 'première pensée' and the final plaster. See *La statue équestre de Louis XV. Dessins de Bouchardon, sculpteur du roi, dans les collection du musée du Louvre* (Paris, musée du Louvre, 1973), nos 31–2.

21 For the drawings see J. Guiffrey and P. Marcel, *Inventaire général des dessins du musée du Louvre et du musée de Versailles. Ecole française*, 10 vols (Paris, 1906–35), vol. II, pp. 14–15, nos 885–93. The drawings are numbered in an eighteenth-century hand which tends to suggest that there was once an (unfulfilled) intention to publish the drawings as a series of prints. From 1738 Jacques Huquier had successfully published books of 'différentes figures d'académies dessinées d'après le naturel' by Bouchardon.

22 See D. Diderot, 'Observation sur la sculpture et sur Bouchardon', in *Oeuvres complètes de Diderot*, ed. J. Assezat and M. Tourneux, 20 vols (Paris, 1875–1939), vol. XIII, p.42.

23 'Bouchardon. Proposition de payement', p. 162. On the use of life casts in sculptural practice see Diderot's comments on Pierre-Philippe Mignot's *A Sleeping Bacchante* (1763) in *Salono*, ed. J. Seznec and J. Adhemar, vol. I (Oxford, 1975), pp. 247–8.

24 'Bouchardon. Proposition de payement, pp. 163–4. For the tools and procedures of sculpture in marble current in the eighteenth century, see D. Diderot and J. Le Rond d'Alembert, *Encyclopédie ou dictionnaire raisonné des sciences, des arts et des métiers*, 17 vols (Paris, 1751–65), vol. XIV, pp. 841–2.

25 'Bouchardon. Proposition de payement', p. 164.

26 *Ibid.*, p. 163.

27 See Caylus, *La Vie d'Edmé Bouchardon*, pp. 6–7; Diderot, 'Observations', pp. 41–2.

28 Significantly, Bouchardon's earliest, untutored, drawings after the life-model became collectors' items, along with his later, accomplished *Académies*. See, *Catalogue raisonné des différents objets de curiosité dans les sciences et les arts qui composoient le cabinet de feu M. Mariette* (Paris, 1775), lot 1093: 'Huit Académies, aux crayons noir & blanc faites par l'Auteur, à Chaumont, lieu de sa naissance, avant son séjour à Paris'. See also lots 1103, 1105 and 1109.

29 Caylus, *La Vie d'Edmé Bouchardon*, pp. 12–13.

30 For a recent and excellent discussion of enthusiasm, and enthusiasm's relation to gender and sexuality, see M. Sheriff, 'Passionate spectators: on enthusiasm, nymphomania and the imagined tableau', *Huntington Library Quarterly*, 60 (1999), pp. 79–98.

31 Diderot, 'Observations', pp. 12–13.

32 Item 4l bis of Bouchardon's *inventaire après décès* (18 August 1762) includes the following item: 'une boete en portefeuille, contenant les études du *Cheval* et de l'*Amour* …' Quoted from A. Roserot, *Edmé Bouchardon, dessinateur* (Paris, 1895), p. 7.

33 Mariette, 'Lettre a M.***', pp. 122–3.

34 On the tradition of sight's touch, see S. Gilman, *Sexuality: An Illustrated History* (New York, 1989), pp. 148–60.

35 See C. de Brosses, *Lettres familières écrites d'Italie en 1739 et 1740*, 2 vols (Var, 1976), vol. I, p. 43. On Bernini's restorations of antiquities, see J. Montagu, 'The influence of the baroque on classical antiquity', in H. Beck and S. Schulze (eds), *Antikenreception im hochbarock* (Berlin, 1989), pp. 85–108.

36 Mariette argues indeed, 'il est si simple & si naturel qu'on se plait à jouir de ces différentes oppositions: elles ne font aucun tort, quelque riches qu'elles puissent être, à la figure même': Mariette, 'Lettre a M.***', p. 123.

37 *Ibid.*, p. 125.

38 It is worth noting here that Bouchardon put his name to and was involved in the production in 1741 of a book of anatomy 'nécéssaire pour l'usage du dessein', a literal view beneath the surface. See H. Ronot, 'Le Traité d'anatomie d'Edmé Bouchardon', *Bulletin de la Société de l'histoire de l'art français* (1970), pp. 93–100. For a wonderfully suggestive discussion of the relationship between skin and identity or ego but in a different genre and historical context, see J. Fleming, 'The Renaissance tattoo', *RES,* 31 (Spring 1997), pp. 34–52.

39 '[Bouchardon] aimoit le fini, et sans doute il avoit raison. En effet, il semble qu'on ne peut pas regarder quelque chose comme véritablement et complètement beau qu'il ne soit achevé.[…] Mais, si le fini est un mérite, son excès un défaut. M. Bouchardon

modeloit avec un esprit, une justesse et une netteté admirable; mais lorsqu'il travailloit le marbre, son extrême passion pour le fini a pu le mener trop loin ...' C. N. Cochin, *Mémoires inedits de Charles-Nicolas Cochin sur le comte de Caylus, Bouchardon, les Slodtz,* ed. C. Henry (Paris, 1880), p. 86.

40 *Ibid.*, p. 105.

41 Claude Courouve in his *Vocabulaire de l'homosexualité masculine* (Paris, 1985) gives as an example of the use of 'Sodomiste' in the eighteenth century a poem by Mérard de Saint-Just entitled *Le Peintre* in which an artist having posed a young model for a St Sebastien responds thus: 'L'oeil en feu, le vit raide, / Le peintre admire, et le trouvant si beau, / En fait soudain un nouveau Ganymède' (p. 200). Though dating from the 1790s, the poem was apparently based on a much earlier ode by Jean-Baptiste Rousseau which in turn derived from Anacreon. A tradition thus existed of rewriting the hetero-sexual myth of the artists and the model in homosexual terms. For a variation of the Pygmalion myth in which a wax Cupid is bought in anticipation that a desiring touch will bring him to life and love, see A. Dacier, *Les Poésies d'Anacréon et de Sapho traduites en français* (Paris, 1716), ode X, pp. 35–7.

42 On the motif of the artist and his model in eighteenth-century France, see M. Sheriff, *Fragonard. Art and Eroticism* (Chicago and London, 1990), pp. 185–202. It is perhaps worth noting that Bouchardon's invoice, by contrast, made much of the influx of a whole variety of specialists into the studio once the business of making sculpture was under way. See 'Bouchardon. Proposition de payement', p. 164. One gets a sense of a personal space invaded and made public by the requirements of execution. Thus, in the discourse of exchange and financial settlement, the studio appears the very antithesis of the secret and sexually charged studio/boudoir of myth.

43 See A. Roserot, 'Bouchardon intime', *Réunion des beaux-arts des départments, mémoires* (1901), pp. 354–67.

44 According to Cochin, Bouchardon rarely dined out *(Mémoires,* p. 38) and though he was in touch with Mme Géoffrin he seems not to have taken part in the famous *lundis.* Indeed, not only did he keep himself to himself, Antoine Dézallier d'Argenville further reported with a hint of reproach accusations that Bouchardon's studio was 'plus fermé que le jardin des Hespirides', in *Abrégé de la vie des plus fameux sculpteurs depuis la renaissance des arts* (Paris, 1787), Minkoff facsimile reprint (Geneva, 1972), p. 326.

45 Art theory had long advanced celibacy as the ideal, indeed the only possible, state for the artist of virtue. See for example A. Dufresnoy, *L'Art de la peinture, traduit en françois. Enrichi de remarques, revû, corrigé et augmenté par Monsieur de Piles,* 4th ed. (Paris, 1751), pp. 76, 242. For a discussion of this ideal informed by Freud's concept of sublimation, see E. Walter, 'Le complexe d'Abelard ou le célibat des gens de let-tres', *XVIIIe siécle,* XII (1980), pp. 127–52. On the notion that the artist should have experienced the emotion that he chooses to represent, see, for example, D. Diderot, *Essai sur la peinture,* in *Oeuvres aesthétiques de Diderot,* ed. P. Vernière (Paris, 1965), pp. 696–711.

46 See Diderot's comments in 'Observations', p. 41, and Grimm's elaboration of them in 'Ma réponse à Diderot', *Correspondence litteraire* (March 1763), vol. 3 (1813), pp. 338–39.

47 Though the sketch model and the final plaster were shown respectively in the Salons of 1739 and 1746, the marble was never exhibited. This was not the first time Mariette had acted as 'porte parole' for Bouchardon In 1746 the amateur had written a critical

account of the rue de Grenelle fountain for the *Mercure de France* published in March 1746.

48 Mariette, 'Lettre a M.***, p. 119.

49 La Font de Saint-Yenne, to cite but one example, noted the importance of moment in sculpture owing to the narrative constraints of the medium. See *Réflexions sur quelques causes de l'état présent de la peinture en France* (The Hague, 1747), pp. 125–6.

50 My understanding of the workings of allegory has been informed by W. Benjamin, *The Origin of German Tragic Drama*, trans. J. Osborne (London and New York, 1997) esp. pp. 159–235; P. de Man, *Blindness and Insight: Essays in the Rhetoric of Contemporary Criticism* (Minneapolis, 1983), pp. 187–208; *idem*, *Allegories of Reading: Figural Language in Rousseau, Nietzche, Rilke, and Proust* (London and New Haven, 1979), pp. 57–78; and especially by G. Day's excellent discussion of current theories of allegory based on an exposition of the above texts: 'Allegory: between deconstruction and dialectics', *Oxford Art Journal*, 22, 1 (1999), pp. 103–18.

51 See, for example, A. Furetière, *Dictionnaire universel*, 4 vols (The Hague, 1727), vol. I, 'Amour'; J. F. Dreux du Radier, *Dictionnaire de l'amour* (The Hague, 1741), 'Cupidon'; H. -F. Gravelot and C. -N. Cochin, *Iconographie par figures*, 2 vols (Paris, 1765–91), vol. I, 'Amour'.

52 For an explicitly phallic interpretation of Cupid's arrows, see the doggerel cited in P. -J. Le Roux, *Dictionnaire comique, burlesque, libre et pastoral* (Amsterdam, 1750), 'Flèche'.

53 The poet Charles-Etienne Pesselier, who published verses on the *Amour* (*Mercure de France* (September 1750), p. 148), in another context explored the respective merits of the mouth and the eyes as expressive of the movements of the soul. See 'La bouche et les yeux' from *Fables nouvelles* (1748) reprinted in *La fable au Siècle des Lumières 1715–1815: anthologie des successeurs de La Fontaine, de La Motte à Jauffret*, (ed.) J. -N. Pascal (Saint-Etienne, 1991), p. 80.

54 On the auto-erotic, selfish, nature of infant sexuality see S. Freud, 'Infant sexuality', *On Sexuality* (London and Harmondsworth, 1987), pp. 88–126.

55 On the element of time in symbol and allegory see Benjamin, *The Origin*, pp. 164–6.

56 See Furcy-Raynaud, 'Inventaire des sculptures', pp. 45–7.

57 For the history of this room from 1710 when it ceased to be the location of the royal chapel, see most recently A. and J. Marie, *Versailles au temps de Louis XV, 1715–1745* (Paris, 1984), pp. 188–203. For Vassé's bronzes, see F. Souchal, *French Sculptors of the 17th and 18th Centuries. The reign of Louis XIV*, 3 vols (Oxford, 1977–87), vol. III, pp. 438–40.

58 Fernand Engerand publishes Le Moyne's *mémoire* or invoice for the ceiling which amounted to 25,000 *livres;* his heirs were subsequently paid a total of 30,000 *livres*. See *Inventaire des tableaux commandés et achetés par la direction des bâtiments du roi (1709–1792)* (Paris, 1900), pp. 281–2. Bouchardon had to settle for 21,000 *livres*, still an extraordinary sum for this kind of sculpture. See Furcy-Raynaud, 'Inventaire de sculptures', p. 52 and A. Roserot, *Edmé Bouchardon* (Paris, 1910), pp. 89–90.

59 The *explication* was originally published in the *Mercure de France* in 1736 and was later reprinted with the comte de Caylus's life of François Le Moyne (1748) in F. B. Lépicié, *Vies des premiers peintres du Roi depuis M. Le Brun jusqu'à present*, 2 vols (Paris, 1752), pp. 127–37. The present quotation appears on pp. 127–8.

60 The use of a leafy branch sprouting from a marble figure's supporting tree stump as a veil was, of course, a fairly conventional device – see, for example, Antoine Coysevox's

copy of *Castor and Pollux* (1712) for the gardens at Versailles where olive serves the purpose – but here convention takes on narrative significance.

61 For a discussion of the myth in antiquity see N. B. Kampen, 'Omphale and the instability of gender', in *Sexuality in Ancient Art*, ed. N. B. Kampen (Cambridge, 1996), pp. 233–46. For its treatment in the eighteenth century by Le Moyne and Boucher, see *Loves of the Gods: Mythological Painting from Watteau to David* (Fort Worth, 1992), nos 23 and 42; and M. D. Sheriff, 'Reading otherwise: or Ovid's women in the eighteenth century', *Archeologia Transatlantica*, special issue, *Myth, Sexuality and Power: Images of Jupiter in Western Art*, ed. F. Van Keuren (1998), pp. 79–98.

62 For a discussion of Freud's theory of the modalities of desire and its application to the structure of narrative plotting see P. Brooks, 'Freud's masterplot: questions of narrative', *Yale French Studies*, 55/56 (1977), pp. 280–300 and *idem*, 'Fictions and the Wolfman: Freud and narrative understanding', *Diacritics*, 9 (Spring 1979), pp. 72–81.

63 In a letter to the architect Gabriel and dated November 1752 Marigny noted that 'le Roy ne la (the statue) veut absoluement pas dans le salon d'Hercule' (Furcy-Raynaud, 'Inventaire des sculptures', pp. 52–3); however, according to the memoirs of the duc de Luynes it was not removed until August 1754. See Luynes, *Mémoires*, vol. XIII, p. 314.

64 Quoted from J. Jacquiot, 'La place des medailles, des medaillons, des camées et des intailles dans l'art et l'histoire de 1715 à 1774', in *Louis XV. Un moment de perfection de l'art français* (Paris, 1974), p. 539. In another entry in his journal Marais noted that Louis XV had acquited himself 'avec une grace merveilleuse' and that 'en habit de novice il ressembloit à l'Amour'. See M. Marais, *Journal et mémoires de la régence et du règne de Louis XV (1715–1737)*, 4 vols (Paris, 1863–68), vol. II, p. 364.

65 See Jacquiot, 'La place des medailles', pp. 523–32.

66 For sixteenth- and seventeenth-century examples, see S. Orgel, 'Gendering the crown', in *idem, Subject and Object in Renaissance Culture* (Cambridge, 1996), pp. 133–65; M. Franko, 'The king cross-dressed: power and force in royal ballets', in *idem, From the Royal to the Republican Body: Incorporating the Political in Seventeenth- and Eighteenth-Century France* (Berkeley and Los Angeles, 1998), pp. 64–84. For Louis XV and the politics of love, see T. E. Kaiser, 'Louis *le Bien-Aimé* and the rhetoric of the royal body', in *ibid.*, pp. 133–61.

67 The point had earlier been made by the completed decoration of the *salon de la Paix* which juxtaposed Coysevox's bas-relief with Le Moyne's *Louis XV Giving Peace to Europe* (1729).

68 See Lépicié, *Vies*, p. 128. See also J. -L. Bordeaux, 'François Le Moyne's painted ceiling in the "Salon d'Hercule" at Versailles. A long overdue study', *Gazette des beaux-arts*, 83 (1974), pp. 301–18.

69 See C. Vivanti, 'Henri IV, the Gallic Hercules', *Journal of the Warburg and Courtauld Institutes*, 30 (1967), pp. 176–97.

70 See for example the token for the extraordinary expenses of the war, 'Novis Suppetet Loboribus' (1744), and that for the ordinary expenses, 'Pacato Orbe Quiescit' (1746). A set of counterproofs of the designs exists in the Cabinet des Estampes at the Bibliothèque Nationale (Pb 31 res. pet. fol.).

71 See M. A. A. E. Raunié, *Chansonnier historique du XVIIIe siècle*, 10 vols (Paris, 1879): 'La Cour et les coutisans' (1748), vol. VII, p. 119; 'L'Etat de la France' (1749), p. 141; 'Imprécations contre le Roi' (1749), p. 144.

72 For a characterisation of Louis as idle see *ibid.*, 'L'Etat de France', vol. VII, pp. 140–3. Furetière in discussing the modality of love similarly noted its propensity to incapacitate, citing Corneille: 'L'*Amour* est l'enfant du loisir'; and Saint-Evremont, 'Le mouvement le plus délicat de *l'amour* c'est la langueur'. See Furetière, *Dictionnaire*, vol. I, 'Amour'.

73 J. -B. Bossuet, *Politics Drawn from the Very Words of Holy Scripture*, trans. P. Riley (Cambridge, 1990), p. 96.

74 See D. Diderot, *Salons*, ed. T. Seznec and J. Adhemar, 4 vols (Oxford, 1960), vol. II, p. 67. Pompadour does appear to have ordered a copy of the *Amour* though she can have had nothing to do with the original commission. See *La Statue equestre de Louis XV*, no. 32, p. 21.

75 On the soubriquet 'le bien aimé' see Kaiser, 'Louis *le Bien Aimé*'.

76 De Man, *Allegories of Reading*, pp. 76–8; and esp. Day, 'Allegory', pp. 110–13.

77 Cochin, *Mémoires*, pp. 89–90.

78 Voltaire to Caylus, 9 January 1739, quoted from 'Edmé Bouchardon. Proposition de payement', p. 167.

79 La Font de Saint-Yenne, *Réflexions*, p. 125.

80 Diderot, 'Observations', p. 45.

81 See *Catalogue ... de M. Bouchardon* (Paris, 1762), pp. 47–8, no. 345. Originally in the Falconieri collection, these three paintings in addition to *The Forge of Vulcan* entered the royal collection under Louis XIV. See F B. Lépicié, *Catalogue raisonné des tableaux du roy avec un abrégé de la vie des peintres*, 2 vols (Paris, 1752), vol. II, pp. 253–8.

82 Baudet engraved these paintings in 1672 for the *Calcografia Romana Camerale*. Once the paintings were acquired by Louis XIV they were engraved a second time by Benoit I. Audran at the end of the seventeenth century for the *cabinet du Roi*. Verses accompanied this later rendition of which those for *The Forge of Venus* are as follows: 'Aussitôt les Amours en troupes se divisent / Les uns forgent des traits, les autres les aiguisent / L'un arrondit son arc, l'autre remplit son carquois, / Les plus promts sur un arbre élèvent un parois; / Et le coeur mis en bût à leurs fleches nouvelles / Reçoit de toutes parts des blessures nouvelles.' For these two sets of prints see *Inventaire du fonds français: graveurs du XVIIe siècle* (Paris, 1939), vol. I, pp. 112–13, nos 63–6.

83 See Furetière, *Dictionnaire*, vol. I, 'Coude'. 'Hausser le coude', meanwhile, was associated with working-class debauchery. See P. Richelet, *Dictionnaire de la langue française*, 3 vol (Amsterdam, 1732), vol. I, 'Coude'; *Dictionnaire des proverbes françois* (Frankfurt, 1750), 'Coude'.

84 See R. Barthes, 'The third meaning. Research notes on Eisenstein stills', in *idem*, *Image, Music, Text*, trans. S. Heath (Glasgow, 1977), pp. 52–68.

85 Cochin, *Mémoires*, p. 89.

86 The same title and description was given for the plaster model in the 1746 *livret* as for the 1739 terracotta, but then Bouchardon added: 'Il y a quelques années que l'on a vu dans le Salon un petit modèle en terre de cette figure, accompagné de la même description, mais ce n'étoit qu'un premier travail, qui ne donnoit que la pensée. Le modèle qo'on expose aujourd'huy est plus épuré, tout y est arrêté et fait d'après nature, et c'est sur ce modele que la statue, de grandeur naturelle, s'exécute en marbre pour le Roy.' Guiffrey, *Collection des livrets*, vol. I, *livret, 1746*, no. 57.

87 [Saint-Yves], *Observations sur les arts et sur quelques morceaux de peintures et sculptures exposés au Louvre* (Leyden, 1748), p. 122.

88 *Ibid.*, Mariette, 'Lettre', esp. p. 126. The cult of the noble 'petit pied' had of course long since been celebrated in Charles Perrault's fairy tale, 'Cendrillon ou la petite pantouffle de verre' (1697). See C. Perrault, *Contes des Fées* (Paros, 1781), pp. 93–118.

89 'La seule idée des calus, que l'exercise de la sculpture donne souvent aux mains, peut défigurer l'amant de Psyche', argued Voltaire. See 'Edmé Bouchardon. Proposition de payement', p. 167. For a poetical examination of the antimony *noble/roturier* via an emblematic casting of the hand, see J. -L. Aubert, 'La main droite et la main gauche', in *Fables nouvelles* (Paris, 1756), reprinted in *La Fable*, pp. 90–1.

90 This tendency in many ways draws on a more general anxiety about the types of models available to artists. Dandré-Bardon having noted that 'la Nature, envisagée comme le modèle du vrai beau, ne doit être ni noueuse, ni maigre', went on immediately to remark that, 'Elle est rarement parfaite dans les personnes qui vendent à prix d'argent l'image de leur traits' and concluded that the student draughtsman must thus always improve upon nature. See M. F. Dandré-Bardon, *Traité de peinture suivi d'un essai sur la sculpture* (Paris, 1765), p. 14.

91 On noble anxiety of the potential deformities wrought on the body by work, particularly the inward curving of the shoulders, see G. Vigarello, 'The upward training of the body from the age of chivalry to courtly civility', in M. Feher (ed.), *Fragments for the History of the Human Body*, 4 vols (New York, 1989), vol. IV, pp. 149–99. See also in a different context, S. McTighe, 'Perfect deformity, ideal beauty and the *imaginaire* of work: the reception of Annibale Carracci's *Arti di Bologna* in 1646', *Oxford Art Journal*, 16 (1993), pp. 75–91.

92 For wonderfully suggestive discussions of the fragmented body, see the essays in D. Hillman and C. Mazzio (eds), *The Body in Parts: Fantasies of Corporeality in Early Modern Europe* (London, 1999).

93 The documentation concerning the building and subsequent maintenance of the *orangerie* at Choisy is to be found in A.N. O1 1344 and 1348. See in particular 'Etat des orangers qui sont à Choisy', dated 9 September 1750 (A.N. O1 1344/131) and the very full memorandum by Hazon drawn up in 1773 and which gives details of the plantings of tulips (A.N. O1 1348/325, p. 10).

94 *L'Isle de France ou la nouvelle colonie de Vénus* (Amsterdam, 1752), p. 16 and *passim*.

95 Raunié, *Chansonnier*, vol. VI, pp. 291–2: 'Nous vivons tous à gogo / Sans craindre aucun vertigo; / Nous aimons l'incognito, / Et de peur du quidproquo, / Chacun à son numero / Pour aller faire dodo.'

96 See A. J. Dézallier d'Argenville, *Voyage pittoresque des environs de Paris* (Paris, 1762), p. 304. On the *château* and the architectural transformations of the 1740s and 1750s, see C. Tadgell, *Ange-Jacques Gabriel* (London, 1978), pp. 151–5.

97 In Charles Sorel's *Les Recreations galantes* (Paris, 1661) is collected a mass of games and charades enjoyed by *honnête* society in the seventeenth century and beyond. These included, for instance (p. 66), a 'jeu du bastiment et du jardinage'.

Notes to Chapter 5

This project originated as an M.A. thesis at the Courtauld Institute of Art, University of London. This chapter is a revised version of an essay published in *Art History*, XIV, 4 (December 1991). All translations are my own unless otherwise noted.

1 L. Irigaray, 'The "mechanics" of fluids', in *idem*, *This Sex Which is Not One*, trans. C. Porter (Ithaca, 1985), pp. 106–7.

2 T Gautier, 'Salon de 1863', *Moniteur universel*, 164 (13 June 1863), p. 1.

3 In spite of the title given in the Salon catalogue, most critics referred to Baudry's painting as a birth of Venus. *Explication des ouvrages de peinture, sculpture, gravure, lithographie et architecture des artistes vivans exposés au Palais des Champs Élysées le 1 May, 1863 (Paris,* 1863) p. 14, cat. no. 91.

4 A number of critical responses to these paintings also included a general discussion of the Venus theme. A perusal of the press indicates there was a general interest in Venus. See for example F. R. Cambouliu, *Les Femmes d'Homère* (Paris, 1854); C. de Sault, 'Les femmes grecques,' *Revue germanique,* 1ère partie (1 May 1863), 2ème partie (1 June 1864); E. des Essarts, 'L'amour dans l'antiquité', *Revue française* (1 June 1863), pp. 184–96 (this article is immediately followed by a review of the 1863 Salon that discusses the Venuses). E. Deschanel, *Les Courtisanes grecques,* 3rd ed. (Paris, 1859). See C. Parsons and M. Ward, *A Bibliography of Salon Criticism in Second Empire Paris* (Cambridge, 1986), for invaluable bibliographical information on the Salon during this period. Virtually all Salon reviews I have consulted had substantial discussion of the Venuses. Most that did not were specialist journals such as architectural journals, which only reviewed the architectural section of the Salon, a hunting review which only reproduced a few pictures of animals, or some popular illustrated magazines which tended to reproduce and describe genre painting and landscape for the most part. Most reviews specifically referred to the Baudry and Cabanel Venuses as the most popular things in the exhibition. Many of them included Amaury-Duval's *Birth of Venus* in their discussion. In November and December 1863, the *Gazette des beaux-arts* published an engraving of Baudry's *The Pearl and the Wave* and Cabanel's *Birth of Venus.*

5 For an excellent discussion of the nude as a category see L. Nead, *The Female Nude: Art, Obscenity and Sexuality* (London and New York, 1992).

6 For a classic discussion of the nude in the 1860s see T. J. Clark, *The Painting of Modern Life: Paris in the Art of Manet and his Followers* (Princeton, 1984). Claudine Mitchell has described some of the predominant themes of Second Empire criticism: 'recurrent subject of discussion was that of the "décadence" and "abaissement" of French art. The signs of decadence, the critics thought, were multiple and conspicuous. They deplored the absence of that kind of unity which would constitute a "French school", and the absence of a leader, a great artist as Ingres and Delacroix had been during the Restoration. Now there was a multiplicity of small "individualités" who had "talent" but no "genius". They saw the disintegration of the hierarchy of genres, the collapse of history painting, and the "invasion" of every genre by landscape …': C. Mitchell, 'What is to be done with the Salonniers?', *Oxford Art Journal,* 10, 1 (1987), p. 110.

7 See C. Planté, '"Ondine", ondines – femme, amour et individuation', *Romantisme* LXII (1988), pp. 89–102, on metaphors of flux and water which inflected nineteenth-century discussions of woman.

8 For example Charles Gueullette wondered whether the paintings by Cabanel and Baudry were not better described as genre scenes than as works of high art. See C. Gueullette, *Les Peintres de genre au Salon de 1863* (Paris, 1863), p. 6.

9 W. Bürger [Théophile Thoré], *Salons de W. Bürger 1861 à 1868,* vol. I (Paris, 1870), pp. 428–9.

10 *Grand Dictionnaire universel du dix-neuvième siècle,* ed. Pierre Larousse, vol. XV (Paris, *c.* 1875), p. 875. The 'Avant Propos' to the *Grand Dictionnaire universel, premier supplement* states that the first volume of the dictionary was begun in 1865 and the last went

on sale by 1876. Work on the dictionary is said to have extended throughout the period between these dates, thus the ideas expressed there can be said to have had common currency in the mid-1860s and early 1870s.

11 *Grand Dictionnaire universel*, p. 876.

12 *Ibid.*

13 *Ibid.*

14 *Ibid.*, p. 877. Early in this section the Venuses are divided up according to the four stories of their birth. They are also classified by Pausanias' description of three statues of Venus: 'Vénus Céleste, qui marquait un amour pur et dégagé des convoitises corporelles', 'Vénus la Populaire, qui marquait un amour impudique' and 'Vénus Apostrophia, ainsi appelée parce qu'elle détournait les coeurs de toute impureté'. But the writer of the *Grand Dictionnaire* noted that even the ancients had difficulty classifying the many types of Venus and he himself had an especially difficult time finding a place for the Venus of Courtisans: 'La Vénus Céleste et la Vénus Marine sont identifiées par le récit même d'Hésiode, qui fait naître Aphrodite à la fois des deux éléments. Cicéron fait naître Eros de Mercure et le confond ainsi avec Hermaphrodite, en même temps qu'il avoue l'analogie des deux Vénus, l'une fille de la Mer et l'autre fille de Jupiter … D'après cette distinction des diverses Vénus par leur origine, où faut-il placer Vénus Populaire ou Pandème?' Thus a contemporary preoccupation with separating the 'femme honnête' from the 'fille publique' or prostitute, linked to a negative definition of the autonomous and productive female body, structures the understanding of Venus and the attempt to classify her many types. See Clark, *The Painting of Modern Life*, pp. 108–9.

15 A. Delvau, *Dictionnaire érotique moderne* (Paris, 1864), p. 295.

16 M. Du Camp, 'Salon de 1863', *Les Beaux-Arts à l'Exposition Universelle et aux Salons de 1863, 1864, 1865, et 1867* (Paris, 1867), p. 31.

17 O. Merson, 'Salon de 1863. IV. Aphrodite', *L'Opinion nationale*, 148 (1 June 1863).

18 T. Laqueur, 'Orgasm, generation and the politics of the reproductive body', *Representations*, XIV (Spring 1986), p. 3. See also T. Laqueur, *Making Sex: Body and Gender From the Greeks to Freud* (Cambridge, MA, 1990).

19 Nineteenth-century biology itself was fundamentally associated with the female body. The word 'cellule' entered into scientific vocabulary in part through the study of embryology, a discipline which led to a revolution in the understanding of female anatomy and reproduction. See T Moreau, *Le Sang de l'histoire, Michelet, l'histoire et l'idée de la femme au xixe siècle* (Paris, 1982), p. 82.

20 Raciborski, *Du Rôle de la menstruation* (Paris, 1840), p. 117, quoted in Moreau, *Le Sang de l'histoire*, p. 89

21 According to Laqucur, although as early as 1672 de Graaf had argued that the 'female testicle' produced eggs, no one observed a mammalian egg until 1827 when Karl Ernst von Baer demonstrated its existence in the ovarian follicle and the fallopian tube of a dog. At the time that he showed this direct evidence of ovulation, von Baer still believed that animals only ovulated when sexually stimulated. In 1843, an experiment conducted by Theodor L. W. Bischoff showed that ovulation in dogs occurred independent of male interaction with the female in coitus. F A. Pouchet considered this discovery so important that he formulated it as the principal point of his magnum opus, *Théorie positive de l'ovulation spontanée et de la fécondation des mammifères et de l'éspèce humaine* (1847). See Laqueur, 'Orgasm, generation', pp. 25–6.

22 See Moreau, *Le Sang de l'histoire*, p. 84. The legitimacy of these theories was hotly debated, especially by the Church. We might see a parallel structure operating in the discourse of the 'right to life' whose stress on the importance of conception of a foetus promotes the importance of the male role in the creation of life while demoting the importance of physical processes by which the female body participates in the conception, development and growth of the foetus. Like the critical focus on the conception of a work of art, this right to life discourse sees the entire outcome already implied in the initial conception. It is of course no accident that the right to life is a Christian discourse and its proponents predominantly male, for it, like the discourse of the ideal in art, works to preserve the pre-eminence of God's and then man's creative power.

23 E. Legouvé, *Cours d'histoire morale des femmes* (Paris, 1848), pp. 8–9, quoted in Moreau *Le Sang de l'histoire*, p. 83.

24 Serres, quoted in Moreau, *Le Sang de l'histoire*, p. 85.

25 Michelet's influence on the intellectual life of France during this period cannot be underestimated. His widely circulated books, *L'Oiseau* (1856), *L'Insecte* (1857), and *La Mer* (1861), popularised a natural history of the world which put forth a progressive pro-science and anti-clerical view, while the Republican politics espoused in works such as *Le Peuple* (1846) and *Histoire de la Revolution Française* (1847–53) have made him an important figure for the Left in the twentieth century. Yet, as we shall see, on the level of gender politics Michelet was far from progressive. See for example, R. Barthes, 'Modernité de Michelet', *Revue d'histoire littéraire de la France*, VII, 5 (September–October 1974) and *Michelet*, trans. R. Howard (New York, 1987). For a discussion of Michelet's politics see L. Orr, *Jules Michelet, Nature, History, and Language* (Ithaca, 1976), pp. 1–24.

26 J. Michelet, *L'Amour*, 5th ed. (Paris, 1861). All references will be drawn from: J. Michelet, *Oeuvres Complètes XVIII 1858–60*, ed. P. Viallaneix (Paris, 1985). The first edition of 2,000 copies of *L'Amour* sold within a few weeks. The second edition of 22,000 was followed by two more editions before the end of 1859. Michelet was able to write of this unprecedented sale in 1859 that 30,000 copies had sold in the course of two months. By 1861 *L'Amour* was in its fifth edition (Michelet, *L'Oeuvres*, pp. 30–1). *L'Amour* and its sequel *La Femme* sparked a debate which included criticism from both Catholics – as in the anonymous *L'Amour. Renversement des propositions de M. Michelet par un libre penseur* (Paris, 1859) and C. P. M. Haas, *La Femme: réfutation des propositions de J.* (Paris, 1860) – and feminists – as in a work by Mme J. P. d'Héricourt, *La Femme Affranchie. Réponse à MM Michelet, Proudhon etc.* (Paris, 1860). *L'Amour* was satirised in a play first performed at the Palais-Royal on 16 March 1859: Eugène Labiche et Edouard Martin, *L'Amour, parodie mêlée de couplets en un acte* (Paris, 1859).

27 Michelet, *Oeuvres*, pp. 58–61.

28 *Ibid.*, pp. 61–2. He reinforces this model by contrasting physical differences between healthy male and debilitated female bodies: 'Elle ne fait rien comme nous … Son sang n'a pas le cours du nôtre; par moments, il se précipite, comme une averse d'orage … elle ne digère pas comme nous. Sa digestion est troublée à chaque instant par une chose: elle aime du fond des entrailles. La profonde coupe d'amour (qu'on appelle le bassin) est une mer d'émotions variables qui contrarient la régularité des fonctions nutritives.'

29 *Ibid.*, p. 62.

30 *Ibid.*, p. 64.

31 See *ibid.*, p. 124.

32 Michelet describes the menstrual blood as the result of 'un accouchement continuel, l'ovaire toujours dèchiré et toujours guéri': *ibid.*, p. 225. See further pp. 225–7 where Michelet gives a resumé of recent medical research in this area.

33 Laqueur, 'Orgasm, generation', p. 25.

34 Michelet, *Oeuvres*, p. 225. See also *ibid.*, p. 85.

35 *Ibid.*, pp. 64–5. The class specific nature of the account reveals itself when speaking of the perpetual state of woman's weakness. Michelet states: 'Partout [ou] la femme n'extermine pas son sexe par un travail excessif (comme nos rudes paysannes qui de bonne heure se font hommes), partout [ou] elle reste femme, elle est [generellement] souffrante aux moms une semaine sur quatre.

36 *Ibid.*, p.75.

37 *Ibid.*, p. 76.

38 *Ibid.*, p. 124.

39 *Ibid.*, p. 228. Michelet cites the work of Stark and Burdach as evidence that 'pour le chien, le premier occupant influe plus que vingt qui peuvent suivre; il marque leurs enfants de sa ressemblance'.

40 C. Beaurin, 'La femme au point de vue du beau, I', *L'Artiste*, II (16 October 1865), pp. 169–73; *idem*, 'La femme au point de vue du beau, II', *L'Artiste*, I (15 January 1866), pp. 25–31.

41 *Ibid.*, p. 28.

42 *Ibid.*

43 *Ibid.*, p. 26.

44 *Ibid.*, p. 28. For an account of the way these notions about female changeability influenced the critical reception of work by women see T. Garb, 'Berthe Morisot and the feminizing of Impressionism', in T. J. Edelstein (ed.), *Perspectives on Morisot* (New York, 1990), pp. 57–66.

45 *Ibid.* Of course, Beaurin's reading of the woman's inner state from her external characteristics partakes in a more general culture of visibility predominant in the nineteenth century and earlier which included such pseudo-scientific disciplines as physiogomy and phrenology and were used to 'scientifically' justify imperialism and other forms of domination and descrimination. The science of physiognomy was incorporated by Le Brun into academic painting theory in the late seventeenth century and remained part of its stock in trade.

46 *Ibid.*, p. 31.

47 *Ibid.*, p. 28.

48 *Ibid.*, p. 31.

49 Originally published in the *Gazette des beaux-arts* in instalments from 1860 until 1867, Blanc's book reflected and transformed academic theories of art, conceptions of its purpose and rules for its execution. It became one of the most important sources of artistic theory for years to come. The most important sections for my argument, the 'Principes', were published from April 1860 to August 1861. For a discussion of the impact of Blanc's *Grammaire des arts du dessin*, see M. Song, *Art Theories of Charles Blanc 1813–1882* (Ann Arbor, 1984).

50 C. Blanc, *Granimaire des arts du dessin* (Paris, 1867), p. 6.

51 *Ibid.*

52 *Ibid.*, p. 7.

53 *Ibid.*

54 V. Cousin, *Du Vrai, du beau et du bien* (Paris, 1853). All translations will be taken from Cousin, *The True, the Beautiful and the Good*, trans. O. W. Wight (New York, 1890). For example, Cousin states: 'Everything that is real is imperfect … The traits of beauty are scattered and diverse. To reunite them arbitrarily … without any rule that governs this choice and directs these borrowings, is to compose monsters; to admit a rule is already to admit an ideal different from all individuals. It is this ideal that the true artist forms to himself in studying nature. Without nature, he never would have conceived this ideal; but with this ideal he judges nature herself, rectifies her, and dares undertake to measure himself with her': *ibid.*, p. 156.

55 Du Bosc de Pesquidoux, 'Beaux-Arts, Salon de 1863', *L'Union*, 161 (20 June 1863). Similarly, in 'De la Moralité dans la littérature et dans l'art', Antonin Rondelet states: 'L'oeuvre d'art la plus belle n'est celle qui reproduit avec la plus fidelité la nature: c'est au contraire celle qui s'en détache volontairement pour se mettre à la poursuite de l'idéal': *Revue contemporaine*, XXXIII, 265 (15 April 1863), p. 547.

56 Blanc, *Grammaire*, p. 11. Seventeenth-century academic theory serves as the root for much of Blanc's own theory of art. However, Blanc's account is more explicitly dependent on gender, and his demotion of the feminine is perhaps tied to a more general crisis in academicism which many contemporary critics blamed on the prevalence of female nudes in 'high art' paintings.

57 *Ibid.*, p. 10. Blanc capitalises this sentence in the middle of a paragraph to show its importance as a basic tenet of Art.

58 *Ibid.*, p. 7.

59 *Ibid.*, p. 11. Blanc describes the three aspects of Art, in ascending order as '*l'individualité*', '*le charactère*' and *la beauté*': 'L'artiste qui se borne à imiter la nature n'en saisit que *l'individualité:* il est esclave. Celui qui interprète la nature en voit les qualités heureuses: il en démele le *caractère:* il est maître. L'artiste qui l'idéalise y découvre ou y imprime l'image de la *beauté:* celui-là est un grand maître … C'est ici que va éclater la supériorité de l'art. La nature, en effet, ne produit que des individus: l'art s'élève à la conception de l'espèce.' Within this hierarchy, Nature is described as a term inferior to Art and, by inference, inferior to man who creates art.

60 Similarly, in a review of the Salon of 1863, Georges Lafenestre comments: 'le caractère commun de ces grandes oeuvres est de tenir peu de compte de la réalité contemporaine et passagère; soit qu'elles traduisent un grand fait du passé ou du présent, soit qu'elles symbolisent les sentiments et les pensées de leur temps, l'interprétation de l'homme et de la nature par le génie individuel de l'artiste y tient la meilleure place; sorties de l'imagination elles s'adressent directement à l'imagination, et ceux qui ne possèdent pas cette faculté ne les sauraient comprendre'. See G. Lafenestre, 'La Peinture au Salon de 1863', *Revue contemporaine*, 33 (15 June 1863), p. 604.

61 Blanc, *Grammaire*, p. 22.

62 *Ibid.*, p. 23.

63 *Ibid.*, p. 24.

64 *Ibid.*

65 Not surprisingly due to the indexical nature of photography which prevented the kind of transformation described by Blanc, there was much difficulty with the concept, let alone the display, of the photographic 'nude' in this period. Those promoting the status of photography as an art, such as Disdéri and Alexandre Ken, felt their cause

would be undermined by the photographic display of the female body which when shown in provocative detail would draw attention to the un-idealising aspects of the photographic apparatus. See Alexandre Ken, *Dissertations historiques, artistiques et scientifiques sur la photographie* (Paris, 1864), reprint ed. (New York, 1979); A. F. Disdéri *L'Art de la photographie* (Paris, 1862). On photography and the female body see A. Solomon-Godeau, 'The legs of the countess', *October*, XXXIX, (1986), pp. 65–108, and idem, 'Notes on erotic photography: towards a project of historical salvage', in Abigail Solomon-Godeau, *Photography at the Dock: Essays on Photographic History, Institutions and Practices* (Minneapolis, 1990).

66 Cousin, *The True*, p. 157.

67 On the deployment of 'sexuality', see M. Foucault, *The History of Sexuality, vol I: An Introduction*, trans. R. Hurley (London, 1980).

68 Blanc, *Grammaire*, p. 419.

69 *Ibid.*

70 *Ibid.*, pp. 510–11. In Blanc's account, the sculpture of Greek antiquity functions as evidence of a society in which the individual and the type, the real and the ideal, were not antithetical. Blanc contrasts this to the visual culture of modern society, with its preference for painting – the record of superficial, changing appearances, the art that is feminine. Blanc takes the Grecian Venus, which both includes chastity and hints at its opposite, as an example of the most successful portrayal of the nude: 'Greek antiquity … knew how to preserve an individual physiognomy even in ideal beauty … The Greek artist thus has searched for the absolute idea of grace and knowledge, and he took from nature the traits that characterised Venus …': *ibid.*, p. 12.

71 Claude Vignon [Noémie Cadiot], 'Le Salon de 1863', *Le Correspondant* (June 1863), pp. 363–92. Rather than assuming that Vignon's comments represented her personal interactions with paintings, one must interpret them in light of the discursive structures which underpin their descriptions and the power structures which these serve to mobilise and reinforce. For the critic Claude Vignon, a woman, was also an academic sculptor – Noémie Cadiot – who had studied with Jean-Jacques Pradier and had exhibited at the Salon. As a female critic writing from an academic perspective under a male pseudonym, it was only possible to use a 'masculine' descriptive language and interpretative model.

72 *Ibid.*, p. 381. Similarly, Paul Mantz noted that Cabanel's *Venus* was 'savamment rhythmée dans son attitude' and that 'la ligne générale se déroule harmonieuse et pure', thus linking the painter's controlling thought expressed through rhythm and line to the success of the work: Paul Mantz, 'Salon de 1863', *Gazette des beaux-arts*, XIV, 6 (1 June 1863), p. 484. There are several excellent accounts which contrast Cabanel's *Birth of Venus* to the painting of the avant-garde. See C. Armstrong, 'Degas and the representation of the female body', in S. R. Suleiman (ed.), *The Female Body in Western Culture* (Cambridge, Mass., 1986) and Clark, *The Painting of Modern Life*.

73 Vignon, 'Le Salon de 1863', p. 381. Similarly, Girard de Rialle described Venus as 'la femme type, la beaute, l'amour materiel divinisé': *A Travers le Salon de 1863* (Paris, 1863), p. 58. G. de Saint Valry described Cabanel's figure as a chaste body whose expression suggested the unchaste: 'Si le corps est d'une déesse, la physionomie est tout ce qu'il y a de moins antique et de moins divin; cc sourire, ces yeux provoquants contrastent avec le caractère de chasteté si bien saisi dans tout le reste': G. de Saint Valry, *Pays* (19 May 1863).

74 Vignon,'Le Salon de 1863', p. 381.

75 *Ibid.*, p. 382. Critics focused on the foot as a problem point in this painting. In this respect it is interesting to note that 'un coup de pied de Vénus' was a familiar phrase for venereal disease.

76 J. A. Castagnary, 'Salon de 1863', in *idem, Salons* (Paris, 1892), p. 113. Similarly, Lamquet suggested that Baudry's *Vénus* showed the trace of a garter on her leg: Lamquet, 'Salon de 1863 – genre historique', *Les Beaux-Arts,* 6 (1 June 1863), p. 327.

77 Mantz, 'Le salon de 1863', p. 484.

78 Lafenestre, 'La peinture au salon de 1863', p. 606.

79 H. Francingues, 'Exposition des beaux-arts – la peinture au salon de 1863', *Revue des races latines,* XXXVIII (June 1863), p. 585.

80 Un Bourgeois de Paris, 'Salon de 1863', *La Gazette de France* (7 July 1863).

81 Vignon,'Le Salon de 1863', p. 382.

82 *Ibid.*

83 A similar descriptive strategy is used by Adrien Paul who implies that the crowds that gather around Cabanel's Venus are attracted to her: A. Paul, 'Beaux-Arts. Salon de 1863', *Le Siècle,* 10263 (3 June 1863).

84 This was a common area for prostitutes. See Clark, *The Painting of Modern Life,* pp. 86–7

85 Du Camp, *Les Beaux-Arts,* p. 12.

86 *Ibid.*, p. 26.

87 *Ibid.*, p. 38.

88 *Ibid.*, p. 33.

89 *Ibid.*

90 *Ibid.*, p. 84.

91 *Ibid.*

92 *Ibid.*, p. 36.

93 *Ibid.*

94 *Baudry 1828–1886,* Musée d'Art et d'Archéologie La Roche-sur-Yon, 17 janvier–31 mars (1986), p. 77.

95 Du Camp, 'Le salon de 1863', p. 35. Ernest Chesneau also referred to Baudry's painting as 'La Vague', thus implying that the wave was the main subject of the picture and equating it with the woman: Ernest Chesneau, 'Beaux Arts – Salon de 1863', *Le Constitutionnel,* 132 (5 May 1863), and 181 (30 June 1863). Interestingly, this slippage continued. In the 1867 Universal Exposition, the painting was exhibited under the title *La Vague et la perle.* In the Baudry catalogue of 1986, though the title is given in the catalogue as *La Perle et la vague,* the first sentence for the entry starts: 'Baudry expose ce tableau au Salon de 1863 sous le titre: *La Vague et la perle':* Baudry *1828–1886,* p. 77

96 Du Camp, 'Le salon de 1863', pp. 26–7.

97 *Ibid.*, p. 3. Similarly, J. Graham, the critic for *Le Figaro,* set up an opposition between 'le côté des hommes' and 'le côté des dames', between 'art héroïque' and 'art érotique'. Graham placed both Baudry and Cabanel on 'le côté des dames': J. Graham [Arthur Stevens], 'Un Etranger au Salon', *Figaro,* 865 (31 May 1863), p. 2.

98 Du Camp, 'Le salon de 1863', p. 3.

Notes to Chapter 6

This paper was originally delivered as a conference paper at the Association of Art Historians Conference in 1993. My thanks to Tamar Garb and Briony Fer for inviting me to participate in the session 'Metaphor and Power' that they organised. I am grateful to Joanna Woodall and Alex Potts for helpful comments at an early stage of the project.

1 *Burne-Jones: The Paintings, Graphic and Decorative Work of Sir Edward Burne-Jones 1833–98*, exhibition catalogue, Arts Council (1975), p. 54.

2 *Athenaeum* (1879), pp. 415–16. The review extends over two columns on these two pages.

3 The notice, which was written in advance of the paintings' exhibition at the Grosvenor Gallery, refers to this picture as *The Goddess Fires*.

4 Interesting commentary on Pygmalion stories, and the complexities of the cultural association of Pygmalion with artistic creation, sculpture and eroticism are to be found in: P. De Man, *Allegories of Reading: Figural Language in Rousseau, Nietzsche, Rilke, and Proust* (New Haven and London, 1979), ch. 8; J. Elsner and A. Sharrock, 'Re-viewing Pygmalion', *Ramus*, 20 (1991), pp. 149–82; K. Gross, *The Dream of the Moving Statue* (Ithaca and London, 1992); and G. Marshall, *Actresses On the Victorian Stage: Feminine Performance and the Galatea Myth* (Cambridge, 1998).

5 R. K. Cook, *Purpose and Passion: Being Pygmalion and Other Poems of 1870* (London, 1870), p. 25.

6 T. Woolner, *Pygmalion* (London, 1881).

7 *Ibid.*, p. 79.

8 *Ibid.*, p. 71.

9 W. Brough, *Pygmalion; Or the Statue Fair* (London, 1867), p. 21.

10 W. Morris, *The Earthly Paradise* (1868–70) (London, 1896).

11 For the different stages of the project see: *Burne-Jones*, exhibition catalogue, Sheffield, Mappin Art Gallery (1971), pp. 22–3; *Burne-Jones*, exhibition catalogue, Arts Council (1975), pp. 54 and 83–4; and *Visions of Love and Life: Pre-Raphaelite Art from the Birmingham Collection*, exhibition catalogue by S. Wildman, Seattle, Art Museum; Birmingham, Birmingham Museums and Art Gallery, etc. (1995), pp. 301–9.

12 Morris, *Earthly Paradise*, vol. II, pp. 252–3.

13 For an interesting interpretation of the series see R. Virag, 'Burne-Jones, Pygmalion, and the Creative Interior', unpublished conference paper delivered at the conference *Edward Burne-Jones*, Birmingham, Barber Institute, January 1999.

14 Virag points out the role of water in testing marble for colour and cooling the sculpting tools.

15 G. Deleuze, 'Coldness and cruelty' (1967), in G. Deleuze and L. von Sacher-Masoch, *Masochism* (New York, 1991).

16 E. Eastlake, *Life of John Gibson R.A., Sculptor* (London, 1870) and T. Matthews, *The Biography of John Gibson R.A., Sculptor, Rome* (London, 1911).

17 Matthews, *Biography*, p. 32.

18 *Ibid.*, p. 24.

19 Eastlake, *Life*, p. 226.

20 Matthews, *Biography*, p. 76.

21 This makes possible a variant on narcissism where the key moment is not the being enamoured of the self but the confusion between the reflection of the self and the

image of the twin sister. Gibson cites this version of the Narcissus myth in relation to his own statue of Narcissus. He is drawing on the version of the story told by Pausanius rather than that told by Ovid, where the twin sister is not mentioned. See S. Hornblower and A. Spawforth, *The Oxford Classical Dictionary* (Oxford and New York, 1996), p. 1026.

22 Eastlake, *Life*, p. 213.

23 Matthews, *Biography*, p.172.

24 Deleuze, 'Coldness and cruelty', p. 63.

25 E. Burne-Jones, letter.

26 Matthews, *Biography*, p. 15.

Notes to Chapter 7

1 Werefkin (1869–1938), who trained in the Moscow Academy and studio of the well-known painter Ilya Repin, came from St Petersburg to Munich in 1896. She devoted herself initially to promoting the career of Alexej Jawlensky, her partner at the time. While she wrote theoretical treatises, it was only after 1906 that she resumed sketching and painting. Werefkin was unsystematic in dating her works. The medium and style of this work on paper would seem consistent with her Munich period (1896–1914) and could date from between 1906 and 1914. For a summarised account of her life and work, consult S. Behr, 'Marianne Werefkin', in D. Gaze (ed.), *Dictionary of Women Artists* (London, 1997), vol. 2, pp. 1141–5.

2 At the turn of the century, the increasing visibility of women artists in studio and museum-life appeared to threaten the hegemony of male artistic practice. *Malweiber,* as they were called, became the butt of caricaturists in the specialist media press. In art and literary journals, they were portrayed as either overtly feminine and unsuited to the task or as severely masculinised. The satirist Bruno Paul, for instance, depicted the woman artist as unattractive, lanky and lacking femininity. Watching over the shoulder of the male artist, who is demonstrating how to paint, the woman is informed: 'Sehen Sie, Fräulein, es gibt zwei Arten von Malerinnen: die einen möchten heiraten und die andern haben auch kein Talent' ('You see, miss, there are two sorts of women painters: the one wants to marry and the others also have no talent') *Simplicissimus*, 6, 15 (1901), p. 117. For a comprehensive account of the social and institutional status of women artists, see R. Berger, *Malerinnen auf dem Weg ins 20.Jahrhundert: Kunstgeschichte als Sozialgeschichte* (Cologne, 1982), pp. 58ff.

3 The debate was initiated by feminist art historians, as conveyed in the pivotal essay by C. Duncan, 'Virility and domination in early twentieth-century vanguard painting', in N. Broude and M. Garrard (eds), *Feminism and Art History: Questioning the Litany* (New York, 1982), pp. 293–313. For a focus on the critical language applied to the female nude consult L. Nead, *The Female Nude: Art, Obscenity and Sexuality* (London, 1992), p. 58.

4 This is effectively discussed by J. Lloyd, 'The *Brücke* Studios: A testing ground for Primitivism', in idem, *German Expressionism: Primitivism and Modernity* (New Haven and London, 1991), pp. 21–49; by G. Perry, 'Expression and the body', in C. Harrison, F. Frascina and G. Perry (eds), *Primitivism, Cubism, Abstraction: The Early Twentieth Century* (New Haven and London, 1993), pp. 67–81; and more recently by C. Rhodes, 'Through a looking glass darkly: gendering the primitive and the significance of

constructcd space in the practice of the Brücke', in L. Durning and R. Wrigley (eds), *Gender and Architecture* (London, 2000).

5 The rapid changes that overtook patterns of artistic training, production and display during the late Wilhelmine era in Germany appeared to echo transformations brought about by technical modernity in the social, economic and political spheres. In the period before the First World War, an unprecedented degree of urbanisation informed the tensions that emerged between the urban and rural, town and country, civilisation and nature. Cultural criticism emanated from a complex set of pre-industrial and utopian assumptions that perceived the modernising world as fallen, chaotic and compromised. Notwithstanding the right wing, conservative persuasion of some critics (e.g. Julius Langbehn), their ideas were imbued with a vitalist philosophy, expounded as well in Friedrich Nietzsche's writings. For a summarised account of the role of 'intuitionist' theories in the modern period, see A. Bowie, Critiques of culture', in E. Kolinsky and W. van der Will, *Modern German Culture* (Cambridge, 1999), pp. 132–52.

6 E. L. Kirchner, *Chronik KG Brücke*, 1913, translated in R. Heller, *Brücke: German Expressionist Prints from the Granvil and Marcia Specks Collection* (Evanston, Ill., 1988), p. 16.

7 Here the terminology employed, i.e. 'matter [of the body]', with its multiple implications as a material form and as a topic of discourse, derives from J. Butler, *Bodies That Matter: On the Discursive Limits of 'Sex'* (New York and London, 1993).

8 See P. Lasko, 'The student years of the *Brücke* and their teachers', *Art History*, 20, 1 (March 1997), pp. 61–99.

9 See Lloyd, 'The *Brücke* bathers: back to nature', in idem, *German Expressionism*, pp. 102–29.

10 For the most up-to-date publication see A. Hoberg and H. Friedel (eds), *Der Blaue Reiter und das neue Bild: von der 'Neuen Künstlervereinigung München' zum 'Blaue Reiter'* (Munich, 1999).

11 Three volumes of Werefkin's journals, dating from between 1901 and 1905, are held in the Fondazione Marianne Werefkin, Museo Comunale d'Arte di Ascona. Abridged extracts have been published in German and English but none of these sources provide transcriptions of the original French. See M. Werefkin, *Briefe an einen Unbekannten*, ed. C. Weiler (Cologne, 1960); J. Hahl-Koch, 'Marianne Werefkin und der russische Symbolismus: Studien zur Ästhetik und Kunsttheorie', *Slavistische Beiträge*, 24 (1967); M. Witzling, *Voicing our Visions* (London, 1992), pp. 132–46. For *On the Spiritual in Art* see W. Kandinsky, *Complete Writings on Art*, ed. K. Lindsay and P. Vergo (London, 1982), vol. I, pp.119–219.

12 M. Nordau, *Degeneration*, translated from the second edition of the German work (New York, 1895).

13 *Ibid.*, dedication. Lombroso's *Genio e Folio* (*Genius and Insanity*, 1863) was one of the principal sources of inspiration for Nordau's *Degeneration*. George L. Mosse provides an illuminating account of Nordau's life and writings in his introduction to the translation (Lincoln and London, 1993), pp. xiii–xxxiii.

14 See C. Diethe, *Towards Emancipation: German Women Writers of the Nineteenth Century* (New York and Oxford, 1998), p. 194.

15 *Ibid.*, p. 171.

16 P. Jelavich, 'Munich as a cultural center: politics and the arts', in *Kandinsky in Munich 1896–1914* (New York, 1982), p. 22.

17 Long before he opened his Institute of Sexual Science in Berlin in 1919, the sexologist Magnus Hirschfeld campaigned against Paragraph 175, the law in Germany's penal code against male homosexuality. Since 1895, he struggled for the rights of what he termed the Third Sex by publicising his views in periodicals, such as *Annals of Sexual Intermediacy* (1900–23). See A. Kaes, M. Jay and E. Dimendberg (eds), *The Weimar Republic Sourcebook* (Berkeley, Los Angeles and London, 1994), p. 693. Citing Morel and Lombroso for the derivation of the term, Nordau characterised 'stigmata' as brandmarks that betrayed degeneracy either as physical deformity or mental aberration. See *Degeneration*, pp. 17–18.

18 K. Scheffler, *Die Frau and die Kunst* (Berlin, 1908), p. 92: 'daß die Frau, die ihre harmonische Geschlossenheit zerstört und sich zu einseitigem männlichen Wollen zwingt, diesen Entschluß fast immer mit Verkümmerung, Krankhaftigkeit oder Hypotrophie des Geschlechtsgefühls, mit Perversion und Impotenz bezahlen muß.'

19 *Ibid.*, pp. 27–8: 'Zwingt sie sich zur Kunstarbeit, so wird sie gleich männlich. Das heißt: sie verrenkt ihr Geshlecht, opfert ihre Harmonie und gibt damit jede Möglichkeit aus der Hand, original zu sein. Denn echte Originalität ist nur dort, wo innere Notwendigkeit ist … Da die Frau also original nicht sein kann, so bleibt ihr nur, sich der Männerkunst anzuschließen. Sie ist die Imitatorin par excellence, die Anempfinderin, die die männliche Kunstform sentimentalisiert und verkleinert … Sie ist die geborene Dilettantin.' Translation after R. Heller, *Gabriele Münter: The Years of Expressionism 1903–1920* (Munich and New York, 1998), p. 46.

20 M. Werefkin, *Lettres à un Inconnu*, vol. III, p. 257 (30 October 1905): Je ne suis pas lâche et je tiens la parole donnée. Je suis fidèle à moi-même, féroce à moi même et indulgente aux autres. Voilà moi homme. J'aime le chant de l'amour – voilà moi femme. 'Je me crée consciemment des illusions et des rêves – voilà moi artiste.' Je suis le meilleur des camarades, l'ami le plus honnête, un artiste (p. 258) dans le plus vaste sens de ce mot. Je suis cruelle dans mes affections les plus tendres, j'ai des dégoûts pour les choses qui me sont les plus chères, rien ne m'emporte parce que tout est si clair, je rêve grand, je vois petit, je ne sais pas plier. Je suis forte parce que je me possède, 'je suis faible parce que j'ai besoin pour être moi-même de la chaleur de l'amour.' Ce qu'on me donne je le rend en force mais il faut qu'on me donne la chaleur du coeur. Je n'ai pas trouvé mon pair parce que qui me comprendrait comme je me comprends serait un fort, un qui n'aurait pas besoin de moi. Et ceux que je trouve sur mon chemin sont trop peu pour apprécier tout ce (p. 259) pourait leur venir de moi. Je suis vouée à la solitude morale. Comme se trompe ceux qui croient que j'ai besoin damour. J'ai besoin de l'amour pour me grandir parce que sous sa chaude haleine toutes mes facultés prennent des ailes se détachent du quotidien et cherchent l'idéal. 'Je suis un homme bien plus qu'une femme.' Le besoin de plaire et le pitié seuls me font femme. 'J'écoute et je prends notes. Tous les jugements tombent à côté. Il est beaucoup trop jeune pour comprendre ce qu'il pouvait avoir en moi. Je ne suis ni homme, ni femme: je suis moi.'

21 W. Kandinsky, 'Kritika Kritikov', *Novosti dnia* (Moscow, 1901), *Complete Writings*, p. 43. For further commentary on Kandinsky's critique of anthropological positivism, equated by him with Tolstoy's realist aesthetic, see C. McKay, '"Fearful dunderheads": Kandinsky and the cultural referents of criminal anthropology', *The Oxford Art Journal*, 19, 1 (1996), pp. 29–41.

22 G. J. Wolf, 'Ausstellungsrezension', *Die Kunst für Alle*, November 1910: 'Man greift sich wie von Sinnen an den Kopf wenn man vor diesen Gebilden steht […] Und wenn

man sich endlich wohl oder übel entschließt, die Sachen ernst zu nehmen, so steigen einem wohlberechtigte Zweifel pathologischer Natur auf [...] Einzelnes ließ ich mir eingehen, wenn darunter stünde "Farbskizze für einen modernen Teppich". Aher weit gefehlt! Die leute, die hier ausstellen, sind sich zu gut, sich mit "Kunstgewerblern" auf eine Stufe stellen zu lassen.'

23 W. Kandinsky, 'Rückblicke', *Der Stum*, (Berlin, 1913), *Complete Writings*, pp. 373–4.

24 See H. K. Roethel and J. K. Benjamin, *Kandinsky: Catalogue Raisonné of the Oil Paintings*, vol. 1, 1900–15, (London, 1982), no. 389, p. 374: *Nude (Akt)*, 1911, oil on canvas, 147.3 x 99 cm., private collection.

25 W. Kandinsky, *Über das Geistige in der Kunst (1912)*, (Bern, 1963), p.78: 'Das Kombinieren des Verschleierten und des Blossgelegten wird eine neue Mögliehkeit der Leitmotive eine Farbenkomposition bilden.' For further discussion of this, see R. C. Washton Long, *Kandinsky: The Development of an Abstract Style* (Oxford, 1980), pp. 65–74.

26 P. Weiss, *Kandinsky and Old Russia: The Artist as Ethnographer and Shaman* (New Haven and London, 1995), p. 63.

27 W. Kandinsky, 'Cologne Lecture' (1914), *Complete Writings*, pp. 395–6.

28 See *Kandinsky: Catalogue Raisonné*, no. 388, p. 373: oil on canvas, 106 x 158 cm., Staatliche Armenische Gemäldegalerie, Erevan.

29 W. Kandinsky, 'Arabisches III (Zweikampf)', 1911: Gabriele Münter- und Johannes Eichner-Stiftung, Städtische Galerie im Lenbachhaus, Munich (I thank Ilse Holzinger for making this text available): '*Thema:* Hier wollte ich mich des Trivialen bedienen: 2 Araber (em Jüngling und ein Bösewicht) kämpfen um eine Schöne Frau. Ihre Bewegungen sind trivial. Die Schöne Frau ist trivial. Zu der schönen Orientalin gehört unbedingt ein Wasserkrug.'

30 W. Kandinsky, 'Rückblicke' (1913), *Complete Writings*, p. 373.

31 See V. Burgin, 'Fantasy', in E. Wright (ed.), *Feminism and Psychoanalysis: A Critical Dictionary* (Oxford, 1992), p. 85.

32 *Ibid.*, p. 84. Burgin speaks of this as the 'desire neither for a thing nor for a person, but for a fantasy – the mnemic traces of the lost object'.

33 *Kandinsky: Catalogue Raisonné*, p. 373. Due to the outbreak of the First World War, Kandinsky had to leave Germany in haste in August 1914. He never retrieved many of his pre-1914 works from Gabriele Münter.

34 B. Ddrygulski Wright, '"New man", eternal woman: Expressionist responses to German feminism', *The German Quarterly*, 60, 4 (Fall 1987), pp. 582–3.

35 P. Hatvani, 'Spracherotik', *Der Sturm* (1912), as cited in Wright, '"New man", eternal woman', p. 595: 'Und da der Künstler doch im ewigen Gegensatz zu Stoffe lebt, wird dieser weibliche Stoff des expressionistischen Künstlers em Urquell seiner erhöhten Männlichkeit.'

36 R. Betterton, 'The body in the works: the aesthetics and politics of women's painting', *Issues in Architecture. Art and Design* (June 1995), pp. 8–9.

37 For an account of the tradition of the feminine in definitions of the male artist, see C. Battersby, *Gender and Genius: Towards Feminist Aesthetics* (London, 1989), p. 8.

38 F Marc, 'Zur Ausstellung der "Neuen Künstlervereinigung" bei Thannhauser', September 1910, in A. Hüneke (ed.), *Der Blaue Reiter: Dokumente einer geistigen Bewegung* (Leipzig, 1989), pp. 30–3.

39 M. Werefkin, *Lettres à un Inconnu*, vol. II, p. 97 (17 November 1903): 'Et mes yeux se tournent vers l'autre que j'aime [] si fort, si tendrement, si jeunement, vers cet amour

où il n'y a eu peu que nous deux, où tout est si personnel, où moi je suis moi sans aucune raison (p. 98) raisonnable. J'entends des paroles de tendresse, je vois des yeux m'adorant, je sens une caresse qui jamais n'a osé se donner. Mon moi se dédouble. Mon moi lutte. Et pour me redonner l'unisson je me jette à corps perdu dans mon art.' For translation also see Witzling, *Voicing our Visions*, p. 139.

40 See J. Rivière, 'Womanliness as a masquerade' (1929), in V. Burgin, J. Donald and C. Kaplan, *Formations of Fantasy* (London and New York, 1986), p. 38.

41 This was discussed by Mara Witzling in an unpublished paper 'My beautiful, my unique, my self, my muse: Werefkin's "Inconnu" and women artists' appropriation of artistic authority', College Art Association, 1993.

42 For a discussion of women artists' negotiation of self-portraiture see S. Behr, 'Die Arbeit am eigenen Bild: Das Selbstporträt bei Gabriele Münter', in A. Hoberg and H. Friedel (eds), *Gabriele Münter 1877–1962* (Munich, 1993), pp. 85–91.

43 Hoberg and Friedel, *Der Blaue Reiter*, p. 349.

44 For further discussion of this image see S. Behr, *Women Expressionists* (Oxford, 1988), p. 26.

45 M. Werefkin, *Lettres à un Inconnu*, vol. I, p. 24 (1901): 'J'ai attrapé sur moi, sur mes belles épaules, de ces regards d'homme qui demandent des gifles. J'ai vu les artistes traiter la femme nue qui devait aider leur travail avec le mépris dont jadis les blancs récompensaient le nègre.'

46 See B. Fäthke, *Marianne Werefkin: Leben und Werk 1860–1938* (Munich, 1988), figure 30, p. 32.

47 The psychoanalytical co-ordinates of the Venus de Milo are discussed in P. Fuller, *Art and Psychoanalysis* (London, 1980).

48 M. Werefkin, *Lettres à un Inconnu*, vol. I, p. 24 (1901); also see Witzling, *Voicing our Visions*, pp. 33–4

49 The centrality of the *flâneur* to modernist discourse has been well documented. For the nineteenth-century context of the *flâneuse* see J. Wolff, 'The invisible *flâneuse*: women and the literature of modernity', in idem, *Feminine Sentences: Essays on Women and Culture* (Cambridge, 1990), pp. 34–50.

50 P. Heller, 'A quarrel over bisexuality', in G. Chapple and H. H. Schulte (eds), *The Turn of the Century: German Literature and Art 1890–1915* (Bonn, 1981), pp. 87–115. For a comprehensive account of the stereotypes of Jewish identity and difference see S. Gilman, *The Jew's Body* (New York and London, 1991).

51 F. W. Huebner, 'Alexander Sacharoff', *Phöbus*, 1, 3 (1914), pp. 103–4.

52 M. A. Doane, 'Film and the masquerade: theorising the female spectator', *Screen*, XXV, 3–4 (September–October 1982), pp. 74–88.

53 M. Foucault, *History of Sexuality*, vol. I (London, 1980), p. 10.

Notes to Chapter 8

I would like to thank the Courtauld Women Teachers' Group for including me in the Venus project; I have much appreciated the stimulus and feedback afforded by the group during the process of completing this piece. Paul Overy's help and advice have been invaluable.

1 Juno, Minerva and Venus were the Roman names for Hera, Athena and Aphrodite. On the iconography of the *Judgment of Paris*, see H. Damisch, *The Judgment of Paris*, trans. J. Goodman (Chicago and London, 1996).

2 The *Société des Arts Décoratifs* was founded in the wake of the 1900 Paris Exhibition with the aim of supporting and promoting the work of French *artistes décorateurs*. For further information on the *Société*, see Y. Brunhammer and S. Tise, *French Decorative Art: The Société des Artistes Décorateurs 1900–1942* (Paris, 1990): pp. 84–120 deals with the 1925 Paris Exhibition.

3 The hall also included a bas-relief by Henri Laurens. For details of Robert Delaunay's *Ville de Paris. La femme et la tour*, see no. 233 in G. Habasque, *Robert Delaunay: Du cubisme à l'art abstrait* (Paris, 1957). C. Green discusses Léger's painting in *Léger and the Avant-Garde* (New Haven and London, 1976), p. 291ff.

4 See T. Gronberg, *Designs on Modernity: Exhibiting the City in 1920s Paris* (Manchester and New York, 1998).

5 Sonia Delaunay (née Terk) was born in the Ukraine, adopted by her maternal uncle in St Petersburg and received a private income until the 1917 Revolution.

6 For a discussion of Sonia Delaunay's artistic identity in relation to that of Robert Delaunay, see W. Chadwick, 'Living simultaneously: Sonia and Robert Delaunay', *Women's Art Magazine*, 53 (July/August 1993), pp. 4–10 and Chadwick's essay of the same title in W. Chadwick and I. Courtivron (eds), *Significant Others: Creative and Intimate Partnerships* (London, 1993). Also, my review of S. Baron and J. Damase, *Sonia Delaunay: The Life of an Artist*: 'Working in tandem', *Art History*, 19, 2 (June 1996).

7 Sonia Delaunay with the collaboration of Jacques Damase and Patrick Raynaud, *Nous irons jusqu'au soleil* (Paris, 1978), pp. 38–9; also quoted in *Le Centenaire Robert and Sonia Delaunay*, Musée d'Art Moderne de la Ville de Paris (Paris, 1985), p. 59.

8 On Robert Delaunay's *Ville de Paris*, see for example M. Hoog, *Robert et Sonia Delaunay*, Musée National d'Art Moderne (Paris, 1967), pp. 55–6; S. A. Buckberrough, *Robert Delaunay: The Discovery of Simultaneity* (Ann Arbor, 1982), pp. 84ff. V. Spate, *Orphism: The Evolution of Non-Figurative Painting in Paris 1910–1914* (Oxford, 1979), pp. 180–7; D. Cottington, *Cubism in the Shadow of War: The Avant-Garde and Politics in Paris 1905–1914* (New Haven and London, 1998), esp. p. 117.

9 Delaunay, *Nous irons*, p. 38 and *Centenaire*, p. 59. The novel *L'Eve future* by the Symbolist Villiers de l'Isle-Adam was published in 1886. See A. Michelson, 'On the Eve of the future: the reasonable facsimile and the philosophical toy', in A. Michelson *et al.* (eds), *October: The First Decade, 1976–1986* (Cambridge, Mass., 1986).

10 On the imagery of robots see P. Wollen, 'Modern times: cinema/Americanisation/the robot', in idem, *Raiding the Icebox: Reflections on Twentieth-Century Culture* (London and New York, 1993). The fantasies enacted by robot and android figures are not restricted to the early twentieth century as evidenced by more recent films such as *The Stepford Wives* (1975) and *Blade Runner* (1982).

11 Blaise Cendrars, 'The Eiffel Tower' (1924), in A. A. Cohen, *The New Art of Color: The Writings of Robert and Sonia Delaunay* (New York, 1978), pp. 171–6. The essay was first delivered as a lecture in Brazil in June 1924 and subsequently published in *Aujourd'hui* (Paris, 1931). See M. Perloff's discussion of this essay in 'Deus ex machina: some futurist legacies', in idem, *The Futurist Moment: Avant-Garde, Avant Guerre, and the Language of Rupture* (Chicago and London, 1986).

12 Perloff discusses the imagery of the Eiffel Tower as a scene of conquest in Perloff, *The Futurist Moment*, p. 211.

13 See, for example, Chadwick, *Significant Others*, p. 46: 'his career languished'.

14 See the reproduction of the relevant catalogue pages for the *Ambassade Française* in *Robert Delaunay*, Galerie Gmurzynska (Cologne, 1983), p. 64.

15 On the dealer system see M. Gee, *Dealers, Critics, and Collectors of Modern Painting. Aspects of the Parisian Art Market Between 1910 and 1930* (New York and London, 1981) and C. Green, *Cubism and its Enemies* (New Haven and London, 1987).

16 'Futurist exhibits by Sonia Delaunay – some modern model mannequins', *The Home* (1 October 1925) and 'Der Einfluss der "Exposition des Arts décoratifs"', Paris 1925', *Das Leben* (January 1926). *The Home*, first published in 1924, was an upmarket women's magazine; see N. D. H. Underhill, *Making Australian Art 1916–49: Sydney Ure Smith Patron and Publisher* (Oxford and New York, 1991). I am grateful to Peter McNeil for information concerning *The Home*.

17 These are 'Hommage à Blériot' (1914) and 'Hélice' (1923), the choice of two paintings based on airplane imagery at least partly motivated by a desire to represent a continuity between Delaunay's pre- and post-war practice. In P. Francastel, *Robert Delaunay: du cubisme à l'art abstrait* (Paris, 1957), p. 125, Delaunay represented the 'Blériot' as an example of his most advanced pre-war painting.

18 The *Tower with Curtains* painting pictured in the Mme Mandel portrait, previously dated 1912, has now been dated as 1920–22. See M. Drutt, 'Simultaneous expressions: Robert Delaunay's early series', in *Visions of Paris: Robert Delaunay's series*, Guggenheim Museum (New York, 1997), pp. 34–6. Delaunay's practice of reprising earlier themes – and predating his paintings – has been the subject of extensive scholarly discussion: see for example, Buckberrough, *Robert Delaunay* and Spate, *Orphism*.

19 See Green's discussion of Cubism and decoration in *Cubism and its Enemies*, p. 222 and his reference to Robert Delaunay's view that the 1925 Exhibition constituted a 'triumph for Cubism', p. 214.

20 'Sonia Delaunay by Sonia Delaunay (1967)', written for the catalogue of the Sonia Delaunay retrospective at the Musée National d'Art Moderne (Paris, 1967–68), in Cohen, *The New Art of Color*, p. 197.

21 Sonia Delaunay, 'Collages of Sonia and Robert Delaunay' (1956), from *XXème Siècle*, 6 (January 1956) in Cohen, *The New Art of Color*, p. 210.

22 André Salmon, for example, pronounced: 'Il arrive que Mme. Marval peigne un peu comme on se maquille'. A. Salmon, *L'Art Vivant* (Paris, 1920), p. 282. See my discussion of these issues in '*Toile* and *toilette*: representations of woman as author' in ch. 4 of *Cité d'Illusion: Staging Modernity at the 1925 Paris Exposition Internationale des Arts Décoratifs et Industriels Modernes* (Ph.D., The Open University, 1994). For a comprehensive study of femininity and avant-garde painting in Paris see G. Perry, *Women Artists and the Parisian Avant-Garde: Modernism and 'Feminine' Art, 1900 to the late 1920s* (Manchester and New York, 1995).

23 Delaunay, 'Collages', pp. 210–11.

24 The 1913 exhibition was probably the first Herbstsalon at Galerie der Sturm Berlin. On collage, see for example C. Poggi, *In Defiance of Painting: Cubism, Futurism, and the Invention of Collage* (New Haven and London, 1992); D. Waldman, *Collage, Assemblage and Found Object* (Oxford, 1992); J. Elderfield (ed.), *Essays on Assemblage*, Museum of Modern Art (New York, 1992) and the chapter 'The invention of collage', in Perloff, *The Futurist Moment*.

25 Delaunay, 'Collages', p. 210.

26 Buckberrough describes the 1913 dress in terms of a transfer of Delaunay's illustration to the realm of fashion, as 'various patches of brilliantly colored fabrics, cut in the rectangles and arches of the *Prose du Transsibérien*': Buckberrough, *Robert Delaunay*, p. 210. For a discussion of Delaunay's dress in relation to the 'theatricalization of avant-garde style', see J. Weiss, *The Popular Culture of Modern Art: Picasso, Duchamp, and Avant-Gardism* (New Haven and London, 1994), p. 207. See also Cottington's arguments, 'Sonia and Robert Delaunay: populism, consumerism and modernity', in his *Cubism in the Shadow of War.*

27 See for example C. Greenberg, 'Cubism was not a question of decorative overlay', p. 80 in Collage', in *Art and Culture: Critical Essays* (Boston, 1961), pp. 70–83. First published as 'The pasted paper revolution', in *Art News* (1958); see '14. The pasted paper revolution', *Modernism with a Vengeance, 1957–1969* [vol. 4 of *Clement Greenberg: The Collected Essays and Criticism*], pp. 61–6. For a recent discussion of Cubist collage, see R. E. Krauss, *The Picasso Papers* (London, 1998).

28 Sometimes referred to as 'tapestry' coats, Sonia Delaunay's coats were produced from about 1924. She experimented with an embroidery technique called 'point du jour' or 'point populaire' (similar to the 'point d'Hongrie'). The coat with rectilinear motifs (shown in the 1925 *Ambassade* photograph) seems to have been a particularly popular model and was produced in a number of versions involving different combinations of furs, fabrics and embroideries. (One, sold to Gloria Swanson, involved only embroidery.) See E. Morano, *Sonia Delaunay: Art into Fashion* (New York and London, 1991), p. 21. A review of the 1925 Boutique Simultanée commented on 'these sumptuous coats': 'She also worked in furs in a quite individual way ...; she mixed furs and embroidery, metal and wool or silk, but she only ever used metal with certain matt tones, stressing its rich and discreet elegance': Armand Lanoux quoted in J. Damase, *Sonia Delaunay: Fashion and Fabrics* (London, 1991), p. 117. The geometric patterns of these coats accorded well with 1920s French furriery styles which often used furs of inferior quality: 'on trace sur les peaux des lignes géométriques, on risque des coloris qui sont de pure fantasie': *Encyclopédie des arts déoratifs et des industries modernes au XXe siècle*, official publication of the 1925 Exhibition (Paris, n.d.), vol. IX, p. 26.

29 Damisch, *Judgment of Paris*, p. 133.

30 J. V. Emberley, *Venus and Furs: The Cultural Politics of Fur* (London, 1998), p. 4.

31 L. von Sacher-Masoch, *Venus in Furs* (1870) in G. Deleuze/L. von Sacher-Masoch, *Masochism* (New York, 1991), pp. 229 and 249.

32 Sacher-Masoch, *Venus in Furs*, p. 149

33 'Like the feminine despot, the femme fatale "has power *despite herself*"', precisely because, as Mary Ann Doane elaborates, she 'is attributed with a body which is itself given agency independently of consciousness': Emberley, *Venus and Furs*, p. 219, n.16.

34 Sacher-Masoch, *Venus in Furs*, p. 268.

35 Emberley, *Venus and Furs*, p. 103. Pat Rubin has kindly pointed out to me that the painting today known as *La Fornarina* (Galleria Nazionale, Rome) does not depict fur. It may be that Sacher-Masoch's and Davey's references relate to the *Portrait of a Young Woman* 'at one time considered a portrait of the Fornarina ... exhibited in the Tribuna of the Uffizi since 1589 with the designation "Raphael"': see P. de Vecchi, *The Complete Paintings of Raphael* (London, 1969), no. 99.

36 Emberley, *Venus and Furs*, p. 104, quoted from J. Berger, *Ways of Seeing* (London, 1972), p. 61.

37 Damisch, *Judgment of Paris*, p. 11.

38 In his 1927 essay on fetishism, Freud claimed that 'fur and velvet – as has long been suspected – are a fixation of the sight of the [female] pubic hair': see S. Freud, 'Fetishism', in idem, *On Sexuality*, vol. 7 of The Pelican Freud Library (Harmondsworth, 1984), p. 354.

39 Monique Manoury-Schneider refers to the incident: 'Robert Delaunay exécute pour le hall une *Femme à la Tour* au sexe trop lisible.' See her 'Les Delaunay flirtent avec le cinéma', in E. Toulet (ed.), *Le Cinéma au rendez-vous des arts France, années 20 et 30* (Paris, 1996), p. 88. For contemporary responses see G. Ponset, 'Libre Opinion – Sur le cubisme à l'Exposition', *L'Ère Nouvelle* (3 June 1925) and L. Werth, 'Aux Arts Décoratifs – Visite à l'Ambassadeur', *L'Impartial français* (16 August 1925). A more recent account appears in Green, *Léger*, p. 298.

40 For a discussion of the privileged status of the female nude *vis-à-vis* art, see L. Nead, *The Nude: Art, Obscenity and Sexuality* (London and New York, 1992).

41 'Bergère ô tour Eiffel le troupeau des ponts bêle ce matin', from *Alcools* (1913), *Oeuvres Poétiques d'Apollinaire* (Paris, 1959), p. 39. Translated as 'O Eiffel Tower shepherdess the bridges this morning are a bleating flock', in *Apollinaire Selected Poems* (London, 1970), p. 20. See Perloff's discussion of the Eiffel Tower as an 'emblem of sexual duality' and (quoting Roland Barthes) as an object that has 'both sexes of sight ... the vantage point of seeing ... as well as an object that is seen'. Perloff, *The Futurist Moment*, p. 210. Tamar Garb discusses the sexualised imagery of the Eiffel Tower in 'Powder and paint: framing the feminine in George Seurat's *Young Woman Powdering Herself*', in idem, *Bodies of Modernity: Figure and Flesh in Fin-de-Siècle France* (London, 1998), pp. 114–43.

42 Cendrars, 'The Eiffel Tower', in Cohen *The New Art of Color*, p. 174.

43 'Pour le Simultané Delaunay, à qui je dédie ce poème,
 Tu es le pinceau qu'il trempe dans la lumière'
 'For the Simultaneous painter Delaunay, to whom I dedicate this poem
 You are the brush he dips in light'
 'Tour/Tower' (August 1913), in W. Albert (ed.), *Selected Writings of Blaise Cendrars* (New York, 1966), pp. 144–5.

44 A. Hollander, 'Mirrors', in her *Seeing Through Clothes* (Berkeley, Los Angeles and London, 1993), pp. 392–3.

45 Damisch, *Judgment of Paris*, p. 142. For a recent feminist reading of a three graces motif (Della Grace's 'The Three Graces'), see P. Adams, *The Emptiness of the Image: Psychoanalysis and Sexual Difference* (London, 1996), ch. 9, 'The three (dis)graces' and 10, 'The bald truth'.

46 See also Abigail Solomon-Godeau's related arguments in relation to the nineteenth century: 'The other side of Venus: the visual economy of feminine display', in V. De Grazia with E. Furlough (eds), *The Sex of Things: Gender and Consumption in Historical Perspective* (Los Angeles and London, 1993).

Notes to Chapter 9

Sincere thanks to Pierre Buraglio, Galerie J. & J. Donguy, Julia Hontou, Jean Lancri, Laurent Mercier, Jacques Miège, Alain Oudin, Maxime Sigaud and Adrian Sina.

1 Marcel Paquet, *Michel Journiac. L'Ossuaire de l'Esprit* (Paris, 1977), p. 7.

2 Rachilde, *Monsieur Venus*, 1889 (Paris, 1977), trans. L. Heron, preface M. Barrès, afterword M. Johnston (Sawtry, 1992), p. 4.

3 Rachilde was alternatively described as 'a virgin who was I believe quite out of her depth' by Maurice Barrès, in his preface, *ibid.*, p. 4.

4 *Ibid.*, see pp. 28, 31–2, 53, 62, 66–7, 121, 125.

5 Journiac's penchant for Rachilde was confirmed by the artist's friend, M. Jacques Miège.

6 Paquet, *Michel Journiac*, p. 73.

7 See Roland Barthes, *S/Z* (Paris, 1970), trans. R. Miller (London, 1975).

8 See C. Robinson, *Scandal in the Ink. Male and Female Homosexuality in Twentieth-Century French Literature* (London, 1995). Genet's play *Les Paravents (The Screens)* (1961) (performed 1966) and Guyotat's *Eden, Eden, Eden* (1970), trans. G. Fox (London, 1995) were both critiques of the Algerian war involving explicit homoeroticism and gay sex (Guyotat's book was banned for eleven years).

9 C. Beurdeley, *L'Amour Bleu* (1977), trans. M. Taylor (Cologne, 1994).

10 M. Foucault, *La volonté de savoir* (Paris, 1976), *The History of Sexuality, an Introduction* (London, 1980), and *Herculine Barbin, Being the Recently Discovered Memoirs of a Nineteenth-century French Hermaphrodite* (1978), intr. M. Foucault, trans. R. McDougall (Brighton, 1980).

11 See M. Foucault, *The Uses of Pleasure* (1984), vol. 2 of *The History of Sexuality*, trans. R. Hurley (Harmondsworth, 1986), pp. 53, 40, 250.

12 G. Dorfles, *Il Kitsch, antologia del cattivo gusto*, ed. G. Mazzotta (Milan, 1969), *Le Kitsch, un catalogue raisonné du mauvais goût* (Paris, 1978), with H. Broch, 'Quelques remarques sur le problème du kitsch' (1950–51, published 1955), pp. 58–82 and C. Greenberg, 'Avant-garde et kitsch' (1939), pp. 122–34. See also J. Sternberg, *Chefs-d'oeuvres du Kitsch* (Paris, 1971).

13 *La Venus de Milo ou les dangers de la célébrité*, Ready Museum, Brussels, and Musée des Arts Décoratifs, Paris, Palais du Louvre, Pavillon de Marsan (1973), unpaginated; reviewed by M. Conil Lacoste, *Le Monde* (26 January 1973).

14 For Kenneth Koch's *The Construction of Boston*, directed by Merce Cunningham at the Maidman Playhouse, New York, 4 May 1962, see A. Dempsey, *The Friendship of America and France, A New Internationalism, 1961–1965* (Ph.D., University of London, 1999), ch. 5. pp. 138–47.

15 Paquet, *Michel Journiac*, p. 99.

16 'One reads in Macrobius that the statue of Venus in Cypress represents her with women's clothes but as tall as a man, with a beard, leading one to think, he says, that she has two sexes.' 'The Celestial or Uranian Venus of the Greeks, the Syrian Venus, apparently possessed the two sexes, the ceremonies of her cult were various and for the celebrations mens' or womens' clothing was used according to the circumstances' (Macrob. Saturn. III. c. 8.), in G. de la Chau, *Dissertation sur les attributs de Vénus* (Paris, 1776), pp. 20 and 51, with illustrations of the ithyphallic 'Vénus Celeste ou Uranie'. Doubled gods, the bearded Aphrodite and bald Etruscan Venus, studied by Marie Delcourt in *Hermaphrodite: mythes et rites de la bisexualité dans l'Antiquité classique* are discussed by Catherine Clément, in 'Mythe et sexualité', *Miroirs du Sujet*, 10/18 (Paris, 1975), pp. 76–9 (reproduced from *Critique*, special Marie Delcourt number).

17 'Entretien avec Michel Journiac', *Artitudes* (8–9 July 1972), in F. Pluchart, *Art Corporel* (Paris, 1983), pp. 78–9.

18 See R. P. Conner, *Blossom of Love. Reclaiming the Connections between Homoeroticism and the Sacred* (San Franscico, 1993).

19 Manzoni's work with eggs, balloons, naked women, etc., are framed by his parodies of the mass, 'signing' (blessing) and distributing bread, working with shroud-like white linen, etc.

20 Journiac consistently lied about his age, giving his birthdate as 1943. His C.V. mentions 'Licence de philosophie scolastique, licence d'ésthétique, maîtrise spécialisee d'esthétique, DEA d'ésthétique, Preparation d'un doctorat ésthétique: "Le corps sociologique"... 1973-5: Maître de conférences de l'Histoire de l'Art, Ecole des Beaux-Arts de Versailles.' From 1972, Journiac taught at the Université de Paris-I Panthéon-Sorbonne, UER d'Arts Plastiques et Sciences de l'Art.

21 Unpublished letter (typescript), dated 'Damas: mai 1962 / juin 1962', communicated to me by M. Jacques Miège.

22 See V. -E. Guitter, 'La blessure négligée', in *Michel Journiac. Rituel de transmutation 'du corps souffrant au corps transfiguré'* (Châteauroux, 1994), p. 5.

23 These paintings, salvaged by Journiac from a destroyed body of work, are illustrated in Paquet, *Michel Journiac*, pp. 28–9, 32–3, 40–1. They may be stylistically affiliated to the work of Paul Rebeyrolle, Louis Fernandez and Bernard Requichot.

24 'Parcours – Piège du sang', October 1968, consisting of *Porte, Portique, Autel I and II, Autel circulaire, Icones petit model, Icones grand model.*

25 M. Journiac, *Le Sang Nu*, preface J. Cassou (Paris, 1968), unpaginated; dedicated to his brother Jean.

26 '*Transformer Aspekte de Travestie*, Lucerne, Kunstmuseum, included Urs Luthi, Castelli, Juergen Klauke, Werner Alex Meier, Ist, Alex Silber, Luigi Ontani, Marco, Pierre Molinier from France, Andrew Sherwood, Andy Warhol's women (sic), Eno (Brian Eno), Mick Jagger. For the title, see Lou Reed, *Transformer*, produced by David Bowie and Mick Ronson, RCA International, 1972 (thanks to Nick Adams for this source).

27 G. Hocquenghem, 1972; *Homosexual Desire. Guy Hocquenghem* (1972), trans. D. Dangoor, preface J. Weeks, intro. M. Moon (Durham and London, 1993). See also G. Hocquenghem, *L'Après-mai des faunes. Volutions* (Paris, 1974).

28 See G. Hocquenghem, *Race d'Ep! Un siècle d'images de l'homosexualité* (Paris, 1979), pp. 158–60. The macho gay American leather-look is dated to 1976 in J. Girard, *Le Mouvement homosexuel en France, 1945–1980* (Paris, 1981), p. 115.

29 'Adresse à ceux qui se croirent "normaux"', 'Adresse à ceux qui sont commes nous', *Tout* (review directed by Jean-Paul Sartre), 12 (23 April 1971), in Hocquenghem, *L'Après-mai des faunes*, pp. 143–5.

30 Hocquenghem, *Race d'Ep!*. Chapters involve artists such as Elisaar von Kupfer; the photographer Wilhelm, Baron van Gloeden, Magnus Hirschfeld's photographed case histories, photographic reportages from 1930s Germany, and a plethora of cartoons accompanied by both historical and fictional writing.

31 For the changing legal situation from Vichy through to the 1970s, see Robinson *Scandal in the Ink*, pp. 2–5.

32 Girard, *Le Movement homosexuel*, pp. 142–5.

33 *Ibid.*, pp. 150–5: 'David et Jonathan. Christianisme et homophilie, un menage difficile'; p. 153 details the denunciation of 'grave depravity' by the 'Congregation for the Doctrine of Faith', 1976, and the furore generated by Roger Peyrefitte's revelation of Pope Paul VI's own homosexuality. The 'Centre du Christ Libérateur', 1976, and its

research into the pastoral problems of homosexuality sponsored by the Ecumenical Council of Churches in Geneva, is discussed pp. 159–60.

34 The testimony or 'témoignage' now given full weight in the context of Holocaust studies, has yet to be reconciled with dominant approaches within gay/feminist psychoanalytic theory.

35 See the substantial catalogue by Charles Dreyfus, *Happenings & Fluxus*, Paris, Galerie 1900–2000 (1989) (Journiac is not included).

36 *Piège pour un voyeur,* June 1969, cage of fluorescent tubes, life-size photographs of a 1.80 x 1.25, polaroids as requested, portrait with blood and individual acrylicised clothes. The complexity of Journiac's parodies of Duchamp extending from chequesigning (after Yves Klein) to electoral posters, parodying De Gaulle's fateful referendum in 1970, acknowledging Duchamp's 'Wanted' poster (after Warhol), etc., go beyond the scope of this chapter.

37 *Messe pour un corps,* comprising a white altar and five 'portable altars' – hinged sculptures; 1) Buttocks, 2) Sex, 3) Arms, 4) Masturbation, 5) Legs.

38 Transatlantic performance with the critic and *animateur* Pierre Restany, who linked the Galerie Bonino, New York, by telephone and telex to Paris; Journiac's *boudin* recipe was promoted for a New York public.

39 *Tout* was banned by the police, and editor Jean-Paul Sartre replied to the charges with much publicity.

40 'Parodie d'une collection', April 1971: see Journiac's full list in *Artitudes*, 6-8 (December 1973–March 1974), p. 26.

41 *Artitudes*, 1 (October 1971), 'Le corps matériel de l'art'.

42 *Hommage à Freud,* photographs mounted on formica, 75 x 50 cm.; edition of 10 for France, 10 for America; issued as poster folded into four and posted, signed 'm. j.' 'photographie: m.'.

43 The currency of the term 'masquerade' over two decades of feminist studies, deriving from Joan Riviere's 'Womanliness as a masquerade' (1929) would have had no contemporary resonances in terms of Journiac's games with 'travestissement'. Lacan's *The Four Fundamental Concepts of Psychoanalysis* (1973) (London, 1994), churlish towards both women and 'Anglo-Saxon research', does not even name Riviere when he introduces the concept in the essay 'From love to the libido', p. 193. For the Anglo-French critical history, see my essay 'Feminities-masquerades', in *Gender Performance in Photography,* New York, Solomon R. Guggenheim Museum (1997), pp. 135–55.

44 Pacquet, *Michel Journiac,* p. 86 (the Moebius strip metaphor, central to Jean-François Lyotard's contemporary description of a 'libidinal economy' was very prevalent) and Dominique Pilliard, 'Entretien avec Michel Journiac', *Artitudes*, 8–9 (July 1972), p. 28.

45 See H. Heyward and M. Varigas, *Une antipsychiatrie* (Paris, 1971), and G. C. Rapaille, *Laing* (Paris, 1972).

46 G. Deleuze, 'Préface', in Hocquenghem, *L'Apres-mai des faunes,* pp. 8–9. For similar statements by Journiac, see J. Hontou, *La photographie dans l'oeuvre de Michel Journiac,* Dossier de DEA (Paris, 1988), vol. I, p. 17 and idem, *Le conception de l'art corporel de Michel Journiac,* Mémoire de DEA (Paris, 1998), vol. II, pp. 55–7.

47 *Piège pour un travesti,* Galerie Stadler (1972). A transvestite performance was given by Gérard Castex or Jean-Pierre Casanova according to two varying accounts.

48 *24 heures dans la vie d'une femme,* Arthur Hubschmidt éditeur (Paris and Zurich, 1974). Dedicated to Dominique Pilliard.

49 See unpublished interview between *Marie-Claire* and Michel Journiac, in Hontou, *Le conception de l'art corporel*, vol. II, part III.C.1.2., p. 63.

50 Michel Journiac, 'Dix questions sur l'art corporel et l'art sociologique', *Artitudes International*, 6–8 (December 1973–March 1974), pp. 4–5.

51 See F. Crews, 'The revenge of the repressed', a critical discussion of several publications relating incest and 'incest work' to repressed, recovered and false memories: *New York Review of Books* (17 November 1994), p. 54.

52 'Prélable à l'inceste', from 'L'Acte Indécent de Michel Journiac', *Artitudes*, 21–23 (April–June 1975), p. 17 (extract), republished as 'Prélable à …', in M. Journiac, *Délit du Corps* (Paris, 1978), pp. 11–12.

53 M. Journiac, 'Espace-meurtrier du corps: Famille I, novembre, 1981', in *Méfaits d'hiver*, Paris, Musée d'Art Moderne (1982), unpaginated.

54 Hocquenghem in *Partisans* (July 1972), quoted in Girard, *Le Mouvement homosexuel*, p. 91. Girard discusses the reversibility of the politics of pride and the politics of shame, underlining the constant condition of otherness: p. 93.

55 See *Marking: Action of the Excluded Body*, 1983, and *Action: Marking in the Present, August 1993*, with texts and illustrations in *Michel Journiac: Rituel de transmutation*, pp. 24–7.

56 *Action du corps exclu*, performance curated by Blaise Gauthier, Centre Georges Pompidou, Paris (June 1983). A photograph of Journiac nursing the bloody babe accompanies the luxury boxed edition of François Pluchart's *Art corporel* (Paris, June 1983).

57 See E. de Rubercy, 'Le "je" organique de Michel Journiac', *Artitudes*, 39–44 (April–November 1977), p. 43.

58 'Rituel de transmutation, du corps souffrant au corps transfiguré' was the title of an action in twelve stages, extending from 1993 to 1995: see *Michel Journiac. Rituel de transmutation*. M. Jacques Miège confirmed that Journiac's cancer diagnosis was given in February 1993.

59 See Hontou, 'Le corps: "ouvroir de la mort"', in *La conception de l'art corporel de Michel Journiac*, vol. I, pp. 28–30, where she relates Journiac to the context of the death-games of his contemporaries, Ben, Christian Boltanksi, Gina Pane and Günther Saree in the 1970s. A discussion of works such as *Inquest for a Body* (December 1970), *Contract for a Corpse* (1972), or *Ritual for a Dead Person* (December 1975) go beyond the scope of this article.

60 Jean-Luc Moulène, *Portrait mortuaire de Michel Journiac* (16 October 1995), reproduced in Vincent Labaume, *Le Tombeau de Michel Journiac* (Marseilles, 1998).

61 For a powerful critique of the show, the catalogue *fémininmasculin: le sexe de l'art*, Paris, Centre Georges Pompidou/ Gallimard/Electa, 1995 (ed. Marie-Laure Bernadac and Bernard Marcadé) and its ambivalent relationship to the Anglo-American scene of scholarship, see Jan Matlock, 'Hedonism and hegemony: bodily matters at a loss', *Mosaic*, 30 (September 1977), pp. 211–39.

62 Quoted from the film by Simon Backes and Audrey Dubouch, *Michel Journiac, la philosophie dans le boudin* (Paris, 1994); see also M. Foucault, 'Des caresses d'homme considérés comme un art', *Libération*, 323 (1 June 1982), p. 27.

63 M. Foucault, *The History of Sexuality, vol. 1: An Introduction* (1976), trans. R. Hurley (London, 1987), p. 156.

Select bibliography

Adler, K. and Pointon, M., *The Body Imaged: The Human Form and Visual Culture Since the Renaissance* (Cambridge and New York, 1993).

Armstrong, C., 'Degas and the representation of the female body', in Susan Rubin Suleiman (ed.), *The Female Body in Western Culture* (Cambridge, Mass., 1986).

Barrell, J., '"The dangerous goddess": masculinity, prestige, and the aesthetic in early eighteenth-century Britain', *Cultural Critique* (Spring 1989), pp. 101–31.

Baskins, C., *'Cassone' Paintings, Humanism, and Gender in Early Modern Italy* (Cambridge and New York, 1998).

Bataille, G., *Eroticism*, trans. M. Dalwood (London and New York, 1987; 1st pub. 1957).

Bersani, L., *The Freudian Body: Psychoanalysis and Art* (New York, 1986).

Betterton, R., 'Maternal figures: the maternal nude in the works of Kathe Kollwitz and Paula Modersohn Becker', in G. Pollock (ed.), *Generations and Geographies in the Visual Arts: Feminist Readings* (London and New York, 1996), pp. 160–79.

Blanc, C., *Grammaire des arts du dessin* (Paris, 1867).

Buckberrough, S. A., *Sonia Delaunay: A Retrospective*, Albright-Knox Art Gallery (Buffalo, NY, 1980).

Bullen, J. B., *The Myth of the Renaissance in Nineteenth-Century Writing* (Oxford, 1994).

Burgin, V., Donald, J. and Kaplan, C. (eds), *Formations of Fantasy* (London and New York, 1986).

Butler, J., *Bodies That Matter: On the Discursive Limits of 'Sex'* (London and New York, 1993).

Camille, M., *The Gothic Idol: Ideology and Image-Making in Medieval Art* (Cambridge and London, 1990).

Chadwick, W. and Courtviron, I. (eds), *Significant Others: Creative and Intimate Partnerships* (London, 1993).

Clark, T. J., *The Painting of Modern Life: Paris in the Art of Manet and his Followers* (Princeton, 1984).

Conner, R. P., *Blossom of Love: Reclaiming the Connections between Homoeroticism and the Sacred* (San Francisco, 1993).

Cousin, V., *Du Vrai, du Beau et du Bien* (Paris, 1853).

Cusset, C. (ed.), *Libertinage and Modernity*, special issue of *Yale French Studies*, 94 (1998).

Damisch, H., *The Judgment of Paris*, trans. J. Goodman (Chicago and London, 1992).

Deepwell, K. (ed.), *Women Artists and Modernism* (Manchester, 1998).

Deleuze, G., 'Coldness and cruelty' (1967), in G. Deleuze/L. von Sacher-Masoch, *Masochism* (New York, 1991).

Demoris, R., 'Esthetique et libertinage: amour de l'art et l'art d'aimer', in F. Moureau and A.-M. Rieu (eds), *Eros philosophique. Discours libertins des lumieres* (Paris, 1984), pp. 149–61.

Dempsey, C., *The Portrayal of Love: Botticelli's 'Primavera' and Humanist Culture in the Time of Lorenzo the Magnificent* (Princeton, 1992).

Dorfles, G., *Kitsch. An Anthology of Bad Taste* (London, 1970).

Duncan, A. (ed.), 'Art and psychoanalysis', *Issues in Architecture, Art and Design*, 4, 1, (1995).

Emberley, J. V., *Venus and Furs: The Cultural Politics of Fur* (London, 1998).

Feher, M. (ed.), *The Libertine Reader: Eroticism and Enlightenment in Eighteenth-Century France* (New York, 1997).

fémininmasculin, le sexe de l'art, Paris, Centre Georges Pompidou (1995).

Fineman, J., 'The structure of allegorical desire' (1980), in A. Michelson *et al.* (eds), *October: The First Decade* (Cambridge, Mass. and London, 1987), pp. 373–92.

Foucault, M., *The History of Sexuality, vol 1: An Introduction* (1976), trans. R. Hurley (London, 1987).

Foucault, M., *The History of Sexuality, vol. 2: The Uses of Pleasure*, trans. R. Hurley (Harmondsworth, 1986).

Fuller, P., *Art and Psychoanalysis* (London, 1980).

Gallagher, C. and Laqueur, T. (eds), *The Making of the Modern Body: Sexuality and Society in the Nineteenth Century* (Los Angeles, 1987).

Gender Performance in Photography (New York, Solomon R. Guggenheim Museum, 1997).

Gilman, S., *Difference and Pathology: Stereotypes of Sexuality, Race and Madness* (Ithaca and London, 1995).

Ginzburg, C., 'Tiziano, Ovidio e i codici della figurazione erotica nel '500', in *Tiziano e Venezia: Convegno Internazionale di Studi, Venezia, 1976* (Venice, 1980), pp. 125–35.

Gombrich, E., 'Botticelli's mythologies: a study in the Neo-Platonic symbolism of his circle', in idem, *Symbolic Images: Studies in the Art of the Renaissance* (London, 1985; 1st pub. 1972).

Gronberg, T., *Designs on Modernity: Exhibiting the City in 1920s Paris* (Manchester and New York, 1998).

Gross, K., *The Dream of the Moving Statue* (Ithaca and London, 1992).

Grosz, E., *Volatile Bodies: Towards a Corporeal Feminism* (Bloomington, 1994).

Harrison, C., Frascina, F. and Perry, G., *Primitivism, Cubism and Abstraction: The Early Twentieth Century* (London and New Haven, 1993).

Havelock, C. M., *The Aphrodite of Knidos and her Successors: A Historical Review of the Female Nude in Greek Art* (Ann Arbor, 1995).

Heinrichs, K., *The Myths of Classical Lovers in Medieval Literature* (University Park, Pa. and London, 1990).

Hocquenghem, G., *Homosexual Desire: Guy Hocquenghem*, trans. D. Dangoor, preface J. Weeks, intro. M. Moon (Durham and London, 1993).

Hollander, A., *Seeing Through Clothes* (Berkeley, Los Angeles and London, 1993).

Hontou, J., *La photographie dans l'oeuvre de Michel Journiac*, Dossier de DEA Paris-I, Sorbonne (1988), 2 vols; *Le conception de l'art corporel de Michel Journiac*, Mémoire de DEA Paris-I, Sorbonne (1998), 2 vols.
Hunt, L. (ed.), *Eroticism and the Body Politic* (Baltimore and London, 1991).

Irigaray, L., 'The "mechanics" of fluids', in idem, *This Sex Which is Not One*, trans. Catherine Porter (Ithaca, 1985).

Jordanova, L., 'Natural facts: a historical perspective on science and sexuality', in C. MacCormack and M. Strathern (eds), *Nature, Culture and Gender* (Cambridge, 1980), pp. 42–69.

Kampen, N. B. (ed.), *Sexuality in Ancient Art* (Cambridge, 1996).
Klein, M., *Envy and Gratitude and Other Works 1946–1963*, intr. H. Segal (London, 1988).
Kristeva, J., *Powers of Horror: An Essay on Abjection* (1980), trans. L. S. Roudiez (New York and London, 1982).

Lapalanche, J. and Pontalis, J. B., *The language of Psychoanalysis* (London, 1988).
Laqueur, T., *Making Sex: Body and Gender from the Greeks to Freud* (Cambridge, Mass. and London, 1990).
La Vénus de Milo ou les dangers de la célébrité, Ready Museum, Brussels, and Musée des Arts Décoratifs, Paris, Palais du Louvre, Pavilion de Marsan (1973).
Lindner, I., Schade, S., Wenk, S., Werner, G. and Wechsel, B., *Konstruktioinen von Mannlichkeit und Weiblichkeit in Kunst und Kunstgeschichte* (Berlin, 1989).
Lomas, D., 'A canon of deformity: *Les Demoiselles d'Avignon* and physical anthropology', *Art History*, 16, 3 (September 1993), pp. 426–46.

Michel Journiac: Rituel de transmutation 'du corps souffrant au corps transfiguré', (Châteauroux, 1994).
Mitchell, C., 'What is to be done with the Salonniers?', *Oxford Art Journal*, 10, 1 (1987), p. 110.
Moreau, T., *Le Sang de l'histoire, Michelet, l'histoire et l'idée de la femme au xixe siècle* (Paris, 1982).

Nead, L., *The Nude: Art, Obscenity and Sexuality* (London and New York, 1992).

Paquet, M., *Michel Journiac. L'Ossuaire de l'Esprit* (Paris, 1977).
Pardo, M., 'Artifice as seduction in Titian', in J. G. Turner (ed.), *Sexuality and Gender in Early Modern Europe: Institutions, Texts, images* (Cambridge and New York, 1993), pp. 55–89.
Perry, G., *Women Artists and the Parisian Avant-Garde: Modernism and 'Feminine' Art, 1900 to the late 1920s* (Manchester and New York, 1995).
Potts, A., *Flesh and the Ideal: Winckelmann and the Origins of Art History* (New Haven and London, 1994).
Prettejohn, E., (ed.), *After the Pre-Raphaelites* (Manchester, 1999).

Rachilde (M. Eymery), *Monsieur Venus*, trans. L. Heron, preface by M. Barrès, afterword by M. Johnston (Sawtry, 1992).

Robinson, C., *Scandal in the Ink: Male and Female Homosexuality in Twentieth-Century French Literature* (London, 1995).

Rocke, M., 'Gender and sexual culture in Renaissance Italy', in J. C. Brown and R. C. Davis (eds), *Gender and Society in Renaissance Italy* (London and New York, 1998), pp. 150–70.

Rosand, D., 'So-and-so reclining on her couch', in R. Goffen (ed.), *Titian's 'Venus of Urbino'* (Cambridge and New York, 1997), pp. 37–62.

Rose, J., *Sexuality in the Field of Vision* (London, 1986).

Ruggiero, G., *The Boundaries of Eros: Sex, Crime and Sexuality in Renaissance Venice* (Oxford, 1985).

Sacher-Masoch, L. von, *Venus In Furs* (1870), in G. Deleuze/ L. von Sacher-Masoch, *Masochism* (New York, 1991).

Salomon, N., 'The Venus Pudica: uncovering art history's "hidden agendas" and pernicious pedigrees', in G. Pollock (ed.), *Generations and Geographies in the Visual Arts. Feminist Readings* (London and New York, 1996), pp. 69–87.

The Sexual Subject: A Screen Reader in Sexuality (London, 1992).

Sheriff, M., *Fragonard: Art and Eroticism* (Chicago and London, 1990).

Solomon-Godeau, A., 'The legs of the countess', *October*, XXXIX (1986), pp. 65–108.

Solomon-Godeau, A., 'The other side of Venus: the visual economy of feminine display', in V. De Grazia with E. Furlough (eds), *The Sex of Things: Gender and Consumption in Historical Perspective* (Berkeley, Los Angeles and London, 1993).

Sonia & Robert Delaunay, Bibliothèque nationale de France (Paris, 1977).

Suleiman, S. R., *The Female Body in Western Culture: Contemporary Perspectives* (Cambridge, Mass. and London, 1985).

Talvacchia, B. L., *Taking Positions: On the Erotic in Renaissance Culture* (Princeton, 1999).

Weir, D., *Decadence and the Making of Modernism* (Amherst, 1995).

Witzling, M., *Voicing our Visions* (London, 1992).

Wolff, J., *Feminine Sentences: Essays on Women and Culture* (Cambridge, 1990).

Woodall, J., 'Love is in the air: amor as a motivation and message in seventeenth-century Netherlandish painting', *Art History*, 19, 2 (1996), pp. 208–64.

Wright, E. (ed.), *Feminism and Psychoanalysis: A Critical Dictionary* (London, 1992).

Index

Note: A page range shown in italics indicates that an illustration is contained within that page range; 'n.' after a page reference indicates a note on that page.